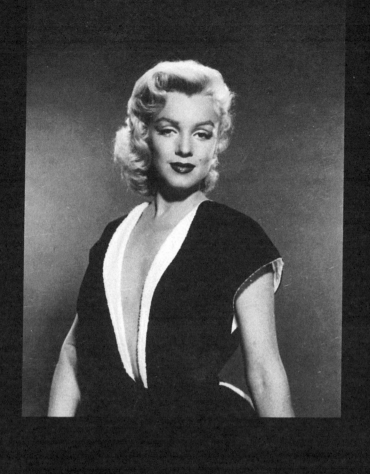

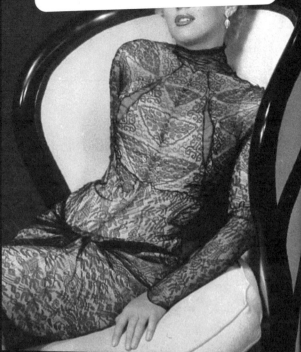

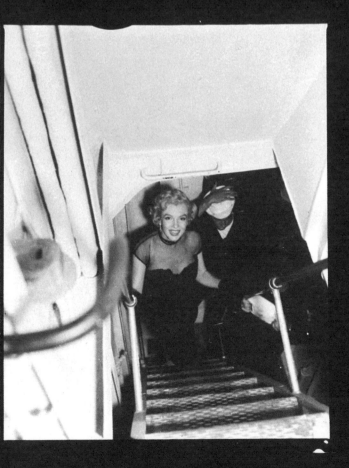

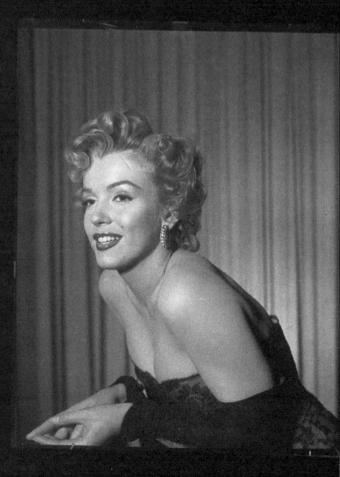

MM—PERSONAL

MM - PERSONAL

MM–PERSONAL

from the Private Archive of

MARILYN MONROE

BY LOIS BANNER

PHOTOGRAPHS BY MARK ANDERSON

ABRAMS, NEW YORK

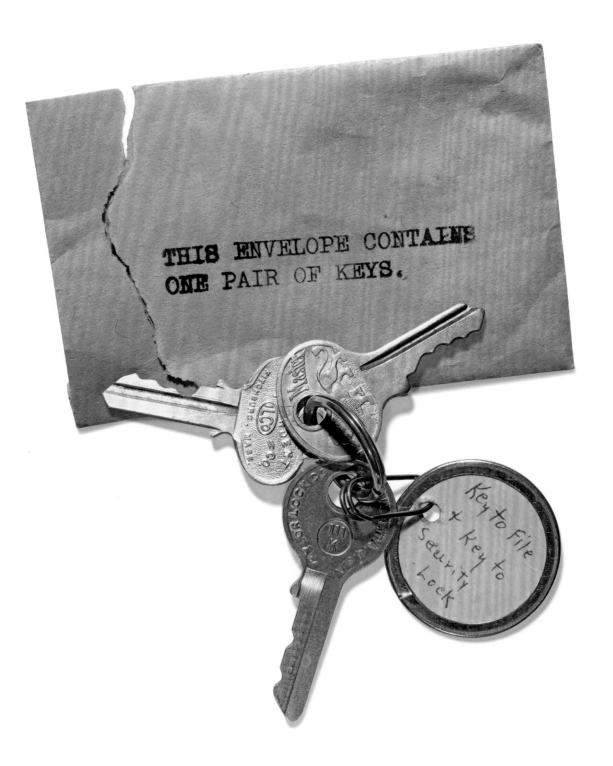

CONTENTS

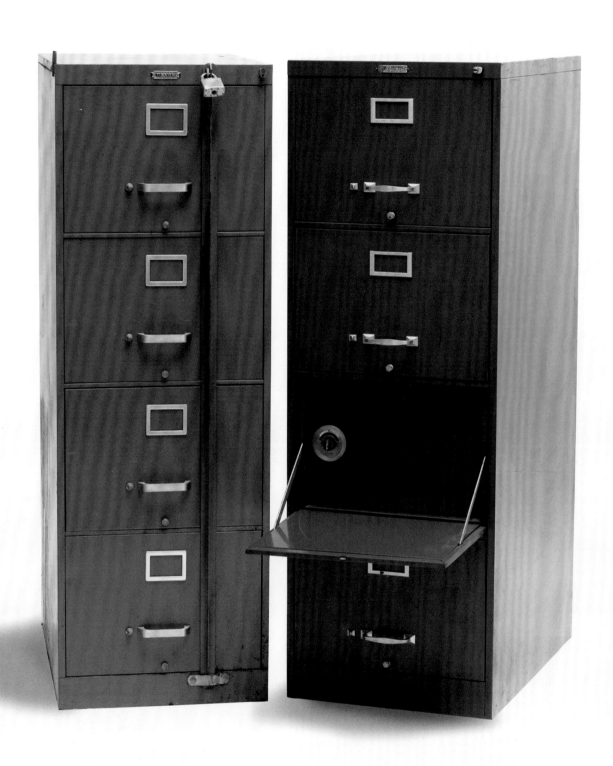

Monroe was an infinity of character and mystery that
was impossible for me, or anyone else, to explore, because
it was so vast. There is always more and more and more.

—MAURICE ZOLOTOW[1]

INTRODUCTION

Two file cabinets—one tan and one gray—stand tall and commanding, like sentinels guarding their contents. A safe has been built into the third drawer down on the gray cabinet for added protection. Most of the items in these cabinets are arranged in file folders; *MM—Personal* is the name on one folder. The cabinets contain some five thousand documents and photographs, including letters, telegrams, business cards, bills, receipts, financial records, and four hundred checks, each signed by the most renowned female icon of the twentieth century: Marilyn Monroe. These are Marilyn's personal archives, the Monroe Collection, thought to be lost for more than forty years.

Kept in private hands since her death, the Monroe Collection has never before been seen by the public. It is the largest single collection of Marilyn materials still existing in one location. It was long thought to be the Rosetta Stone of Marilyn scholarship, the one source that might unlock the mysteries of her life and death. It isn't quite as definitive as that, but what it does reveal about Marilyn, from her childhood to her death, constitutes a new and invaluable biographical resource that helps us to better understand both her public and private lives.

The story of these cabinets and their rediscovery begins with Inez Melson. Inez was Marilyn's business manager from 1954 to 1956 and the guardian of Marilyn's mother, Gladys Baker Eley—diagnosed as schizophrenic and placed on and off into mental institutions—from 1954 to 1967. Inez was also the administrator of Marilyn's Los Angeles estate after her death. The story ends with the collaboration between Mark Anderson, a photographer, and me, a writer and university professor of history.

Joe DiMaggio first brought Inez into Marilyn's life. He met her through his lawyer, Loyd Wright Jr., and later recommended her to Marilyn in October 1953, after the death in late September of Grace Goddard, Marilyn's childhood guardian, who had helped her with business matters for the past several years.[2] Given the huge success that Marilyn had achieved by 1953, Joe realized that she needed to hire a professional to manage her finances, not another family member. Marilyn had issues with Joe, but she trusted his business instincts—Joe was an excellent businessman.

Joe saw Inez as someone who could protect and support the often fearful, often fragile Marilyn. Inez was a "man's woman" who knew baseball stats and liked to go hunting and fishing—major interests of Joe's—and she could provide him with another link to Marilyn among the growing coterie of advisers who surrounded her. And Inez was friendly with Sidney Skolsky, the dean of Hollywood reporters, who was close to Marilyn and whom Joe liked. Suspicious by nature, Joe didn't make friends easily, but he took to Inez.

Kind and well-spoken, deferential and discreet, Inez could also be tough and assertive when necessary. She ran a successful business as an insurance broker and business manager, with Hollywood clients and an office on Sunset Boulevard, only a few blocks from Marilyn's apartment on Doheny Drive in Beverly Hills. With dark hair and high cheekbones inherited from a Cherokee great-grandmother, Inez was a dead ringer for Margaret Dumont, the haughty aristocrat in several Marx Brothers comedies.

On October 30, 1953, five days before the glittering Hollywood premiere of *How to Marry a Millionaire*, Inez came to Marilyn's Beverly Hills apartment to interview for the position of business manager. She was charmed when Marilyn offered her a cup of tea and then made it herself in her small kitchen, but she was surprised that Marilyn didn't have a maid or a large apartment, as most major stars did. Like most everyone else, Inez instantly felt compelled to protect her. "I loved her from the moment I met her," Inez stated in an interview with Barry Norman of the BBC. "She seemed like a fluffy toy."[3]

Marilyn hired Inez on the spot; given the demands of her career, she didn't have much time to devote to such decisions. Knowing from Joe that Marilyn couldn't stand being controlled, Inez was gentle with her. Shortly after their first meeting, Marilyn asked Inez to oversee Gladys's care, and Inez agreed, impressed that Marilyn supported her mother financially, since under California law a child abandoned by both parents before the age of sixteen was not required to do so.

On January 14, 1954, Joe and Marilyn were married in a civil ceremony at the city hall in San Francisco, where Joe had been raised and which he still considered his home. Inez found them

Telephone: WHitehall 4-1948

88971
Inv. 23803

Empire Office Furniture Company

NEW AND USED
=== WOOD AND STEEL OFFICE EQUIPMENT ===
BOUGHT AND SOLD

100 PINE STREET, NEW YORK 5, N. Y.

Date January 31, 1958

Marilyn Monroe Productions, Inc.
444 East 57th St.
New York City
 Att: Miss Reis

Your Order No. Terms: Net 10 days

1	File with lock gray - 3 legal drawers and 1 vault	85	00
	3% City Sales Tax	2	55
		87	55

96
4/30/58

#38533
Apt. 13 E

Ownership of merchandise described above is vested in Empire Office Furniture Co. until paid.

a house to rent in Beverly Hills that June, when Marilyn returned to Hollywood to film *There's No Business Like Show Business*. As the marriage rapidly fell apart, Joe was often gone, flying to New York for his job as a TV newscaster for baseball games or going to San Francisco to see his birth family. Inez spent many evenings with Marilyn—although Marilyn was often with her acting coach, Natasha Lytess, studying scripts and preparing roles, or with her singing coach, Hal Schaefer, a jazz pianist and composer who was her lover.

On several occasions Marilyn went to Inez's house in the Hollywood Hills, surrounded by woods, to play with the parakeets that Inez raised and trained—she had a play station for them in her living room. She also watched the deer and squirrels that lived in the woods and came into Inez's backyard to eat the food that Inez put out for them. Marilyn, who loved nature and animals and enjoyed Inez's birds, later acquired two parakeets of her own.

On October 5, 1954, soon after returning to Hollywood from a week of location shots in New York for *The Seven Year Itch*, Marilyn publicly announced that she and Joe were separating. Inez was deputized to answer the phone inside the DiMaggio-Monroe home and to deal with the crowd of reporters that showed up outside, waiting for Marilyn to appear. She also testified on Marilyn's behalf at her divorce hearing three weeks later. Inez cited an incident in which Joe refused to take Marilyn to the racetrack with him; he didn't want to sit in the box seats unnoticed while she attracted all the attention—Inez considered the incident trivial, but it had upset Marilyn. In her divorce action, Marilyn brought more substantial charges: that Joe withdrew into silence for days at a time and that he refused to let her invite her friends to their house. She didn't mention his physical abuse of her. A masculine man, raised in an Italian fisherman's family with roots in Sicily, Joe was offended by Marilyn's sexual displays and lashed out against her physically, as well as verbally. He was suspicious of Marilyn's relationship with Hal Schaefer, but he didn't raise the issue in the divorce hearing, which he didn't attend.

Once Marilyn and Joe separated, Inez helped Joe clean out the Beverly Hills home and store their possessions, some of which ended up in Inez's house (Joe apparently left cartons of possessions with Inez that he never retrieved). When Marilyn moved to New York in December, Inez sold Marilyn's car and got her out of a lease she had impulsively signed on a Hollywood apartment. Joe was bereft after Marilyn left Los Angeles, and he came to Inez for a shoulder to cry on. In a letter to Joe, Inez called Marilyn "our baby."[4]

In December 1955, Inez resigned her position as Marilyn's business manager because, she said, Marilyn's finances had become too complicated for her to handle. She would later regret the decision, but at the time she probably realized that, living in Los Angeles, she was too distant from Marilyn's other advisers, who were mostly in New York.

She also may have wanted to exit from the politics of Marilyn Monroe Productions (MMP), the company that Marilyn had formed in December 1954 with photographer Milton Greene to produce her films and gain some independence from Twentieth Century-Fox, the studio with which she was under contract.[5] After a year of negotiations, Marilyn signed a new contract with Fox on New Year's Eve 1955. During these negotiations, Inez worked closely with Frank Delaney, the lawyer for Milton Greene and MMP. Once the contract was signed, Delaney resigned from MMP because of what he claimed was Marilyn's poor treatment of him. Inez's resignation as Marilyn's business manager coincided with Delaney's resignation, suggesting that he influenced her.[6]

From then on, Marilyn remained friendly with Inez but pulled back from their earlier intimacy. "Once Marilyn moved to New York," Inez told Barry Norman, "we didn't have as much contact as we formerly had." Inez did occasionally continue to give Marilyn financial advice, report to her about Gladys, and exchange information about Bobo and Butch—parakeets that hairdresser Sidney Guilareff had given to Marilyn in the summer of 1958 when she came to Hollywood to film *Some Like It Hot* and that Inez trained for her. When Marilyn returned again to Los Angeles in 1960 to film *Let's Make Love*, she brought Butch along with her, and Inez babysat him when he became too noisy on the set. After Marilyn moved back to Hollywood in August 1961, Inez complained to Mickey Rudin, Marilyn's lawyer in Los Angeles, that she rarely saw Marilyn, who made appointments with her and then broke them.[7]

The year before she died, Marilyn was dealing with emotional issues and probably abusing alcohol and drugs, and she failed to show up for a lot of appointments. But Inez suspected that Marilyn's assistants kept them apart. She told Barry Norman that Patricia Newcomb, Marilyn's press agent, acted like Marilyn's keeper and kept Inez at arm's length. When she read Marilyn's interview in *Life* magazine published on August 3, 1962, Inez worried about her emotional state: "I just wanted to run up to that house [Marilyn's home in Brentwood] and pound on the gates to get in."[8]

On August 4, 1962, at some point between 9:00 PM and midnight, Marilyn died in her Brentwood, California, home, from an overdose of the barbiturate Nembutal—probably self-administered—together with a lot of the sedative chloral hydrate. The official story was that Eunice Murray, Marilyn's companion and sometime housekeeper, discovered her body at 3:30 AM and called Marilyn's psychiatrist, Ralph Greenson, informing him that Marilyn was dead. It was Greenson who called the police at 4:30 AM. In several interviews, Inez placed herself at the house. She told Marilyn biographer Fred Guiles that Mickey Rudin had arrived at Marilyn's house soon after the police, that he called her to come over, and that they waited together for the coroner to arrive. She also told Guiles that the numerous pill bottles on Marilyn's bedside table had shocked her so much that she had wanted to throw them all out, but she hadn't.[9]

She told Barry Norman a different story. In this tale, she wasn't at Marilyn's house the night of her death. Rather, she first went to the house on August 6, the Monday after Marilyn died. The house was sealed, she said, but an assistant coroner let her in. The pills were still on the bedside table, and she flushed them down the toilet and threw the pill bottles in the trash. The problem with this story is that, soon after the police arrived at the Brentwood house in the early morning hours of August 5, they confiscated most of the pills and the pill bottles. They couldn't have been there the next day. If Inez had removed any of them, she had to have done it before the police arrived.

A Melson family legend about Inez's involvement in the events surrounding Marilyn's death offers a third version of the story. In this scenario, Mickey Rudin arrived at Marilyn's house at midnight on the night Marilyn died and immediately called Inez, because she was the only person he could think of who possessed the combination to the safe in the gray file cabinet, and he wanted to remove all incriminating evidence about the death from the safe. No independent source supports this family story, nor did Inez relate any of it to her two interviewers. Nor is there any explanation as to why Marilyn would have given Inez the combination to the safe. But the family story places Inez at the center of a cover-up that supposedly occurred. Inez may have provided a clue when she told Barry Norman that she and Eunice Murray were at odds during the last summer of Marilyn's life, but that "I can't tell you what it was that happened." Unfortunately, Norman didn't press Inez further.

Mickey Rudin's first official contact with Inez was not until Sunday or Monday, because, as Gladys's court-appointed guardian, she qualified as Marilyn's closest relative in Los Angeles and could arrange for her burial. In fact, Inez claimed that it was she and not Marilyn's half sister, Berniece Miracle, as most biographers assert, who signed the document releasing Marilyn's body from the morgue to be brought to the Westwood Village Memorial Park Mortuary for interment. Rudin also contacted Joe DiMaggio, and Joe and Inez together made arrangements for the funeral.[10]

Soon after the funeral, Rudin petitioned the probate court overseeing Marilyn's estate to have Inez appointed administrator ("administratrix" in the document) of Marilyn's Los Angeles holdings, which would then make her responsible for liquidating them. Once appointed, Inez took action. She sold Marilyn's house, held an auction to dispose of large items, and boxed up the remainder. She sent the boxes—and the funds realized from the auction and the sale of the house—to Lee Strasberg, head of the Actors Studio in New York and Marilyn's acting teacher, who was the major beneficiary under her will.

Here is where the file cabinets reenter our story. Marilyn initially bought them in 1958 in New York: A receipt for the gray file cabinet, dated January 31, 1958, is in one of the file folders.

The receipt notes that a "vault," or safe, had been installed in the third drawer down.[11] Marilyn kept that cabinet in the study of her New York apartment, along with the tan one, which is identified as having been there in a 1962 memo from Cherie Redmond, one of Marilyn's secretaries. At the end of January 1962, Marilyn bought the house in Brentwood after living in the small Doheny Drive apartment since the previous August. The Brentwood house wasn't large, but it had enough space for file cabinets, so she decided to ship them to Los Angeles from New York.

In mid-February she went back to New York with Cherie Redmond to sort out the files. Cherie shipped the tan file cabinet, filled with business records, to Marilyn's suite at Twentieth Century-Fox, while she shipped the gray file cabinet, filled with personal correspondence, to Norman Jeffries, a handyman at Marilyn's Brentwood house and the nephew of Eunice Murray. In a note to Jeffries, Cherie explained that the file was "steel-banded." In other words, a locked steel band had been placed around it to prevent theft. Cherie warned Jeffries: No one is to remove the band unless Marilyn is present.[12]

Soon after Inez was appointed administrator, she abandoned her disinterested stance, working to make certain that the file cabinets would wind up in her possession. She had the tan file cabinet in Marilyn's studio suite shipped to her home office. At the estate auction she had arranged, she bought the gray file cabinet for twenty-five dollars under the name of a nephew, Walter Davis. When contacted recently, Davis stated that he wasn't at the auction and that he knew nothing about the file cabinet or the use of his name. Since Inez listed her business office as his address in the forms she submitted to the probate court, it's likely that she did indeed use his name to conceal her purchase of the cabinet.

Inez also kept other posessions of Marilyn's. These included a bronze Rodin statue called *The Embrace* that Marilyn bought in May 1962 at a Beverly Hills gallery; the green sequined dress, designed by Norman Norell, that she wore in March of that year when she accepted a Golden Globe Award from the Hollywood Foreign Press Association as the "World Film Favorite"; and a Jean Louis dress made out of translucent flesh-colored silk soufflé with hand-sewn brilliants that Marilyn wore to sing "Happy Birthday" to John F. Kennedy at his forty-fifth birthday celebration at Madison Square Garden.

Not until Lee Strasberg wrote to Inez demanding the statue and the Norell and Jean Louis dresses did Inez send them to him. He didn't ask for anything else, although he complained that Inez had held the auction without consulting him. He hadn't visited Marilyn during her last year in Hollywood, so he didn't know what was in her house.[13]

Inez also may have kept furs, mementos, and a faux-alligator men's jewelry case with high-end designer jewelry in it. These items were later stored in a large wardrobe beside the

file cabinets. The jewelry case had the initials "JDiM" embossed on it in gold and a combination lock geared to the number 5—Joe's number when he played center field for the Yankees, repeated three times. Thus, we can reasonably assume that the alligator jewelry case had belonged to him and that some, if not all, of the women's jewelry contained within it had belonged to Marilyn.

We can only speculate as to why Inez kept some of Marilyn's possessions. In biographies of Marilyn, Inez is portrayed as a shadowy figure, and indeed she didn't want to be in the spotlight. One possibility is that Inez may have been motivated by what she saw as Marilyn's ingratitude for her services. In the mid-1960s, Inez claimed to have been Marilyn's only employee who didn't manipulate her for money. It's probable that Inez was honest in her dealings with Marilyn but became annoyed when she was late in paying the Rockhaven bills, forcing Inez to pay them herself. Moreover, Inez had received no financial compensation for taking care of Gladys until 1959, when Marilyn agreed to have her appointed Gladys's official guardian by the court. Even after that happened, Inez received very little compensation, while bills for Gladys weren't paid. It's also possible that Inez was angry that Marilyn didn't leave her anything in her will, and so she kept the possessions.

Why did Inez invent an elaborate ruse to keep the gray file cabinet, putting it up for auction and buying it under a nephew's name? Perhaps she didn't want anything incriminating in it to become public knowledge, and she thought she could establish an airtight justification for possessing it through its sale and purchase. Perhaps Inez was concerned about the documents in it pertaining to Gladys, whose mental issues she didn't want publicly exposed. For Gladys lived in a fantasy world in which she was a Christian Science nurse trying to help people cure themselves without using medication. She spent a lot of time reading Mary Baker Eddy's *Science and Health*, the central text of Christian Science, and in line with her nurse fantasy, she dressed in white, with white shoes and stockings, her hair tidily arranged in a hairnet.

Gladys was also hostile to Marilyn, another fact that Inez didn't want revealed to the public. In 1935, after a severe mental breakdown, Gladys was committed to Norwalk State Hospital (later named Metropolitan State Hospital) for mental disorders. In 1936 she was transferred to Agnews State Hospital, near San Jose, where she remained for nine years. Marilyn rarely visited her there; she was a child during most of these years, and Gladys was usually sullen, or argumentative. After Gladys was released from Agnews in 1945, she came to live with Marilyn in Los Angeles for a time, but the arrangement didn't satisfy her, and she went off on her own.

Then, in 1952, another tragedy caused Gladys to break down as severely as she had in 1935. John Eley, whom she had married in 1949, turned out to be a bigamist. Now she developed

the obsession that she had committed a sin by having had sexual intercourse with men, and that her daughter Marilyn—the nation's sex symbol—was deeply flawed. Fearing that Gladys might become violent, Marilyn participated in committing her to Rockhaven Sanitarium, a private facility near Glendale, where she remained until 1966. Marilyn, and then Aaron Frosch, the lawyer who managed the Monroe Estate after her death, sometimes paid Gladys's bills, but Inez often paid them out of her own funds. But Marilyn didn't visit her mother, who was liable to berate her if she showed up. Inez took over, visiting Gladys every week, supervising her care, buying her birthday and Christmas presents, and signing the cards that went along with them in Marilyn's name.[14] In keeping the contents of Marilyn's private archive out of the public eye and the historical record, Inez may have been trying to protect Marilyn's memory and the details of Marilyn's relationship with Gladys.

Another possible reason that Inez kept the file cabinets—and invented the elaborate ruse regarding the sale of the gray one—was that someone involved in the suspected cover-up asked her to do so the night Marilyn died. But did the documents contain anything incriminating? Was there anything in them about Marilyn's involvements, for instance, with the Kennedy brothers or with Twentieth Century-Fox? They don't contain such materials today.[15] Of course, it's possible that someone other than Inez removed material from the gray file cabinet the night Marilyn died. Marilyn biographers have targeted numerous possible culprits, including Peter Lawford, brother-in-law to John and Robert Kennedy; Fred Otash, a private investigator who worked for Hollywood stars; the FBI, the CIA, the Mafia, or Twentieth Century-Fox representatives. Whether or not any of these claims are correct, the file cabinets and a lot of the material that was originally in them remain today.

For forty-five years the cabinets, files, and accompanying memorabilia from Marilyn's home remained stored in Inez's Hollywood Hills home, kept from the public, with only a few documents made available to biographers. Inez died in 1986, and she left the Monroe Collection to Ruth Conroy, her sister-in-law and close friend, who had it moved to her house in Downey. After Ruth died in 2001, her son Millington "Mill" Conroy took possession of it. Conroy, a businessman who at the time was involved with a cosmetics company called Bodyology, contacted Mark Anderson, a well-known photographer whose work has appeared on the covers of more than 150 magazines, in November 2005 to photograph the collection for a book to be based on it.

A year later, after reading an article in a local paper about my interest in Marilyn, Mark invited me to Mill's house, where he now kept the file cabinets and their contents. The house was an upscale tract home in Rowland Heights, a suburban community built by developers about forty miles east of downtown Los Angeles—an unlikely location for the then-unknown Monroe Collection.

Mark, a fan of Marilyn's since his childhood in Sydney, Australia, when he saw *Some Like It Hot* and fell in love with her innocent, comic persona, had spent many months photographing the archive before my arrival. An author of feminist biographies and a history of physical appearance, I had been researching Marilyn's life for several years and immediately realized the importance of the archive. I gladly accepted an offer to collaborate with Mark on the project.

We soon suspected trouble. After months of involvement with the collection, we came to believe that Mill didn't own it, that Inez had acquired the materials illegally, and that the Monroe Estate, which is still controlled by Anna Strasberg—the third wife of Lee Strasberg—was the legal owner. But Mill was persuasive. He had a compelling manner that echoed descriptions of Inez Melson's. The two houses and numerous cars that he owned seemed to indicate that he was well-off. He talked a lot about his cosmetics company and about the years he had spent as a manager of a bank.

In fact, Anna had sued Mill in 1995 for false ownership of the Monroe materials, after he put a number of items in the file cabinets up for auction and the auction catalog came to the attention of her attorney. The jury in the case gave most of the items up for auction to Anna, but they returned a few to Mill. We pressed Mill on the matter. According to him, seven years had passed since the court case with the Monroe Estate, and he had not been contacted about any other items in his possession. Thus, by his estimation, the seven-year statute of limitations for any further litigation over the collection had been exceeded, and he owned it.

At first, we accepted his explanation, but then we decided to find the original judgment in the action between Mill and the Monroe Estate. What we discovered was that, on appeal, a judge had ruled that when Inez Melson bought the gray file cabinet under an assumed name, she had committed fraud. We consulted a lawyer, who told us that there was no statute of limitations on fraud and that Mill was probably not the legal owner of the collection.

We told Mill what we had found. Realizing that his ownership of the collection could be in jeopardy, he threatened to sell it on the black market, even though he had told us all along that he wanted to put it on display under his own name before donating it to a museum. We wanted to ensure that the Monroe Collection remained intact and that it would eventually be shown to the public, so we informed Anna Strasberg of its existence. We were not privy to her ensuing negotiations with Mill. All we know is that, in the end, they reached a settlement. The collection is now in her possession, and we thank her for her generosity in authorizing us to publish this book.

In October 2008, in its twenty-fifth anniversary issue, *Vanity Fair* published a cover story on this collection and on Mark's photos of it, titled "The Things She Left Behind." The magazine as-

sumed that the file cabinets, furs, jewelry, and other memorabilia all were Marilyn's. Even before the article appeared, I had been researching the items' history. Since then I have continued to track their provenance. I have consulted experts on Marilyn's handwriting, talked to individuals who knew Marilyn personally, and researched archives in the United States and Europe.

While I have concluded that the documents and other items in the file cabinets were definitely Marilyn's, the provenance of the items in the wardrobe is murky. There are no photos of Marilyn wearing the jewelry, and only a few receipts in the file cabinets pertain to it. It's possible that the jewelry was given to Marilyn by her many admirers and that Joe or Inez then put it in Joe's jewelry case, or that Joe gave it to Marilyn. During their courtship and marriage he gave her gifts all the time: a $10,000 fur coat, an expensive watch, a necklace of real pearls, and perhaps more. And gift-giving was endemic in Hollywood and New York; it constituted a bonding ritual to hold these often fractious communities together. Henry Rosenfeld, a wealthy admirer of Marilyn's, gave her a diamond bracelet; Laurence Olivier and Vivien Leigh gave her an expensive wristwatch at the end of filming for *The Prince and the Showgirl*; and Frank Sinatra gave her emerald earrings when they were romantically involved in 1961.[16]

It is also possible that some of this jewelry and memorabilia may have been gifts from Marilyn to Inez. Marilyn was generous to a fault, and Inez served her for a long time. Marilyn gave Natasha Lytess, her first acting coach, a car, an antique cameo brooch framed in gold, an expensive vicuna coat, and money for a down payment on a house. Patricia Newcomb, her press assistant from the summer of 1960 until her death, received a black mink coat, an automobile, and, after Frank Sinatra broke up with Marilyn in the winter of 1961, the emerald earrings that he had given her. Marilyn gave Lee Strasberg $10,000 to study Kabuki and Noh theater in Japan and Paula Strasberg a huge salary, $10,000 in stocks, and the string of pearls she had received from the Japanese emperor during her honeymoon with Joe in Japan. Arthur Miller stated that: "She was generous to a fault. She would give anything away." When Marilyn's press agent Rupert Allan cautioned her about the money she spent on gifts, she responded: "Don't worry. It's all tax deductible."[17]

There is no hard evidence that Inez sought to profit from the Monroe Collection, although the impulse to make money off of Marilyn existed even when she was alive and has flourished since her death. By the 1970s, individuals who had hardly known her were claiming to have been her lover, her best friend, or even her husband. Marilyn left neither a partner nor a husband to counter the many claims that were made, and her true friends kept quiet. Some of those friends, especially those experiencing financial difficulties, sold the gifts she had given them at auction. Over time, so many items supposedly owned by Marilyn have appeared for sale that most of them have to be fakes.[18]

The jewelry in the case with DiMaggio's initials on it has been appraised as high-end; whoever bought it was very well-off. The quality of the jewelry, considered along with the close relationship between Joe and Inez, suggests that Marilyn owned at least a portion of the collection. It is also possible that someone added the jewelry and memorabilia to the archive to increase its potential commercial value. Mark and I have included photographs of some of the jewelry and mementos in *MM—Personal*, but we have added the word "fakes" to the title of the corresponding section of the book in order to cover this possibility.

In assembling this book, Mark and I have included photos of items from my own collection of Marilyn materials, including those I purchased at the auctions of Marilyn possessions held by Bonham and Butterfields auction house in Los Angeles in 2008 and by Julien's auction house in Las Vegas in 2009. Many of the items I bought were in folders that obviously came from the file cabinets; they are the same exact size, with the same markings and labels. They indicate that someone obtained materials from the file cabinets and eventually sold them. We have also included in *MM—Personal* magazine articles and photographs not contained in the file cabinets, but only when they are referenced in letters to Marilyn or documents concerning her. Our only other addition is a never-before-seen photograph of Marilyn at a party of surfers in Malibu in 1947. In researching Marilyn's life, I met with individuals from this group who are still alive. They knew Marilyn as a young woman who came to the Santa Monica beach to be with them when they were sports idols after World War II.

Considered as a whole, the Monroe Collection contains new information about Marilyn's childhood, the years she struggled to become a star, her contract difficulties with Twentieth Century-Fox, and the internal politics of MMP. It reveals how Marilyn dealt with negative media portrayals of her and made decisions about her film roles, the photographs taken of her, and her publicity.

The collection also provides an intimate portrait of the private Marilyn: her skill at making friends, her love of animals, and her humanity and concern for others. It offers poignant testimony about the frustrations of one of the greatest film stars of all time as she attempts to combine career and marriage and to embody the very nature of femininity in the 1950s—an era in which the idea of women as innocent and erotic sex objects for men reached a twentieth-century high. We learn, for instance, that Marilyn understood the power of being a "blonde bombshell," but that she also subtly rebelled against it. Using the concealed irony that was often her style, she stated: "I love to live in a man's world, as long as I can be a woman in it."[19]

From documents in the file folders, we can construct a narrative of the clothes, books, and cosmetics that Marilyn bought, the dress designers that she frequented, and the doctors and psychiatrists that she consulted. We can see that Marilyn worried about her

appearance and her weight, and that she went to bookstores to buy books and to markets and drugstores to buy groceries, cosmetics, and pills. She had many appointments with cosmetic specialists for facial treatments—including those at Madame Renna's in Hollywood and Erno Laszlo's in New York—her soft, babylike skin was important to her look.

Letters and documents in the file cabinets further clarify the mental disturbance of Marilyn's mother and the extent to which Gladys turned against her daughter, and why it was that Marilyn avoided her. The contents of the file cabinets also reveal new truths about the circumstances leading up to Marilyn's death. We learn that Marilyn's assistants and secretaries tried to sort out her finances and keep comity in the midst of the byzantine intrigues swirling around her; they kept Inez at arm's length because they thought that yet another adviser—especially one still close to Joe DiMaggio—would only confuse Marilyn. A March 1962 letter from her press agent Patricia Newcomb, sent to Marilyn after her release from the psychiatric ward of a New York hospital, where she had been treated for suicidal depression, urges her to keep up her spirits and to know that her assistants, who are her friends, will care for her. During the last years of Marilyn's life, former teachers and friends wrote to her, complaining that they hadn't seen her—they didn't seem to realize that she was having difficulty putting her life back together again and, tragically, would never get the chance to do so.

The contents of the file cabinets also challenge the assumption that Marilyn didn't keep a record of her life. In fact, she kept bills, contracts, photographs, correspondence, and other documents. Her lawyers and accountants pressed her to keep these items, since she was often audited by the IRS and involved in lawsuits. Thus she did so—even keeping scraps of paper on which she wrote the cash amount she spent on minor expenses like lunch, postage, and drugstore purchases, which her accountants used to calculate her business expenses. In reproducing the materials from the Monroe Collection that are most relevant to a more complete understanding of Marilyn's life, our intention in *MM—Personal* is to provide the basis of a revised biography, a clarified account of her genius and her legend.

Most important, as might be expected of an archive containing Marilyn's private papers, the contents of her file cabinets paint a positive portrait of her. Overtones of her emotional difficulties are in the documents—in bills from psychiatrists, doctors, and hospitals, and in drug receipts, for example. But her correspondence with Norman and Hedda Rosten, in addition to a tribute Arthur Miller wrote to her and the many telegrams and greeting cards she received over the years, questions the negative portrayals of her in her three most recent biographies—by Jeffrey Meyers, Ted Schwartz, and J. Randy Taraborrelli.[20] All of these authors highlight her drug abuse and her mood swings to conclude that she was incapable of real maturity in friendship and marriage. Though the contents of the file folders do not refute Marilyn's drug abuse (though one might question the extent of it), they do reveal a Marilyn who had many friends.

They also contest the claim made by many writers that Marilyn didn't like to cook and never learned how to do it. In fact, in letters between Marilyn and the editor of *Ladies' Home Journal* about their friendship and Marilyn's cooking, Marilyn expresses an interest in writing a cookbook.

MM—Personal also has an aesthetic dimension. Mark and I began this project with a deep respect for Marilyn. Over the years of working on it, we have become aware of her deficiencies, but we continue to admire her achievements. As a professional photographer of women, Mark has used his skills to reveal Marilyn through the documents and possessions that were important to her. He has regarded them as landscapes haunted by the image of Marilyn. Their meanings become deeper and more multifaceted when infused by his light and dark shading, which give a special resonance to the ups and downs of Marilyn's life.

Mark has sometimes shot the letters with an image on them, or with roses or petals as a border. Marilyn loved roses and sent bouquets to friends, who sent them to her in return. The story is that she asked Joe DiMaggio to replace roses on her grave every week after she died, as Dick Powell had for his lover, Jean Harlow. Joe did so for twenty-five years.

As a scholar, a historian, and one of the founders of "second wave" feminism in the 1960s, I was drawn to Marilyn as the major historical exemplar of the sexual objectification of women that we challenged in our quest for gender equality. Yet in studying her, I came to realize that her life and career offered a significant challenge to our approach. For as much as Marilyn was a semi-pornographic object for men, she also exemplified sexual pleasure—the joy of physical expression in sensuality and in intercourse. As much as she constructed herself for the male gaze, she rebelled against that gaze, operating as an agent of her own destiny who saw herself as a sexual pioneer against the resurgent conservatism of the post–World War II era. A skilled comedian, she often burlesqued and ironically complicated her sex-goddess image. Sympathetic to workers and ethnic groups, she was a political radical by at least 1960, when she wrote to *New York Times* editor Lester Markel about her support for Fidel Castro.[21] Displaying business talent, she formed her own production company—a radical act for a woman in Hollywood. Stubborn to the core, she faced down the patriarchs who had founded the Hollywood film industry and who still exerted major control over it in the 1950s.

Yet she had no gender framework to carry her through her struggle, no way of conceptualizing her situation beyond her individual self, to encompass the broader society of women whose rights were limited in the patriarchal society of the U.S. in the 1950s. Had she lived a few years longer, into the mid-1960s, the feminist movement could have offered the concept of sexism as a way to understand the oppression she endured and the idea of sisterhood as a redemptive possibility.

In our conversations with her, Anna Strasberg told us that she would place the Monroe Collection in a museum. We hope that she will do so. Marilyn belongs to the nation. As with those of any national figure, her papers should be available to scholars and the public. In her last interview, with Richard Meryman of *Life* magazine, Marilyn said, "There aren't really any kind of monuments or museums [in Hollywood]. . . . Nobody left anything behind." The film producers who ruled the studios, she said, made "millions and billions of dollars," and "they took it, they grabbed it, and they ran."[22] Shortly before her death Marilyn donated a thousand dollars to become a founding member of a new Hollywood museum dedicated to preserving its history.

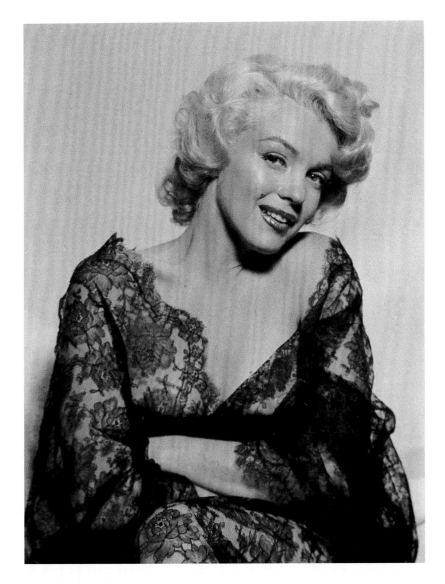

Stamp

Living
Less A

TEL. PLAZA 9-3990
TIONERY
tationers
CARDS FOR ALL OCCASIONS

474
Serial No.

IF THIS PURCHASE IS NOT
WE WILL BE HAPPY TO

Raeph

$30

00 Stam
$2

100 St
Book

BLACK STAR

Vacuum Cleaners
Electric Fans
20 EAST 58th ST.
PLaza 3-09A0
SOLD TO
ADDRESS
DELIVER TO
ADDRESS
DELIVERY DATE
QTY.
Martha Me

BRENTANO'S
BOOK SELLERS
TO THE WORLD

$ 01.95→E
$ 00.06 E
22 589.*$ 02.01TLE

MARILYN MONROE: HER LIFE

To understand the material in the file cabinets, we need to know the story of Marilyn's life and to realize that no biographer has fully appreciated the complexity of that life in the context of her genius as an actor, a singer, a dancer, and one of the greatest photographic models of the twentieth century. Nor have her obsessive ambition, her intense work ethic, and her drive for perfection and control over her self and her surroundings been fully understood. Possessed both by megalomania and its opposite, a deep inferiority complex, ruled by a mind that could be scattered and then focus in a flash, and worried that, like her mother, she might wind up permanently institutionalized, Marilyn balanced the many parts of her self in ways that were sometimes in harmony but often at odds. These parts were grounded in her childhood, her education—both in school and out of it—and the history of the times in which she lived.

*I was a mistake. My mother didn't want to have me. I guess she
never wanted me. I probably got in her way. I know I must have
disgraced her. A divorced woman has enough problems getting
a man, I guess, but one with an illegitimate baby. . . . I wish,
I still wish, she had wanted me.*

—MARILYN MONROE, *MARILYN MONROE IN HER OWN WORDS*

THE EARLY YEARS: JUNE 1926—AUGUST 1946

Marilyn Monroe was born Norma Jeane Mortenson in the charity maternity ward of Los An-
geles County General Hospital on June 1, 1926. Her father never acknowledged her, and her
mother, Gladys Baker, was a low-level, poorly paid film editor in Hollywood. Gladys named her
daughter "Norma Jeane" after a child she had once cared for—not after film stars Norma Tal-
madge and Jean Harlow, as was long presumed. "Mortenson" came from Edward Mortensen,
to whom Gladys was still married at the time of the birth, although she had left him the pre-
vious year. Soon after Norma Jeane was born, Gladys placed her with Ida and Albert Wayne
Bolender, who was called "Wayne." A childless married couple who raised foster children in
their home, they lived across the street from Gladys's mother, Della, in Hawthorne, a town
fifteen miles southwest of Hollywood, accessible by car and by the trolley system that extended
throughout the Los Angeles region.[23]

Gladys visited Norma Jeane after work and on the weekends. Sometimes she brought her
daughter to Hollywood, took her to the movies, and encouraged her to dream of becoming
a star. On a wall of Gladys's apartment was a photo of a man she said was Norma Jeane's
father. He had dark hair and coloring, and he looked like Clark Gable. For a long time
Norma Jeane thought that Gable was her father; her real father probably was Charles Stanley
Gifford, called "Stan," a supervisor at the editing studio where her mother worked.

When Norma Jeane was seven, her mother brought her to live with her in Hollywood,
buying a house near the Hollywood Bowl with money she had painstakingly saved from her
salary. To increase her income, Gladys rented out rooms in the house to a family of English ac-
tors—George and Maude Atkinson and their grown daughter, Nellie—who worked as stand-
ins for British stars appearing in Hollywood movies and who helped Gladys care for Norma

Jeane. After a few months, however, the stress of working full-time, owning a house, and caring for her daughter caused Gladys to have a nervous breakdown. It's possible that a boarder in the house sexually abused Norma Jeane, further escalating Gladys's anxiety. Gladys was diagnosed as paranoid schizophrenic, declared legally insane, and committed to Norwalk State Hospital.

Grace McKee, who was Gladys's best friend and a supervisor at the editing studio where Gladys had worked, became the legal guardian for both Norma Jeane and Gladys. She continued to take Norma Jeane to the movies and to encourage her dreams of becoming a star. So did the Atkinson family, with whom Norma Jeane lived, first in the house that Gladys owned and then in an apartment they rented, for nearly a year and a half after Gladys's breakdown. Once the Atkinsons moved back to England in June 1935, Gladys placed Norma Jeane for several months with the Harvey Giffen family. Harvey was a sound engineer at the Radio Corporation of America, and his family included a girl Norma Jeane's age; they lived near the home that Gladys had owned. The Giffens wanted to adopt Norma Jeane and take her to New Orleans with them, but Gladys refused to allow her to be adopted—she believed that she would be able to go back to work and form a family with Norma Jeane. Once the Giffens left, Grace intended to have Norma Jeane live with her permanently, but in August 1935 she married Ervin "Doc" Goddard, a sometime inventor and minor film actor. She took his last name and became the stepmother to his three children.

Coping with her new responsibilities, Grace followed the state requirement that a "half orphan" (a child whose only known parent was institutionalized) should be evaluated in an orphanage for a year before entering foster care. Thus in September 1935 she placed Norma Jeane in the Los Angeles Orphan Home (later named Hollygrove), located in Hollywood. Norma Jeane didn't like the orphanage, which she regarded as an institution like the one in which her mother lived. She wanted to be part of a family, and she continued to dream of being a movie star—proving her worth without question, never being abandoned, always being loved. Norma Jeane remained in the orphanage for a year—from September 1935 to October 1936—but by then she was so depressed that Grace took her to live with her family. A year later, however, Grace had to move her to the home of another family member, either because an inebriated Doc made a pass at Norma Jeane or because Grace had gotten a job and couldn't care for her.

In 1938, when Norma Jeane was twelve, Grace finally found an ideal place for her: with Grace's own aunt, Ana Lower. A practitioner in the Christian Science Church, Aunt Ana provided spiritual counseling to church members. Divorced and in her sixties, and with no children of her own, she was strong, centered, and caring, and she became like a mother to Marilyn. "She was all kindness and love," Marilyn later stated. "She changed my life." In the gray file cabinet Marilyn kept a letter from Aunt Ana, which is still there today. The letter is filled with loving

advice about how to overcome difficulties through persistence and faith in God. However, Ana had a heart condition, and several years after Norma Jeane moved in with her, it began acting up. At the same time, Grace and Doc had to relocate to West Virginia for Doc's job, and so a new home had to be found for Norma Jeane.

Norma Jeane was now fifteen and in her sophomore year of high school. She was shy, her grades were mediocre, and she had been a failure in school plays. World War II was under way, and tensions were high on the West Coast. Norma Jeane's voluptuous body attracted every male in sight, and Grace worried that she might not be able to handle them. What should Grace do? She had run out of family members willing to take Norma Jeane in. The only alternative seemed to be to send her back to the orphanage until she reached the legal age of eighteen.

Then Grace, always resourceful, came up with a novel scheme. Next door to the Goddards lived the Dougherty family and their son James, twenty-two years old and a local celebrity ever since he had been the quarterback of the Van Nuys High School football team, as well as student body president and a star in school plays. Grace trusted his integrity and his ability to take care of Norma Jeane. Girls were marrying at young ages during the war, and, even though she dreamed of movie stardom, Norma Jeane was not immune to adolescent fantasies of romances with high school football players—and the drama of weddings. And she was aware that Jim was a catch for a girl who was probably illegitimate and who may have inherited a tendency toward mental illness from her mother; illegitimacy and mental illness were huge stigmas in the 1940s. With Grace's encouragement, Norma Jeane dropped out of high school at the end of her sophomore year to marry Jim.

During her later climb to stardom, Marilyn reconfigured this atypical, less-than-ideal, but reasonably supportive childhood into a saga of abuse in order to gain public sympathy. Fan magazines embellished her confessions, producing further exaggeration. Ida and Wayne Bolender, for example, were effective caregivers, not religious fanatics who beat her, as these exaggerations claimed. The orphanage was caring and well-run, not a Dickensian workhouse. The foster families she lived with were part of Grace's network of family and friends, and their members weren't strangers to her when she moved in with them—she had known them through Grace. Even the marriage to James Dougherty wasn't that bad. Norma Jeane liked the wedding and arranging her new home. She later stated that she hadn't enjoyed the sex, but Jim disagreed.

In 1944, two years after his marriage to Norma Jeane, Jim joined the Merchant Marine and was shipped overseas. Like millions of other women during World War II, Norma Jeane got a job on an assembly line in an aircraft factory, becoming a "Rosie the Riveter." In 1945, David Conover, a pinup photographer shooting beautiful women on those assembly lines for the army magazine *Yank*, chanced upon Norma Jeane. Impressed by her photogenic quality, he

sent her to Emmeline Snively, head of the Blue Book Modeling Agency, one of the premier modeling agencies in Los Angeles. Snively signed her and recommended her to other pinup photographers. Her rise to success was meteoric. Within a year, photos of her were featured in the many pinup magazines for men that had been launched during the war, such as *Laff, Peek, See, Parade,* and *Glamorous Models.*

Norma Jeane's voluptuous body and her cheerleader face fit the day's pinup ideal. Big breasts, an hourglass shape, and an innocent face had come into fashion for women in the 1940s, after a decade in which thin frames and sophisticated countenances were popular. The dislocations of World War II had nurtured a sexual rebellion among the young, as well as a conservative backlash. The voluptuous body epitomized this new sexuality, while the childlike face, called the "girl next door look," made the model look virginal and suggested that her eroticism would soon be contained within marriage, thus calming conservative fears of out-of-control sex.

Photographs of seminude women had circulated sub rosa for centuries. They now went mainstream. The sexual-yet-respectable pinup—mostly Hollywood starlets in bathing suits and negligees—became a symbol of American freedom against European authoritarianism, and young men, especially the soldiers overseas, collected the photographs. As the conflicts of World War II transitioned into those of the cold war, the pinup continued to represent the innocent, carefree, and youthful United States, now pitted against the puritan and dour Soviet Union. Norma Jeane became the major symbol of the U.S. ideal—and later, as Marilyn, the major pinup of the Korean War (1950–53)—because she portrayed the innocence and sexuality better than anyone else.

As a model, she was a photographer's dream. Norma Jeane suffered from severe stage fright when she had to perform before an audience or a movie director, but it didn't appear if she spoke no lines and had no audience. Possessing indomitable energy, she could hold complex poses for a long time. Her skin had a glow that created an aura. Cinematographers called it "flesh impact" and said that they hadn't seen anything like it since Greta Garbo.

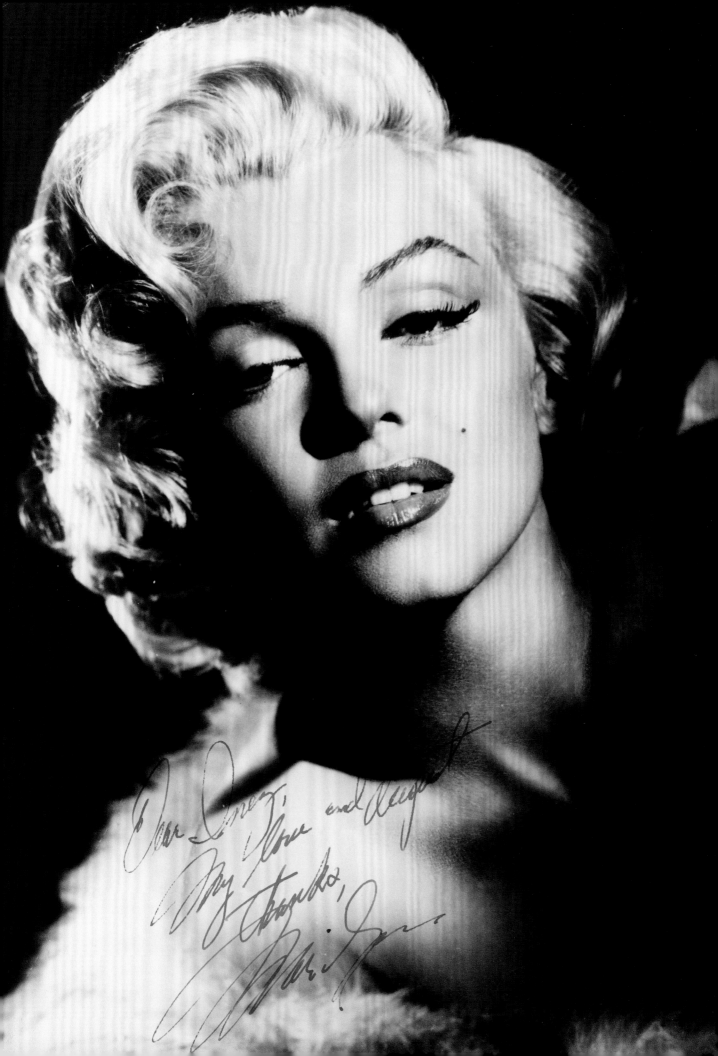

There must be thousands of girls sitting alone like me
and dreaming of becoming a movie star. But I'm not
going to worry about them. I'm dreaming the hardest.

—MARILYN MONROE, *MY STORY*

HOLLYWOOD: SEPTEMBER 1946–DECEMBER 1954

Because of her success as a model, Norma Jeane was offered a contract by Twentieth Century-Fox in August 1946. In the studio rite of renaming its new players, her name was changed to Marilyn Monroe—more euphonious and catchy than Norma Jeane Dougherty. Her new initials, MM ("m-m-m-m," when spoken aloud) gave her name a sexy lilt. Ben Lyon, head talent scout at Fox, chose the name "Marilyn," after Marilyn Miller, a 1920s star of the Ziegfeld Follies whom he thought Norma Jeane resembled. Norma Jeane herself chose the name "Monroe," her mother's maiden name. When her husband, Jim, objected to this new career, she divorced him.

Norma Jeane's "discovery" while she worked at an aircraft factory and her Hollywood name-change catalyzed both a Faustian ambition in her and a work ethic she hadn't shown as a child, as her childhood dream of Hollywood stardom suddenly seemed within reach. But signing the Fox contract was no guarantee of stardom, for many other beautiful young women signed similar contracts. The standard terms were for seven years, with the salary guaranteed for only forty weeks a year. The studio controlled everything else: roles assigned, layoffs, firing, the amount of salary paid, and any work done for other studios or for advertising agencies or television. So one-sided were the contracts that the studios could "loan out" their players to other studios for sums much larger than their contractual salaries—and then pocket the difference.

Studio executives placed their "starlets" in the "contract pool" and used them for publicity, walk-on roles, and entertaining visiting bigwigs. A few might become stars, but most were dropped after a year or two. Marilyn knew that she had to stand out, and she did everything possible to get noticed. She volunteered for extra publicity work, hounded press agents and publicists, made friends with journalists, perhaps slept with agents and producers, and used her charismatic personality to find mentors and champions.

She had a genius for making friends. Her natural combination of sex and innocence was magnetic. She often seemed like a waif needing protection, which aroused sympathy in others. As her adult personality developed out of the cocoon—or prison—of her childhood and early marriage, she began to display a joyful and infectious abandon; an ironic, self-deprecating wit; a kooky, offbeat manner; and an empathy and sadness in her eyes that seemed to come from deep within. She had a zany sense of humor, and she loved to play jokes. She was also canny and shrewd, with a will of iron, and, at times, calculating and manipulative—she could be cold and unresponsive, withdrawing into a shell. Without these traits she couldn't have survived in Hollywood.

Her mentors and champions included Joe Schenck, a cofounder of Twentieth Century Pictures (which merged with Fox Film Corporation in 1935), who was in his seventies. Makeup artist Allan "Whitey" Snyder, respected throughout his profession, did her makeup for her first screen test and later became her personal makeup artist. Sidney Skolsky, a major Hollywood columnist, plotted strategy with her. Louella Parsons, who vied with Hedda Hopper to be the doyenne of Hollywood columnists, met Marilyn at one of Joe Schenck's dinners and, completely charmed by her, always praised Marilyn in her columns. Hopper, on the other hand, often criticized her.[24]

Despite Marilyn's efforts, by the end of 1948 she had gotten nowhere. In turn, Fox and Columbia had signed her to a contract, then dropped her—Fox in August 1947, after one year, and Columbia in the fall of 1948, after six months—and Metro-Goldwyn-Mayer wasn't interested. The chief executives of these studios, Darryl F. Zanuck at Fox, Harry Cohn at Columbia, and Louis B. Mayer at MGM, regarded her as little more than a big-breasted blonde with little talent. She redoubled her efforts, studying with the best acting, singing, and dancing teachers in Hollywood. Sometimes she spent so much of her income on lessons that she hardly had enough money left for food.

From 1947 to 1949 she studied at the Actors' Lab, established by Broadway actors in Hollywood to hone their acting skills. She also studied voice with Phil Moore, an African-American musician whom she met through her friend Dorothy Dandridge, an African American and a fellow student at the Actors' Lab, who later became a film star. Once Columbia dropped her, she persuaded Natasha Lytess, head drama teacher there, to become her personal acting coach, and Lytess, who often directed her from the sidelines during filming, remained with her for six years.

Yet success eluded her until she met aging superagent Johnny Hyde at a Hollywood party on New Year's Eve 1948. A vice president of the William Morris Agency, he had mentored Lana Turner and Rita Hayworth to fame, and he later contended that he immediately saw "star quality" in Marilyn. That may be true, but the case may also be that she proved adept at seduc-

ing him and that, married for many years and with a serious heart condition, he was looking for a young lover to rejuvenate him. Nonetheless, he fell in love with her and promoted her tirelessly, taking her with him to the major Hollywood nightclubs frequented by stars and gossip columnists and showing her photographs and her movies to every producer in Hollywood.

He wanted to marry her, but she refused—she didn't love him, and she feared that such a marriage might be seen as so calculating on her part that it would cut off her chances at stardom. No matter her romantic involvements, Marilyn lived an independent life, with friends in it, many of them older women. The standard assertions of Marilyn biographers that she didn't have friends and that women avoided her because they feared that she would steal their male partners away through her sexual appeal aren't accurate. Marilyn was drawn to older women because of their wisdom and as stand-ins for her mother and for Ana Lower, who died in April 1948. For a brief time she lived with Lucille Ryman Carroll, head of the talent department at MGM, and her husband, John Carroll. She became close to Xenia Chekhov, the wife of renowned acting teacher Michael Chekhov, with whom she studied on and off from 1951 until she moved to New York in late 1954. She became close to Lotte Goslar, the world-famous mime with whom she studied in 1953 and who advised her on a number of her films.

Her closest female friend in Hollywood was probably Anne Karger, the mother of Fred Karger, who was her voice coach and lover during her six months at Columbia, where she made the inconsequential *Ladies of the Chorus*. Anne was a former vaudeville performer and a Hollywood grande dame whose husband, Max Karger, had been a Hollywood pioneer in the 1910s before his untimely death soon after. Everyone in Hollywood knew Anne. A loving matriarch, she opened her home to her grown children. Between divorces, Fred and his daughter Terry lived with Anne, and Anne's daughter Mary and her children lived with her when Mary's husband was overseas with the military. Karger family members recall Marilyn as living on and off across the street from their home, and often being in their house. Marilyn, who often felt like an orphan cast adrift, liked to become part of families, and the Kargers welcomed her into theirs. They found her sweet and loving, and they especially appreciated her zany sense of humor and her love of playing practical jokes. She came to their Sunday night songfests, their Thanksgiving and Christmas celebrations, and even their children's birthday parties. Anne gave her advice about performing and about the Hollywood film industry. In addition to Anne, Marilyn also became pals with Mary and with Fred's ex-wife, Patti, who remained close to the family after she and Fred divorced. Marilyn's romance with Fred lasted about a year, but she remained close to the Karger women for the rest of her life.[25]

Twentieth Century-Fox had initially slotted Marilyn as a girl-next-door type, then Columbia redesigned her as a glamour girl. When neither persona seemed to work, she made herself

into the sexiest actress in Hollywood, debuting this new Marilyn in a walk-on role in the Marx Brothers film *Love Happy*, soon after she met Johnny Hyde. That summer, she went on a six-city tour to publicize the film. When she didn't seem to be making much of an impression on anyone, she sparked up her visibility by telling New York columnist Earl Wilson that she wore no underwear, a revelation that caused a sensation when Wilson published it.[26] The late 1940s was an era in which most women wore molded bras, girdles, and full slips, encasing their bodies in line with the moral conservatism of the time, which was enforced by women's clubs, the Catholic Legion of Decency, and the Motion Picture Production Code Authority, the official censor of Hollywood films since its establishment in 1930. These groups all looked askance at Marilyn's displays of sexuality.

As if to contradict them, she created a fan magazine image of herself in which she was a loner who stayed home at night studying her scripts and reading literary classics, not dating actors or going to nightclubs. In this scenario, her career demands were so heavy that she rarely dated anyone except for Joe DiMaggio, after she met him in early 1952, and he was often in New York, reporting on baseball for television, or in San Francisco, visiting his family. Reporters called Marilyn the new Greta Garbo.[27]

Those fan magazine stories were far-fetched, but, like the exaggerated stories about her childhood, they weren't inaccurate. Marilyn did work hard. She didn't date Hollywood actors, and she didn't often go to nightclubs. She did read the classics; she loved books. There were a lot of well-educated people in Hollywood, and she wanted to be like them. The image of Marilyn as a reader and a loner suggested that the "real" Marilyn was different from her sexualized persona.

She underlined the desexualized version of herself when, like many young Hollywood actresses at the time, she dressed casually in jeans, T-shirts, and capri pants, clothing that anticipated the rebellious look of young women in the 1960s. In this streetwear garb, Marilyn looked like a Southern California beach girl, not a sex icon. She wore her tight, décolleté, sequined dresses only for evening events. Indeed, in 1947 she had spent a lot of time at the Santa Monica beach with Tommy Zahn, a fellow contract player at Fox and a renowned surfer. Marilyn wasn't a surfer or much of a swimmer, but she had an athletic body and rode tandem with Tommy, sitting on his shoulders or balancing on his board and holding on to him as he rode the waves. The surfers drew adolescent girls to them like magnets, and these girls lined the beach, sunning themselves and watching the wave riders. Marilyn, still a starlet at the studio, was, as Tommy Zahn's partner, the envy of them all.

By late 1949, Johnny Hyde, along with Lucille Ryman Carroll, the head talent scout at MGM, had secured a breakout role for Marilyn in MGM's *The Asphalt Jungle*, playing the young mistress of an aging lawyer for a criminal gang. The next spring Hyde called in a favor to get her cast in

Fox's *All About Eve* as an aspiring actress/call girl. Both films were hits: *All About Eve* won six Oscars and was nominated in eight additional categories. Marilyn shone in these films, playing against all-star casts. Her cultivation of friends and mentors was finally beginning to pay off.

Johnny Hyde's death in December 1950 seemed a disaster for her, but her career survived and then prospered without him. It was her good fortune that early in 1951 she was chosen Miss Cheesecake of the year by the army magazine *Star and Stripes*, and that the Fox publicity department, whose members had been charmed by her sweet, joking personality, flooded the media with photos of her. The extensive posing she had done for pinup photos was now giving her career a major boost, as were her continuing sexual shenanigans. In March 1951 she slowly walked the six blocks from the Fox wardrobe department to the photography studio to pose for publicity photos, barefoot and wearing a see-through negligee, causing a near-stampede on the lot, as all the men there rushed to watch her. Several weeks later she arrived late at a party for visiting exhibitors, wearing one of her décolleté, skintight dresses, causing stunned silence when she entered the room. She caught the eye of Spyros Skouras, a founder of Fox who controlled the studio from New York. The story is that, charmed by Marilyn, Skouras ordered Darryl Zanuck, her nemesis, to cast her in every Fox film with a young blonde character in it.

Skouras also ordered Zanuck to sign the contract that Johnny Hyde had negotiated for her before his death and that Fox had simply ignored since then. The contract wasn't exceptional: It replicated the terms of her 1946 contract, including studio control over salary, layoffs, and the roles she would play, but her salary was raised to $500 a week, with raises every six months, to a maximum of $3,500. Those sums were actually small for a major star, but Fox would continue to hold her salary down throughout her career, to the point that she was, conceivably, the poorest-paid star in the history of Hollywood.[28]

In the autumn of 1951, persuaded by Sidney Skolsky, Jerry Wald cast her in RKO's *Clash by Night*. Hers was a supporting role, but it was one in which she could demonstrate her skill as a dramatic actress. Playing a young cannery worker in the film, she was cocky and tough, an inpendent woman in the making. Natasha Lytess's coaching and the acting lessons with Michael Chekhov were producing results. When she stole the show from another all-star cast, Zanuck took heed, casting her as a psychotic babysitter in *Don't Bother to Knock*, her first dramatic starring role. But her mixed reviews for the film convinced him again that she wasn't really talented for dramatic roles, so in January 1952, he had her play a dumb blonde secretary in *Monkey Business*.

By late February of that year, a scandal had broken over a nude calendar photo of her taken in 1949 and released in 1951. As the calendar appeared on the walls of saloons and men's gyms,

it became obvious that Marilyn was the model in the photo. Fox executives held their breath: No major Hollywood actress had ever appeared nude in a public display. They pressed her to deny that she was the model, but Sidney Skolsky advised her otherwise, and he was right. Her personas as a poor Orphan Annie during her childhood and as a stay-at-home girl during her career as an actress blunted criticism, while the jokes she made about the photo rendered it amusing, not immoral. Reporters asked her, "What did you have on when the photo was taken?" "The radio," she replied. And she quipped: "I've been on calendars, but never on time." (The reference was to her lateness to almost every appointment she made, a trait continually discussed by the media.)

Within several weeks it was apparent that, instead of destroying her career, the nude photo had increased her popularity, as sales of the calendar soared and several columnists defended it. Her popularity was further evident that spring when a journalist discovered her mother, alive and well, working in a local rest home. Since Marilyn had always said that Gladys was dead, the discovery that she had lied was potentially damaging. But she survived it by explaining that she had lied to protect her mother from public exposure. Perhaps pressured by the studio, the press quickly forgot about Gladys, who was given a train ticket to visit her daughter Berniece in Florida.

Then, in early summer, Marilyn thumbed her nose at critics when she played the murderous wife in *Niagara* as a sexy film-noir villainess, competing with Niagara Falls for attention. Publicity for the film went over the top, as Marilyn was shown draped across the falls, wearing a clinging dress, with the advertising copy alluding to the mythical sirens who tempted sailors to their doom: It described Marilyn as "a Lorelei flaunting her charms as she lured men to their eternal destruction." Yet she had already been cast as a different sort of Lorelei in *Gentlemen Prefer Blondes*, in which she would play the siren as a sexual and knowledgeable naïf. That Lorelei would become her signature character.

In addition to the sensational nude calendar, Marilyn was everywhere on the screen in 1952, with the release of five films featuring her: *Clash by Night*, *We're Not Married*, *Don't Bother to Knock*, *Monkey Business*, and *O. Henry's Full House*. In early 1953, *Niagara* was released, and she made her great hits, *Gentlemen Prefer Blondes* and *How to Marry a Millionaire*. Even *River of No Return*, a Western she made at the end of the summer of 1953, was a huge box-office success. In that film she played a saloon singer who wore skimpy 1890s showgirl costumes while performing, but who donned tight blue jeans while battling river rapids and tussling with Robert Mitchum as they escaped from warlike Indians. She called it her "Z" Western, but, as in *Clash by Night*, she was bold and sassy, showing a Marilyn different from her Lorelei character.

As early as 1953, her fame was supersized. She was receiving as many as twenty-thousand fan letters a week—a new Hollywood record. Requests from reporters to interview her also hit new highs for Hollywood stars. Photographers and newsreel cameramen hounded her; she was the first major paparazzi celebrity. Her sexual double entendres, which she continued to invent, were called "Monroeisms" by the press and widely reprinted. Comic "dumb blondes" had made such comments ever since Anita Loos had created the type in her 1926 novella *Gentlemen Prefer Blondes* (the basis for Marilyn's 1953 movie). But Marilyn's were classics. A reporter asked her, "What do you wear to bed?" Her reply: "Chanel No. 5." Another asked, "Do you wear falsies?" Her answer: "Those who know me know better"—a response that was vintage Mae West. By 1953 Marilyn was being touted as "a national institution as well known as apple pie, hot dogs, and football" and "the most photographed girl in the world."[29] In June she imprinted her hands and feet in wet concrete outside Grauman's Chinese Theatre in the major rite confirming Hollywood stardom.

Norma Jeane constructed many Marilyns in these early films and photographs—as well as in her life. The basic Marilyn was the sex goddess, erotic and forthright. Another Marilyn was elegant and subdued, with the sculptured perfection of the glamour stars of the 1930s, like Marlene Dietrich or Greta Garbo. Still another Marilyn was captured by elite photographers like Eve Arnold and Milton Greene in photos that tell a story without words and that display Marilyn's gift for irony and subtle drama. In November 1953, Marilyn appeared in *Look* magazine in a series of sophisticated photos by Milton Greene, wearing a slinky silk dress and a bulky sweater, cradling a balalaika in her arms.[30] Now she was going upscale. On the other hand, Marilyn sometimes took her sexualized persona to an extreme. When she performed an outré version of Marilyn with a fish-pucker mouth, glistening lips, hooded eyes, and an undulating walk, she looked like a parody of herself.

The many Marilyns came together in her "dumb blonde" character, which was Norma Jeane's greatest creation. She perfected it as Lorelei Lee in *Gentlemen Prefer Blondes*, and she continued to play variations on it throughout her career. Her "dumb blonde" was soft, sexy, and innocent, with brilliant comic timing, a zany logic, and a childlike ability to speak elemental truths that no one else perceived. Groucho Marx called this Marilyn a combination of Theda Bara, Mae West, and Little Bo Peep.[31] When Norma Jeane added sadness to the mix, she resembled Charlie Chaplin.

Once she had achieved worldwide stardom, Marilyn became vocal about her desire to be cast in dramatic roles, but Darryl Zanuck remained determined to cast her only as an erotic/comic blonde. He refused to loan her out to other studios, even though he could have made a good profit under such arrangements. From his perspective, Fox was engaged in a life-and-death struggle with television and independent film production companies for audiences, and

casting Marilyn as a dumb blonde was a guaranteed moneymaker. Zanuck regarded her as the next Betty Grable, the box-office favorite during World War II who had played a blonde showgirl in her films again and again, and who had made millions for Fox. Marilyn was willing to play such roles if she judged their scripts to have merit and if she could play some dramatic roles as well. Her agents began negotiating with Zanuck for a new contract, but he wasn't enthusiastic about meeting her demands for more creative control over her films. Those negotiations would continue for the next two years, as Marilyn refused or put off every contract he offered her.

Marilyn upped the ante in her struggle with Zanuck when she married Joe DiMaggio in January 1954 and then turned down a role as a blonde showgirl in *Pink Tights*. She had never before refused a Fox role, and she had no right to do so under her contract. Zanuck put her on suspension, stopping her salary. Cleverly, she put her issues on hold when she went on a "honeymoon" trip with Joe in February to Japan, where he was holding baseball clinics. Then she scored two major—and unexpected—coups when Japanese fans greeted her, not Joe, with frenzied attention, and when the audiences on a four-day tour she made to ten military bases in Korea greeted her with thunderous applause and rapturous attention. She entertained a total of one hundred thousand soldiers on that tour.

Zanuck lifted the suspension as a "wedding gift" to Marilyn, but he maneuvered her into playing a showgirl in *There's No Business Like Show Business* when she returned from Japan. She didn't enjoy doing the film because she felt outclassed by the well-known singers and dancers who were her costars: Mitzi Gaynor, Dan Dailey, Ethel Merman, and Donald O'Connor. But doing that film had been a condition for Zanuck's allowing her to play "The Girl" in *The Seven Year Itch* that fall. The character in the latter was a "dumb blonde," but she had verve and a celestial quality that Marilyn liked. Marilyn correctly intuited that the film would be a hit, although she couldn't have guessed that Sam Shaw's photo of her in a scene from the film, standing on a subway grate with the exhaust from the subway blowing up her skirt, would be wired around the world and published on the front page of newspapers everywhere, establishing it overnight as a major icon of the twentieth century.

Marilyn again captured the nation's headlines when she secured a preliminary divorce decree from Joe in late October 1954. Yet Zanuck replied by ordering her to play another "dumb blonde" part in a movie that she thought had little merit. In *How to Be Very, Very Popular*, she was to play a showgirl in a hypnotic trance who hides out in a male college dormitory from killers who are stalking her. She had had enough: Breaking her contract with Fox, she moved to New York and formed her own production company with Milton Greene (acting as her collaborator and partner). Other actors were forming production companies to gain control

over their careers and lessen their tax burden, since the percentage paid on corporate prof-
its was 53 percent and the salary tax as high as 88 percent. But Marilyn was among the
first actresses to form such a company. More than that, she called her company by her own
name: Marilyn Monroe Productions (MMP). That was a radical act at the time for a woman
in Hollywood.[32]

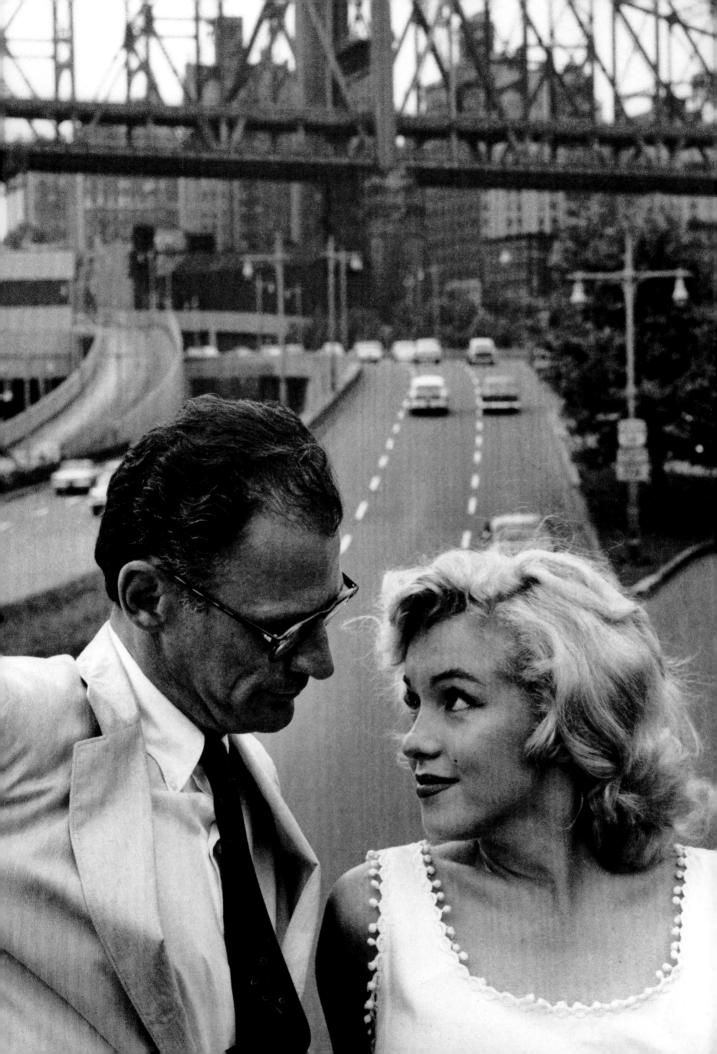

I want to be an artist, not an erotic freak. I don't want
to be sold to the public as a celluloid aphrodisiac.
It was all right for the first few years. But now it's different.

—MARILYN MONROE, *MY STORY*

THE NEW YORK YEARS: JANUARY 1954–JANUARY 1961

Marilyn was fed up with Hollywood when she moved to New York in December 1954, and she was attracted to Manhattan as the nation's center of art, theater, and fashion. Its avant-garde group of writers and actors welcomed her. She began studying acting with Lee Strasberg, cofounder and head of the Actors Studio. Strasberg was acclaimed as the founder of Method acting, in which the actor plumbs the internal self to find memories that can be used as the motivations for playing characters. To match her new life, Marilyn constructed a new, more elegant persona. She wore chic designer clothing, and she eventually decorated her apartment in white and beige with mirrors everywhere—an art deco mélange that 1930s glamour stars like Jean Harlow had used to decorate their homes.

Marilyn was also drawn to New York because it was the home of playwright Arthur Miller. She first met him in January 1951, a month after Johnny Hyde's death, when Arthur came to Hollywood to sell a screenplay he had written. Although they spent only a few days together, they had established a bond. At the time, Arthur was married—although unhappily—and Marilyn was involved with his friend, director Elia Kazan. She would marry Joe DiMaggio three years later, but she never forgot Arthur. Shortly after she arrived in New York, she began to date him, although they kept the relationship a secret because Arthur was still married.

Lee Strasberg and Arthur Miller dominated her years in New York, but, as usual, she made many friends. As was her pattern, she joined family groups—usually playing the role of beloved child, sister, or older, wiser aunt. She became close to the children in these families, as well as their parents, and all of them responded to her playfulness and her charisma. Milton Greene and his wife Amy, a high-fashion model who helped Marilyn create a new

elegant look for herself, schemed with her on her rebellion against Fox while she lived with them in Connecticut for several months. Marilyn also became close to photographer Sam Shaw and his family, poet Norman Rosten and his family, and especially Lee and Paula Strasberg and their children.

Marilyn had met Sam Shaw when she was a contract player at Fox, and she visited him and his family when she came to New York to see Joe DiMaggio during their cross-country courtship. As was the case with many of her New York friends—Arthur Miller, Lee Strasberg, Norman Rosten, Milton Greene, among others—Sam grew up in a poor New York Jewish immigrant family. Largely self-taught, Sam was a leftist populist who identified with working people and ethnic minorities, but he also liked to photograph beautiful women. With a background as a photojournalist who shot sharecroppers, coal miners, and jazz musicians, Sam often had Marilyn tone down her makeup when he photographed her so that she would be a natural beauty, not a plastic person constructed according to Hollywood artifice. Marilyn gave her close friends playful names, and she called Sam Shaw "Sam Spade," after the popular fictional detective.

Sam introduced Marilyn to Norman Rosten and his wife, Hedda, who had been friends with Arthur Miller since their undergraduate days at the University of Michigan. Hedda Rosten worked as a psychiatric social worker before she gave up her career to raise their daughter, Patricia; Marilyn would later employ Hedda as a trusted assistant. At first Marilyn viewed the Rostens as a means to reconnect with Arthur, but she was attracted by their nurturing natures and their casual lifestyle. She began attending the poetry readings they held at their house and went with them to inexpensive neighborhood restaurants and movie theaters. Marilyn, Norman stated, could put off showbiz glamour and go to a part of herself in which she was a childlike and beautiful young woman, bright and inquisitive, always asking questions.[33] Marilyn called Norman "Claude," after the actor Claude Rains, whom she thought Norman resembled.

Marilyn and Norman bonded over their shared love of poetry. Marilyn read and wrote poetry, and she memorized verses from poets she liked—Walt Whitman and William Butler Yeats, for example. She liked poems about the promise and perils of love, as well as elegies about the omnipresence of the shadow of death in life. Norman wrote: "She understood, with the instinct of a poet, that [poetry leads] directly to the heart of experience. She knew the interior floating world of the poem with its secrets, phantoms, and surprises. And somewhere within her she sensed a primary truth: that poetry is allied with death. Its intoxication and joy are the other face of elegy. Love and death, opposite and one, are its boundary—and were hers."[34]

During the spring of 1955, while Marilyn was connecting with the Strasbergs, Shaws, and Rostens, she was dating Arthur Miller. Both Marilyn and Arthur were at a transition point in

their lives, and both were looking for new directions to take. Marilyn was espousing sophistication and the well-to-do New York lifestyle, and Arthur had a house in Connecticut, essential to that lifestyle. New realms of possibilities opened to Marilyn. She was only thirty years old, still discovering who she was. She was fascinated by the world of books, and as she so often did in her quest for knowledge and fame, she linked herself to a star in that firmament. Arthur, like Sam, Norman, and Lee, could teach her about literature, poetry, drama, and politics. Under Arthur's influence, she became a committed leftist, not simply a humanitarian who identified with the underdog, as she had previously been.

By the fall of 1955, Marilyn had exceeded all her expectations in making new friends, finding a new lover, and embarking on acting lessons that might lead to a career as a dramatic actress. But there were downsides. Experiencing difficulties falling asleep at night, even when she took sleeping pills, she sometimes took a taxi to the Strasbergs' apartment in the middle of the night. Deeply depressed, once she arrived she drank champagne and took more pills, while Lee and Paula played the role of good parents, comforting her until she fell asleep. Elation and depression—Marilyn easily cycled between those two emotional states, as the scenarios of her life slowly unfolded and she was never entirely certain what the outcomes would be.

When Arthur reconnected with Marilyn in 1955 he was forty years old, facing middle age. Although he was still a radical in his politics, he was questioning the Marxism he had espoused since the 1930s—as well as a soured marriage—and he was searching for a new purpose in life. Marilyn provided it. Her combination of sensuality and spirituality at first seemed to him to constitute a revolt against the puritan mores that he associated with the anti-Communist movement, which he considered a destructive social force. He internalized her animus against the Production Code Authority to the point that he proudly accompanied her to events where she wore her most sexualized clothing. He saw in her a femininity and a humanity connected to nature that could be used as a symbol for change; together they might create a model marriage and justify his divorce.

Then, on New Year's Eve 1955, Marilyn finally signed a new seven-year contract with Twentieth Century-Fox, just as MMP was running out of money. The contract seemed to give her what she wanted: back pay, a higher salary ($100,000 for each film she made for Fox), and creative control over directors and cameramen. But she wasn't given script control, and that omission would cause her problems. The contract obligated her to make four pictures for Fox; one for every independent film she made for MMP or for some other studio. That didn't seem a burden as she prepared to make *Bus Stop* for Fox and then *The Prince and the Showgirl* for MMP. On the other hand, difficulties could arise if she made an independent film, and then didn't like the scripts Fox submitted to her for her required film for the studio. (Indeed, that's exactly what

happened.) Moreover, neither Arthur nor Marilyn fully realized how difficult it would be for Marilyn to balance her desires for a family with the demands of her career—and her growing addiction to prescription drugs.

Arthur certainly realized that Marilyn's new affluence might help him with his financial problems, since he was paying large alimony and child support payments and his revenues from his plays were declining. He also must have figured out that her popularity could help him in his struggles with the House Un-American Activities Committee (HUAC), whose members had already forced many of his friends to identify other friends as members of Communist organizations. Arthur considered it to be only a matter of time before he was called to testify, and he was right. During April and May of 1956 he went to Reno to obtain a divorce. Marilyn was then in Hollywood and in Phoenix filming *Bus Stop*. On June 21, Arthur was subpoenaed to appear before the committee, and although he denounced the Communist Party, he refused to name names. Marilyn bravely supported him, risking her career by appearing at a press conference with him.

Nonetheless, the committee censored him, and the House of Representatives voted him in contempt of Congress. A year later, a District Court judge upheld the contempt citation, sentencing him to a $500 fine and a suspended sentence of a month in prison. But in the summer of 1956, Marilyn and Arthur went ahead with their plans: They were married on July 1, and on July 13 they left for London.

There were fissures in their marriage from the beginning. The experience of filming *The Prince and the Showgirl* in England turned into a disaster. Paula Strasberg and Arthur wound up disliking each other; Milton Greene and Arthur had serious disagreements; and Laurence Olivier, the director of the film and Marilyn's costar, came to detest her—and the feeling was mutual. Their acting styles and personalities were simply too different for them to get along. Marilyn began taking heavy doses of prescription drugs to go to sleep at night and keep alert during the day. Then she discovered Arthur's open journal in his study, exposing a page in which he excoriated her for her emotionality and supposedly loose sexuality—words to the effect that he thought he had married an angel who turned out to be a devil. Marilyn never got over the shock of finding that page, for it brought to the surface all her feelings of worthlessness.

There were also issues with Milton Greene. He seemed to be the source of her drugs, and that possibility increased the paranoia of everyone involved in making the film, while Marilyn became furious at him when he listed himself as the producer—a title she reserved for herself—and when she suspected that he was using MMP funds to buy antiques for his home. Marilyn, who retained 51 percent of MMP stocks and thus a controlling interest, fired Milton in early April 1957. In what

was probably an unwise move, Arthur, his lawyer, and his brother-in-law replaced Milton and his lawyer on the board of directors of MMP. Arthur was now in the middle of Marilyn's career, creating the potential for more conflicts between them.

Yet once they returned to New York from London in November 1956, their marriage entered a halcyon period. They decorated a new apartment in New York, purchased a new farm in Connecticut, and spent the summer of 1957 in a farmhouse they rented in Amagansett, Long Island, near the beach. Casting herself as the perfect wife, Marilyn took up cooking and gardening, often rode her bicycle and played with Hugo, Arthur's basset hound. By the summer of 1958, parakeets Bobo and Butch had joined the family. The bliss of those months lingered throughout their marriage, but the suspicions engendered by the London experience festered beneath the surface and sometimes broke through. The HUAC charges remained a source of anxiety, since Arthur could wind up blacklisted or even in jail, until an appeals court judge overturned the contempt citation in August 1958, just as Marilyn began filming *Some Like It Hot*.

Three miscarriages—in July 1956, August 1957, and December 1958—plunged Marilyn into serious depressions and exposed her raw emotions. She easily fell into melancholia or burst into rages; she called her anger her "demon." She told cinematographer Jack Cardiff, "A lot of people like to think of me as innocent, so that's the way I behave to them. If they saw the demon in me they would hate me. I'm more than one person, and I act differently each time." [35]

Marilyn was emotionally volatile; Arthur seemed rock solid. She paid little attention to money; he was frugal. When she fell into a rage, he retreated into silence. In some ways, it was like her marriage to Joe DiMaggio all over again. Arthur was another of the tall, dark, older men—who looked like Abraham Lincoln or Clark Gable—whom Marilyn easily fell for, probably trying symbolically to find the father who had abandoned her. But the ones she chose turned out to be set in their ways.

Marilyn had consulted psychoanalysts in Hollywood, and she became committed to the Freudian approach in New York, going to therapy sessions most weekdays. Her devotion to Freudian views, which she called her "religion," is not surprising. Psychoanalysis dominated the therapeutic community in the 1950s, as well as the day's conceptions of the individual self. Freud's theory that a primitive id, seething with base urges, underlaid human personality and was controlled only with difficulty by a rational ego, made sense after the brutality of World War II and Hitler's rule in Germany. Yet Freud's Oedipal and Electra complexes—the incestuous desires among father, mother, and child—which individuals had to master to achieve maturity, were seriously confused in Marilyn's case. How did she fit into the Freudian schemas? The psychoanalysts who treated her, among the best-known in the nation, may have kept her functioning, but they weren't able to affect much fundamental change in her troubled self.

Then there was her dependence on prescription drugs. Ever since the beginning of her career in Hollywood, she had taken diet pills to keep her weight down. She also took downers to go to sleep at night and uppers to get up in the morning. That was standard practice among Hollywood actors. Shooting on films usually began early in the morning and could last well into the evening. Performers had to arrive very early to have their makeup applied, their hair styled, and their costumes put on before appearing on the set. Studio doctors dispensed the pills on orders from the studio heads, who often ran the studios as factories in which they attempted to make as many movies as possible in the shortest amount of time. In this system, stars had to function efficiently so production goals could be met. No one seemed to worry about the danger of drug addiction.

Hollywood may have been a center for such drug taking, but the practice was not unknown in literary and acting circles in New York. Tennessee Williams and Truman Capote were both reputed to be major prescription drug takers, as were Carson McCullers and Montgomery Clift. Famed New York doctor Max Jacobson, known as a "Dr. Feelgood," gave injections of vitamins laced with amphetamines to both John and Jackie Kennedy, as well as other celebrities; no one investigated what the injections contained. Prescription drugs such as Nembutal and Seconal were passed around. Susan Strasberg was amazed that Marilyn knew so much about drugs.[36] According to Susan, "she was a walking pharmacy . . ." Such detailed knowledge is not uncommon among drug addicts.

Over time, Marilyn also developed a dependency on alcohol. She began as a teetotaler, but the dependency crept up on her, especially when doctors recommended that she drink a glass of wine or a shot of vodka to calm herself down. It didn't help that in the 1950s, drinking was standard at social events.

Marilyn also took painkillers for endometriosis, a menstrual and endocrine disorder involving fibroid-like growths that can produce severe pain. Beginning in 1954, she had periodic surgery to remove them—a standard procedure even today—but the beneficial effects lasted only a year or so. Overall, she had a strong constitution, and she recovered quickly from drug overdoses and the respiratory illnesses, like bronchitis, from which she often suffered. To what extent each bout of illness was fabricated, psychosomatic, or due to taking drugs that weakened her bronchial passages or her lungs is difficult to determine. Beginning with *There's No Business Like Show Business*, she often called in sick, claiming that she had a high fever, a cough, a migraine headache, congested nasal and lung passages, a stuffed-up head—perhaps she was fabricating it all. She often went to doctors, though, and it wasn't difficult for her to get them to write prescriptions. There they are in the file cabinets, filled at pharmacies near her apartments in New York and Hollywood, with codes for the prescriptions that are impossible to decipher.

At some point, probably when she was making *The Prince and the Showgirl*, Marilyn lost a lot of control over her drug use. Sometimes she seemed to kick the habit but, typical of drug addicts, she

would relapse. There were overdoses that may have been accidental, a plea for help, or a suicide attempt. Arthur had to revive her on several occasions. Despite her addictions, Marilyn continued to make films: She made *The Prince and the Showgirl* in 1956, *Some Like It Hot* in 1958, and *Let's Make Love* and *The Misfits* in 1960. In April 1962, she began filming *Something's Got to Give*, which was never completed. Problems emerged during each production. Marilyn argued with her directors; she was often late to appear, or she called in sick. During the filming of *Let's Make Love*, she had an affair with her costar, Yves Montand. But Montand broke it off, and Marilyn was disconsolate for a time. When he told Hedda Hopper that Marilyn had suffered from a "schoolgirl crush," she was furious.

Only a few weeks after production ended on *Let's Make Love*, Arthur and Marilyn went to Reno to film *The Misfits*, which he had written for her. Marilyn's costars were Clark Gable, Eli Wallach, and Montgomery Clift, playing aging, down-on-their-luck cowboys mesmerized by the pantheistic radiance of Marilyn, who played a former showgirl who has traveled to Reno for a divorce. Marilyn was thrilled to be playing opposite Gable, the fantasy father figure of her childhood. He was gentle with her, and he showed little annoyance over her chronic lateness to the set. (Anyway, under the terms of his contract, he was permitted to leave the set at 5:00 PM every day.)

The Misfits is a brilliant film, considered a masterpiece today. But it's a wonder they ever finished it. Marilyn and Arthur weren't getting along: Arthur was eyeing other women, and Marilyn was taking far too many pills and arriving at the set very late or not at all. To further complicate matters, John Huston, the film's director, spent most nights gambling and drinking, and he and Arthur kept rewriting the script. The temperature was well over one hundred degrees, and there wasn't much shade in the desert locations they used. The professionalism of Clark Gable and his affection for Marilyn kept them going. Clark sympathized with her irritations over the constant rewrites. When Arthur wanted to reshoot the ending with a different resolution of the film, Clark realized Marilyn's growing hysteria and refused to do it. Marilyn didn't have script approval, but Clark did. The ending wasn't reshot. Soon after photography on the film wrapped, Clark died of a heart attack—a tragic event that troubled Marilyn.

Shortly thereafter, in November 1960, Marilyn announced that she and Arthur were divorcing. On January 20, 1961, the day of John F. Kennedy's inauguration as president, the divorce was finalized in Juárez, Mexico. In February, Marilyn broke down completely. She was devastated by the divorce and by news stories that Kay Gable, Clark Gable's widow, considered her responsible for his death because of her continual lateness. Kay Gable denied these stories, but they continued to bother Marilyn. She became suicidal. Her psychiatrist, Marianne Kris, placed her in the Payne Whitney Clinic in New York. When she discovered that she was in a hospital for psychotics, not for detoxification, she vigorously protested. But her protests were disregarded, and she was placed in isolation in a locked ward. She had entered what appears, in retrospect, to be the last period of her life.

It's hard to think that Kris would have placed Marilyn in Payne Whitney without good reasons, although she later claimed that she had simply made an error in judgment. Now in an institution that seemed similar to the ones to which her mother had been committed, Marilyn was desperate. She managed to phone Joe DiMaggio, who forced the hospital to release her, and then took her to a private room at Columbia-Presbyterian Hospital to dry out and get some rest. After several weeks there, she went with Joe to Florida for a few weeks to recuperate.

Over the next six months, Marilyn went back and forth from New York to Hollywood. She rekindled her romance with Joe and established a new one with Frank Sinatra. In August 1961, she rented an apartment in Hollywood and settled there. She didn't give up her apartment in New York; she intended to live a bicoastal life. But, for the moment, Marilyn was disenchanted with New York, and she wanted to engage in intensive therapy with her Los Angeles psychiatrist, Ralph Greenson. She hoped that her affair with Frank Sinatra might end in marriage, although he, like others, didn't approve of her drug use. In December 1961, Greenson put her through a detox program in her apartment, with nurses stationed round the clock to monitor her. She seemed to kick her drug habit for a time, but by the spring of 1962, she was observed behaving erratically in public.

Twentieth Century-Fox pressured her to fulfill the terms of her contract, and she agreed to do *Something's Got to Give*. Production began in early April and soon encountered difficulties, with Marilyn exhibiting her usual lateness and calling in sick. And the screenwriters kept rewriting the script, making changes that she didn't like. It was a difficult situation for her, since she had no contract rights over the script.

Doctors confirmed that she had a serious viral infection, but the studio executives refused to believe them. When she went to New York to sing "Happy Birthday" to the president on May 19, the studio was furious. If she managed to show up at a performance in New York, why couldn't she appear on the set? Showing her mettle, she filmed a scene in which she swam alone in a swimming pool in the nude, and she made certain that still photographers were there. The results appeared on the cover of *Life* magazine and in countless newspapers worldwide. Despite this bid to mollify them, Fox executives fired her early in June.

As was typical of Marilyn, hitting the bottom brought her up again. At first she was distraught at the firing, especially when studio publicists planted negative stories about her in the newspapers. But soon she fought back. She gave interviews to journalists for major magazines like *Life* and *Redbook*, and she posed for major photographers like George Barris and Bert Stern.

She displayed her star power. The week before she died, Fox reinstated her in the film, offering her a new contract under which she would make a million dollars for two pictures.

There is still controversy over the events and interpretations of the last months of her life. Recent research suggests that she was drinking heavily and taking many drugs, although it is puzzling why Ralph Greenson, who saw her almost every day, thought she was weaning herself from those very same drugs. Suspicion centers around the shots she was being given by Hyman Engleberg, her internist and Greenson's colleague, although those shots may have contained gradually lessened doses of liquid Nembutal on a program of slow detoxification.

There is also debate over her relationships with Jack and Bobby Kennedy, though all her biographers agree that she had a brief affair with Jack that spring. And there is no disagreement over her having encountered Bobby Kennedy that spring and summer at the home of his sister Patricia Kennedy Lawford and her husband, Peter Lawford. Whether Bobby and Marilyn had an affair or whether Bobby met with her to persuade her to end her fantasies about Jack remains in dispute. Some authors contend that Bobby came to her house the day she died to stop her from talking about Jack publicly. Others contend that he was never there. Evidence exists to support both positions.

It may be the case that Marilyn killed herself because of unrequited love. During the spring and summer of 1962, she overdosed several times and had to be revived. Some recent narratives claim that Marilyn kept a diary of the Kennedys' musings about politics during bedroom conversations and that, when they dropped her, she threatened to hold a press conference to expose them; therefore, killers from the Mafia, the FBI, the CIA, or the Teamsters gave her a drug-filled enema or an injection as a speedy way to induce drugs into her bloodstream. Other biographers have challenged those narratives and speculations, pointing out that the supposed diary detailing her affairs with the Kennedys has never surfaced and that the informants about the plots to kill her are untrustworthy.

What about the belief that there was a cover-up the night Marilyn died? That has more credibility, since a lot of evidence surrounding her death disappeared, including her phone records and the tissue and organ samples taken at her autopsy. The police didn't do a proper investigation. The coroner and the district attorney seemed primarily concerned with gathering expert psychiatric testimony that she was in a suicidal state of mind the days before she died. Some biographers offer evidence of a conspiracy headed by Los Angeles police chief William Parker to keep the Kennedy name out of the investigation; in that era, which was outwardly more moral than our own, a politician's sexual indiscretions could destroy his career. But a cover-up doesn't imply that the Kennedys were involved in her death.

In the case of Marilyn's death, people believe what they want to believe. She lives in the fantasies of the national imagination, enshrined in a story with endless possibilities, plots, characters, and events.

Any real information about her final hours is subject to the whims of the media, fixated on trumpeting any new sensationalist evidence—whether credible or not. At least once a year, usually on the anniversary of her death in August, some new conspiracy, plot, or person claiming to be a reincarnation of Marilyn makes headlines. Marilyn's life and death have become flexible, plastic representations of a real person and a real event. That is the fate of celebrities and stars in the modern era: to become icons worshipped by their subjects, then continually reinvented by them, especially after they die.

As an icon of glamour and beauty, Marilyn remains celebrated around the world. Her image is endlessly reproduced on posters, photographs, and billboards, on playing cards, umbrellas, and handbags. The Sam Shaw photo of her with her skirt flying up, taken during the filming of *The Seven Year Itch*, has become one of the most iconic images of the twentieth century. No one can deny the power of her representation: She is the ur-blonde who has haunted the American imagination.

Marilyn was a genius at self-creation and posing in front of the camera. That may be the ultimate act of self-presentation for women in the twenty-first century, driven by technology, visuality, and the homogenization of world cultures. The innocence and sorrow in Marilyn's eyes, clearly transmitted in her photographs, makes us, like the audiences in her own day, want to comfort and protect her. We want to know what would have happened to her if she had lived longer. To construct any approximation of that future, we need to know about her past, who she was when she was alive. The Monroe Collection helps to give voice to this, the real Marilyn, and to realign the trajectory of that imagined future for generations to come.[37]

1. Maurice Zolotow, introduction to the revised edition of his 1960 biography, *Marilyn Monroe* (New York: Harper and Row, 1990), 7.

2. Loyd Wright Jr. to Inez Melson, December 2, 1954, Marilyn Monroe Collection (MC hereafter).

3. Transcript of Inez Melson interview with Barry Norman, BBC, for *The Hollywood Greats, Marilyn Monroe*, MC. The television program, which didn't include the entire Melson interview, was broadcast on August 24, 1979.

4. Fred Guiles, *Legend: The Life and Death of Marilyn Monroe* (New York: Stein and Day, 1984), 278. See Inez Melson to Loyd Wright Jr., October 25, 1955, MC; *New York Post*, October 27, 1954; and Inez Melson to Joe DiMaggio, September 6, 1962, MC.

5. I follow the practice used in Marilyn's day of denoting the studio as "Twentieth Century-Fox," with the hyphen indicating that the company had been formed by the merging of Twentieth Century Pictures and the Fox Film Corporation. The practice today is to drop the hyphen.

6. Frank Delaney to Inez Melson, June 22, 1965; and Melson to Delaney, June 24, 1965, MC.

7. Inez Melson to Milton Rudin, February 22, 1962, MC.

8. Melson interview with Barry Norman.

9. The best analysis of Marilyn's death is David Marshall et al., *The DD Group: An Online Investigation into the Death of Marilyn Monroe* (New York: iUniverse, 2005).

10. Donald Spoto interview with Milton Rudin, Spoto tapes for *Marilyn: The Biography* (New York: HarperCollins, 1993), Margaret Herrick Library, American Motion Picture Academy of Arts and Sciences, Beverly Hills, California.

11. Receipt for file cabinet, MC.

12. Cherie Redmond to Norman Jeffries, March 2, 1962, MC; and Eunice Murray with Rose Shade, *Marilyn: The Last Months* (New York: Pyramid Books, 1975), 82–83.

13. Paula Strasberg, who replaced Natasha Lytess as Marilyn's acting coach, handled the Strasberg's business affairs, but by 1962 she was suffering from debilitating bone cancer. She died in 1966. Lee later married Anna Mizrahi and, after his death in 1982, she inherited the Monroe Estate. In 1998 she sold the Norell dress and the "Happy Birthday" dresses at an auction of Marilyn's posessions at Christie's in New York. The "Happy Birthday" dress sold for $1.26 million.

14. Author interview with Patricia Traviss, July 18, 2008. Traviss was the director of Rockhaven during Gladys's years there.

15. Inez showed a letter from Jean Kennedy Smith to Marilyn joking about a "relationship" between Marilyn and Bobby, which Inez said she had found in a drawer. The letter is not in the file cabinets today.

16. Maury Allen, *Where Have You Gone, Joe DiMaggio? The Story of America's Last Hero* (New York: Dutton, 1975), 139; Hortense Powdermaker, *Hollywood, the Dream Factory: An Anthropologis Looks at the Movie-Makers* (Boston: Little Brown, 1950), 85; Radie Harris, *Radie's World* (New York: W. H. Allen, 1976), 188; and author interview with Patricia Newcomb, September 25, 2007.

17. Christopher Bigsby, *Arthur Miller, 1915-1962* (Cambridge, Mass.: Harvard University Press, 2009), 634; Rupert Allen interview with Antonio Villani, in Villani, "'Hold a Good Thought for Me': *Marilyn and Friends: The Script That Never Was*," unpub. ms., in author's possession. On Marilyn's generosity, see also Sam Shaw and Norman Rosten, *Marilyn Monroe Among Friends* (New York: Henry Holt, 1977), 140–41; Claire Evans, "I Was Marilyn Monroe's Roommate," *This Week Magazine*, November 21, 1954; James Dougherty, *The Secret Happiness of Marilyn Monroe* (Chicago: Playboy Press, 1976), 64; Maurice Zolotow interview with Whitey Snyder, Maurice Zolotow Papers, Harry Ransom Center, University of Texas, Austin; and Marilyn Monroe, *My Story* (New York: Stein and Day, 1974), 67.

18. Robert W. Welkos, "Taking It on Blond Faith: Marilyn Monroe's Fans Spend Extravagantly on Memorabilia," *Los Angeles Times*, March 23, 2006, reported that thirty-five thousand items associated with Marilyn were for sale on eBay during the last three months of 2005. Richard Meryman, "Fame May Go By . . . An Interview," *Life*, August 3, 1962, in *Marilyn Monroe: A Composite View*, ed. Edward Wagenknecht (Philadelphia: Chilton, 1969), 78.

19. Randall Riese & Neal Hitchens, *The Unabridged Marilyn: Her Life From A to Z* (London: Congdon and Weed, 1987), 410.

20. Jeffrey Meyers, *The Genius & The Goddess: Arthur Miller and Marilyn Monroe* (London: Hutchinson, 2009); Ted Schwartz, *Marilyn Revealed: The Ambitious life of an American Icon* (London: Rowman & Littlefield, 2009); and J. Randy Taraborrelli, *The Secret Life of Marilyn Monroe* (New York: Hachette, 2009).

21. Marilyn Monroe to Lester Markel, March 29, 1960, MC.

22. Meryman, "Fame May Go By," 11.

23. My reconstruction of Norma Jeane's childhood draws from Michelle Morgan, *Marilyn Monroe: Private and Undisclosed* (New York: Carroll and Graf, 2007), and the Roy Turner collection, especially the court documents in it: Superior Court, State of California, Report, Petition, and Current Account of Guardianship, February 19, 1937, February 7, 1940. I have also used Berniece Baker Miracle and Mona Rae Miracle, *My Sister Marilyn: A Memoir of Marilyn Monroe* (New York: Boulevard Books, 1994), and Taraborrelli, *Secret Life*. At this point, Norma Jeane's childhood became even more complex. In November 1937, Grace moved her to the family of her uncle Marion Monroe. Then, five months later, the Los Angeles River overflowed, flooding the San Fernando Valley and rendering the Monroe home uninhabitable. For a few months Grace moved Norma Jeane to the Compton home of her brother, Bryan Atchinson, before settling her with Ana Lower. Because she often babysat the child of Enid Knebelcamp, Grace's sister, Marilyn might have added Enid (and her husband) to her list of foster parents.

24. Zolotow, *Marilyn Monroe*, 36.

25. Author interview with Terry Wasdyke, Fred Karger's daughter, August 18, 2009.

26. Earl Wilson, "My Super-Six," *Eye*, March 1953.

27. See Jack Wade, "Too Hot to Handle?" *Modern Screen*, March 1952; "All About Marilyn Monroe," *People Today*, June 18, 1952; and Sidney Skolsky, *Marilyn: The Marilyn Monroe Story* (New York: Dell, 1954), 26–30.

28. In 1952 Jane Russell made $150,000 for her role as Marilyn's sidekick in *Gentlemen Prefer Blondes*, while Marilyn was paid $18,000. Over the course of her career, Fox made $200 million from her films, while Marilyn made $2 million.

29. See *Movieland*, April 1953, 74; and James Wandworth, "One Man Woman," *Motion Picture and Television Magazine*," September 1953.

30. *Milton's Marilyn: The Photographs of Milton H. Greene*, ed. Joshua Greene (with text by James Kotsilibas-Davis) (London: Schirmer, 1994), 23.

31. Monroe, *My Story*, 90.

32. Joan Fontaine had previously formed a production company, Rampart Productions. Major stars like Errol Flynn, Cary Grant, and Burt Lancaster had also formed such companies. See Kate Buford, *Burt Lancaster: An American Life* (New York: Alfred A. Knopf, 2000).

33. Norman Rosten interview with Antonio Villani, "Hold a Good Thought for Me."

34. Norman Rosten, *Marilyn: An Untold Story* (New York: Signet Books, 1973), 23.

35. Jack Cardiff, *Magic Hour* (London: Faber and Faber, 1996), 211.

36. Susan Strasberg, *Marilyn and Me: Sisters, Rivals, Friends* (New York: Warner Books, 1992), 93–94.

37. Throughout the book, many letters are from carbon copies of originals made during typing the original letters. The documents on pink paper were photographed from a collection of xeroxes of the originals made by Ruth Conroy.

MARILYN MONROE PRODUCTIONS INC.
BY-LAWS

THE PUBLIC MARILYN

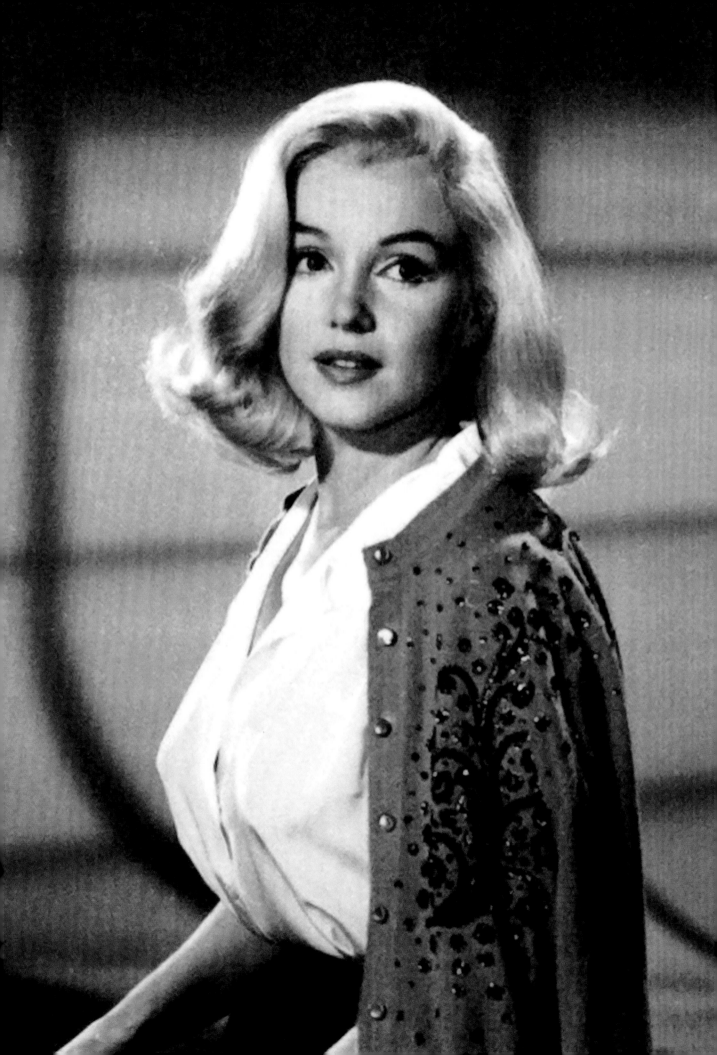

"I feel as though it's all happening to someone right next to me. I'm close, I can feel it, I can hear it, but it isn't really me."

MONROE ON MONROE

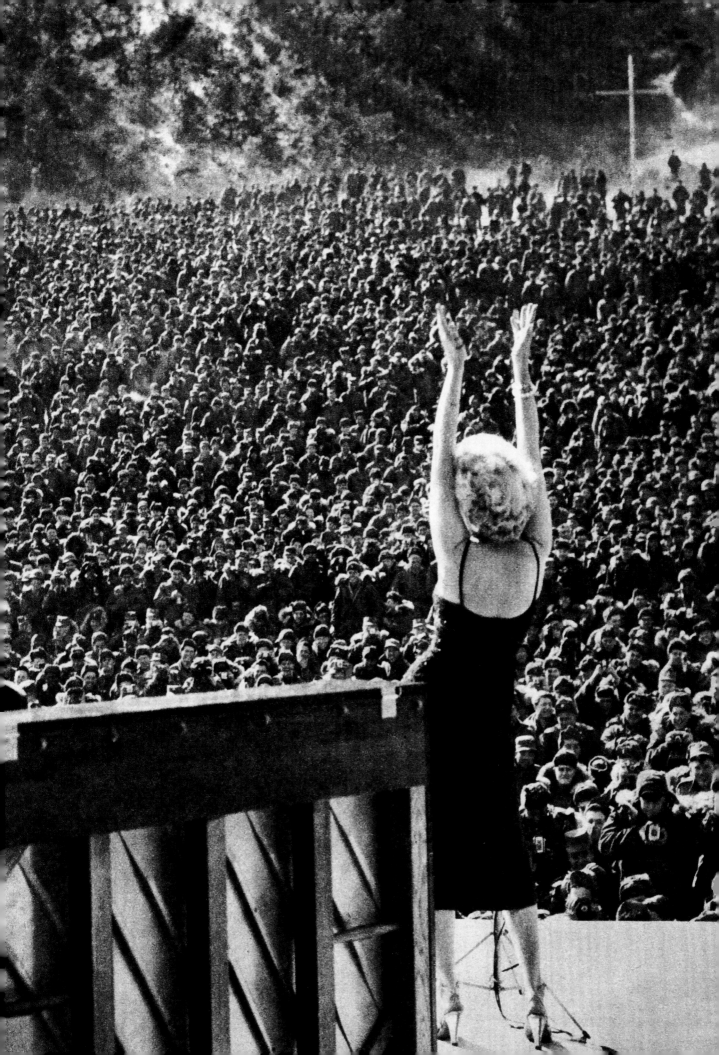

MARILYN MONROE is best known for her career as a film actress—extending over sixteen years and twenty-nine movies—but she was also an accomplished singer, mime, and photographic model. Marilyn's singing voice was low-register, sultry, and intimate (though she could belt out a line when needed), which is surprising given the breathy, childlike quality of her speaking voice in many films. She had never been formally trained as a dancer, but her study of mime with Lotte Goslar and her work with choreographer Jack Cole enabled her to move her body effectively in musical numbers. And Marilyn's genius as a photographic model was perfectly described by none other than famed photographer Richard Avedon: "She gave more to the still camera than any actress—any woman—I've ever photographed. . . . She was able to make wonderful photographs with almost any photographer, which is interesting—and rare. Her ideas were always dominated by what she felt her public image should be. She would pore over the contact sheets for hours. She was looking for what she called an 'honest picture,' a 'real,' or a 'right' picture." *Life* magazine photographer Philippe Halsman, however, interpreted her genius as more singularly and self-consciously sexual: "She knew that the camera lens was not just a glass eye but a symbol for the eyes of millions of men."[1]

Marilyn was also a gifted publicist. Roy Craft, her press agent at Twentieth Century-Fox, stated that her quips and "newsmaking frivolities" were her own ideas, not his or any other studio publicist's. "She was a literate, perceptive gal," said Craft, "and she didn't need anyone to dream up her stunts."[2] Those stunts were constant: walking down the Fox lot in March 1951 barefoot, wearing only a negligee, and stealing the show as the grand marshal at the 1952 Miss America Pageant parade in Atlantic City by wearing a plunging neckline

as she cruised on the back of a convertible and threw roses to the crowd. Both the day she married Joe DiMaggio and the day that she publicly announced her separation from him, she telephoned Fox publicists to ensure that a lot of reporters would be present. She played the role of the grieving wife to perfection at the latter event. In late December 1954, she disappeared from Hollywood after refusing to sign a contract with Fox, and no one knew where she had gone until about a week later, when she resurfaced in Connecticut, living with Milton and Amy Greene. In March 1955, she wore a skimpy showgirl costume and rode on the back of a pink elephant at a charity event in Madison Square Garden. Seven years later, in May 1962, she performed as a very outré and sexualized Marilyn at the birthday party for John F. Kennedy held in the same space.

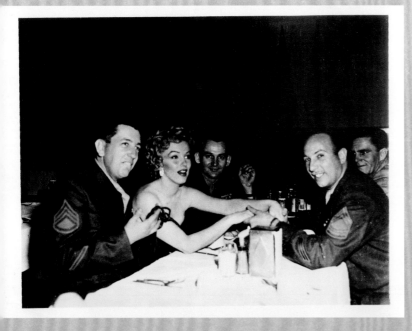

Throughout her entire career, Marilyn was responsive to her fans, eagerly signing autographs and posing for anyone with a camera. She often stated that the "common people," not the studio, had made her a star. She capped her work as a photographic model with her brilliant performances for Cecil Beaton in what I call the "Japanese photo" in February 1956 and for Richard Avedon in the "siren photos," taken in September 1958. But her enduring fame had already been guaranteed through the many pinup photographs taken of her and the still photography from her brilliant acting in *Gentlemen Prefer Blondes* and *How to Marry a Millionaire*, *The Seven Year Itch*, *Bus Stop*, *The Prince and the Showgirl*, *Some Like It Hot*, and *The Misfits*. For her work in *Gentlemen Prefer Blondes* and *How to Marry a Millionaire*, she won a best actress of the year award in 1954 from *Photoplay* magazine, as well as awards from major French and Italian film organizations for her work in *The Prince and the Showgirl*. In 1962, the Hollywood Foreign Press Association honored her as "Female World Film Favorite 1961." But the Oscar statuette eluded her—she was never even nominated for the award. Some have speculated that this lack of recognition from the members of the Academy of Motion Pictures and Sciences was due to their anger against her for publicly walking out on Hollywood, but it also may have been simply a reflection of the enduring general opinion that she was nothing more than a dumb blonde—despite her many attempts to prove otherwise.

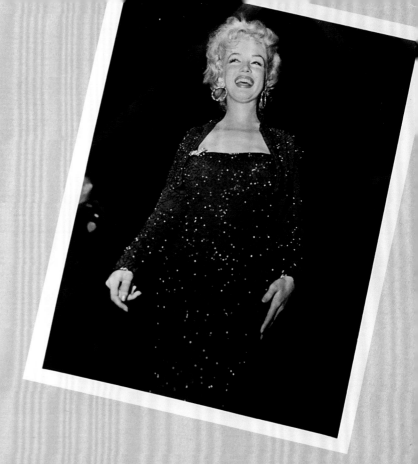

KOREA

A high point of Marilyn's career was her four-day trip to Korea in February 1954—a detour during her honeymoon with Joe DiMaggio in Japan. The trip was her thank-you to the troops for their many fan letters. Wearing army fatigues when traveling by helicopter and a purple sequined cocktail dress when performing, she visited ten bases, each with audiences of ten thousand servicemen. The Los Angeles Times *reported that she electrified these audiences, who sometimes acted like "bobbysoxers besieging a crooner."*[3] *Marilyn often said that the enthusiasm of her huge audiences in Korea finally made her feel like a star.*

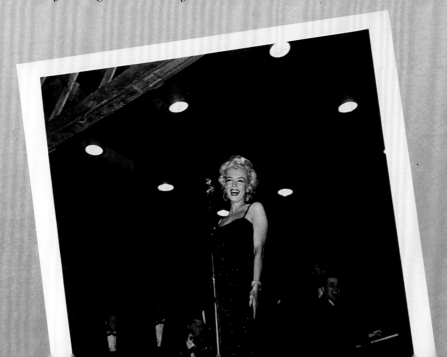

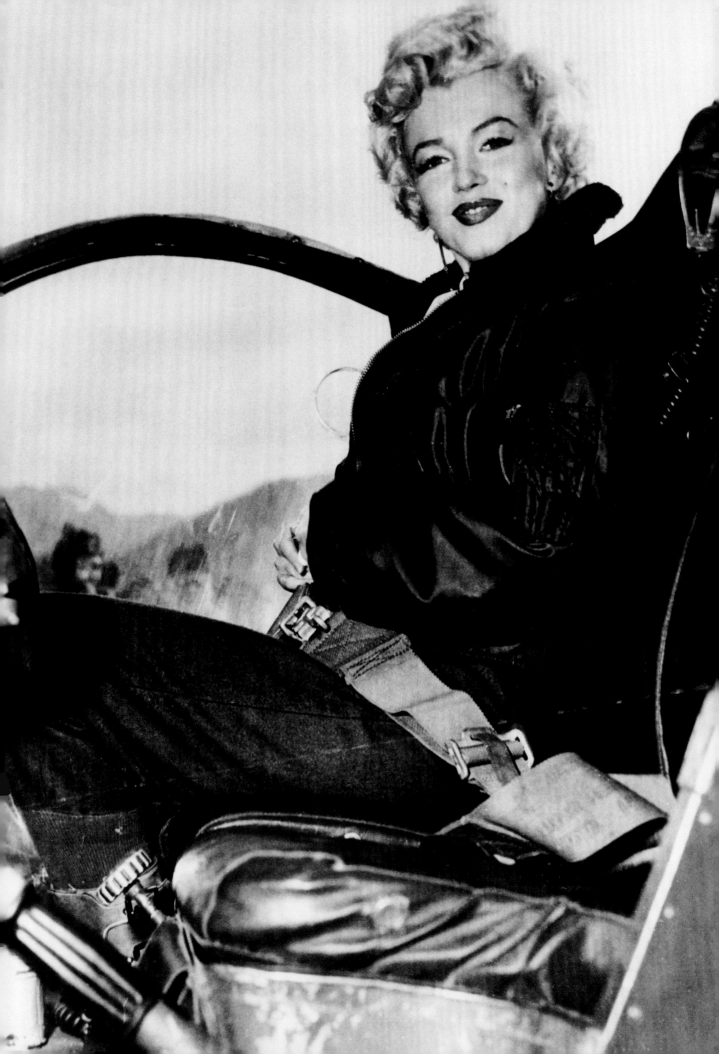

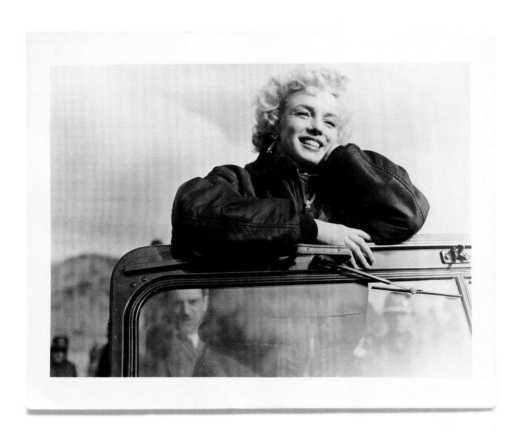

I like this one the best.

The thousand members of the 102nd Airborne Division held a contest for the best photo of Marilyn taken when she performed at their base. Robert Eversen took the winning photo, of Marilyn in a helicopter. The 102nd Airborne sent his photo to Marilyn, along with a second one that Eversen had taken of her riding in a jeep. The jeep photo was Eversen's favorite, and he wrote to Marilyn telling her so. Marilyn agreed with him, writing on the back of the photo, "I like this one the best." She kept both of Eversen's photos in her file cabinets.

June 11, 1947

Twentieth Century-Fox Film Corporation
Beverly Hills, California

Gentlemen:

 Whereas, I did heretofore enter into a personal
services contract with you, dated August 24, 1946, and,
whereas at that time I was a minor, and whereas I did,
on June 1, 1947, become twenty-one (21) years of age,
please be advised that I do hereby ratify and confirm all
of the terms and provisions of my said contract of employ-
ment with you as the same may have been heretofore
amended.

 Yours very truly,

 Marilyn Monroe

 Norma Jeane Dougherty

THE EARLY CAREER

On June 1, 1947, Marilyn turned twenty-one and attained
her legal majority. By then she had divorced James Dougherty.
The studio decided that it was necessary for her to countersign
with the name "Marilyn Monroe" should any legal complications
arise over its original contract with her.

(OPPOSITE)

(above) In September 1950, Richard Miller took
this photograph of Marilyn in the Hollywood Hills.

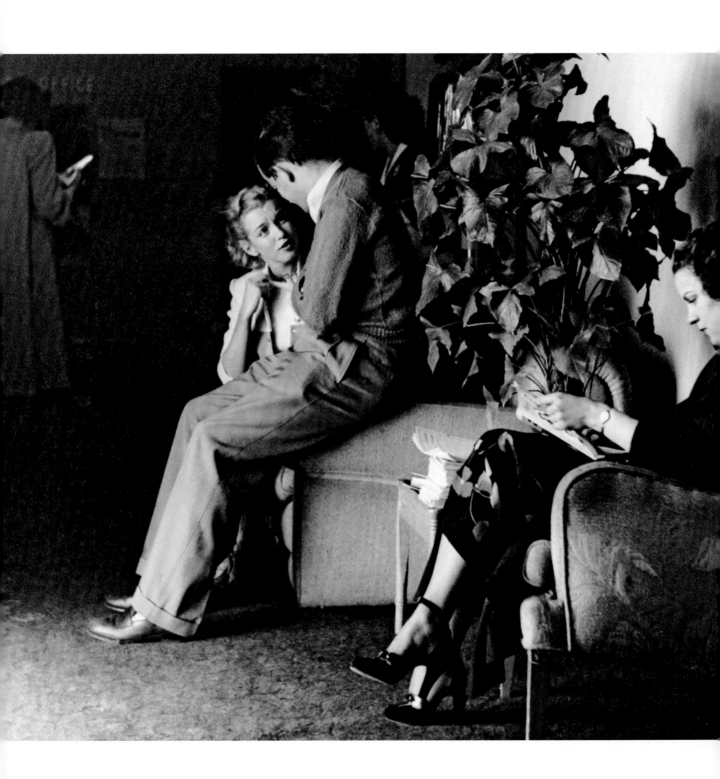

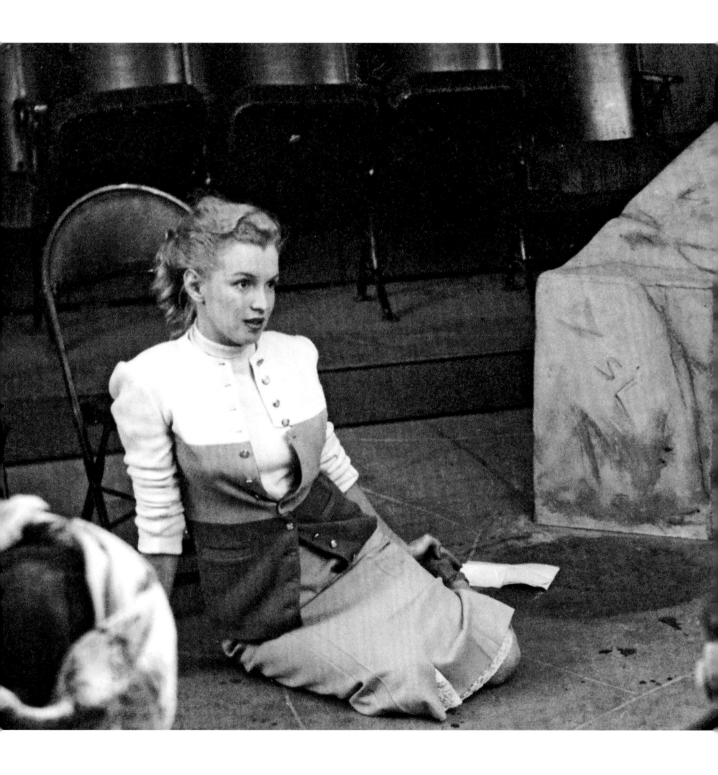

From the beginning of her career, Marilyn wanted to become a well-regarded dramatic actress. In these photos, taken by Richard Miller in the spring of 1950 at the Players Ring Theater near Beverly Hills, Marilyn reviews a script in the lobby and auditions in the theater for Street Scene *by Elmer Rice. The Players Ring was a small theater that opened in February 1950. Marilyn wasn't cast in the production.*

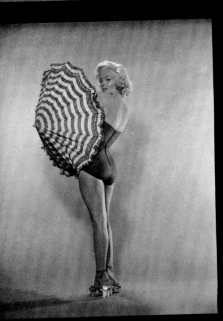
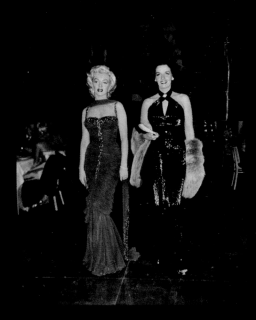
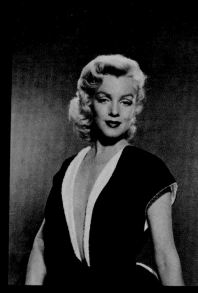

GENTLEMEN PREFER BLONDES & HOW TO MARRY A MILLIONAIRE

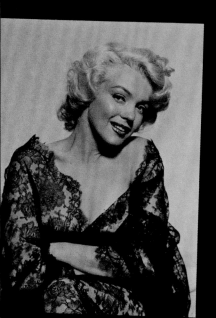

WESTERN UNION (33)

1220

W. P. MARSHALL, PRESIDENT

he filing time shown in the date line on telegrams and day letters is STANDARD TIME at point of origin. Time of receipt is STANDARD TIME at point of destination

LA209 SS B480

LLD502 LONGPD=WUX TDL WEST LOS ANGELES CALIF 9 217PMP=

MARILYN MONROE=DELIVER DO NOT PHONE

 CARE OF MRS. INEZ C. MELSON 9128 SUNSET BLVD LOSA (WH)=

YOU ARE HEREBY NOTIFIEDAND INSTRUCTED TO REPORT TO THE
STUDIO OF TWENTIETH CENTURY FOX FILM CORPORATION LOCATED
AT 10201 WEST PICO BOULEVARD LOS ANGELES AND PARTICULARLY
TO MR. W. L. GORDON CASTING DIRECTOR AT HIS OFFICE IN THE
ADMINISTRATION BUILDING FORTHWITH FOR THE PURPOSE OF
RENDERING YOUR SERVICES UNDER AND PURSUANT TO THE TERMS OF
THAT CERTAIN EMPLOYMENT AGREEMENT DATED APRIL 11, 1951
BETWEEN YOU AND THE UNDERSIGNED CORPORATION. PLEASE BE
ADVISED THAT THE SERVICES WHICH WE NOW REQUIRE ARE IN
CONNECTION WITH RETAKES AND ADDED SCENES FOR THE MOTION
PICTURE ENTITLED "RIVER OF NO RETURN" IN WHICH YOU HAVE
HERETOFORE RENDERED SERVICES IN PRINCIPAL PHOTOGRAPHY=
 TWENTIETH CENTURY FOX FILM CORPORATION BY
 FRANK H. FERGUSON ASSISTANT SECRETARY=

II. THE MATURE CAREER

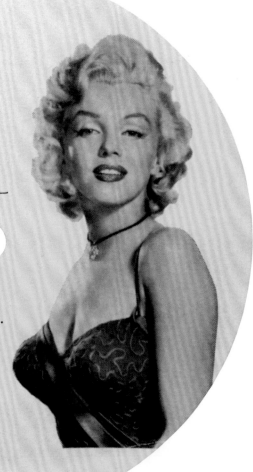

NOT FOR SALE

RCA VICTOR

PROMOTION DISC

Simon House
ASCAP

(20-5745)
E4-VB-3143

THE RIVER OF NO RETURN
(Ken Darby-Lionel Newman)
(from the 20th Century-Fox CinemaScope Prod.
"River Of No Return")

MARILYN MONROE
with Orchestral Accompaniment

Time: 2:14

RCA Victor signed Marilyn to a recording contract.
This promotional disc contains songs from The
River of No Return. *The film was made in August*
and September 1953.

Marilyn Wedding Wraps Film Career in Mystery

Monroe—DiMaggio Love Story

Marilyn and Joe's Story Book Romance Grew the Hard Way

Boy meets girl, and marries her, regularly in this land of ours. But when a Joe Di Maggio meets a Marilyn Monroe and the sparks ignite a blazing romance that lights them to the altar, it deserves the telling. This is the first of two gripping stories about the pair that became one yesterday.

By GENE COUGHLIN
—Chapter One—

It could only happen here, in America, this storybook romance of Marilyn Monroe and Joe Di Maggio that had its big chapter written in San Francisco when they finally got married yesterday.

Both of them—one of the most desirable women in the world and the baseball hero of the current generation—had to fight their way to fame and fortune, and to each other.

One in a birthday suit, as a foundling and, later, as a collar, and, later, as a New York Yankee baseball suit, runaways from his father's fishing business and the schoolbooks.

Both made the grade and, if you follow the traditions of time romantic tales, were destined to meet, fall in love, and stay that way. The road was rough and rocky, especially the past few weeks when a nation of romantics, the women especially, kept wanting to know:

"Did Joe and Marilyn get married? Do you suppose they're already man and wife and keeping it a secret? Wouldn't it be thrilling if they were?"

National Interest At Boiling Point

Mr. and Mrs. America, and Junior and Miss too, followed the pair like DiMaggio at the plate used to follow the flight of a curve ball or the "high hard one" successfully enough to make baseball fans put him up near the niche that Babe Ruth held in the Yankee outfield.

The national interest reached a boiling point last Jan. 4 when Marilyn didn't report at her studio, 20th Century-Fox, to make a picture called "Pink Tights," couldn't be located, and was placed on suspension.

"That means she and Joe have eloped," the whisper went around. Then came a flash from New Orleans, forwarded by an airport employe whose eyes don't deserve to gander a figure like Marilyn's.

"She got off a plane with Actor Rock Hudson," this benighted citizen reported. "And they went scurrying away in a limousine with the curtains drawn."

"Nuts!" was the disgusted reply of those who know their romance, and their batting average. "Hudson couldn't hit .218 with Elmira."

Beauty Turned In In Joe's Home Town

It was a false (terrible word in the Monroe vocabulary) report. She turned up in San Francisco, Joe's home town, and let it be known that the only reason she hadn't reported at the studio was because she hadn't been given the chance to read the script, to approve or disapprove.

"Are you and Joe planning

(Continued on Page 5, Col. 1-2)

Rain? Maybe

L.A. May Get Brief Showers Tomorrow

Rain tomorrow?

Perhaps, but not much. Here's the way the Weather Bureau puts it in its forecast for Los Angeles and vicinity:

"Variable high clouds today. Low clouds or local fog near coast tonight and Saturday morning. Partly cloudy Saturday with a chance for a few light showers near foothills."

Showers will bring snow flurries at the 3000-foot elevation, the bureau said.

The Civic Center had a low temperature of 45 degrees this morning before the mercury rose to 55. Yesterday's high was 54.

The bureau's five-day forecast says that except for the possible light showers tomorrow no rain is indicated through next Wednesday. Temperatures will rise above normal after Sunday.

Corner Crash

Street Car Derailed, Injures Auto Driver

Derailed by a faulty switch, a street car crashed into a passing automobile and then a telephone pole at Pico and Georgia streets, seriously injuring the motorist, police reported today.

The streetcar, driven by Gilbert Herrera, hit the faulty switch at the intersection and jumped the tracks. Mrs. Hortense Riddel, 58, of 1100½ South Kingsley drive, was driving through the intersection when the mishap occurred and the uncontrolled streetcar mashed her automobile against a utility pole.

She was treated at Georgia Street Receiving Hospital for injuries suffered in the mishap. No passengers on the streetcar were injured.

YOUR DREAM HOME AT REAL SAVINGS

Not for years have so many desirable homes at real selling prices appeared on the market. If you have waited, now is the time to make your selection. You'll be surprised and perhaps solve your home problem for years to come. Turn to the Classified Section now.

HOME BARGAIN DIRECTORY

"Quality Homes at Moderate Prices"

Continue Fight on Dog Law

(Pictures on A-3)

Angry citizens today lashed at the action of the City Council in unanimously adopting a committee report calling for an ordinance for the compulsory vaccination of dogs.

Strong difference of opinion still exists in the Council on the proposed legislation, it was made plain.

Several councilmen who voted to withdraw the city attorney to draw up the ordinance said that they eventually would introduced drastic amendments before approving the final draft of the unpopular law.

When the ordinance is finally drafted by the city attorney it must still get the approval of 10 of the council's 15 members.

NEED 12 VOTES

Twelve votes would be necessary for passage if Mayor Norris Poulson should veto it.

Richard Hill, a prominent dog breeder, threatened court action to head off the unpopular ordinance.

"We will fight this issue through the City Council and if necessary through the courts. Our matter is so serious as to call for a Grand Jury investigation. False and misleading statements have been made which suggest that some pretty sinister forces are behind the ordinance.

"The dog haters apparently will stop at nothing to gain their cruel and unnecessary ends."

OPPOSES LAW

Councilman Charles Navarre, opposing the ordinance, said:

"Let's be governed by reason and sanity, not fear and hysteria.

"I've counted members expressed deep dissatisfaction with the ordinance which has been branded illegal and unnecessary.

Mrs. Anna McIlvain, a dog owner also was up in arms

(Continued on Page 6, Col. 6)

Special Features

Amusement News	C-1 to C-12
Cafes and Night Spots	A-12
Clubs	C-14, 15, 16
Comics	D-5, 6
Cecil Carmen	C-10
Crossword Puzzle	D-4
Dan Carnegie	D-8
Drama and Screen	A-14, 15
Rich Days in Los Angeles	C-1
Editorial Page	C-12
Fashions by Marie Mode	C-16
Financial News	B-4
Gossip News	B-3
Right "Do It Every Time"	B-8
Horoscope	D-8
Sam Balson	D-8
H.J. Sidelights	A-12
Society	A-13
Our Home Town, Kennedy	D-4
Sports Pages	A-8, 9, B-1
Radio and TV	A-7
Romance Clinic	B-1, 2, 3
Shopping News	D-6
Fashions by Ben Burroughs	D-8
Sports World at Society	A-9
Society	C-14, 15, 16
Theaters	B-6, 7, 10
Sports Motoring	B-10
George S. Sokolsky	D-5
Vital Statistics	D-1
Walter Winchell	D-8
Want Ads—Classified	D-1, 7
Wishing Well	D-5

L.A. Smogless For Eighth Day

For the eighth consecutive day Los Angeles was smog-free, it was reported by the Air Pollution Control District. Early breaking inversions and winds were to be thanked.

WHAT'S IN A NAME

HOUSTON, Texas, Jan. 15—A cafe's name proved too inviting for a burglar, police reported yesterday. They said someone bucked into the Duck Inn ad Wobble Out Cafe and wobbled out with $25.

Report Asks Hike in U.S. Judges Salaries

Board Urges $12,500 Pay Increase for Congressmen

WASHINGTON, Jan. 15 (INS)—A special commission recommended today that congressmen vote themselves a pay boost of $12,500 a year, an increase of more than 80 per cent.

The 18-member commission set up by Congress last year also advocated substantial salary increases for Chief Justice of the Supreme Court Earl Warren, the eight associate justices and other federal judges.

REPORT SUBMITTED

A report urging the increased congressional pay and judicial scales was submitted this morning to President Eisenhower, Vice President Richard M. Nixon, House Speaker Joseph W. Martin Jr., Republican of Massachusetts, and Chief Justice Warren.

Presently, senators and House members receive a salary of $12,500 a year and an additional tax-exempt $2500 for expenses for a total annual pay of $15,000.

(Continued on Page 11, Col. 4)

Proposed Pay Hikes for U.S. Solons, Judges

WASHINGTON, Jan. 15 (AP)—Following are the major changes in officials' compensation proposed by the commission on judicial and congressional salaries:

Positions	Present	Proposed
Chief Justice of the United States	$25,500	$35,000
Associate Justices of the Supreme Court	25,000	35,000
Members of Congress	15,000	27,500
Judges of the United States Courts of Appeals, of Customs and Patent Appeals, and of Military Appeals and of Claims	17,500	25,500
Judges of United States District Courts, Customs Court and Tax Court	15,000	22,500

Coffee Prices

Colombia Hikes It 88c To $1.20

MEDELLIN, Colombia, Jan. 15 (AP)—Colombian dealers boosted the retail price of coffee today from 88 cents to $1.20 a pound.

A cup of coffee in restaurants and coffee houses jumped from four cents to six cents.

Colombia is one of the major producers in South America of light coffee.

Stocks Soar To New High

NEW YORK, Jan. 15 (INS)—The January bull market in stocks picked up steam today as it carved out its fourth successive session of advances.

Leading issues advanced fractions to more than a point, many to new highs for the 1953-54 period.

MARILYN MONROE
And Her Form!—Calendar Gave the Bare Facts

JOE DiMAGGIO
Joe Had Baseball Form For Knocking Homers

THEY KISS SIDEWISE—LIKE IN THE MOVIES
Kissing Before Cameras Is Tricky Business—Marilyn Is Well Trained, Of Course, and Joe Is Learning Quickly

JOHNNY CRIES AT DIVORCE

Johnny Ray, the famous weeping crooner, really cried yesterday. His wife, the former Marilyn Morrison, divorced him in Juarez, Mexico, and although they parted amiably together (above), Johnny wept after the hearing. "I don't think any man likes to see a marriage go on the rocks," said Johnny.

London Press 'Whoops It Up' for Marilyn

LONDON, Jan. 15 (AP)—Marilyn Monroe's marriage wiped a good deal of politics and disaster news off front pages in London's space-pinched papers today.

An the austere Times, in a brief notice, identified the bridegroom as "Mr. Joe DiMaggio, an American"... former baseball player.

Blonde Marilyn has been getting a great deal of attention lately here. Two of her pictures are showing simultaneously in glittering West End cinemas, "Gentlemen Prefer Blondes" and "How to Marry a Millionaire."

She has been getting surprisingly friendly notices from the stern critics, while the comment in the pubs and clubs is usually a low whistle and an expression of rapture.

Reports of the wedding duly

(Continued on Page 10, Col. 1)

She Wants 6 Kids

Pair in Secret Hideout

(Other Photos A-8)

While Joe Di Maggio and his platinum-plated blonde bride, Marilyn Monroe, honeymooned "somewhere in California," the future of her lucrative film career appeared to be wrapped in mystery and conjecture today.

Officially she is under suspension at Twentieth Century-Fox, and officially she isn't even expected out on the lot.

Unofficially, it was reported that she was expected to return to Hollywood next Thursday, with a possibility that peace talks might return her to the sound stages for "Pink Tights," which is in a state of unravelment due to her absence.

The wriggly, giggly blonde was married to the ex-Yankee centerfielder yesterday, and the couple departed immediately on a top-secret honeymoon.

WANTS SIX KIDS

Before they took off, Marilyn remarked that "I'd like to have six children."

"We'll have at least one," Joe amended.

In San Francisco's city hall yesterday, they were married by Municipal Judge Charles S. Peery, who later complained that in all the excitement he forgot to kiss the bride.

Although the marriage was supposed to have been a secret, 500 persons jammed the corridor outside the judge's courtroom, Joe's best man was Reno Barsocchini, whose wife was matron of honor. Also present were Tom DiMaggio, Joe's brother, and his wife, and Mr. and Mrs. Lefty O'Doul.

BIG DIAMOND

The 25-year-old Marilyn, regarded as Hollywood's most valuable blonde, was dressed in a chocolate brown suit, wore false eye-lashes and a huge diamond ring.

DiMaggio, 39, and graying, wore a blue suit and a bashful smile.

He puffed on a cigar while reporters shot questions at his giggling and merry bride.

Asked whether she planned to give up the movies for home-making, Marilyn kicked one of her shapely legs and said:

"What difference does it make? I've been suspended."

OFF SALARY

She referred to the fact that her studio, 20th Century-Fox, took her off salary for refusing to report for the film "Pink Tights."

DiMaggio interjected impatiently:

"All right, fellows. I don't want to rush you but we've got to get on with the ceremony."

The ceremony was to have

(Continued on Page 10, Col. 3-4)

1954 Models Galore in 31st L.A. International Auto Show Edition—Section C

Marilyn and Joe were married on January 14, 1954, after dating for two years. "The Marriage of the Decade" was the headline nationwide.

(following spread) This Cecil Beaton photo of Marilyn, shot on February 22 in Beaton's suite at the Ambassador Hotel in New York, was Marilyn's favorite professional photograph of herself. She kept copies of it in a file folder to give to friends and fans.

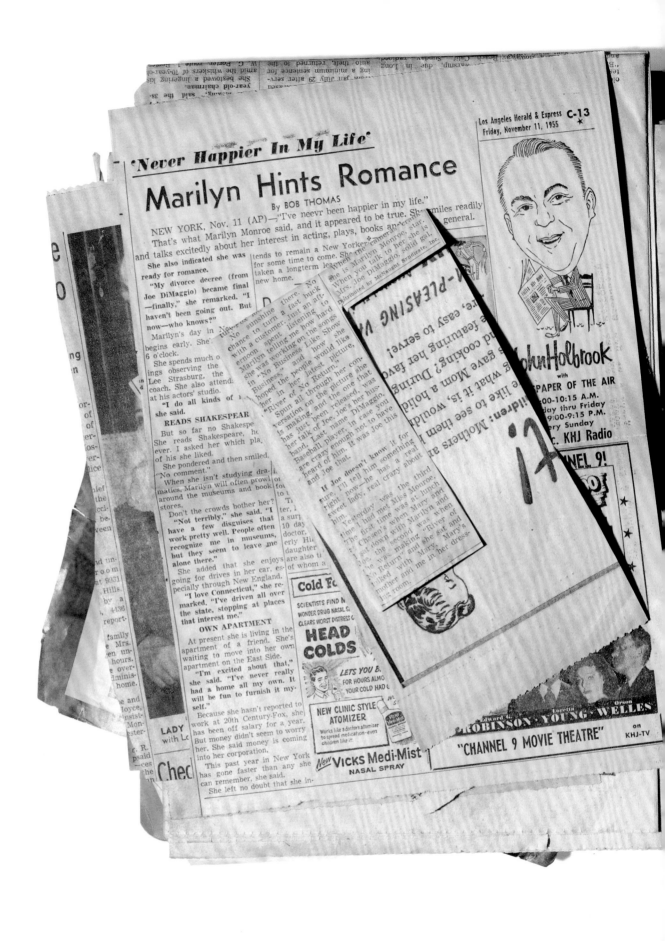

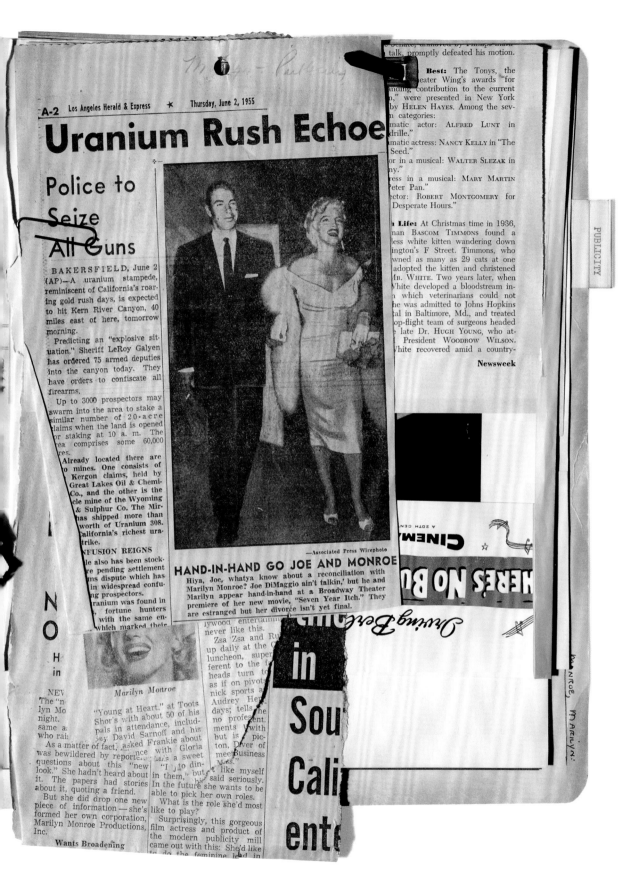

PUBLICITY

A-2 Los Angeles Herald & Express ✶ Thursday, June 2, 1955

Uranium Rush Echoe

Police to Seize All Guns

BAKERSFIELD, June 2 (AP)—A uranium stampede, reminiscent of California's roaring gold rush days, is expected to hit Kern River Canyon, 40 miles east of here, tomorrow morning.

Predicting an "explosive situation," Sheriff LeRoy Galyen has ordered 75 armed deputies into the canyon today. They have orders to confiscate all firearms.

Up to 3000 prospectors may swarm into the area to stake a similar number of 20-acre claims when the land is opened for staking at 10 a. m. The area comprises some 60,000 acres.

Already located there are two mines. One consists of Kergon claims, held by Great Lakes Oil & Chemical Co., and the other is the Miracle mine of the Wyoming & Sulphur Co. The Miracle has shipped more than $ worth of Uranium 308. California's richest uranium strike.

CONFUSION REIGNS

Title also has been stockpile pending settlement claims dispute which has resulted in widespread confusing prospectors.

Uranium was found in the area by fortune hunters with the same enthusiasm which marked their

Marilyn Monroe

NEV The "no" lyn Mo night. same as who rai

"Young at Heart." at Toots Shor's with about 50 of his pals in attendance, including David Sarnoff and his

As a matter of fact, asked Frankie about was bewildered by reporters' ence with Gloria questions about this "new as a sweet look." She hadn't heard about it. The papers had stories about it, quoting a friend.

But she did drop one new piece of information — she's formed her own corporation, Marilyn Monroe Productions, Inc.

Wants Broadening

"I to dinin them," but said seriously. In the future she wants to be able to pick her own roles.

What is the role she'd most like to play?

Surprisingly, this gorgeous film actress and product of the modern publicity mill came out with this: She'd like to do the feminine lead in

—Associated Press Wirephoto

HAND-IN-HAND GO JOE AND MONROE

Hiya, Joe, whatya know about a reconciliation with Marilyn Monroe? Joe DiMaggio ain't talkin,' but he and Marilyn appear hand-in-hand at a Broadway Theater premiere of her new movie, "Seven Year Itch." They are estranged but her divorce isn't yet final.

talk, promptly defeated his motion.

Best: The Tonys, the heater Wing's awards "for anding contribution to the current n," were presented in New York by HELEN HAYES. Among the seven categories:

matic actor: ALFRED LUNT in drille."

matic actress: NANCY KELLY in "The Seed."

or in a musical: WALTER SLEZAK in ny."

ress in a musical: MARY MARTIN Peter Pan."

ctor: ROBERT MONTGOMERY for Desperate Hours."

Life: At Christmas time in 1936, nan BASCOM TIMMONS found a less white kitten wandering down ington's F Street. Timmons, who wned as many as 29 cats at one adopted the kitten and christened MR. WHITE. Two years later, when White developed a bloodstream in which veterinarians could not he was admitted to Johns Hopkins tal in Baltimore, Md., and treated p-flight team of surgeons headed e late Dr. HUGH YOUNG, who at-President WOODROW WILSON. White recovered amid a country-

Newsweek

Herald Tribune—United Press Herald Tribune photo by Ira Rosenberg

INTERVIEW WITH MARILYN—Screen star Marilyn Monroe at the Plaza yesterday where she and Sir Laurence Olivier announced that they will do a movie together.

Herald Tribune—United Press

MISHAP—During the interview, one of the shoulder straps of Miss Monroe's low-cut black velvet cocktail sheath broke. She was snapped by the photographer while trying to fix it with a safety pin.

'My Hope and Dream'

Marilyn Monroe Is Happy: Will Co-Star With Olivier

By Judith Crist

Sir Laurence Olivier and Marilyn Monroe announced yesterday that they will co-star in a film version of Terrence Rattigan's "The Sleeping Prince," to be produced by Marilyn Monroe Productions Inc. and directed by Sir Laurence.

"My hope and dream was to have him not only star but also direct," Miss Monroe said breathlessly.

"I was very interested in doing the film when the offer came," Sir Laurence reported with less emotion.

Goodly Crowd Was There

The two made their announcement before 200 reporters, photographers, newsreel and television camera men, assorted press agents and fortunate passers-by who managed to infiltrate the Terrace Room of the Hotel Plaza during the noon hour.

Monroe leaned back, smiling brightly and adjusting her neckline. Then it became apparent that she was toying with one of her shoulder straps that had broken. This reporter proffered a safety pin.

'Extraordinary Gift'

What about a recent statement that Miss Monroe "has more sex appeal than any other woman in the world"—as far as her acting is concerned? Sir Laurence thought a moment, then said, "In my opinion, Miss Monroe has an extremely extraordinary gift of being able to suggest one moment that she is the prettiest little thing and the next that she's perfectly innocent. The audience leaves the theater gently titilated into a state of excitement by not knowing which she is and enjoying it thoroughly."

How did she feel about the

Herald Tribune photo by Ira Rosenberg

"PUT YOUR ARM AROUND HER," cried the photographers, but Sir Laurence only smiled politely. Miss Monroe was more willing to follow the photographer's instructions.

(above) During a press conference at the Plaza Hotel on February 9, 1956, Marilyn and Laurence Olivier announced plans to costar in the film version of the play The Sleeping Prince *(later released as* The Prince and the Showgirl*), with Olivier directing for Marilyn Monroe Productions. Marilyn stole the show when a spaghetti strap on her dress broke and she borrowed a safety pin from reporter Judith Crist to reattach it. She had fixed the strap beforehand so that it would easily detach from the dress.*

(opposite, at left) Josh Logan, director of Bus Stop, *considers Marilyn a brilliant actress and attacks the standard beliefs that beautiful women can't be intelligent.*

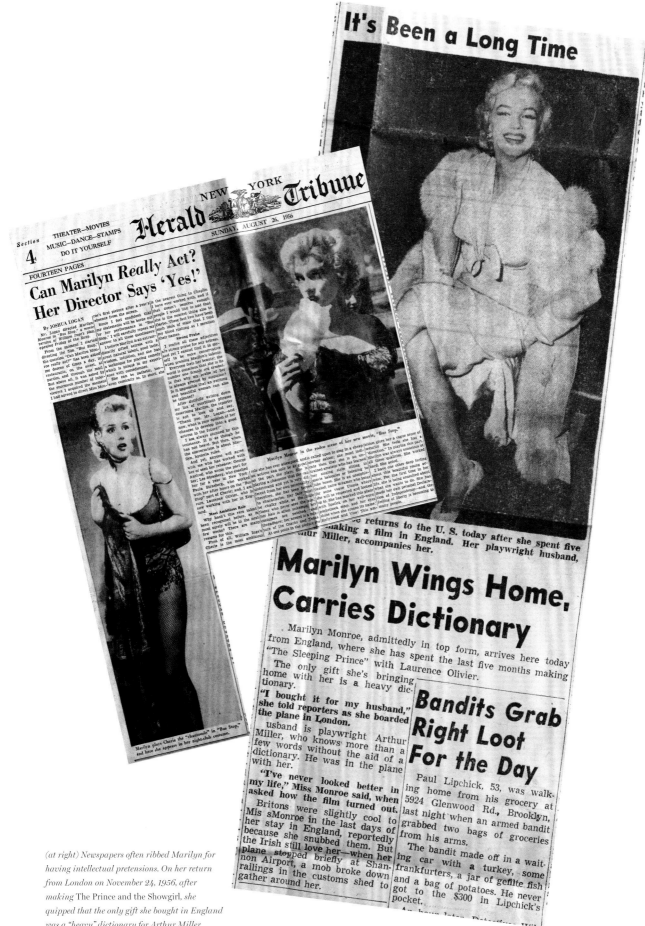

It's Been a Long Time

Herald NEW YORK Tribune

Section **4**

THEATER—MOVIES
MUSIC—DANCE—STAMPS
DO IT YOURSELF

SUNDAY, AUGUST 26, 1956

FOURTEEN PAGES

Can Marilyn Really Act? Her Director Says 'Yes!'

By JOSHUA LOGAN

Mr. Logan directed Marilyn Monroe in "Bus Stop," a movie version of William Inge's play, opening Friday at the Roxy.

From the moment I started directing the film "Bus Stop," the question "Can Marilyn Monroe really act?" has been asked me dozens of times a day, in restaurants, on the street, at parties, and through the mail. But above all, it was asked by the enormous number of interested viewers I acquired the moment I had agreed to direct Miss Mon-

roe's first picture after a year's absence from the screen.

Since I feel confident that my statements will be borne out by her performance in "Bus Stop," I will carefully repeat my answers to all these questions.

I believe Marilyn is an extraordinarily gifted actress with a great natural talent, good taste and real intuition, and she has a technique for playing comedy which is unique in my experience with all these comediennes. She can be pathetic, too—even comically so. In short, she

is the nearest thing to Chaplin I have ever worked with, and if that doesn't mean enough, let me add that she is the nearest thing also to Garbo. These last two have been much blood rushing as I mention their names.

Strong Praise

I realize all these adjectives are strong praise for any actress, and yet I cannot find it in myself to be more conservative when praising Marilyn's talents. Everyone feels her beauty; the world is conscious that she is one female sex symbol number one female sex symbol. It is always agreed by audiences Is it impossible that an exciting and beautiful woman can also be talented?

After dutifully writing down a list of exorbitant phrases describing Marilyn, the reporter is apt to look up and say, "Thank you, Mr. Logan, and now, what is your opinion of her chances to develop into a good actress in the future?"

I am always stunned by this resistance. It is as though he has not heard. But then, when the conversation is about Marilyn, hysteria rules.

And yet, anyone will agree with me who has worked with her or seen her rehearse. George Axelrod, who wrote the part for her; Lee Strasberg, who coached her for a year in New York; Paula Strasberg, who worked with her after hours on the "Bus Stop" part of Cherie; and, I am sure, Laurence Olivier, who is now working with her in England.

Most Ambitious Role

Why hasn't this rare talent been recognized before, as it most surely will be in the next few weeks? There are many reasons for this.

First of all, William Inge's Cherie is the most ambitious

role she has ever attempted, and is called upon to sing in a cheap saloon; she must indicate then that she is an untrained amateur who has learned her singing style by listening to juke boxes. She is an unsophisticated naive dreamer who hopes she will be respected and looked up to. She has married the wrong... with lipstick, map, and her eyes. This am-

At one point in the picture...

billion gives her a vague sense of security. She feels she has a direction. In playing this part, Marilyn was always conscious of these qualities. She acted...

I have one other deep feeling about this beautiful young actress. For the first time in her life, she is being consulted about what she wants to do. She has made her own personal declaration of independence—and the feeling of liberty is becoming to many people.

Marilyn Monroe in the rodeo scene of her new movie, "Bus Stop."

Marilyn plays Cherie the "chanteuse" in "Bus Stop," and here she appears in her night-club costume.

...e returns to the U. S. today after she spent five ...making a film in England. Her playwright husband, ...ur Miller, accompanies her.

Marilyn Wings Home, Carries Dictionary

Marilyn Monroe, admittedly in top form, arrives here today from England, where she has spent the last five months making "The Sleeping Prince" with Laurence Olivier.

The only gift she's bringing home with her is a heavy dictionary.

"I bought it for my husband," she told reporters as she boarded the plane in London.

...usband is playwright Arthur Miller, who knows more than a few words without the aid of a dictionary. He was in the plane with her.

"I've never looked better in my life," Miss Monroe said, when asked how the film turned out.

Britons were slightly cool to Miss Monroe in the last days of her stay in England, reportedly because she snubbed them. But the Irish still love her—when her plane stopped briefly at Shannon Airport, a mob broke down railings in the customs shed to gather around her.

Bandits Grab Right Loot For the Day

Paul Lipchick, 53, was walking home from his grocery at 5924 Glenwood Rd., Brooklyn, last night when an armed bandit grabbed two bags of groceries from his arms.

The bandit made off in a waiting car with a turkey, some frankfurters, a jar of gefilte fish and a bag of potatoes. He never got to the $300 in Lipchick's pocket.

(at right) Newspapers often ribbed Marilyn for having intellectual pretensions. On her return from London on November 24, 1956, after making The Prince and the Showgirl, *she quipped that the only gift she bought in England was a "heavy" dictionary for Arthur Miller.*

THE PUBLIC MARILYN 79

MARILYN MONROE / TONY CURTIS / JACK LEMMON
IN A BILLY WILDER PRODUCTION "SOME LIKE IT HOT"
CO-STARRING GEORGE RAFT / PAT O'BRIEN / JOE E. BROWN
SCREENPLAY BY BILLY WILDER AND I. A. L. DIAMOND / DIRECTED BY BILLY WILDER
AN ASHTON PICTURE / A MIRISCH COMPANY PRESENTATION

THIS IS HOT !

*First prints of special Marilyn Monroe sitting
from world-famous photographer Richard Avedon! Equally great coverage
on Tony Curtis and Jack Lemmon! All to spark the biggest promotion back-up ever
for one of 1959's biggest grossers . . . Billy Wilder's "Some Like It Hot"!*

40th
ANNIVERSARY

THRU
UA

1919

SOME LIKE IT HOT

Richard Avedon took these photos of Marilyn in a flapper dress with long pearls and a ukulele. *Some Like It Hot* was set in the 1920s, when the ukulele was popular, and Marilyn learned to play the instrument for the film.

Marilyn's tardiness, her frequent illnesses, and her demands for many takes caused problems during the filming of *Some Like It Hot*. But Marilyn considered her character, Sugar Kane, to be an airhead, and she disagreed with director Billy Wilder over how the role should be played. She had wanted Frank Sinatra, not Tony Curtis, to play opposite her, and she became furious at Curtis for his remark that kissing her was like kissing Hitler. Curtis now contends that it was a flip remark made when a worker on the set asked him a stupid question about what it was like to kiss Marilyn.[4] Despite the difficulties, *Some Like It Hot* remains one of the highest-grossing comedies in film history and was a major moneymaker for Marilyn, whose agent had negotiated 10 percent of the gross for her with United Artists, the film's distributor.

The handwriting in Marilyn's note about Curtis (on the following page) differs from her normal handwriting during these years, but she had used this controlled handwriting as a young woman, and it appears in some of her correspondence in the file cabinets.

In the *New York Journal American*, the usually mordant Billy Wilder praised Marilyn's work in the film: "I think she's the best light comedienne we have in films today, and anyone can tell you that the toughest of all acting styles is light comedy."

Journal-American

Hot or Cold, They All Like MM

By ROSE PELSWICK

TODAY'S big movie news is that Marilyn Monroe is back on the screen. Her first picture in three years, "Some Like It Hot" today reopens the beautifully remodeled Loew's State Theatre.

It's described as an hilarious spoof of the guys-gals-and-gangsters era back in the Roaring Twenties. Tony Curtis and Jack Lemmon are teamed along with MM, and supporting the three stars are George Raft in the underworld-type role that zoomed him to stardom, Pat O'Brien, Joe E. Brown, Nehemiah Persoff, Joan Shawlee, George E. Stone and Mike Mazurki.

Produced, directed and co-scripted by Billy Wilder for the Mirisch Company and United Artists release, "Some Like It Hot" casts its glamorous blonde as a ukulele-strumming vocalist with an all-girl band.

Tony and Jack Offer Fun

And for comedy complications there are the antics of Curtis and Lemmon as a pair of musicians who don feminine clothes and join the band in an effort to escape the machine-guns of a gang of hoodlums.

Action moves from Chicago to Miami, and the farcical and romantic goings-on have a tune-filled background. Marilyn, who definitely does her own singing, warbles "I Want To Be Loved by You," "Runnin' Wild" and "I'm Through With Love."

Also sung or played are such nostalgic favorites as "Sweet Georgia Brown," "Sweet Sue," "La Cumparsita," "By the Beautiful Sea" and "Down Among the Sheltering Palms."

One of Hollywood's ace film-makers ("The Lost Weekend," "Sunset Boulevard," "Witness for the Prosecution"), Wilder is an enthusiastic MM admirer.

"There are actresses, there are stars, and there are super-stars," he says. "Marilyn is a super-star, one of that exclusive club that includes Garbo and a few others. There is nothing she can't do. I think she's the best light comedienne we have in films today, and anyone will tell you that the toughest of all acting styles is light comedy."

And deploring the current Hollywood standard which sometimes seems to measure talent by means of a tape measure, he adds: "Mind you, I don't deprecate Marilyn's measurements. But they aren't, as with some other Hollywood girls I could mention, the be all and end all. **Marilyn has real style. Her sex appeal stems from many** things including voice, grace of movement and personality. She's an actress—an actress who keeps improving all the time."

LUCKY TONY . . . Who wouldn't like to be in Tony Curtis' togs—he makes love to Marilyn Monroe in "Some Like It Hot," highly-touted United Artists film that reopens Loew's State today.

There is only one way he could comment on my sexuality and I'm afraid he has never had the opportunity!

Meeting, April 3,1958, 2:30PM
 444 E. 57th Street

Present: Lew Wasserman
 Mort Viner
 Marilyn Monroe
 Arthur Miller

Discussed how to settle Skouras
situation. Decided:

1) At Wasserman's suggestion, it
would be best to approach Skouras
once Marilyn had decided to do the
Wilder picture.

 Sinatra will be in or out
according to Wasserman within a day
or two.

 MCA on the Coast has told
Wilder that there are "legal techni-
calities holding up her decision"
so as not to offend Wilder. Actually,
she is waiting for Sinatra to enter
the picture. She still doesn't like
Curtis but Wasserman doesn't know
anybody else.

 Wharton office: Sale of
PRINCE AND SHOW GIRL would be
Capitol Gain. Wasserman will consult

ROGERS & COWAN, INC.

PUBLIC RELATIONS

JOSEPH WOLHANDLER
VICE-PRESIDENT

JANUARY 19, 1959

MRS. ARTHUR MILLER
444 E. 57TH STREET
NEW YORK, N. Y.

DEAR MARILYN:

THAT ISSUE OF LIFE MAGAZINE
THAT CARRIED YOUR PICTURE SET
AN ALL-TIME RECORD IN SALES.
MORE COPIES WERE SOLD OF THAT
ISSUE THAN ANY OTHER ISSUE IN
THE HISTORY OF LIFE. THE
FIGURE WAS 6,300,000 AND MORE
COULD HAVE BEEN SOLD IF THEY
HAD PRINTED MORE. LIFE'S
CIRCULATION DEPARTMENT TELLS
ME THAT THIS IS THE HIGHEST
CIRCULATION FIGURE IN THEIR
ENTIRE PUBLISHING CAREER.

BEST REGARDS,

Joe

JOE WOLHANDLER

JW/PW

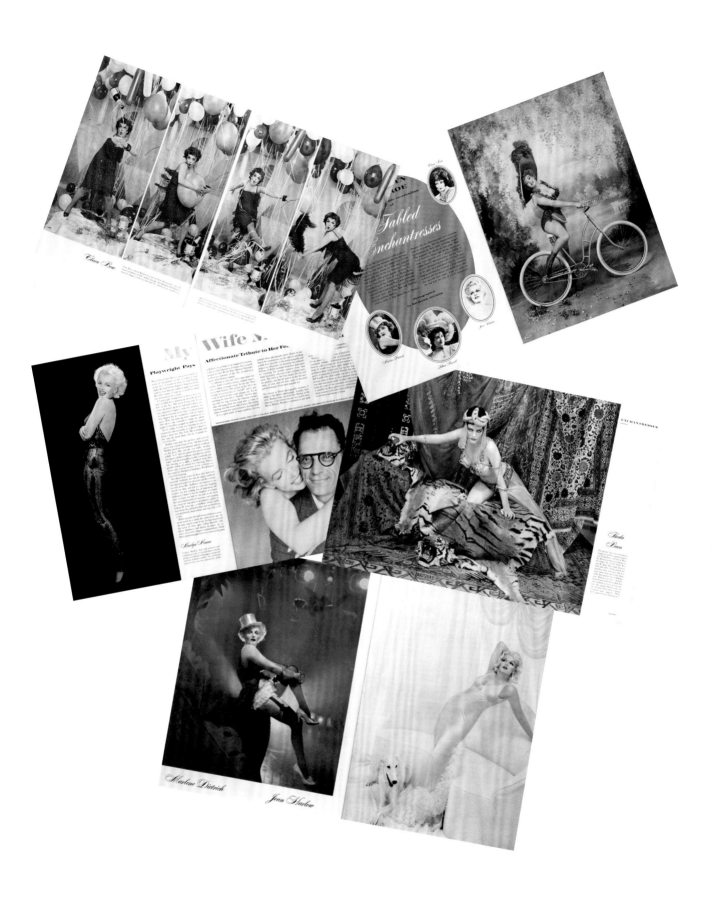

(above) In this famous "siren" series of photos, taken by Richard Avedon and first published in the December 22, 1958, issue of Life *magazine, Marilyn channels burlesques sirens Lillian Russell, Theda Bara, Clara Bow, Jean Harlow, and Marlene Dietrich.*

NA317 PD=FAX NEW YORK NY 26 313PM=

MARILYN MONROE=

444 EAST 57 ST=

1958 JUN 26 PM 3 26

=DEAR MARILYN: THE PICTURES ARE STUPENDOUS. WE HAVE BEEN
CRYING WITH JOY ALL DAY. THANK YOU THANK YOU=

MARY LEATHERBEE LIFE=

WESTERN UNION

Telefax Telefax

CA327

L NB177 FD=NEW YORK NY 9 407PME= 1958 JUL 9 PM 1 48

MARILYN MONROE, HOTEL BEL AIR=

 701 STONE CANYON RD BEL AIR LOSA=

=DEAREST MARILYN THE NEW PHOTOGRAPHS ARE NOT AS GOOD AS
WE BOTH WOULD WANT THEM TO BE STOP WILL CONTACT YOU AS
SOON AS I RETURN FROM EUROPE ABOUT SEPTEMBER 6TH AND
COME TO HOLLYWOOD TO RE-SHOT AT YOUR CONVENIENCE STOP
OH BROTHER WE MISS YOU HERE LOVE

 = DICK=

1270 (1-51)

*Both Avedon and Monroe were perfectionists,
and they didn't like the results from the first
sittings (above), although the Life editors loved
them (opposite). So they reshot them.*

ROGERS & COWAN, INC.

PUBLIC RELATIONS

JOSEPH WOLHANDLER
VICE-PRESIDENT

FEBRUARY 5, 1959

MRS. ARTHUR MILLER
444 E. 57TH STREET
NEW YORK, N. Y.

DEAR MARILYN:

THE JON WHITCOMB COVER
THAT WAS SUBMITTED FOR THE
MARCH ISSUE OF COSMOPOLITAN
IS EXTREMELY BEAUTIFUL AND
IS DONE ALL IN WHITE.

I THINK WHITCOMB HAS
INTENTIONS OF PRESENTING IT
TO YOU HIMSELF. FROM WHAT
I HAVE SEEN, YOU WILL BE EX-
TREMELY PLEASED.

BEST REGARDS,

JOE WOLHANDLER

JW/PW

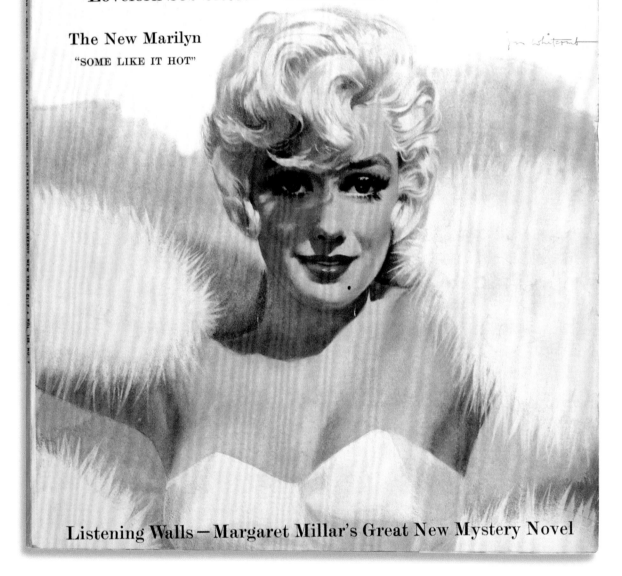

COSMOPOLITAN

SPECIAL ISSUE | Manners and Morals

Swap-Mate Scandals ▪ He-Men and Honor in Business
Our Moral Revolt from 1920 to 1960 ▪ Is Divorce a Disease?
Lovelorn Sob Sisters ▪ Parents Review Sex Education

The New Marilyn
"SOME LIKE IT HOT"

Listening Walls – Margaret Millar's Great New Mystery Novel

*Jon Whitcomb was a major post–World War II illustrator,
known for his drawings of beautiful young women.*

September 24, 1959

Dear Jon,

Please forgive the long delay
in answering, but I have been up to
my derriere in preparations for two
movies for the near future; public-
relations, home-relations -- please
understand.

I would love to have the picture
from you and I repeat 'at last to be
a Whitcomb girl!'.

When you are in New York, my
number is Eldorado 5-2325. I am looking
forward to meeting with you and I want
you to meet Arthur.

Warmest regards,

Mr. Jon Whitcomb
Box 1027
Darien, Connecticut

Here, Marilyn enthusiastically responds to
Whitcomb's portraits of her, writing, "at last
to be a Whitcomb girl!"

Darien, Conn.
Oct. 6, 1959

Dear Marilyn:

Caught a glimpse of you at the Khrushchev
luncheon in Hollywood - but there was such a mob I
wasn't even able to wave hello.

I'll drop the cover off at 444 E. 57th St.
some day this week (plus the second picture which il-
lustrated the article in COSMO) and if for any reason
you're not home, I'll leave them with my pal Gene
Davis, who has the north penthouse. (He's across the
hall from Suzy Parker.) Then all you have to do is
ring him -or he can ring you - I've got to go to Tobago
for SWISS FAMILY ROBINSON for a few days. When
I get back later on this month I'd love to meet Arthur.

Best love,

This letter from Jon Whitcomb to Marilyn, dated October 6,
1959, mentions Gene Davis and Suzy Parker. Gene Davis was
an influential abstract expressionist painter in the 1950s.
Suzy Parker was a high-fashion model who had modest success
in Hollywood films. The luncheon for Nikita Kruschev, the
Soviet premier, occured in September.

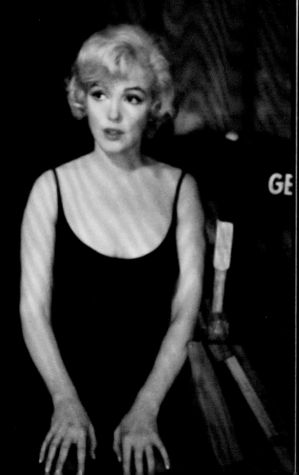
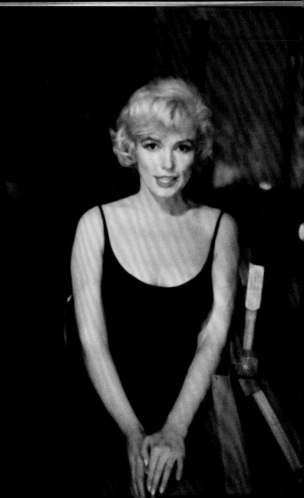

LET'S MAKE LOVE

Publicity stills of Marilyn for Let's Make Love, *photographed by John Bryson. The "GE" on the back of the cloth chair beside Marilyn probably refers to George Cukor, the film's director.*

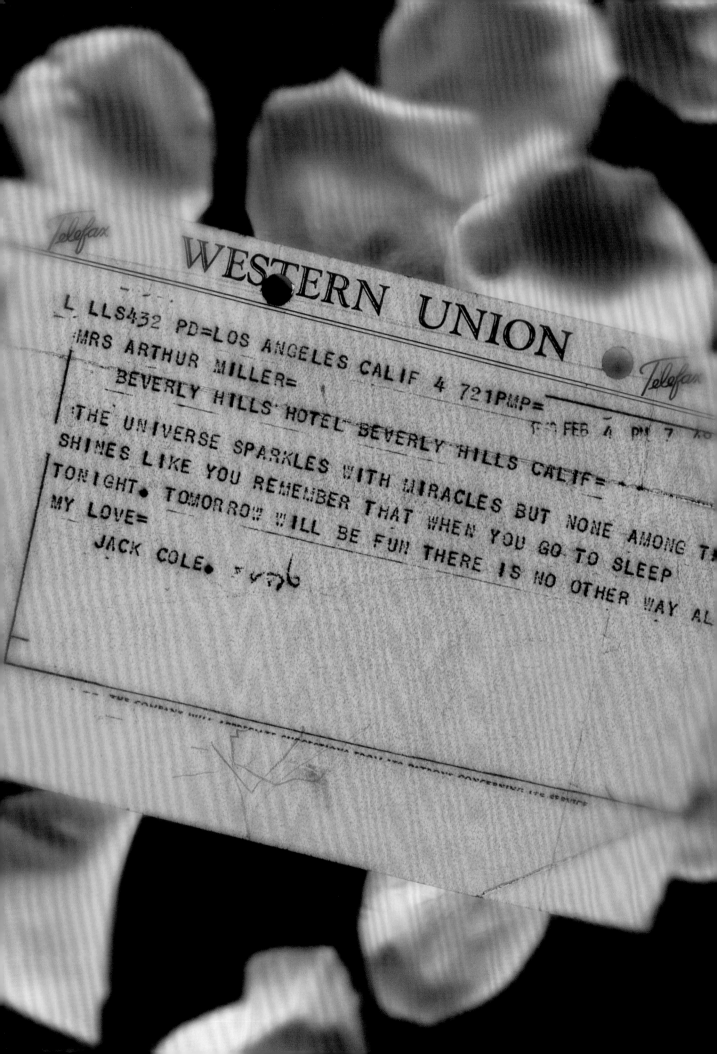

WESTERN UNION

L LLS432 PD=LOS ANGELES CALIF 4 721PMP=
MRS ARTHUR MILLER=
 BEVERLY HILLS HOTEL BEVERLY HILLS CALIF=

THE UNIVERSE SPARKLES WITH MIRACLES BUT NONE AMONG T
SHINES LIKE YOU REMEMBER THAT WHEN YOU GO TO SLEEP
TONIGHT. TOMORROW WILL BE FUN THERE IS NO OTHER WAY AL
MY LOVE=
 JACK COLE.

Beverly Hills Hotel and bungalows
in Beverly Hills, California . . .

Happy Christmas !!

yves Simone

(opposite) *Choreographer Jack Cole encourages Marilyn*
during the difficult filming of Let's Make Love: *"The*
universe sparkles with miracles but none among them
shines like you." Marilyn insisted that Cole choreograph
her dance numbers in her musicals.

(above) *Simone Signoret and Yves Montand drew*
this Christmas card to Marilyn and Arthur Miller
by hand. The two couples were assigned to adjacent
bungalows at the Beverly Hills Hotel during the
filming of Let's Make Love.

John Bryson

Miss Marilyn Monroe
Mapes Hotel
Reno, Nevada

HOTEL

Algonquin

59 WEST 44TH ST., NEW YORK 36, N. Y.

6 August 1960

Dear Marilyn:

Well, the story is closed in LIFE finally and
we got a cover and nine pages. I am half-dead
from four days and nights of fighting and bleeding
and helping lay out and all the things that go
with it; I have fathered three babies and I think
this was tougher than the births of any of them.

I hope you like the story; I don't know whether
I do or not, I am so close to it and feel so
strongly about it that I cannot even look at the
pictures any more.

I had to fight two things: the natural journalistic
interest in Yves and your own damn sexy beauty.
On the latter, the editors are just naturally
attracted to beautiful pictures of you to the
exclusion of some of the things I tried to show,
the long hours, the hard work. We got those in,
but I lost some of the things I loved like the
getting-up-at-five-a-yem and the Monroe Shake and
some of the ones that show how intensely hard you
work.

I am very happy, however, to report that we close
with a larger than full page of the picture of
Arthur swabbing off your back after a hard day's
rehearsal. I think the little girl look in this
is the best picture I ever took of you.

Anyway, it is done and I hope you like it. If

Personal

HOTEL

A

59 WEST 4

you do or do not I would like for yo
that I think you are one of the best
ever known and if you ever need a fr
anything just call day or night. I
such things casually.

Please give my best to Arthur an
me.

Very sinc

John

Miss Marilyn Monroe
Mapes Hotel
Reno, Nevada

PS: I just saw the first color p
and even if it is immodest I mus
looks **great**. My God.

*(opposite) John Bryson shoots Marilyn for
LIFE Magazine's coverage of Let's Make Love.*

How some lovely fans react to Montand

Descending an upcoming scene with Director George Cukor, Yves puffs his toe, with a chaste kiss by poet, while Marilyn in her rehearsed togs posts, chats heartily with her expansive American co-star.

Powerful Stars Meet to Play-Act Romance

(body text columns — largely illegible)

After finishing his day's work, Yves drops into Marilyn's portable dressing room to say goodby. She has to go on working in *Let's Make Love*, a motion picture about an actress in love with a millionaire.

The Star Gets a Kiss, Kind Words, a Rubdown

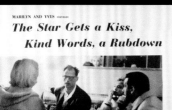

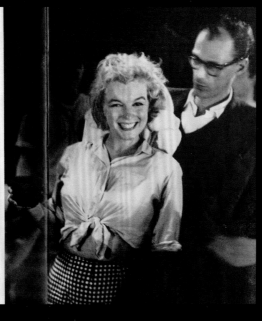

Marilyn, trap light begins husband Arthur Miller say one war, "greet" as him embrace by her own—discreet urges her and to say them because the furs. Watched by Yves and with Simone Signoret, Marilyn plants grateful kiss on Arthur.

Stopping just after a wry-hour dance rehearsal, Marilyn grabs at her husband comes up with a towel to dry her neck and hair. In the sun chair Marilyn, virtually without make-up, in most nearly herself, finding her delight in lazy, hard work.

A Legend Is Costly But It's Worth It

(body text columns — largely illegible)

— Dores Zeidan, Life Correspondent

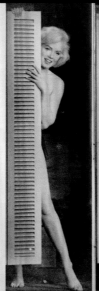

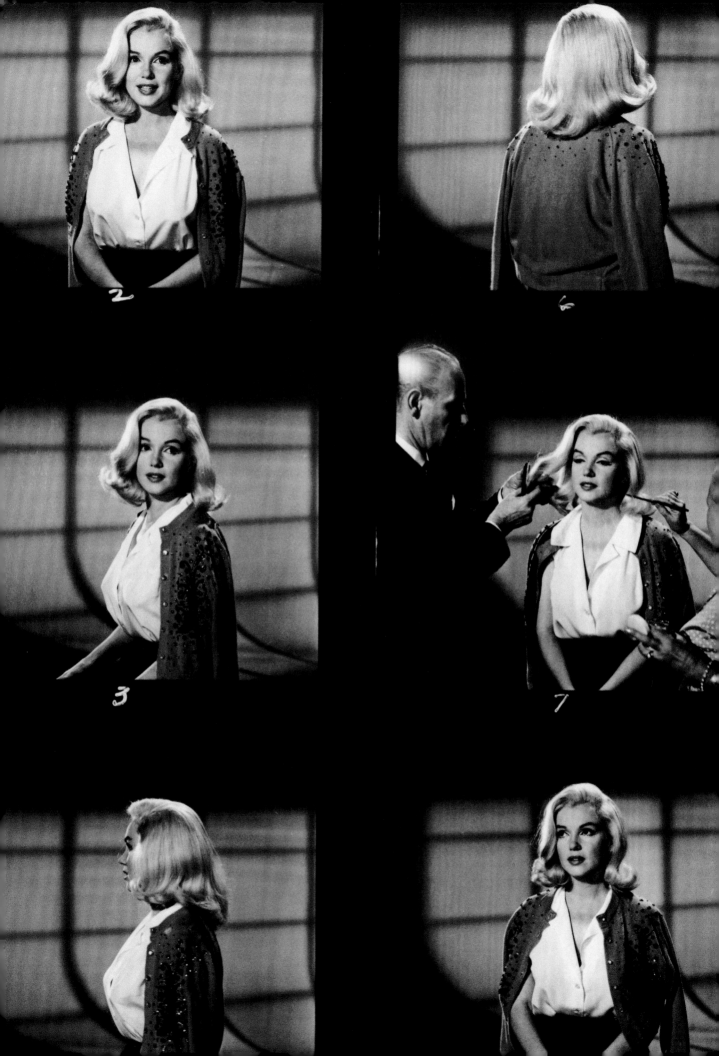

Quantity Negatives: 4x5_____ 8x10_____ 120.

	HOURS	RATE	AMOU
Retouching			
Black & White			
Color			

	QUANTITY	UNIT	AMOU
Developing			
Black & White			
Film Rolls			
Color Processing			
4 x 5			
8 x 10			
Film Rolls			
Copies			
Special Instructions			

THE MISFITS

Arthur Miller had initially written The Misfits as a short story
about two cowboys. He began adapting it into a film script for
Marilyn in the summer of 1957. In the undated note on the
following page, Elia Kazan praises the script but hopes that
Arthur will make changes to it before shooting begins.

Dec 19

Dear Art: Went to bed very early last night, and so woke up
very early - in fact in the middle of the night. So I read
your script. You've got the makings of a superb movie here.
The last big sequence (Mustangs) can be a masterpiece. And
its perfect for Huston. I thought you went on andon about what
it all meant though. I'd have liked it better without nearly
so much thematic finger pointing. And I thought the very end
unresolved. Perhaps it all suffers from not quite pointing to
any definite ending. And to tell it all, I thoughtthe girl a
little too - well too a lot of things, too right, too often, too
pure, too aware. But, on the whole, damned good. I hope you work
on it more before you start shooting. There's no New Haven,
Boston ,Philadelphia in this work. Good luck, and thanks
for letting me read it.

Gadg

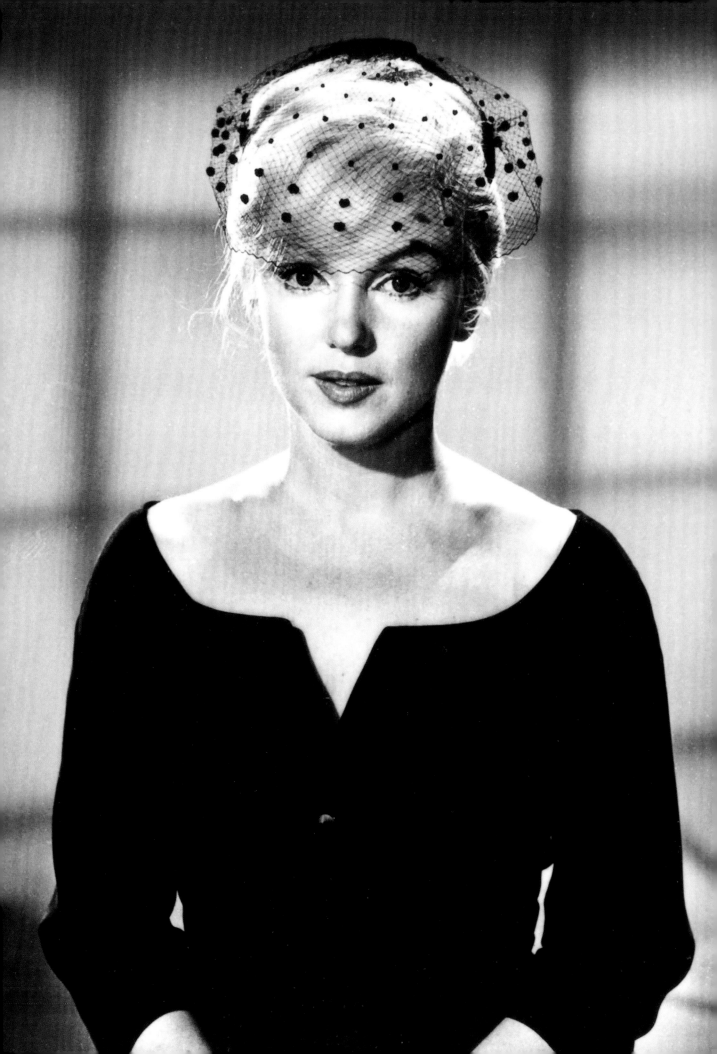

May 3, 1960

Dear Marilyn,

 Although I really feel I should be
replaced--I will continue with your clothes for
"The Misfits" because they are under way and
nearly ready to fit.

 If you like them, I will see them
through to completion. If you are disappointed,
someone else can then take over.

 I am sorry I have displeased you.
I feel quite defeated--like a misfit, in fact.
But I must, above everything, continue to work
(and live) in terms of my own honesty, pride
and good taste.

 I have written John Huston and Frank,
so they will know.

Warmly ever,

DJ

*Dorothy Jeakins was a major Hollywood costume designer
who had done the costumes for both* Niagara *and* Let's Make
Love. *Marilyn could be a perfectionist, and Dorothy didn't
continue her work on* The Misfits. *"Frank" is Frank Taylor,
the film's producer.*

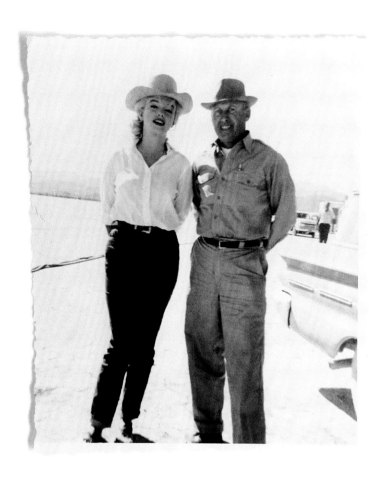

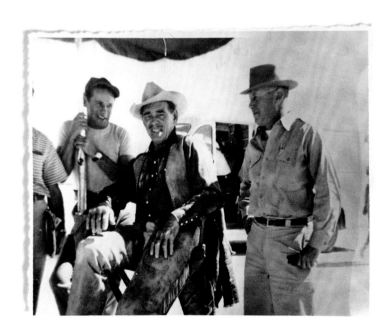

(top) Marilyn with Allan "Whitey" Snyder, Marilyn's personal
makeup specialist on her films (and a close friend).

(bottom) Clark Gable with Eli Wallach, a costar in The Misfits,
and Whitney Snyder.

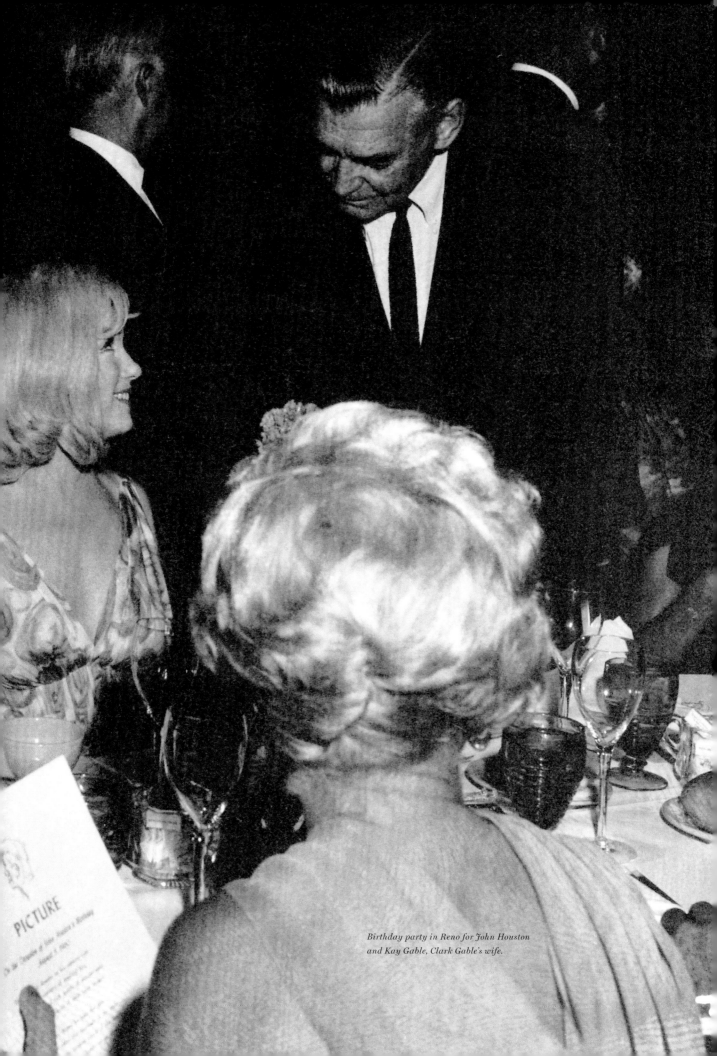

Birthday party in Reno for John Houston and Kay Gable, Clark Gable's wife.

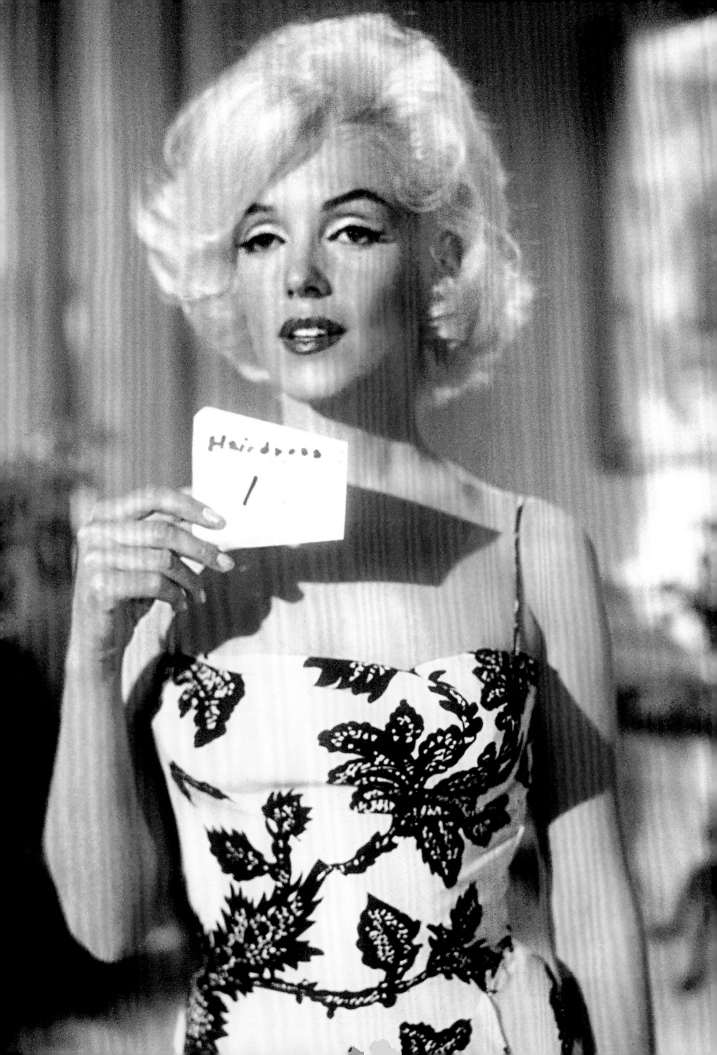

(opposite, above, and overleaf)
Costume, hair, and makeup tests
for Something's Got to Give.

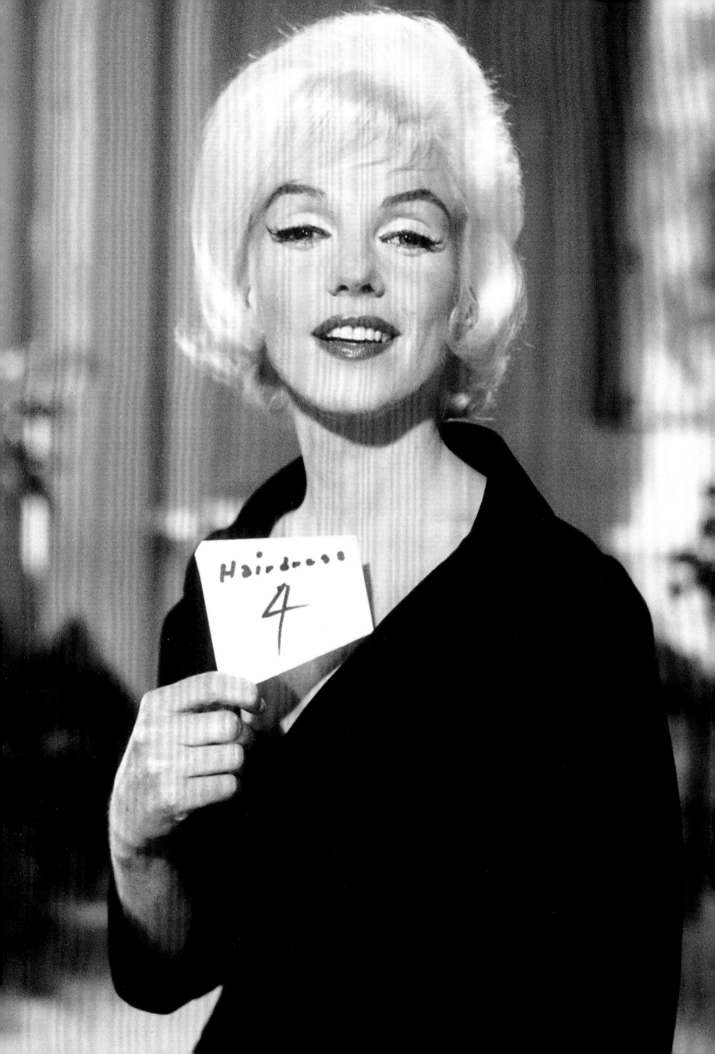

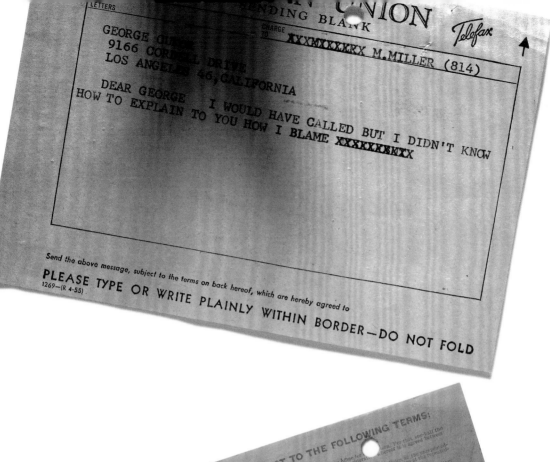

UNION UNION
SENDING BLANK Telefax

LETTERS
CHARGE
TO XXXMXXXXXX M.MILLER (814)

GEORGE CU
9166 CORDELL DRIVE
LOS ANGELES 46,CALIFORNIA

 DEAR GEORGE I WOULD HAVE CALLED BUT I DIDN'T KNOW
HOW TO EXPLAIN TO YOU HOW I BLAME XXXXXXXXXX

Send the above message, subject to the terms on back hereof, which are hereby agreed to

1269—(R 4-55)

PLEASE TYPE OR WRITE PLAINLY WITHIN BORDER—DO NOT FOLD

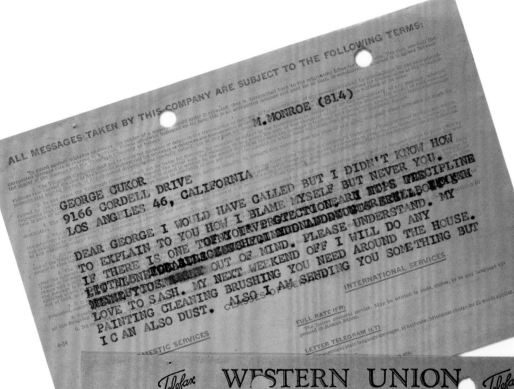

ALL MESSAGES TAKEN BY THIS COMPANY ARE SUBJECT TO THE FOLLOWING TERMS:

M.MONROE (814)

GEORGE CUKOR
9166 CORDELL DRIVE
LOS ANGELES 46, CALIFORNIA

 DEAR GEORGE I WOULD HAVE CALLED BUT I DIDN'T KNOW HOW
TO EXPLAIN TO YOU HOW I BLAME MYSELF BUT NEVER YOU.
IF THERE IS ONE THING YOU EVER NEEDED IT IS DISCIPLINE
LITTLE ONE. PLEASE PUT ME OUT OF MIND. PLEASE UNDERSTAND. MY
LOVE TO SASH. MY NEXT WEEKEND OFF I WILL DO ANY
PAINTING CLEANING BRUSHING YOU NEED AROUND THE HOUSE.
I CAN ALSO DUST. ALSO I AM SENDING YOU SOMETHING BUT

INTERNATIONAL SERVICES

FULL RATE (FR)

LETTER TELEGRAM (LT)

DOMESTIC SERVICES

4-54

Telefax **WESTERN UNION** Telefax
SENDING BLANK

CALL
LETTERS
CHARGE
TO

GEORGE CUKOR -2-

IT'S LATE IN LEAVING. I BEG YOU TO UNDERSTAND.
DEAR EVELYNG SENDS HER BEST WE'RE BOTH CITY TYPES.
LOVE.

 AMANDA MARILYN

cc: Mrs. Murray
 Pat Newcomb

WESTERN UNION ✳ CABLE FROM LONDON ✳ TELEPHONED 2:30 PM

WESTERN UNION
TELEGRAM
W. P. MARSHALL, PRESIDENT

CLASS OF SERVICE		SYMBOLS
This is a fast message unless its deferred character is indicated by the proper symbol.		DL=Day Letter
		NL=Night Letter
		LT=International Letter Telegram

The filing time shown in the date line on domestic telegrams is LOCAL TIME at point of origin. Time of receipt is LOCAL TIME at point of destination

LA203 SSC187 L BHA247 *DOHENYDR*

(L CDVO11 WUA642 UWS3351 OPH3568) 46 PD INTL FR=CD LONDON

VIA RCA 22 1835= 1962 JUN 22 PM 2 11

MARILYN MONROE= *(P.O. BOX 64721 LOSA 64)*

 DOHENYDR HOLLYWOOD (CALIF WH)=

IN FACE OF HARD CRITICISM WE WOULD LIKE TO PUBLISH YOUR

VIEWPOINT TO BRITISH READERS STOP WILL PHONE YOU THROUGH

PAT NEWCOMBE WEEKEND AND ASSURE YOU WILL PRINT WHAT EVER

YOU WISH TO SAY REGARDS=

 TONY WELLS SHOWBUSINESS EDITOR TODAY MAGAZINE

 LONDON.

THE COMPANY WILL APPRECIATE SUGGESTIONS FROM ITS PATRONS CONCERNING ITS SERVICE

(opposite) This undated telegram to George Cukor, director of Something's Got to Give, *was probably sent after the studio fired Marilyn from the film. Marilyn blames herself for her firing and offers to do anything Cukor needs around his house—painting, cleaning, brushing—on her next weekend off as recompense. "I can also dust."*

(above) After Fox fired Marilyn from Something's Got to Give, *its executives planted newspaper stories critical of her behavior. Tony Wells, editor of the U.K.'s* Today *magazine, asks for her response to those stories "in face of hard criticism."*

The New York Times

TIMES SQUARE, NEW YORK 18, N. Y.
LACKAWANNA 4-1000

Korea
February 20, 1954

Dear Stan,

When I mentioned your name, quite by accident, to Marilyn she exploded with
excitement on the spot and insisted that I write a note that she could carry to you.
How can anyone deny her anything that she asks?

The girl was just wonderful out here. She put every ounce of herself into
everything that she did and won the hearts of a hundred thousand smitten G.I.'s. I
doubt if any of them from General on down to Private will ever be the same again.
Maybe we could send Marilyn up into North Korea to win over the Communists. I'm sure
she would succeed and everyone could throw away their rifles and the country would be
unified again. God wouldn't it be wonderful not to see the name Korea in the newspapers
anymore.

Your colleague Don Wilson and I are now fast friends. Bot_____ enjoy the
soft

Dear Mari_____
Because I __
even read it if you l__
nicest things about you. ____

But then there are only f_____
job in Korea for the soldiers and even f__ of th__ ___
now that you could step out on the stage of the ___ ___ in the __
and break every attendance record. That goes for _____
or Ankers also.

My only wish is that you stay just as sweet ___ ___
now. I'm sure that you will.

If you want anything from this part of the world don't hesitate to write to
me at the New York address above. They will forward the letter to me no matter where I
am and foreign correspondents are likely to go anywhere.

The best of luck to you and Joe in your new marriage and I hope that you
both will be very happy. Please give Jean my regards also. I think she's terrific.

Love and kisses,
Bob
Bob Alden

"ALL THE NEWS THAT'S FIT TO PRINT"

*"The girl was just wonderful out here. She put every
ounce of herself into everything she did and won
the hearts of a hundred thousand smitten G.I.'s.
Maybe we could send Marilyn up into North Korea
to win over the Communists." Atop the letter is
a standard army sewing kit given to Marilyn.*

BY 1954 MARILYN was receiving as many as twenty-thousand fan letters a week, setting a new record among film stars. Many of her early fan letters came from servicemen and college boys who liked her pinup photos. But women responded to her innocence and sadness, as well as to the stories of her tragic childhood. In his autobiography, *Timebends*, Arthur Miller described the letters that arrived daily when they were in London making *The Prince and the Showgirl*. Some 15 percent of the letters, he wrote, were simply insane. One man invited her to meet him in a coal mine, another to go fishing in a Scottish lake. And "baffled" women wrote to her wanting to know how they could become wonderful like her. Hedda Rosten, who often worked as Marilyn's assistant during these years, opened and answered the fan mail. She gave Marilyn only those letters that were emotionally touching or encouraging for her to read.[5]

Marilyn received fan letters from all over the world. Her films and photos were popular outside the United States, and movie-fan magazines in many countries carried stories about her. Most of the fan letters have been lost, but Marilyn kept her favorites. They offer another window into understanding her as a woman and a star.

Given how proud she felt about her tour of Korean army bases, it comes as little surprise that Marilyn kept letters from soldiers stationed there. She also kept amusing letters, like the one from the candidate for the "ugliest man on campus" at Iowa State University. Above all, she kept letters that touched her heart, such as a letter from a fan in Italy. She honored his request to send him a lock of her hair and an autographed photo. In the photo he sent her, he is dark and handsome, mirroring the Clark Gable look typical of the men she fell for, like DiMaggio, Miller, and Montand—a look that, perhaps, reminded her of her imagined father.

Feb 25, 1954

Dear Miss Monroe ;—
this
morning I recieved a letter
from my son in Korea, I
think you should know
what he says about your
appearance there. I save
all of his letters, or I would
enclose it. This is what he
wrote.

"Two days ago, Marilyn
Monroe played before 12,000
men of this division. It
was a sunny, cold day but
true to the standards that
have been set for her, she
appeared in a low cut, sheathe
dress of purple glittery sort of
material. She is certainly
beautiful !!! When she ap-
peared on the stage, there was
just a sort of gasp from the
the audience — a single gasp

/multiplied
soldiers pre
a gasp.
system wa
and had
movie fro
songs were
not too w
known w
ing. Hou
matter.
walked o
and smil
have been
might ad
certainly
friends her
izes that
she is here
she doesn
publicity,
being paid
lesser enter
show she

the 12,000 ... was quite ... broadcasting ... stremely poor, ... seen the ... which the ... ken, I'm ... I would have ... she was sing- ... it didn't ... she only ... the stage ... it would ... ough. I ... hat she is ... ing a lot of ... Everyone real- ... here is no reason ... pt to entertain; ... need the ... she is not ... too, unlike ... after the ... napled, chatted,

and posed for pictures. Then thru all the trucks and jeeps she rode perched on top of the seat of her jeep, smiling and waving. All in all I think it was pretty wonderfull that she came to Korea at all, and doubly so that she came to the divisions that have been so long on the line, and by-passed the easy duty in Seoul, Inchon and the southern cities."

You are a real soldier. I know what that trip cost you. But you didn't dissapoint those boys. In our hearts we thank you for your wonderfull generosity and kindness to our son. Your friends Mr & Mrs N. P. Rupe 6315 So Yakima Tacoma Wash

The mother of a soldier in Korea praises Marilyn. Unlike other entertainers who came to his base, Marilyn signed autographs, chatted with the soldiers, and posed for pictures. She performed at bases close to the front lines and bypassed "the easy duty in Seoul and Inchon." "You are a real soldier," the mother concludes.

Jan. 24, 1958

Dear Mr. Miller

tried to reach you by
phone but failed.

Wonder if you might
be interested in the
adoption of a baby girl,
that was born to an unwed
mother about the same
time your wife loss her
child.

It is a healthy and
beautiful baby and the mother
feels that you people would
really make a good happy
home for her, which she can-
not do because of her other
problems.

If you are interested
you can reach me my

phone in Huntington Park
Ludlow 8-3825 or
write to me 6320 Malabar
St., Huntington Park, Calif.
apt J. Stella Yusko.
 This cannot be talked
about with anyone it must
be very Confidential. The
child is now in a foster
home, and she is two months
old.

 Sincerely

 Stella Yusko

CLASS OF SERVICE

This is a full-rate Telegram or Cablegram unless its deferred character is indicated by a suitable symbol above or preceding the address.

publicity

WESTERN UNION

W. P. MARSHALL, PRESIDENT

=(11)=

The filing time shown in the date line on telegrams and day letters is STANDARD TIME at point of origin. Time of receipt is STANDARD TIME at point of destination

1953 NOV 11 12 19

LA278

L.HDA082) NL PD=AMES IOWA 10 VIA HOLLYWOOD CALIF 11=

MISS MARILYN MONROE, ~~CARE BEN GOLDBERG~~
 CARE INEZ MELSON 9128 SUNSET BLVD
~~2393 CASTILLIAN HOLLYWOOD CALIF~~ =

NOTHING SELLS LIKE SEX AND SEX MEANS MARILYN MONROE
COULD YOU AIR MAIL DOZEN OR SO SIGNED PUBLICITY PHOTOS FOR
AUCTION IN CONNECTION WITH CAMPUS CHEST FUND DRIVE
WORTHIEST OF COURSES NEED BY SATURDAY WILL PAY POSTAGE WE
LOVE YOU=

 DICK HIGGS PUBLICITY MANAGER FOR ART BARKOW UGLIEST
MAN ON CAMPUS CANDIDATE=

THE COMPANY WILL APPRECIATE SUGGESTIONS FROM ITS PATRONS CONCERNING ITS SERVICE

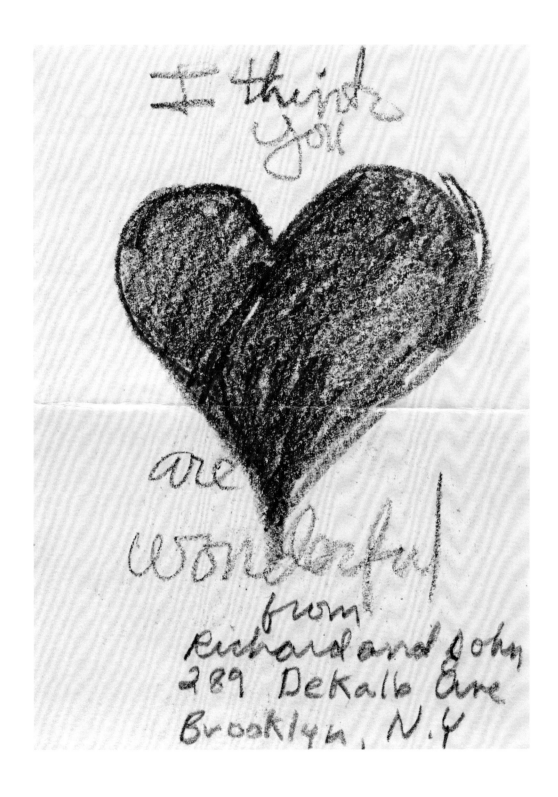

I think
you

are

wonderful

from
Richard and John
289 DeKalb Ave
Brooklyn, N.Y

(opposite) A candidate for the "ugliest man on campus" at Iowa State University asks Marilyn for a dozen signed photos to sell at the campus chest-fund drive. "Nothing sells like sex and sex means Marilyn Monroe," he writes.

(above) A sweet fan letter written by children from Brooklyn, NY.

Cerignola 18-1-56

Alessio Borraccino
Via S. Francesco D'Assisi 44
(Foggia) Cerignola
 Italia

I am about to write a million thoughts of affection to my Miss Monroe that I

Sto per scrivervi e molti pensieri si affacciano alla mia mente senza che io
riesca a riordinarli. Ho tutto il cuore in sussulto perchè so di scrivere ad una
 why I do write to a
grande attrice. great actress

 Da molto tempo vi ho visto lavorare sullo schermo e precisamente dal film:
 of the many times I have seen you work in the movies and presently in
« Niagara », film dal quale lei ottenne molto successo. In seguito ho visto
 film which you attained much success
molti altri suoi films dove maggiormente vi ammirai, dopo vidi: « The
 after I saw
river of no return ». Visto lo spettacolo uscii dalla sala incontento, estatico,
nel vedere come lei seppe lavorare molto bene, e dove ammirai anche la sua
 to admire also your
bellezza. Dopo questo film fu l'inizio di una ben più profonda ammirazio-
Beauty after this film
ne verso di voi, e vi portavo nel mio cuore come se io fossi stato trafitto da
uno strale di "Cupido". D'allora incominciai una caccia spietata alle
vostre fotografie; le tagliavo dai gi... ...rso su album.

To stesso non so come spiegare questa
come un fuoco che tiene sempre ac...
Molte volte bisticcio con gli amici di...
che altre attrici siano più belle di...
In verità io non ho occhi che per...
bella di Venere, e vorrei che voi fos...

Molte volte vi sogno, ed io mi gio...
nel sangue, io vi guardo e mi...
dal fascino della musica, immo...
cielo di stelle, ed esse ci sorri...
trasportare, ma queste par...
To ho studiato per quattro a...

Pics of him e dedication
autographed e
returned also
a lock of hair

Also a letter where
I will carry next
to my heart always—

Miss Monroe,

I begin to write to you and many thoughts come to mind and I cannot manage to organize them. My heart beats because I know that I write to a famous actress.

For a long time I have seen your screen work and particularly in the film Niagara—*a film that brought you much success. After that I saw many of your other films, where I came to admire you even more, especially after seeing* The River of No Return. *After the film, I exited the theater enchanted and ecstatic to see that you know how to work so well, and admiring your beauty as well.*

After this film, I developed a significantly more profound admiration of you, and I carried you in my heart as though I were . . . of "Cupid" in person. From that time, I started a remorseless search for photographs of you; I cut them from newspapers, and I put them in an album. I myself do not know how to explain this flame that burns in my heart: It is like a fire that always keeps a veneration of you lit inside of me. Many times I have argued with school friends because some of them claim that other actresses are more beautiful than you. In truth, I have eyes for no one but you, I adore you as though you were a goddess, you are more beautiful than Venus, and I wish that you were to remain always this beautiful.

Very often I have dreamed of you . . . and I . . . and it penetrates my blood, I look at you the silence in my heart is ended. Moved by the charm of the music, I imagine that you and I dance wrapped in a sky of stars, and they smile at us. I ask for your forgiveness for my letting myself be transported this way, but my heart has spoken these words, not my mind. I have studied English for four years, I could have written to you in your language, but I could not find the right words to express what I feel toward you.

With great joy I want to say to you: "I love you but I am a boy," . . . I say "I am nothing but a fool." Please forgive me if I have dared to say too much, but I believe that you understand me. Now I feel better, I have said what I had to say.

For many months I have had the intention of writing to you but I was afraid to give form to this dream of mine. Now I would like to speak about myself. I am a 17-year-old boy and I attend Liceo Classico and I am in my first course of study. I am sending you two photos of me, one for you to keep as a reminder of me, the other I would like you to return to me with your autograph and a dedication. I would like as well a large photo of you, autographed in your own handwriting with a dedication to me personally. I give to you a small photo album, which will allow you to understand how much I admire you. I desire very much something that belongs to you, here I have discovered it: a curl of your beautiful blonde hair.

I would like you to respond to me with a letter. I would be very grateful for it, I would carry it with me like a knight carries his maiden's colors with him into tournaments.

If it pleases you, I could write to you once in a while, and you might speak of me a bit.

If this summer I move to Rome, and if, by pure chance, you come for work or vacation to the beautiful Italian capital, I will come to find you. Forgive me if, perhaps, I have lost my mind.

I thank you with all my heart and with my eyes in tears, your eternal admirer,

Alessio Borraccino
(Translation by Marla Stone, professor of history, Occidental College)

(opposite) Marilyn makes a note to send her Italian fan a lock of hair and vows to keep his letter close to her heart.

(following spread) Collage enclosed in Italian fan letter, with a photo of the fan in the upper left-hand corner.

Questa mia foto dedico a
Voi affinchèvi sia sempre
presente nel vostro cuore

Marilyn Monroe

Marilyn Monroe considerata ad
Hollywood la rappresentante
numero 1 del sex-appeal, sembra
decisa a convolare a nozze con
lo sportivo Joe Di Maggio.

Marilyn Monroe divide con Gregory Peck l'ambito
primato di aver maggiormente guadagnato durante il
1953. Per contro questa constatazione l'ha fatta il fi-
sco il quale, come è noto, farà la parte del leone.

MARILYN MONROE: 1-6-1928

MARILYN MONROE

Marilyn Monroe è considerata oggi la diva del sex appeal. Il suo fascino ha quasi oscurato le varie Jane Russel, Corinne Calvet e Rita Hayworth. Marilyn ha iniziato la sua carriera posando, come ragazza da copertina per una delle più note riviste americane. È stata scoperta dal produttore Howard Hughes, ma lanciata da John Huston con il film «Giungla d'asfalto». Marilyn Monroe, il cui vero nome è Norma Jean Baker, è nata a Los Angeles ventiquattro anni fa. Rimasta orfana, Marilyn veniva adottata da una ricca signora di Los Angeles che ella ricorda con affetto come Zia Anna.

Paid Bills

MARILYN MONROE - 1962 - Norman Jefferies
EXPENSE ACCOUNT

Paid Bills

MARILYN MONROE - 1962 - Eunice Martin
EXPENSE ACCOUNT

FUR & COAT
STORAGE

MARILYN MONROE

SAVINGS ACCOUNTS

MARILYN MONROE PRODUCTIONS, INC. 1960

M ARILYN WAS A GOOD BUSINESSWOMAN. When columnist Earl Wilson interviewed her in the spring of 1955, he was surprised by her detailed knowledge of incorporation, investments, and contracts.[6] Behind the glamour of golden-age Hollywood stardom was a world of journalists, publicists, photographers, and fans, all demanding Marilyn's attention. Stars of Marilyn's magnitude also had managers, lawyers, accountants, agents, publicists, and secretaries to help with business and career matters. These individuals had to be overseen. Marilyn listened to them, but she made the final decisions herself.

Her agents often sent her novels, scripts, and film treatments as possible starring vehicles, and she in turn suggested material that might have a good role for her. She kept a "script box" containing promising submissions for her and her staff to read. Marilyn met with her lawyers or studio representatives over production matters. Friends asked for favors; charities asked her to attend their functions. Her publicists suggested interviews to do and events to attend. She read the trade papers and the fan-magazine stories about her, or her secretaries and publicists told her about them. Sometimes she became so angry over spiteful write-ups that she considered suing, although she never did.

Throughout her career with Twentieth Century-Fox she fought the studio over her contracts and her films. Her lawyers jostled with Fox lawyers via letters written in legalese that is difficult for the layperson to understand. The disagreements revolved around whether Marilyn had appeared on sets soon enough after the studio assigned her to movies, whether the studio had operated within its contractual time limits,

and how much extra time should be required of her without salary for the days she called in sick. She was often sick during the production of her later films, starting with *There's No Business Like Show Business* in 1954. "Layoffs" and "suspensions" are the terms used in the letters.[7]

Marilyn's lawyers and agents were shrewd in negotiating with Fox, since she was paid one hundred thousand dollars each for two films she didn't make: *The Blue Angel* in 1957 and *Goodbye Charlie* in 1961. The problem for Fox was that, after it had informed Marilyn that she should appear for shooting, its executives weren't able to hire a director or sufficient actors in the time frame specified by Marilyn's 1955 contract. In violating the time requirements on these matters, Fox, not Marilyn, was in breach of contract. Fox executives' anger at Marilyn for often calling in sick or being late to appear on the set for the filming of *Let's Make Love*, and their sublimated anger at her lawyers for outwitting the studio on two films, set the stage for the struggle over *Something's Got to Give* in 1962.

One can only marvel at how Marilyn, often fragile and insecure, handled the many demands made of her, as well as the many disappointments she encountered. One such issue involved her autobiography, *My Story*. Documents in the file cabinets prove that Marilyn dictated it to screenwriter Ben Hecht in late 1953 and early 1954 and that his larcenous agent, Jacques Chambrun, made off with it. Before he was stopped by Marilyn's lawyers, Chambrun was able to sell the manuscript to *Empire News*, a London tabloid, which published a version of it, and he had been attempting to sell the rights to it—which weren't his—to outlets in Australia. Chambrun was never prosecuted, and Milton Greene finally published a copy he had in 1974.

Marilyn's sense of humor must have helped her navigate these difficult situations. It is evident in the fact that she kept amusing letters, such as the "wiggle" letter sent to her by a horse breeder from Australia.

Marilyn often changed agents and lawyers. Harry Lipton was her first agent, from 1946 until 1949. Then Johnny Hyde bought out Lipton's contract and had her sign with his agency, William Morris, that year. By 1952 she had turned to Charles Feldman and his Famous Artists Agency, although she didn't officially sign with Feldman until March 1954, and William Morris collected the agent's percentage on her salary until then. When she rebelled against Fox at the end of 1954, she canned Feldman and signed with Lew Wasserman and his MCA group.

Similarly, Marilyn had many lawyers: Her first lawyer was Loyd Wright Jr., based in Los Angeles, followed by a number of New York lawyers, beginning with Frank Delaney in late 1954, until he quit a year later. She then used Irving Stein, Milton Greene's lawyer, until she broke with Milton and turned to Robert H. Montgomery Jr. and John F. Wharton, who were Arthur's lawyers. In 1959 she accused Montgomery of sexual harassment, and he seems to have been fired or reassigned. When she divorced Arthur, Wharton bowed out because he considered it a conflict of interest to represent both Arthur and her. She then hired New York lawyer Aaron Frosch on the recommendation of Paula Strasberg.[8] When she moved to Hollywood in 1961, she added Hollywood lawyer Milton Rudin to her team. He was Frank Sinatra's lawyer and the brother-in-law to her psychiatrist, Ralph Greenson. At the time of her death, she was considering firing Aaron Frosch.

(following spread) Telegrams were a common mode of communication in the 1950s, and Marilyn's file cabinets contain many.

WESTERN UNION

W. P. MARSHALL, PRESIDENT

FX-1201

(25)

SYMBOLS

DL=Day Letter
NL=Night Letter
LT=Int'l Letter Telegram
VLT=Int'l Victory Ltr.

1954 DEC 14 AM 10 52

LA079 SSB278 L HDA098 (

CDU021) INTL FR=CD MELBOURNE VIA RCA 21 14 1413=

MARILYN MONROE, CARE INEZ MELSON)=

(9128 SUNSET BLVD) HOLLYWOOD (CALIF)=

WESTERN UNION

W. P. MARSHALL, PRESIDENT

publicity

=(11)

SYMBOLS

DL=Day Letter
NL=Night Letter
LT=Int'l Letter Telegram
VLT=Int'l Victory Ltr.

1953 NOV 11 12 19

LA278

HDA082) NL PD=AMES IOWA 10 VIA HOLLYWOOD CALIF 11=

MISS MARILYN MONROE=

CARE INEZ MELSON 9128 SUNSET BLVD

WESTERN UNION

TELEGRAM

W. P. MARSHALL, PRESIDENT

JAN 16 PM 8 42 1961 (4-60)

SYMBOLS

DL=Day Letter
NL=Night Letter
LT=International Letter Telegram

ARB133 LB461

L LLT285 PD TDL WUX WEST LOS ANGELES CALIF 16 448P PST

MARILYN MONROE

444 EAST 57 ST NYK

WESTERN UNION

TELEGRAM

W. P. MARSHALL, PRESIDENT

1201

SYMBOLS

DL=Day Letter
NL=Night Letter
LT=International Letter Telegram

WULO37 SSD196 L BHA163 PD=WUX BEVERLYHILLS CALIF 1 1218P PDT

=MISS MARILYN MONROE DONT PHONE CARE "LET'S MAKE LOVE"=

WESTERN UNION

TELEGRAM

W. P. MARSHALL, PRESIDENT

1201

SYMBOLS

DL=Day Letter
NL=Night Letter
LT=International Letter Telegram

(55)

A302 PD=WUX CHICAGO ILL 14 220PMC=

1959 APR 14 PM 5 58

MRS ARTHUR MILLER=

ATTN MISS MAY REIS 444 EAST 57 ST=

WESTERN UNION

TELEGRAM

W. P. MARSHALL, PRESIDENT

SYMBOLS

DL=Day Letter
NL=Night Letter
LT=International Letter Telegram

LA203 SSC187 L BHA247

DOHENY DR

L CDVO11 WUA642 UWS3351 OPH3568) 46 PD INTL FR=CD LONDON

VIA RCA 22 1835=

1962 JUN 22 PM 2 11

MARILYN MONROE= (P.O. BOX 64721 LOSA 64)

CLASS OF SERVICE

This is a fast message unless its deferred character is indicated by the proper symbol.

NA317 PD=FAX NEW YORK

MARILYN MONROE=

:444 EAST 57 ST:

WESTERN UNION

OA507 BA572

B EBA231 PD=EB NEW YORK

MRS JOE DI MAGGIO=

:508 NORTH PALM D

CLASS OF SERVICE

This is a fast message unless its deferred character is indicated by the proper symbol.

LA552

L LSC157 NL PD=WUX LOS

MARILYN MONROE, CARE A

AR 444 EAST 57 ST NYK

=THINK YOU HAVE A HIT IN

CLASS OF SERVICE

This is a fast message unless its deferred character is indicated by the proper symbol.

NA055 DL PD AR=NEWYORK

MRS ARTHUR MILLER=

:444 EAST 57 ST=

WESTERN UNION

CLASS OF SERVICE

This is a fast message unless its deferred character is indicated by the proper symbol.

NA301 DL PD=BEVERLY H

:MRS ARTHUR MILLER=

WESTERN UNION

NA065 LAT 369 40 PD INT

11 105P=

MRS ARTHUR MILLER=

444 EAST 57TH ST NYK

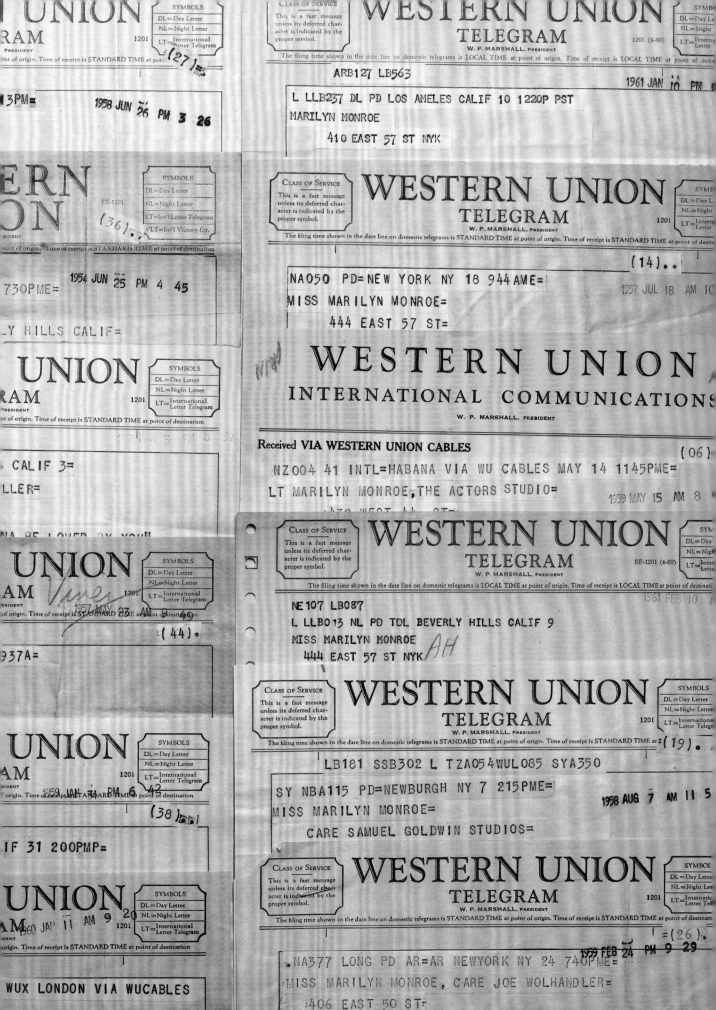

ES92

UW83568 WORKSOP 22 20 1452

LT

MISS MARILYN MONROE 444 EAST57STREET NEWYORK

.ead on phone to Mrs. Murray cc: Mrs. Murray
 Pat Newcomb Pat Newcomb

WESTERN UNION * CABLE FROM LONDON * TELEPHONED 2:30 PM

 MARILYN MONROE
 DOHENY DRIVE

PCD16 CATANIA 22 25 1705=
LT MARILYN MONROE 444 EAST 57 NYK= (444 EAST 57TH ST)

AM AT EXCELSIOR HOTEL CATANIA SICILY WILL BE HERE TWO WEEKS

LETTER FOLLOWING AFFECTIONATELY=

 SYDNEY+

57+

*The "Sydney" in this telegram is probably hairstylist
Sydney Guilaroff, who often created Marilyn's
hairstyles for her films.*

*Marilyn didn't carry out her plan to attend the 1959
Cannes Film Festivals, noted in the opposite telegram
from the Christian Dior house.*

ACR7/CAMR610/CW326

WORKSOP 19 19 1115

RPDOLLARS1.68 MISS MARILYN MONROE 444 EASTFIFTYSEVEN STREET

FRENCH CABLE CO.
10 ROCKEFELLER PLAZA
TEL. Plaza 7-8157,

MAR 8 1958

**DS65/188- PARIS 26 8 1635-VIAFRENCH-

MRS ARTHUR MILLER CARE MARYLIN MONROES PRODUCTIONS NEWYORK CITY

STANDARD TIME

JH

1959 APR 2 PM 1 49 00

MAIL TO 444 E 57TH ST

PA1403

PARIS 33 2 1925

MRS ARTHUR MILLER C/O MARYLIN MONROE

PRODUCTION NEWYORK=

HAPPY YOUR COMING FESTIVAL CANNES DO YOU WISH TO RECEIVE

SKETCHES DRESSES WE COULD MAKE WITHOUT FITTINGS FOR YOUR

ARRIVAL REGARDS

SIMONE NOIR CHRISTIAN DIOR=

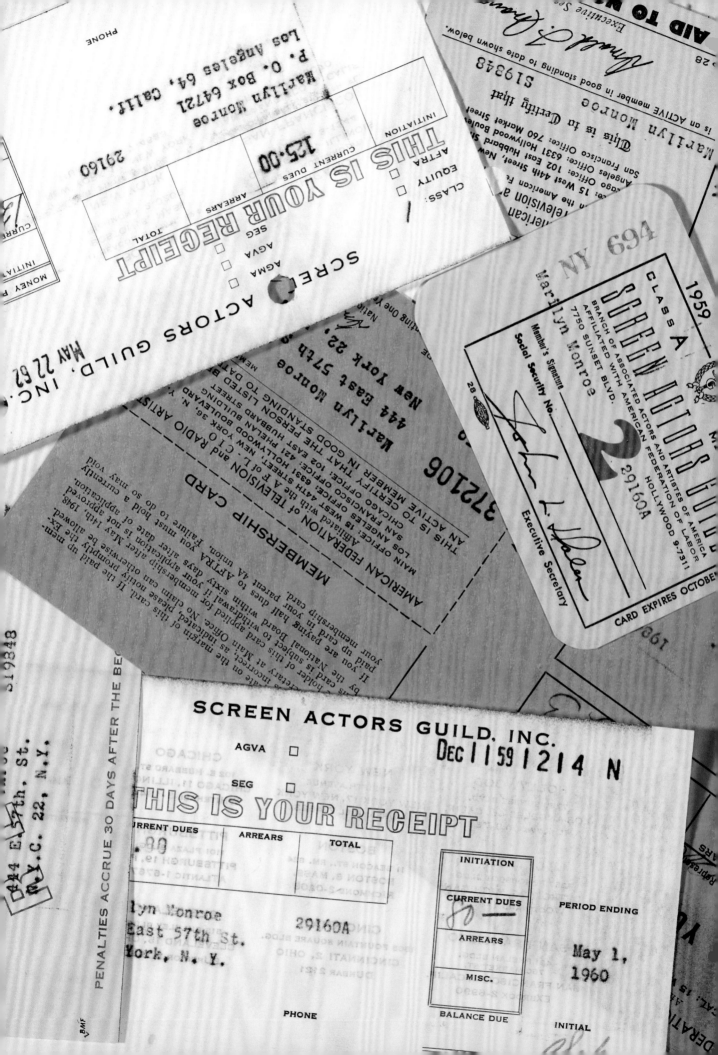

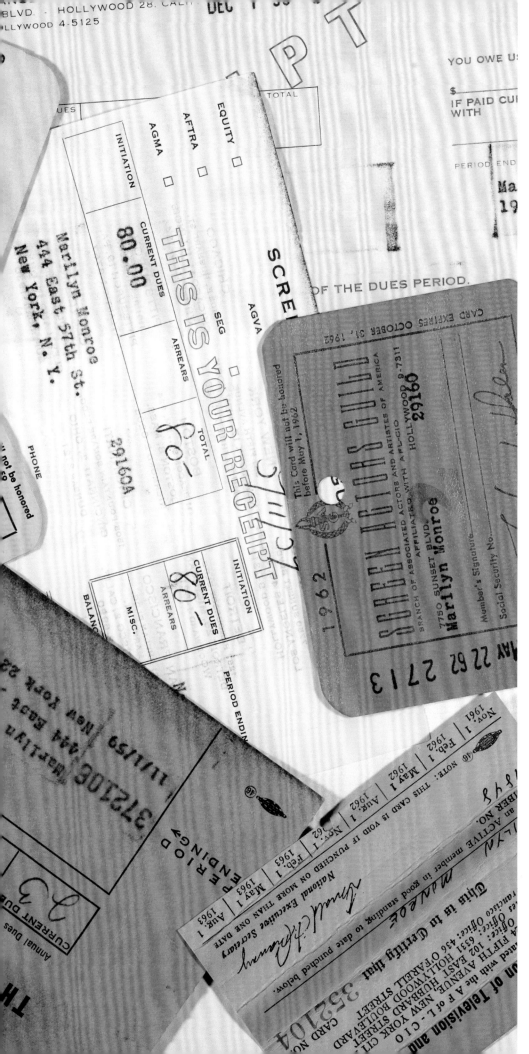

Marilyn belonged to a number of professional organizations. These cards and receipts are from the Screen Actors Guild (SAG). SAG remains the premier organization for Hollywood actors today.

COPY T NTIETH CENTURY-FOX FILM CORPORATION

 WUT182 WUM003 S B006

 L LIM082 NL PD=TDL BEVERLY HILLS CALIF 24=

 DARRYL F ZANUCK
 20TH CENTURY FOX STUDIOS WEST LOSA=

 I FINALLY RECEIPTED SCRIPT. AM EXCEEDINGLY SORRY BUT I DO NOT

 LIKE IT. SINCERELY=

 MARILYN MONROE

 CABLE TO DARRYL F. ZANUCK RE
 "PINK TIGHTS."

On January 25, 1954, Marilyn cabled Fox that she didn't like the script for Pink Tights, *implying her withdrawal. The next day Fox suspended her without pay, citing the 1951 contract. Wanting to cash in on the publicity generated by her* marriage, Fox lifted the suspension as a "wedding gift" and maneuvered her into making There's No Business Like Show Business *by allowing her to be in* The Seven Year Itch *under a production group assembled by Charles Feldman.*

March 16, 1954

Mr. Ben Hecht
2035 South Pacific
Oceanside, California

Dear Mr. Hecht:

This will confirm our agreement as follows:

 1. You are to write the story of my life to date, using material concerning my life which I have heretofore given you for that purpose and which I will hereafter give you for that purpose. The story will be written so as to be used as a magazine article of not to exceed three installments.

 2. All material shall be presented to me for my approval before it is given to anyone else and neither you nor any other person, firm or corporation shall publish the whole or any part of said material without having first received my written approval to do so.

 3. This magazine article shall be signed either by me as the author or by you as the author as I may at my option elect.

 4. Any moneys received from the sale of the above mentioned magazine article shall be retained by you as compensation for your services rendered as author of said magazine article.

 5. It is expressly understood and agreed that the material to be written by you pursuant to this agreement and written by you from the facts concerning my life which I have heretofore given you, and will hereafter give you, shall not be put into book form by you and you shall have no right to the use of the material for anything except one magazine article to be published in the Ladies' Home Journal magazine.

Your signature hereon will constitute this our agreement.

Very truly yours,

Marilyn Monroe

Marilyn Monroe aka Marilyn
Monroe DiMaggio

Accepted and agreed to this
18 day of March 1954.

Ben Hecht

*Marilyn and screenwriter Ben Hecht signed
this contract for her memoir,* My Story, *which
she dictated to Hecht and which he ghostwrote.*

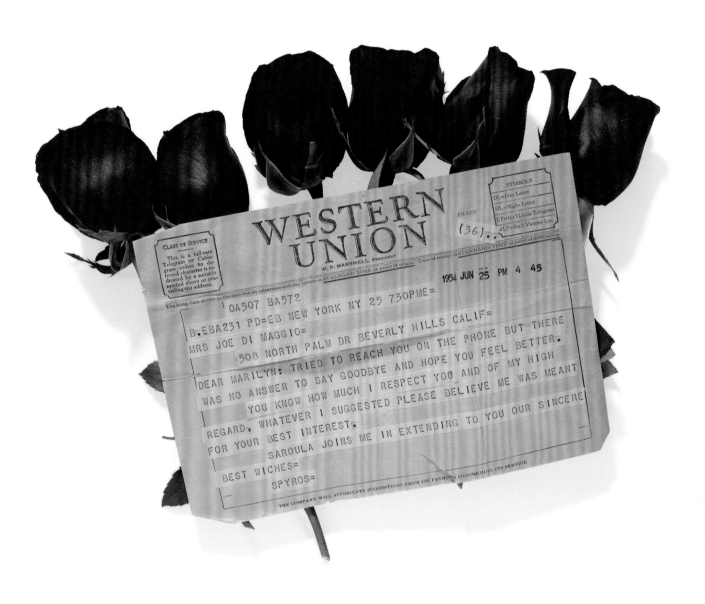

WESTERN UNION

W. P. MARSHALL, PRESIDENT

SYMBOLS
DL=Day Letter
NL=Night Letter
LT=Int'l Letter Telegram
VLT=Int'l Victory Ltr.

FX-1201
(36)..

1954 JUN 25 PM 4 45

1 OA507 BA572

B.EBA231 PD=EB NEW YORK NY 25 730PME=

MRS JOE DI MAGGIO=

:508 NORTH PALM DR BEVERLY HILLS CALIF=

DEAR MARILYN: TRIED TO REACH YOU ON THE PHONE BUT THERE
WAS NO ANSWER TO SAY GOODBYE AND HOPE YOU FEEL BETTER.
YOU KNOW HOW MUCH I RESPECT YOU AND OF MY HIGH
REGARD, WHATEVER I SUGGESTED PLEASE BELIEVE ME WAS MEANT
FOR YOUR BEST INTEREST.
SAROULA JOINS ME IN EXTENDING TO YOU OUR SINCERE
BEST WICHES=
SPYROS=

THE COMPANY WILL APPRECIATE SUGGESTIONS FROM ITS PATRONS CONCERNING ITS SERVICE

(above) In the midst of negotiations over Marilyn's contract, Spyros Skouras, who oversaw Fox decisions from New York, assures Marilyn of his respect and his hopes that her health will improve. Marilyn often called in sick during the filming of There's No Business Like Show Business, which was taking place when Skouras sent this telegram. Skouras could be pleasant, but the bottom line for him, as all studio executives, was profit. Skouras finally forced Zanuck to settle with Marilyn because of her value to the studio.

(opposite) The contract disputes often became nasty. In this exchange, Frank Delaney, Marilyn's lawyer, accuses Fox of attempting to "starve out" Marilyn.

August 9, 1955

Twentieth Century-Fox Film Corporation
Beverly Hills,
California

Attention: Frank H. Ferguson, Esq.

Dear Sirs:

I have your letter of August 1, 1955.

I repeat what I said about "the matter of the tardiness" of
your Corporation in attempting to exercise the current option.
I have read the contract carefully and I have in my opinion
computed the periods accurately.

Since you are only now even becoming interested in the factual
support of my statement of your tardiness, and apparently are
ignorant of these facts, I cannot see how you can have even an
opinion with respect thereto until you take the trouble and
exhibit the courtesy necessary to learn the facts.

You are equally uninformed about your failure to pay Miss Monroe
sums admittedly due to her for services without the payments being
restricted by legends upon your checks releasing you from certain
liabilities.

You ask if there are any such unpaid checks. Yes, there are; and
I enclose photostats thereof, and, in addition, photostat of
your letter of January 14, 1955 rejecting Miss Monroe's request
for the checks without restrictive endorsement which you were not
willing to grant, and with which you returned to her those which
she had sent back to you.

The foregoing position was adopted by you when Miss Monroe was
thought to be in need of money for the necessities of life, and
while I think even now you should make good your default as a
matter of equity, we can only accept if you stipulate that your
default in now paying her salary admittedly due is not cured by
such tardy action.

Of course these checks are small in amount compared with the large
sums you owe her.

TWENTIETH CENTURY-FOX FILM CORPORATION
Beverly Hills, Calif.

Legal Department August 30, 1955

Frank Delaney, Esq.
60 East 42nd Street
New York 17, N.Y.

 Re: MARILYN MONROE

Dear Mr. Delaney:

 We have your letter of August 9, 1955.

 Regardness the matter of tardiness, which now appears
to be of significance to you, it should be noted that the
computation of time under Miss Monroe's contract necessitates
the inclusion of an additional five-day extension, which you
have probably overlooked. This period disposes of any question
of tardiness in exercising the option in question.

 In respect to the matter of uncancelled checks, you
have apparently misconceived our position. We have never been
motivated by a desire to injure or "starve out" Miss Monroe,
as you put it. When our paymaster first returned certain checks
to Miss Monroe, he was merely carrying out established proced-
ures of his department which require that all payroll checks
be issued in one form only. As you know, we later relaxed
this requirement on the basis stated in our March 14 letter.
As stated in our August 1 letter to you, we are agreeable to
exchange any additional outstanding checks on the same basis.

 Our sole and continuing intention is to protect our
contractual rights as we know them. We have no desire to engage
in caustic correspondence either to refute irrelevancies or to
restate positions which we have already clearly set forth in
our earlier letters.

 Yours very truly,

 TWENTIETH CENTURY-FOX FILM CORP.

 By /s/ Frank H. Ferguson

Frank Ferguson of Fox refers to their "caustic correspondence".

INEZ C. MELSON

BUSINESS MANAGEMENT
INSURANCE

CRestview 6-1129
9128 SUNSET BOULEVARD
LOS ANGELES 46, CALIFORNIA

February 15, 1955

MEMO OF CONVERSATION WITH JO BROOKS

JO BROOKS IS HUSBANDOF JULES FOX WHO IS A PUBLICITY AGENT,
HANDLING PUBLICITY FOR ELLA FITZGERALD.

A FEW MONTHS BACK, MISS MONROE VISITED THE TIFFANY CLUB ON
WEST 8TH STREET WHERE ELLA FITZGERALD WAS XXL PLAYING.
MISS FITZGERALD TALKED OF A POSSIBLE FUTURE DATE AT THE
MOCAMBO AND MISS MONROE SAID WHEN THIS HAPPENED, SHE
WOULD LIKE TO GIVE A PARTY FOR MISS FITZGERALD.

MISS FITZGERALD WILL OPEN AT THE MOCAMBO ON MARCH 15 and
MISS BROOKS WANTED TO KNOW IF MISS MONROE WAS SERIOUS
ABOUT GIVING A PARTY. XTXXKD I TOLD HER THAT I DID NOT
THINK THAT MISS MONROE WOULD BE IN TOWN ON THAT DATE BUT
I WOULD TELL HER ABOUT MISS FITZGERALD'S OPENING.

Marilyn was a fan and friend of Ella Fitzgerald, and Fitzgerald influenced Marilyn's creation of her own singing style. Marilyn had intervened the previous November to secure a contract for Fitzgerald from the owners of the Mocambo nightclub on the Sunset Strip by agreeing to attend every performance. According to Dorothy Dandridge, the Mocambo discriminated against Fitzgerald because of her weight and her lack of sex appeal, not because of race.[9] Monroe never did host the party mentioned in the note.

Marilyn Back at

HOLLYWOOD HIGHLIGHTS *Journal American*

Paris Honors MM for Role In 'Showgirl'

By LOUELLA O. PARSONS
International News Service Motion Picture Editor

HOLLYWOOD, April 15. — IF MARILYN MONROE HAD BEEN a few years younger she would have jumped up and down with joy when she telephoned me that she had been given the Paris Cinema Award for the best performance given by a foreign actress in "The Prince and the Show Girl."

She told me she will go to Paris for one day to accept the award some time the last of May or early in June. Her playwright husband, Arthur Miller, will probably not go with her although this has not been definitely determined. Meanwhile Marilyn says she's very busy getting her New York apartment in shape.

This award, I might say, is one of the highlights of the little Monroe girl's life. I don't know whether Sir Laurence Olivier received an award or not.

• • •

MAY BRITT will remain with us for some time. Buddy Adler has taken up her option and will star her in "Color of the Day," by Romain Gary the French Consul who also wrote "Roots of Heaven." Nunnally Johnson, who is producing "Color of the Day," will give it the real Hollywood flavor that is in Gary's book.

I met Mrs. Al Lichtman at the Spyros Skouras dinner and she is so pleased over the success of "The Young Lions," Al's last picture. It really introduced May Britt to the American public.

• • •

HADN'T SEEN Joel McCrea and Frances Dee for ages until I met them at the Spyros Skouras dinner. Joel said that Frances won't leave their 3-year-old Peter. She takes care of him herself. He is 19 years younger than Jody, who is 23 and in the Army. David, 21, is finishing school and goes into the Army next year.

Joel asked me what I knew about Bat Masterson who many years ago, at the time of his death, was sports writer on the Morning Telegraph. He says the life of Masterson is his next picture and he's going to start it possibly in Arizona May 15.

"I'm making it with Harry Mirisch for whom I did 'Wichita' in 1955, which was a financial success for both Mirisch and myself—I have a percentage," Joel said.

MARILYN MONROE
Wins Paris Award

and Walter Chiari are still good friends—but at the moment, no more than that.

"En route from Hollywood

Newspaper reports often inflated the amount of money that Marilyn would receive under the 1955 contract. The actual total was closer to $1 million rather than $8 million. Marilyn settled for $142,000 in back pay and a $100,000 fee for each movie made for Fox. In addition, she accepted a scheme devised by Charles Feldman to lower her tax bill. She optioned the film rights for the novel Horns for the Devil, which she then resold to Fox for a much higher amount, thus paying the lower taxes on corporate gains rather than the higher taxes on salary. Fox paid her $250,000, in installments, for Horns for the Devil. She had paid $5,000 for the rights to the novel, plus a few thousand more for a writer to craft a screenplay from it.[10] If she actually had made four films for Fox, the total for those films would have been $400,000. The payments for back pay and for Horns for the Devil total $392,000. The grand total is $792,000—minus taxes and expenses.

Earl Wilson accurately reports the terms of Marilyn's contract with Fox. She will make four films in seven years for Fox, with approval over her directors. He also notes that she will play a scene from Eugene O'Neill's Anna Christie at the Actors Studio the next week. Reports indicated that she was brilliant in the scene.

ox for $8 Million

WOMEN BACK
RUBBISH PLAN
(See Page 1, Part II)

Mirror News
YOUR INDEPENDENT NEWSPAPER

TURF
RED STREAK
COMPLETE STOCKS

Vol. VIII—No. 74 ⁑ In Three Parts PART I WEDNESDAY, JANUARY 4, 1956 6★ MA 5-2311—145 S. Spring, Los Angeles 53—TEN CENTS

MARILYN MONROE WINS $100,000 FILM STRIKE

Agrees to 7-Yr. Pact, Gets Big Pay Increase

BY EARL WILSON, Mirror-News Columnist

Marilyn Monroe's year-long sitdown strike ended in a victory today when 20th Century-Fox officials privately confirmed that she returns to work next month—richer by more than $100,000 in retroactive pay raises.

A seven-year contract, under which Marilyn will make four pictures in the seven years, is ready to be signed by the studio and Marilyn Monroe Productions. She will have the right to approve her directors.

Marilyn's corporation will "lend" her to the studio at well above $100,000 a picture.

But her services will be "nonexclusive," allowing her to work for other studios and do television and Broadway shows, which would quickly make her one of the big earners in show business.

Her pay raises are the result of better terms which she sought while finishing "There's No Business Like Show Business" and "Seven-Year Itch."

During part of that time she sent back salary checks, pending negotiations for the raise.

The new deal is a triumph for Marilyn, Photographer Milton H. Green, vice-president of Marilyn Monroe Productions, and Atty. Frank Delany, who counseled her to sit tight for a whole year if necessary.

Marilyn returns to Hollywood early next month to star in "Bus Stop," directed by Joshua Logan.

Next week she will have her audition at Actors Studio, appearing with Maureen Stapleton in an episode from the Noel Coward play "Fallen Angels." This will complete almost a year of dramatic training during her holdout.

MARILYN MONROE
Wins by sit-down.

ó Marilyn Monroe al INPI $12,500

MARILYN MONROE, la rubia estrella del cine estadunidense, visitó ayer las instalaciones del Instituto Nacional de Protección a la Infancia y entregó, como ayuda para las niñas desvalidas, 12,500 pesos. En la gráfica, de i. a d. la señora Eva Sámano de López Mateos, presidenta del INPI; capitán José Luis Navarro Salgado, director de ese organismo; la actriz, y el licenciado Justo Sierra.

Salió a Houston el
Lic. Miranda Fonseca

THE PUBLIC MARILYN 141

40 EAST 49TH STREET
NEW YORK 17, N. Y.
PLAZA 9-6272

JOSEPH WOLHANDLER
VICE PRESIDENT

December 16, 1958

Mrs. Arthur Miller
444 E. 57th Street
New York, N. Y.

Dear Marilyn:

I give you my assurance that the type of story that appeared in Time Magazine will not appear any more. We are preparing byline pieces by Jack Lemmon, Tony Curtis, Billy Wilder and the others, all on a strong up-beat approach which will be breaking around the country from here on in.

Basically, every time a vacuum exists, ghoulish press cannot resist perverting and writing as much sensationalism as they can. A couple of selective interviews with you, with complete control of copy, could easily create an entirely new atmosphere. Exposure to press is to have press love you.

As you know, Time Magazine is, of all the ghoulish press, in a class by itself for unmitigated nastiness and inaccuracy. It has been a "middle-class confidential" for a long period. I don't believe they are quoting Wilder and Curtis accurately. We have asked for a retraction although knowing Time, I don't know if we will get it. The retraction was demanded by producer Harold Mirisch.

In light of the disastrous news that you told me on the phone, I certainly don't want to bother you with the countless proposals, interviews, stories and requests that are mounting on my desk. I want you to know that the obviously wrong ones I am discarding and the other ones I am just pushing aside until such time as you and I have a chance to go over them together.

Your health comes first and, believe me, I know how you and Arthur must feel.

Of the countless telegram and phone requests I have gotten, there is only one that seems to have some urgency. United Artists needs one photo sitting with Avedon or

WHOEVER YOU LIKE (AVEDON SEEMS BEST) IN ORDER TO COMPLETE
THEIR AD CAMPAIGN. THESE PICTURES, OF COURSE, WILL HAVE
YOUR FULL APPROVAL AND ARE, BASICALLY, PICTURES THAT
UNITED ARTISTS CAN USE FOR THEIR ADVERTISING. THE PLAN
IS TO RELEASE SOME LIKE IT HOT FOR EASTER AND WITHOUT THIS
PHOTO SITTING, THEY CANNOT PREPARE THE ADVERTISING ON THE
PICTURE. IN MY OPINION THE SITTING IS ESSENTIAL OR, AND
YOU MUST BELIEVE ME, I WOULDN'T EVEN MENTION IT. WILL YOU
BEAR THIS IN MIND AND TUCK IT IN THE BACK OF YOUR HEAD
AND THE FIRST TIME YOU ARE AT ALL UP TO IT, COULD WE SET
UP THIS SITTING?

GOD BLESS YOU AND ARTHUR.

BEST,

JOE WOLHANDLER

JW/PW

In this letter, dated December 16, 1958, Wolhandler responds to Marilyn's anger over a recent article in Time, which contained quotes from Tony Curtis, Jack Lemmon, and Billy Wilder about how difficult she was during the filming of Some Like It Hot. Of all the "ghoulish" press, Wolhandler states, Time stands in a class by itself for "unmitigated nastiness and inaccuracy." Harold Mirisch, the producer of Some Like It Hot, has demanded a retraction. Given her "disastrous" news (her miscarriage), Wolhandler does not bother her with all the requests for interviews he has received.

The Daily Mirror

PROPRIETORS: "TRUTH" AND "SPORTSMAN" LIMITED

TELEPHONE BW 741 (10 LINES)

CONNECTING WITH THE FOLLOWING
DEPARTMENTS AT HOSKING HOUSE
84½ PITT STREET, SYDNEY
MANAGERIAL OFFICES
ADVERTISING DEPT.
GENERAL OFFICES
TELEPHONE M 0424 (9 LINES)

CONNECTING WITH THE FOLLOWING
DEPARTMENTS AT
KIPPAX & HOLT STS., SYDNEY
EDITORIAL
PUBLISHING
CIRCULATION
PRINTER
PRESS ROOM
PROCESS ENGRAVING
TELEPHONE MA 6303 (3 LINES)

CONNECTING WITH JOB PRINTING
MACDONELL HOUSE,
321 PITT STREET, SYDNEY

CODE: BENTLEY'S

ADDRESS CORRESPONDENCE TO

Box 4245, G.P.O.

**KIPPAX AND HOLT STREETS
SYDNEY**

JUNE 17, 1958

Dear Miss Monroe,

For publicity purposes I thought I would inform you that Sydney has a champion two-year-old racehorse -- a filly -- named Wiggle.

It was named by Mrs. Godby, wife of the owner, after your celebrated walk.

Wiggle is perhaps the greatest two-year-old filly ever to race in Australia. She is so good that she was able to beat Australia's outstanding older sprinters in last Saturday's £10,000 Stradbroke Handicap, run over seven furlongs in Brisbane.

Mr. Godby has indicated that he may soon sell Wiggle to America if turf men there are interested in her.

Am enclosing a newspaper clipping, describing Wiggle's Stradbroke success.

Suggest you might write me, explaining whether you are interested in the filly's progress or whether you might be interested in seeing her when she comes to America.

You might enclose some details of any previous experience as a horse-owner, or whether any horses have previously been named after you.

Yours sincerely,

Neville Prendergast,
Racing Writer,
Sydney "Daily Mirror".

News from Australia about a horse that was named "Wiggle," after Marilyn's walk.

ROGERS & COWAN, INC.

PUBLIC RELATIONS

JOSEPH WOLHANDLER
VICE PRESIDENT

40 EAST 49TH STREET
NEW YORK 17, N. Y.
PLAZA 9-6272

JANUARY 23, 1959

MRS. ARTHUR MILLER
444 E. 57TH STREET
NEW YORK, N. Y.

DEAR MARILYN:

DURING THE LAST 24 HOURS I HAVE DENIED THE FOL-
LOWING:

1. AN AP REPORT THAT YOU ARE FLYING TO PARIS
THIS WEEK.

2. A UP REPORT THAT YOU ARE FLYING TO CALIFORNIA
TO START WORKING ON A NEW PICTURE.

3. SEVERAL LOCAL PAPERS, PLUS WIRES, THAT YOU
ARE OR ARE NOT ADOPTING A BABY.

4. HOUSTON PAPERS REPORTING THAT YOU ARE ABOUT
TO ENTER A CLINIC IN HOUSTON, TEXAS.

I AM GOING AWAY FOR THE WEEKEND SKIING SO SOMEONE
ELSE CAN DENY RUMORS FOR ME FOR THE NEXT TWO DAYS. I
WILL BE BACK MONDAY DOING THE SAME THING.

I WILL CALL YOU MONDAY. I AM VERY ANXIOUS TO
SIT DOWN WITH YOU TO DISCUSS WHAT I THINK ARE THE MEAT
AND POTATOES THAT HAVE TO BE DONE ON THE PICTURE AND
WHAT CAN BE IGNORED. I THINK MY PLAN IS A GOOD ONE
AND YOU HAVE TO GIVE ME A HALF-HOUR OF YOUR TIME.

BEST REGARDS,

JOE WOLHANDLER

JW/PW

P.S. I DIDN'T MENTION THE RUMOR IN THE WINCHELL COLUMN
BUT I AM SENDING IT ALONG WITH THIS LETTER. I AM
IN THE BUSINESS 20 YEARS AND I STILL DON'T KNOW
HOW THESE THINGS HAPPEN.

BEVERLY HILLS OFFICE 250 NORTH CANON DRIVE BEVERLY HILLS, CALIFORNIA CRESTVIEW 5-4581

*Writing on January 23, 1959, Joe Wolhandler
informs Marilyn that many inaccurate articles
have recently been published about her: "I am
in the business 20 years and I still don't know
how these things happen."*

MONDADORI PUBLISHING COMPANY, INC.

597 FIFTH AVENUE
NEW YORK 17, N. Y.

A DANESI MURRAY
S. REPRESENTATIVE

PHONE PL 3-054
CABLE, "MONDAPUB"

April 2, 1959

Miss Marilyn Monroe
444 East 57 Street
New York City

Dear Miss Monroe:

 This is our magazine EPOCA which published the lovely Avedo
pictures and Arthur's lovely tribute to you. It created a sensation in Italy
Useless to say well deserved !

 When it will not upset your privacy,our excellent magazines
for women,ARIANNA and GRAZIA,would like a simple picture story on a day in
your life. Our correspondent,Mrs. Vanna Phillips,is at your disposal and also
our photographer Mr. Dauman. I know this is a lot to ask,but I leave it to
you to let us know if this is possible.

 Please remember me to Arthur, and to you my very best
regards.

 Cordially yours,

 Natalia Danesi Murray

NDM:ndm

MONDADORI PUBLISHING COMPANY, INC.

597 FIFTH AVENUE
NEW YORK 17, N. Y.

NATALIA DANESI MURRAY
U. S. REPRESENTATIVE

PHONE PL 3-0540
CABLE, "MONDAPUB" N. Y.

April 2, 1959

Miss Marilyn Monroe
444 East 57 Street
New York City

Dear Miss Monroe:

 This is our magazine EPOCA which published the lovely Avedon
pictures and Arthur's lovely tribute to you. It created a sensation in Italy.
Useless to say well deserved !

 t will not upset your privacy,our excellent magazines
for women,ARIA...........ZIA,would like a simple picture story on a day in
your life.at,Mrs. Vanna Phillips,is at your disposal and also
our photo............... I know this is a lot to ask,but I leave it to
you t...............possib......

 ur, and to you my very best

 ly yours,

 Murray

VIA ITALO PANATTONI 125, ROMA

. CORSINI

February 16, 1959

Dear Miss Monroe, under separate cover you
will receive a copy of PAESE SERA with the
interview that you kindly granted me a...
follow up in the morning edition......
specially grateful for you.................
on the readers Poll..............

days ago............
pon...................
i....................
yo...................

mad...................
full...................
tere...................
world..................
by you.................
of you.................

your wor...............
very soo................
conversat...............
your expec..............

me in sendi.............
A View from..............
fully in Rome...........

VIA ITALO PANATTONI 125, ROMA

G. CORSINI

Rome 29-1-59

Dear Marilyn, "Love and Kisses,"
thank you for the... You have made me very happy.
You... Please come and see me and my
sisters in Rome and my

As to me, I am sorry yesterday I
made a very horrid arithmetic exercise.
Were you good at school? and my sisters

My mother sends here love, and my sisters
I take the liberty of sending you also
love and kisses

yours
Anthony

EPOCA

Per la prima volta
fotografato in casa sua
L'UOMO PIÙ RICCO DEL MONDO

Esclusivo

LE FOTO DELLA NAVE RAPITA DAI PIRATI

MARILYN È LIBERA

IL DIARIO DI GIULIANO
MORTE ALLE SPIE

100 lire - Settimanale - 5 Febbraio 1961 - Anno XII - Numero 540 - Arnoldo Mondadori Editore

Twentieth Century-Fox Film Corporation

STUDIOS
BEVERLY HILLS, CALIFORNIA

July 1, 1960

Marilyn Monroe Productions, Inc.
c/o MCA Artists, Ltd.
9370 Santa Monica Boulevard
Beverly Hills, California

Gentlemen:

Reference is made to that certain agreement between us, dated December 31, 1955, as heretofore amended, relating to the services of Miss Marilyn Monroe in the Photoplays referred to in said agreement.

This letter is to notify you, in accordance with Article Eighth of said agreement, that Miss Monroe's services in connection with the next Photoplay for us under said agreement shall commence on April 14, 1961. In this connection, will you please cause Miss Monroe to report to us at our studio located at 10201 West Pico Boulevard, Los Angeles, California, on April 14, 1961 to commence the rendition of her services for us in connection with the production of said Photoplay, i.e., the motion picture production now known as "GOODBYE CHARLIE". Please notify Miss Monroe that, if she is not otherwise engaged, we desire her to report to our studio one (1) week prior to April 14, 1961, i.e., on April 7, 1961, pursuant to the third paragraph of Article Tenth of said agreement for "pre-production service as described in the third and/or fourth paragraphs of said Article Tenth.

This is to further advise you, in connection with the subject matter of the final paragraph of Article Fourth of the abovementioned agreement, that we, Twentieth Century-Fox Film Corporation, now have in effect with Mr. George Cukor a bona fide subsisting commitment for the rendition of Mr. Cukor's services as director of the Photoplay referred to in the foregoing starting date notice.

FORM APPROVED
20th Century
Fox Film Corp.
Legal Department

Date ___JUL 1 1960___

Very truly yours,

TWENTIETH CENTURY-FOX FILM CORPORATION

By

Its Executive Manager

cc: Marilyn Monroe Productions, Inc.
444 East 57th Street
New York, New York

WESTERN UNION

·0A341

O LSJ049 LONG PD=WUX TDL WEST LOS ANGELES CALIF 2
1145A PDT=
=MARILYN MONROE=
 MAPES HOTEL RENO NEV

=DEAR MARILYN, FRANKIE VAUGHAN CALLED FROM LONDON.
HE IS HURT REGARDING THE COLUMBIA RECORD ALBUM ON
"LET'S MAKE LOVE". HE INSISTS THAT PROPER CREDIT BE
GIVEN HIM ON FRONT ALBUM COVER. CLAIMING THAT IF IT
IS OMITTED IT WILL DAMAGE HIM PROFESSIONALLY. AS YOU
KNOW HE IS ENGLAND'S NUMBER ONE RECORDING ARTIST.
PLEASE RECONSIDER THIS MATTER AND GIVE US YOUR

THE COMPANY WILL APPRECIATE SUGGESTIONS FROM ITS PATRONS CONCERNING ITS SERVICE

1270 (1-51)

PERMISSION TO CREDIT YOURSELF, YVES MONTAND AND FRANKIE
VAUGHAN ON THE FRONT COVER OF ALBUM. AFTER ALL
MARILYN HE SINGS SEVERAL OF THE NUMBERS AND DESERVES
THIS CONSIDERATION. WARMEST REGARDS ARTHUR YOURSELF
JERRY WALD.=.

THE COMPANY WILL APPRECIATE SUGGESTIONS FROM ITS PATRONS CONCERNING ITS SERVICE

1270 (1-51)

(opposite) In this July 1, 1960, letter, Fox orders Marilyn to appear on April 14, 1961, to make Goodbye Charlie. *Marilyn will later refuse to appear. Fox's issues with director George Cukor and the studio's inability to find a replacement from Marilyn's list of approved directors would get her off the hook.*

(above) Jerry Wald writes to Marilyn at the Mapes Hotel, in Reno, to ask her to reconsider her decision to refuse crediting Frankie Vaughan on the front album cover of Let's Make Love. *He is England's top recording artist, and he should receive such credit. Marilyn stayed at the Mapes Hotel during the filming of* The Misfits.

August 3, 1960

The Hon. James Roosevelt
325 House Office Building
Washington, D. C.

Dear Mr. Roosevelt:

Miss Marilyn Monroe has asked me to thank you
for your letter of June 30, suggesting that she record a
brief greeting for the NBC-TV program October 7 on behalf
of the Eleanor Roosevelt Institute for Cancer Research.

Miss Monroe deeply appreciates your interest
in her being a part of this program but, much as she ad-
mires your worthy cause and your mother, she reluctantly
must decline.

As you probably know, she is filming "The Mis-
fits" in Reno, Nevada and out in the desert. They are
working six days a week in summer desert heat. Moreover,
she had no opportunity to rest for this film following her
last one, "Let's Make Love".

I hope that you will understand then, that,
despite Miss Monroe's respect and feelings for your cause,
because of the demands of her work, she must regretfully
decline your request, along with a number of others, in
order to give her full concentration to her work in the
months ahead.

My best regards.

Respectfully yours,

Rupert Allan

RA/lk

*Press agent Rupert Allan turns down a request for Marilyn
to record a brief greeting for a television program on behalf
of the Eleanor Roosevelt Institute for Cancer Research because
she is filming* The Misfits *six days a week in the terrible
summer heat of the desert near Reno.*

November 10, 1960

My dear Marilyn,-

I understand you know that I am now aware of the unhappy situation, so let me hasten to express my personal unhappiness that this should be. I have been both your lawyer and your friend for the last three years. Legal ethics do not permit me to continue as your lawyer, but nothing prevents me, nor ever will prevent me, from being your friend. If you ever believe that I can add one small bit to your happiness or to preventing any threatened unhappiness, do not hesitate to call on me.

Sincerely,

John

*Divorcing Arthur Miller meant that Marilyn had
to secure a new lawyer, since John Wharton judged
it unethical to represent both Arthur and Marilyn.
Marilyn chose Aaron Frosch to replace Wharton.*

Twentieth Century-Fox Film Corporation

STUDIOS
BEVERLY HILLS, CALIFORNIA

April 15, 1960

Dear Marilyn -

It was very sweet of you to send Jack Daniels
over to me. I met him sometime back. He is
a smooth character. Somehow he hit me on the
back of my head about midnight and I was a
sight for sore eyeballs for a couple of days.
This time I am going to watch him.

The offer from you and Whitey is the best I
have had in a h--- of a while. Being here is
a privilege they tell me. Sometimes I wonder.

Sincerely,

Ben

154 MM—PERSONAL

WEISSBERGER & FROSCH
COUNSELORS AT LAW

L. ARNOLD WEISSBERGER
AARON R. FROSCH

HOWARD H. RAYFIEL
SEYMOUR REITKNECHT

120 EAST 56TH STREET
NEW YORK 22, N. Y.

PLAZA 8-0800
CABLE "ARNWEISLAW, N. Y."

August 7, 1961

Miss Marilyn Monroe
c/o Miss Pat Newcomb
Arthur P. Jacobs Company, Inc.
449 South Beverly Drive
Beverly Hills, California

Dear Marilyn:

Before Lee Strasberg left on his trip, he discussed with me his
several meetings with Joe Moskowitz.

Lee said that the meetings had resulted in only one prospect, your
probable interest in a re-make of "Of Human Bondage."

Lee said that Fox would be prepared to acquire the rights and
that he thought that Marlon Brando might well want to do the film
with you.

Early last week I met with Moskowitz, who told me that Fox had
taken an option on "Of Human Bondage" and was prepared to put a
writer to work on doing a treatment. Before doing so, however,
they wanted some direct expression from you of your interest in
the project.

Moskowitz suggested that Marlon Brando would not be available but
that perhaps Paul Schofield would be and that Schofield, in his
opinion, would be an interesting co-star.

Joe Moskowitz still inquired as to your interest in "Celebration"
with George Roy Hill directing.

I explained to him that George Roy Hill held no specific, inimitable
interest for you and that it was my understanding that you were
not interested in "Celebration."

For the director of "Of Human Bondage" Moskowitz suggests Jose
Ferrer.

June 17, 1960

Mrs. Arthur Miller
Beverly Hills Hotel
Beverly Hills, California

Dear Marilyn:

Arthur Jacobs called us yesterday and told us about the article in "Motion Picture" and the squib in Time magazine. In his first talk with us, he said that you wanted to consider a suit for libel. I immediately read the article and asked my partner, Sam Silverman (who is the office libel expert), to read it. We agreed that the article was libelous, but we felt that no suit should be instituted until we had a chance to talk with you personally and explain what you would be called upon to do if you brought such a suit. I will go into this further when I next see you personally; in this letter I shall only say that bringing a libel suit might result in giving Miss Hopper a greater opportunity to display her venom. That doesn't mean that we wouldn't bring the suit if you wish us to. It does mean that we shouldn't bring it until we have had a personal talk with you.

However, in a second talk with Arthur Jacobs, he told me that he thought your greatest concern at the moment was to try

Last night I attended a dinner in honor of
the Attorney-General, Robert Kennedy. He
seems rather mature and brilliant for his
thirty-six years, but what I liked best about
him, besides his Civil Rights program, is he's
got such a wonderful sense of humor.

Well, Dad, I'll close now and I'll be calling
you as soon as I get to New York to let you
know which day to make the reservation at the
hotel. I'll sure enjoy seeing you. I guess
I'd better bring some clothes for warm weather,
isn't that right?

I send all my love and I miss you.

Marilyn's secretaries used this typewriter in 1962.

"I was full of a strange feeling, as if I were two people. One of them was Norma Jeane from the orphanage who belonged to nobody. The other was some-one whose name I didn't know. But I knew where she belonged. She belonged to the ocean and the sky and the whole world."

MONROE ON MONROE

A portrait shot of Marilyn at about
two years of age, wearing her best dress.
Handwriting on the back of the photo identifies
it as having been taken at a Hollywood portrait
studio. Gladys probably had the photo taken.

MARILYN KEPT LETTERS and photographs from her childhood that held meaning for her, as well as cards and letters from friends. The latter were sent by individuals in the Hollywood film industry, the New York intelligentsia, the Broadway theater crowd, and close friends like Hedda and Norman Rosten. Her files also contain receipts for clothing—perhaps because they were tax deductible as a professional expense—and purchases at grocery and liquor stores, restaurants, and pharmacies, including several receipts for Dom Pérignon champagne, which Marilyn liked. It was, according to Norman Rosten, Marilyn's "gesture of emancipation" and success. "Each popping cork proclaimed: Look at me, this is no abandoned child, no orphan!"[11]

Contrary to the assumption that Marilyn wasn't well dressed, she often bought her clothes from fashionable shops. She preferred Jax, a leader among the new boutiques that chic young women in Hollywood and New York frequented. Jax's clothes were youthful, simple, sporty, and beautifully constructed, often of cotton. They were not especially expensive. When she came to New York, she sometimes bought Ceil Chapman designs. By 1954 she frequented the elegant Seventh Avenue shop of Mattie Talmack, which featured the clothes of John Moore, a young designer who in 1953, at the age of twenty-four, had won a prestigious Coty Award from the American Fashion Industry. Moore was known for his black sheath dresses for daytime and beaded dresses for evening, and he created the black silk spaghetti-strap dress that Marilyn wore at the Plaza Hotel press conference with Olivier—she owned several copies of the dress, a design she often wore. Moore's clothing was typically ready-to-wear and less expensive than that of his famed fashion elder, designer Norman Norell, whose designs Marilyn also bought.[12]

During the last years of her life, Marilyn often wore brightly colored simple silk tunics and shifts designed by Emilio Pucci. They were available in New York department stores such as Saks Fifth Avenue and Bloomingdale's. Marilyn's friend, actress Susan Strasberg (Lee and Paula's daughter), contended that Marilyn had copied her in wearing Pucci designs, since she herself had brought Pucci dresses and shirts from Italy before they appeared in New York stores, and had worn them in New York.[13]

Cosmetics were important to Marilyn—they were central to creating her public self. It could take many hours for her to achieve a perfect look. The right makeup base was key, because she had to cover the hair on the sides of her face (a feature common to light-skinned women) and the freckles to which she was prone. To color and shape her lips, she used as many as four shades of lipstick. She had to darken her eyebrows, put on false eyelashes, and apply eyeliner. In addition, she had to have her naturally brown, curly hair straightened, permed, and dyed every few weeks.

The file cabinets also contain receipts for prescription drugs, often from Schwab's Pharmacy in Hollywood, a central meeting place for young actors. Marilyn didn't keep many receipts for prescriptions, possibly because she kept her drug use a secret. On the drugstore receipts, the drugs are identified by code, not by name. According to Eunice Murray, Marilyn's companion during the last months of her life, Marilyn had so many pills because she switched her medications whenever her body developed a tolerance to one type of barbiturate or opiate.[14]

Marilyn's copy of her birth certificate, obtained in February 1962. Whether due to confusion or a desire to conceal the truth, Gladys misidentified Marilyn's father. Gladys was still married to Edward Mortensen, and she listed him as Marilyn's father (although she misspelled the name as "Mortenson"). He was also not a baker, the occupation listed on the birth certificate. "Baker" was the last name of Gladys's first husband, John Newton Baker (called Jasper). In the following years, Gladys most often called herself Gladys Baker and designated Norma Jeane as Norma Jeane Baker.

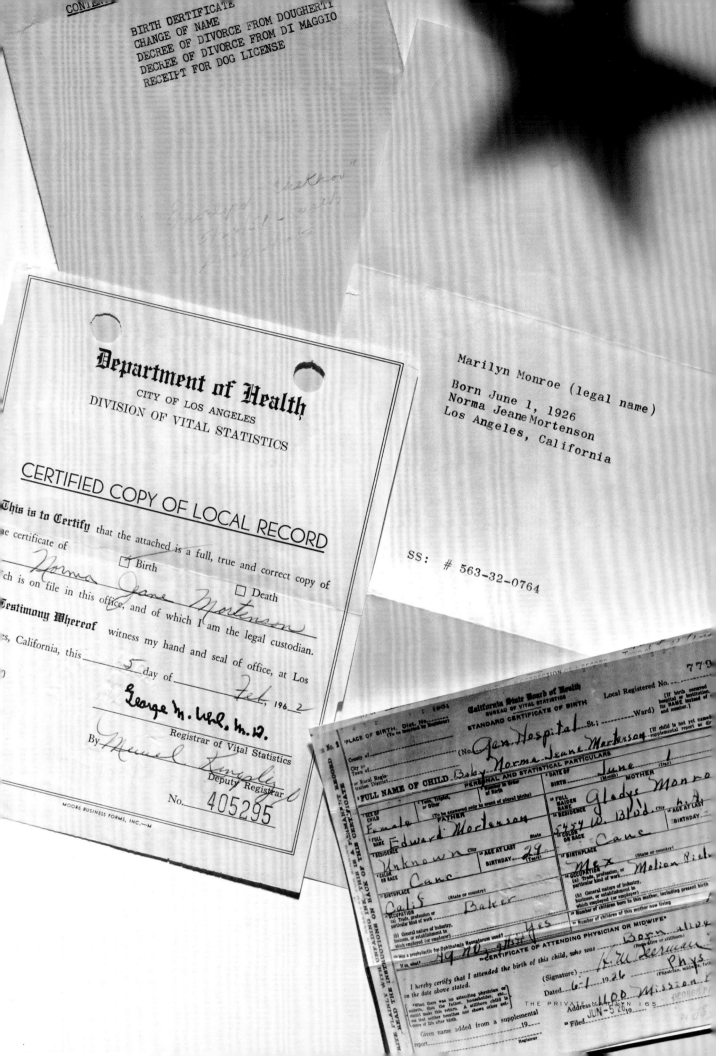

CONTENTS
BIRTH CERTIFICATE
CHANGE OF NAME
DECREE OF DIVORCE FROM DOUGHERTY
DECREE OF DIVORCE FROM DI MAGGIO
RECEIPT FOR DOG LICENSE

Marilyn Monroe (legal name)
Born June 1, 1926
Norma Jeane Mortenson
Los Angeles, California

SS: # 563-32-0764

Department of Health
CITY OF LOS ANGELES
DIVISION OF VITAL STATISTICS

CERTIFIED COPY OF LOCAL RECORD

This is to Certify that the attached is a full, true and correct copy of
the certificate of ☐ Birth

Norma Jeane Mortenson

which is on file in this office, and of which I am the legal custodian. ☐ Death

In Testimony Whereof witness my hand and seal of office, at Los
Angeles, California, this ___5___ day of ___Feb___, 196_2_

George M. Uhl, M.D.
Registrar of Vital Statistics
By Muriel Kingsley
Deputy Registrar

MOORE BUSINESS FORMS, INC.—M

No. 405295

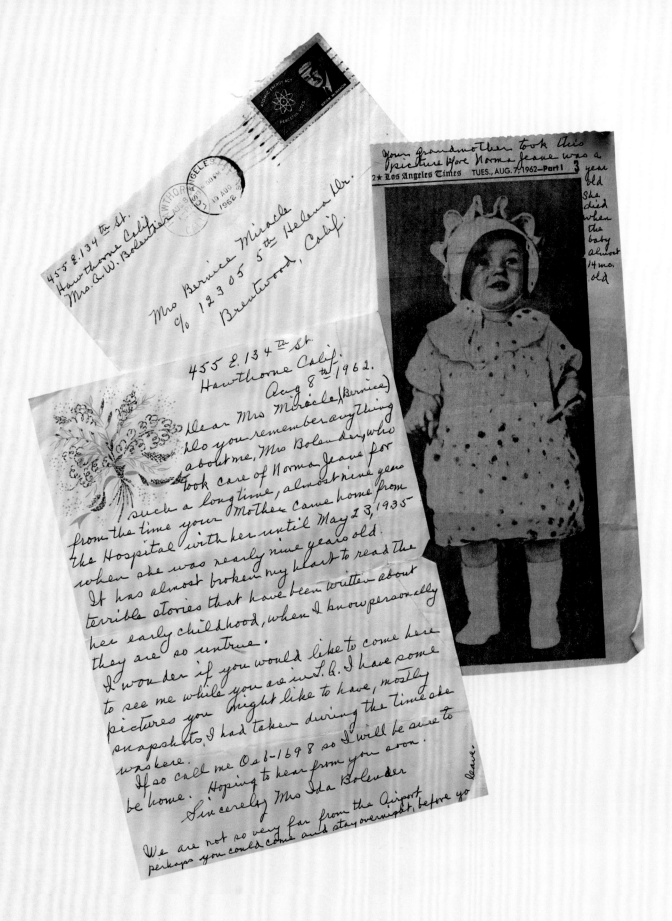

Your grandmother took this picture before Norma Jeane was a 3 year old

2★ Los Angeles Times TUES., AUG. 7, 1962—Part I

year old. She died when the baby almost 14 mo. old

455 E. 134 th St.
Hawthorne Calif.
Aug 8 th 1962.

Dear Mrs Miracle (Berniece)

Do you remember anything about me, Mrs Bolender, who took care of Norma Jeane for such a long time, almost nine years from the time your Mother came home from the Hospital with her until May 23, 1935 when she was nearly nine years old.

It has almost broken my heart to read the terrible stories that have been written about her early childhood, when I know personally they are so untrue.

I wonder if you would like to come here to see me while you are in L.A. I have some pictures you might like to have, mostly snapshots, I had taken during the time she was here.

If so call me O s b - 1 6 9 8 so I will be sure to be home.

Hoping to hear from you soon.

Sincerely Mrs Ida Bolender

We are not so very far from the Airport perhaps you could come and stay overnight before you leave.

455 E. 134 th St.
Hawthorne Calif.
Mrs. A. W. Bolender

Mrs Berniece Miracle
c/o 123 05 5 th Helena Dr.
Brentwood, Calif.

Ida Bolender writes Berniece Miracle, Marilyn's half sister (the daughter of Gladys and Jasper). Ida and her husband, Wayne, took care of Norma Jeane from shortly after her birth until May 23, 1933—not 1935, as the letter states. But Ida is correct in denying the allegations in magazines and newspapers that Marilyn's childhood with them was a very negative experience for her. Ida identifies the photo in the newspaper clipping as having been taken by Marilyn's grandmother, Della.

Norma Jeane, at age four, with Lester, another Bolender
foster child. The family called them "the twins."

MRS. E. ANA LOWER
11348 NEBRASKA AVENUE
WEST LOS ANGELES, CALIFORNIA

Monday 6:45 p.m. Oct. 23. 1944

Dearies,

Your letter reached me to-day.
It seems I've been so busy of
late. No, I've not seen Mom
but I talked to her. She had the
kids pick me a big box of green
tomatoes and I went for them
yesterday but they had gone out.
Muggs was certainly glad to
see me. Her line is busy
now, so I'll try to call her
later. She is happy, so I, that
you are having this fine visit.
If I had time I'd miss you, but I think of you.

How nice for you to have found such a lovely sister and family. I hope they will be out here too later on.

Love arranged this trip for you dear, and Love will bring *you* home at the right time.

Now stop this nonsense about car sickness. God does not cease to be because you board a train, nor do you cease to be His perfect child because you take a car ride or a ship ride.

You just forget to put your

Norma Jeane is visiting her new found half-sister,
Berniece Miracle, in West Virginia. "Mom" refers to Jim
Dougherty's mother, Norma Jeane's mother-in-law.

THE PRIVATE MARILYN 169

terror on. The following
is a lovely thought.

Protection (anonymous)

He who guides the seagull's flight
 High above the water's blue,
Shall He not, by day and night,
 Guard and guide and cherish you?

Sent Oct 31-44

God's law never ceases to
operate, and that is what governs
you every minute day and
night. Use the S. S. of Being often
and pray "Thy will be done." His
will for you is perfect harmony.

There is no nervous excitement
to handle you, see Isa 32:17, 18
Peace at all times is your divine right.

You're not the only one who has a new suit, so when you return we'll step out and show off — maybe.

We are having nice weather now, tho rain is predicted.

Enid read Grace's letter to me over the phone, so I have the news of the trip.

Well, darling, I'll pray God to so fill your consciousness with His presence, power, and love, that there will be no room for error. "The divine understanding reigns, is all, and there is no other consciousness."

Error cannot spoil your trip. Much love to you and all Aunt Ana.

Dear Cousin Marilyn,
Can't help calling cousin for Dear Aunt Ana —my favorite aunt
considered you her girl;

Was so sorry to hear of your d— but as Aunt Ana used
to say a C.S. and a C. could never hit it off together very long.
I shall never forget the time she came up to San Jose
and took care of Sibyl's mother before her passing— the care she gave
her— the tenderness she showed her— and after the end— she sure showed
us what C.S. was. It was a great strain taken off our shoulders.
I wonder if you ever met Aunt Nelle Curtiss—and her other
sister Allis Hill— She thinks you are swell and when I was there
visiting them this last Oct. at Sacramento — she said how very sweet
you were. Curt my son and daughter in law are living in Pomona
she is teaching in the public school there— she took a brush up course
at Stanford this summer and has a very fine position.
Curt is cutting records with his band but the music
game is a mean one and there are lots of heart aches and trouble— and
Lord knows his has some and some great experiences.
Marion said she met you at Grace's funeral— How is Doc getting
along?
Now don't you worry about this d— forget it you are too good
for him and consider it experience.
I came up here to Spokane six years ago after I lost
Sibyl and two years later I married Louise Miller — she and her
brother run a cafe and bakery here at Dishman—she is sure a sweet
woman and I am very greatful to the good Lord for giving me some one
so sweet — as I was a alone and I did not want to stay with either
one of my boys.
If you ever come up this way — let me know in advance
and we'll show you the country and if you like fishing might
consider taking you fishing— I know where they are and we always
get some. Do you like smoked trout? if so I'll send you some
you'll be surprised how grand they really are.
Curt was going to get me a picture of you autographed but
I guess he's never got around to see you yet. I sure have two sweet
granddaughters Lindy and Windy— you'll have to meet them sometime.
They are living now at 1512 Vejar St Pomona,Calif.

Would love to get a line from you and keep CS close to your
heart and you'll get by O.K.
My sincerest best wishes for your continued success
Cousin

Will Sykes

Dearest Marilyn:
We have had the loveliest visit with
Curt and some friends of his and
Marion's who live in Laguna Beach.
The boy has really grown up and I
regret writing as I did to you about
him. I have great hopes for him
now that he has changed his attitude
towards Life. He just drank in
every word Uncle Art and I said to
him and wrote us after getting back
to Laguna, that it was the most
profitable evening he had ever
spent in his life and he would never
forget it.
We had fun at the piano, as always
and he is going to try to set to
music the little poem I had published.

 Faith
Into the heart of a mustard seed
I looked, and Lo! my eyes
Were quickened to a higher sense
Of imagery, God-wise;
For there O saw the patterned growth
Beneath its covering mean
Awaiting Nature's flowering time
In confidence serene.
Into my own uncertain heart
I looked with sense of shame,
That there in God's own masterpiece,
There burned so small a flame.

Uncle Art is wondering when he is
going to get that autographed
picture you promised him.
We would be very happy to hear from
you once in awhile.
I am wondering is you finally got
the letter I addressed to the Studio
because I got a stereotyped answer
inclosing a bill-fold picture. I
felt quite sure you did not send it
without a personal word.
 Bye now, and a
 Merry Christmas.
 Love always,
 Allis

August 15, 1962

281 Highland Drive, Los Osos,
San Luis Obispo, California

Dear Bernice:

I wish with all my heart to learn something about Gladys Baker. She
was the nicest girl I have ever known. I knew her a long time ago and
had hoped we would get married. The tragedy of her sickness was almost
more than I could bear. I saw her every day after her first collapse
and so long as I was permitted to visit her. Later on I was able to see
her in the hospital near San Jose, California. I also wrote to her there
and wrote to you when she asked me to. Later, after she was released
from the hospital she wrote to me from some place in Oregon; that was
late in 1945. But trouble struck me in 1945 after I received Gladys'
letter. A ship I lived on part of the time sank and I lost a lot of my
papers and letters and addresses.

A strange thing happened to me a few days before I heard about the
terrible tragedy to Marilyn Monroe. I accidently found your address
in Oakridge, Tennessee. It had been given to me by Grace Goddard and,
to my astonishment, it had not been lost when the ship went down. Grace
was a wonderful friend to Gladys and me. It is strange that we knew so
few people besides Grace. There was no one who could help me find Gladys
after she went to Oregon and after I lost her. I have prayed for her
many times and cried myself to sleep in lonesomeness for her. I do have
many sweet memories tho; some of which include little Norma Jean. In
the old days when the three of us went places together I felt like they
were my little family; especially when we went into resturants together.
I hoped then that people watching us would think they both belonged to
me and they were mine. One of the last times I saw Norma Jean was at
Christmas time in 1935. I took her over to Hollywood Blvd. to watch the
Christmas Parade. I lifted her onto my shoulder so she could see better.

I remember something else about the evening after we came home from
the Christmas Parade, and before I said good night to them. Gladys asked
Norma Jean to sing for me. It was lovely. Gladys had a Christmas tree
all decorated and Norma Jean stood between the tree and us and sang a
pretty song. I was entranced by it and about everything else that seemed
to have come into my life at the time. After Norma Jean left to go to
bed I talked about it to Gladys. I told her I was very much in love with
her and her little girl. It was less than a month later when tragedy
struck. I almost lost my mind over it.

You may ask why I have remained quiet so long. I tried to find Gladys
again before I learned about Marilyn Monroe. After that I was too afraid
of being misunderstood. But I never stopped loving them.

There is a great deal more that I could tell you and would like to have
that chance, but I will wait until I know whether I am welcome or not.
If I am not I will quietly return to anonymity.

After my sickness and business failures in Southern California and fol-
lowing the year 1945, I went up into Northern California and took over
the operation of a summer resort which prospered fairly well. I sold the
business three years ago and am retired now and living here near the
coast..... I do hope this finds you and you will write to me. And I hope
with all my heart that you will tell me that I can visit Gladys again.

With love, *Harry Wilson* Harry C. Wilson

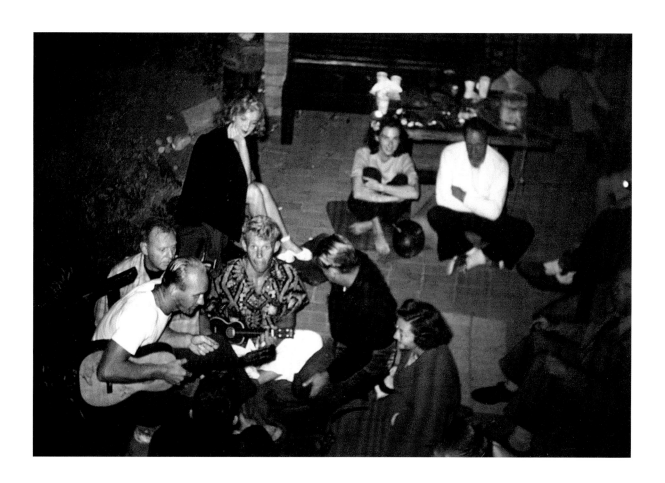

(opposite) The unknown Harry Wilson claims to have been involved with Gladys. The Christmas events he describes might have occurred in 1933—not 1935, as he claims—since Gladys broke down in January 1934. He is correct in asserting that she was in a hospital near San Jose, California, and that she lived in Oregon for a time.

(above) A never-before-seen photo of Marilyn at a party of surfers in Malibu in 1947. Tommy Zahn, a renowned surfer, Fox contract player, and Marilyn's boyfriend at the time, took the photo.

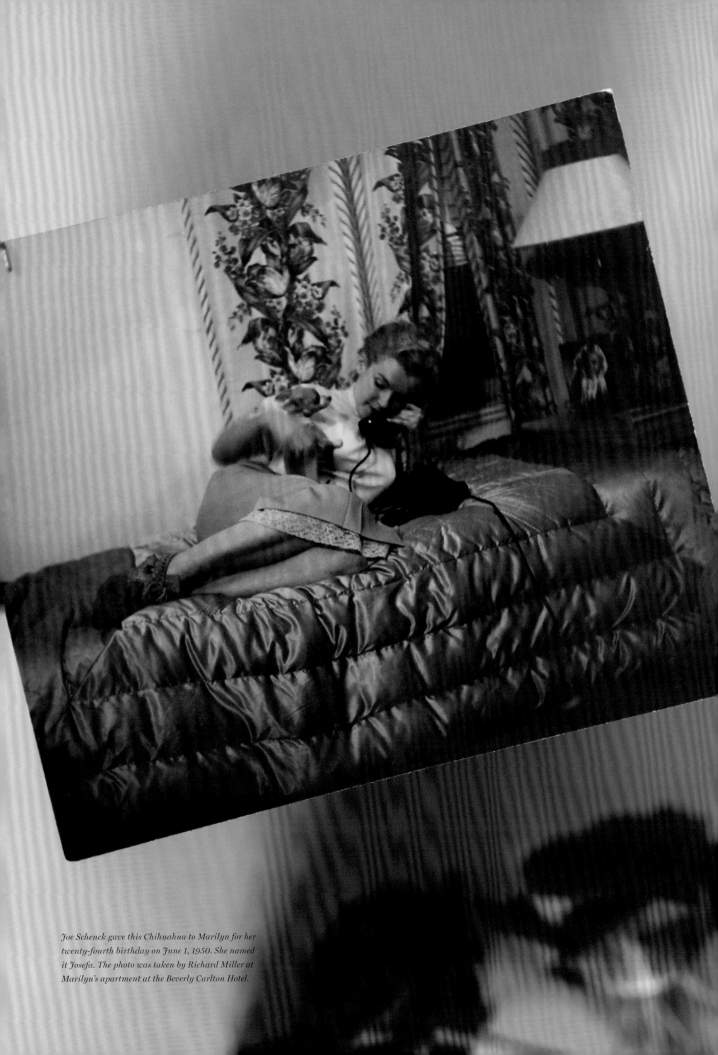

Joe Schenck gave this Chihuahua to Marilyn for her twenty-fourth birthday on June 1, 1950. She named it Josefa. The photo was taken by Richard Miller at Marilyn's apartment at the Beverly Carlton Hotel.

Before Marilyn had an appendectomy in April 1952, she taped
this note to her stomach asking the surgeon to remove as little
as possible—in other words, to protect her reproductive organs.

For their services in arranging and completing this lease, the Lessor agrees to pay in cash to said agent first above mentioned, at time first rental is received, a commission of such amount as will conform to the schedule of commissions of the Beverly Hills Realty Board at date of this lease and Lessor further agrees that said agent may deduct and retain the said commission from any advance rentals collected by said agent hereunder for the account of the Lessor. In the event Lessee or any member of his family should either by sale or exchange, directly or indirectly acquire title to the property herein mentioned during their occupancy or within sixty days after vacation thereof, Lessor herein agrees that said agent shall be considered the main factor or agency in procuring such transfer of title or ownership by reason of this lease and other negotiations relative thereto, and as compensation for such services agrees to pay said agent a commission of five per cent of the total consideration involved in such transfer.

In the event the tenancy of Lessee extends more than two months beyond the date herein mentioned for the expiration or ending of this lease, Lessor agrees to pay said agent a further commission on the additional rental involved, such further commission or commissions to conform to the schedule of commissions of the Beverly Hills Realty Board as of the date of this lease. If the lease is extended for a definite period of time, such further or additional commission shall be payable on each such extension for the full period at the time of extension, but if continued on a month to month basis, the additional commission or commissions shall be payable at the end of two months computed on the month to month basis provided in said schedule of commissions and, if the tenancy month by month extends beyond eight months there shall then be due said agent the difference between the month to month commission and an amount equal to the scheduled commission for a one year lease.

It is agreed that at the expiration of the term hereof or any sooner termination of this lease, Lessee will quit and surrender the premises hereby demised, in as good order and condition as reasonable use and wear thereof will permit, damage by the elements excepted. And if Lessee shall hold over the said term with the consent, expressed or implied, of Lessor, such holding shall be construed to be a tenancy only from month to month, and Lessee will pay the rent monthly in advance at the rate of $ 700.00 per month. The provisions of this lease shall extend to and include and be binding upon the heirs and assigns of Lessor and the executors, administrators, and assigns of Lessee.

```
RENT SCHEDULE:  $700.00 due June 1st, 1954
                 700.00 due July 1st, 1954
                 700.00 due Aug. 1st, 1954
                 513.26 due Sept 1, 1954.
Lessor will pay for pool maintenance, limited to $31.50 per month.
30 days before the expiration of this lease, Lessee will allow the owner or his agent to show
the house for lease, by appointment only and at a reasonable time.
Lessor agrees to clean the following:  Walls, upholstery, carpets, windows and screens throughout
the premises and to repair the window screen in the master bedroom.
To clean out of garage, all trash, furniture, wood, etc.
To repair or clean, as needed the ceiling in the hall
To replace the toilet seat in the downstairs bathroom.
To place the patio furniture in room off garage.
To check all appliances, TV and radio as to working order.
```

IN WITNESS WHEREOF, the said parties have hereinbelow set their hands and seals, the day and year first above written.

Marilyn Monroe Di Maggio
Lessee

LAWRENCE BLOCK CO., INC. + *al Werdsue.*
 by M. Maloney
BY *Bernice B Frederick*
Lessor

Title

LAWRENCE BLOCK CO., INC.
REALTOR
BRADSHAW 2-6171 · CRESTVIEW 5-4384
174 NORTH CANON DRIVE · AT WILSHIRE
BEVERLY HILLS, CALIFORNIA
★ ★ ★
SALES RENTALS
INSURANCE
PROPERTY MANAGEMENT

Dated
Expires
Option
TO
LEASE

(above) Marilyn signed this lease for the house that Inez Melton rented for her and Joe in Beverly Hills in June 1954 as "Marilyn Monroe DiMaggio." Note that the lease ran for four months and that it expired in October—near the time that Marilyn announced she was divorcing Joe.

(opposite) Marilyn informs journalist Sidney Skolsky that she is moving to New York. Skolsky helped her create the Marilyn persona, and he opposed the New York move.

Dear Sidney,

Did you find
some one else? I didn't
hear from you — and
I was going to take
you to dinner. —
I loved the thing
you wrote and I'm
proud you're my friend.
I leave tomorrow 7:00 A.M.
For N.Y. I'll miss you
and I love you — I
promise to write you
You
Marilyn

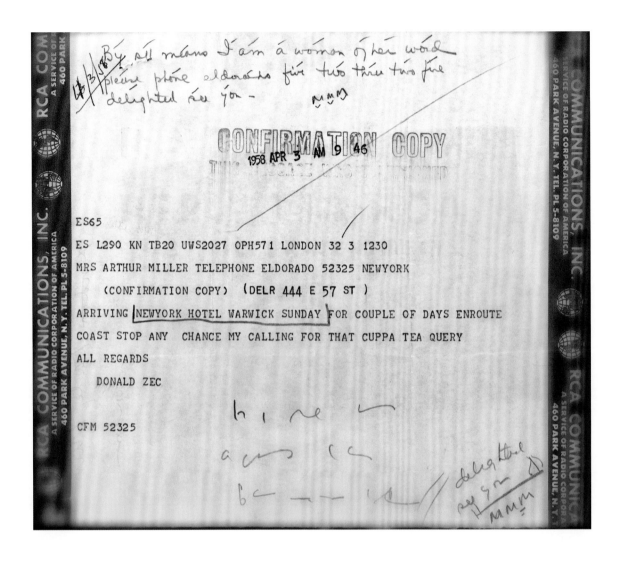

By all means I am a woman of her word
please phone eldorado five two three two five
delighted see you —
MMM

CONFIRMATION COPY
1958 APR 3 AM 9 46

ES65

ES L290 KN TB20 UWS2027 OPH571 LONDON 32 3 1230

MRS ARTHUR MILLER TELEPHONE ELDORADO 52325 NEWYORK

 (CONFIRMATION COPY) (DELR 444 E 57 ST)

ARRIVING NEWYORK HOTEL WARWICK SUNDAY FOR COUPLE OF DAYS ENROUTE

COAST STOP ANY CHANCE MY CALLING FOR THAT CUPPA TEA QUERY

ALL REGARDS

 DONALD ZEC

CFM 52325

A note in Marilyn's hand on an April 3, 1958, telegram from Donald Zec, a well-known London journalist. Marilyn calls herself a "woman of her word" and agrees to meet him when he comes to New York for "that cuppa tea."

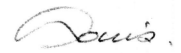

December 20, 1958

Dear Marilyn:

It's grimly ironic that while the rest
of the country was enjoying the comedy
of your impersonations in LIFE, you
were going through your personal
tragedy. We hope you are not taking the
irony too bitterly, and we hope, moreover,
that you will have sufficiently recovered
to get some pleasure from the holidays.

Arthur's tribute was a model of good
taste, artistic balance, and love.
It must be an added comfort to know that
everyone loves you -- especially now.

Louis.

*Louis Untermeyer, a friend of Marilyn's and Arthur's, was
a major poet, essayist, and anthologist. He refers here to the
December 22, 1958, issue of* Life, *containing Marilyn's spoof of
great sirens, and to the miscarriage she suffered that month.*

March 29, 1960

Lester dear,

Here I am still in bed. I've been lying here
thinking -- even of you. I bet you don't know how
fond I am of you - you're one of those ones that one
could say anything one meant or wanted to to.

I loved the way the Sunday piece on O'Casey was
handled and I think it was wonderful of you to tell
people about his very human quality. We need to know
about the few like him.

About our political conversation the other day:
I take it back that there isn't anybody. What about
Rockefeller? First of all he is a Republican like the
New York Times, and secondly, and most interesting,
he's more liberal than many of the Democrats. Maybe
he could be developed? At this time, however, Humphrey
might be the only one. But who knows since it's rather
hard to find out anything about him. (I have no
particular paper in mind!) Of course, Stevenson might
have made it if he had been able to talk to people
instead of professors. Of course, there hasn't been
anyone like Nixon before because the rest of them at
least had souls! Ideally, Justice William Douglas
would be the best President, but he has been divorced
so he couldn't make it -- but I've got an idea -- how
about Douglas for President and Kennedy for Vice-
President, then the Catholics who wouldn't have voted
for Douglas would vote because of Kennedy so it wouldn't
matter if he is so divorced! Then Stevenson could be
Secretary of State!

Now, Lester, on Castro. You see, Lester, I was
brought up to believe in democracy, and when the Cubans
finally threw out Battista with so much bloodshed, the
United States doesn't stand behind them and give them
help or support even to develop democracy. I can under-
stand a "John Daly" on an American national broadcast
making fun of Castro for having appeared at one of his
country's national functions in a tuxedo. (I use the
above as an example.) But the New York Times' responsi-
bility to keep its readers informed - means in an un-
biased way. I don't know, somehow I have always counted

on The Times, and not entirely because you're
there.

How are you, Lester? Did your amaryllis bloom
this year? Mine didn't - it's a little like me.
But maybe there's still hope. How late do they bloom?

I hope Mrs. Markell is well. I take for granted
she is happy since she sits at the foot of your table.

I am enclosing an unfinished letter to you that
I didn't tear up. (started in California).

About Arthur and your Sunday piece. What do you
want me to do - persuade him? Undue influence on my
part wouldn't be quite hocky would it?

It's true I am in your building quite frequently
mostly to see my wonderful doctor as your spies have
already reported. I didn't want you to get a glimpse
of me though until I was wearing my Somali leopard.
I want you to think of me as a predatory animal.

Love and kisses,

P.S. Sloans for late '60:

"Nix on Nixon"

"Over the hump with Humphrey(?)"

"Stymied with Symington"

"Back to Boston by Xmas - Kennedy"

*Marilyn expresses complex political views, including support
for Fidel Castro in Cuba, to Lester Markel, a senior New York
Times editor and friend, in this letter dated March 29, 1960.
She met Markel in the elevator of his apartment building
on Central Park when she came to visit the Strasbergs and
Marianne Kris, her psychiatrist, who also lived in the building.*

Lucille Ryman

16610 Chatsworth St
Granada Hills,Cal.
May 16,1960

Dear Marilyn:

 I have tried to reach you by phone
several times this last year - and have talked with
your secretary. It is not credible to me that
you would not return my calls, so I'm going to
make one last attempt, and only hope your secretary
who screens your mail and messages, will see fit
that you receive this. I refuse to believe the
girl I used to know, who could reach me by phone
any hour of the day or night - no matter how
slight the problem, has so quickly forgotten.

 Since the McCall story concerning
you, I have been approached regarding my personal
story of the Marilyn Monroe I knew. Before
committing myself, I would like to discus it
with you.

 I am assuming Marilyn, that your
secretary in the past has taken too much upon
herself, and has not told you of my attempts
to contact you. So until I know otherwise,
I remain, as always,

 Your friend,

 [signature]

 Lucille Ryman

Empire 3-1234
Empire 3-0300

Lucille Ryman, director of casting at MGM,
persuaded John Huston to cast Marilyn in
The Asphalt Jungle. *There is no record that
Marilyn answered this letter from Ryman,
dated May 16, 1960, or that Ryman told*
her story to McCall's. *What she knew—or
fabricated—about Marilyn was explosive.
She told later Marilyn biographers that
Marilyn had engaged in casual prostitution
in her early years in Hollywood.*

Emmeline Snively
617 So. Vermont Ave.
Los Angeles 5, Calif.

July 31, 1958

I am so happy to hear that you are back in California
making a picture.
We have been following your steady progress over the
years, and our students at Blue Book Models regard
your success and constant development as an inspiration.
I would like to see you if that could possibly be
arranged. I have an idea to discuss with you that I
think you will like.
You may reach me at DUnkirk 8-3545 or 617 South
Vermont Ave, L.A.5.

With love,
Emmeline Snively
Emmeline Snively

31st January, 1961.

Dear Miss Monroe,

Thank you for your charming
telegram of good wishes on my birth-
day. It was extremely kind of you
to think of me; I was touched and
much pleased.

I am so glad to hear that you
are going to play Sadie in the T.V.
production of "Rain." I am sure you
will be splendid. I wish you the best
of luck.

Yours very sincerely,

W. Somerset Maugham

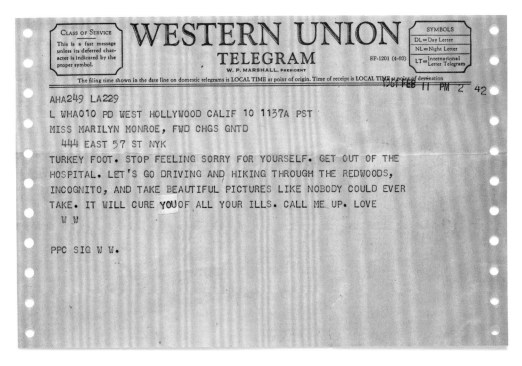

(opposite) *Struggling to stave off her depression over her divorce from Arthur Miller, Marilyn sends these birthday greetings to Somerset Maughan, who wrote the short story "Rain." At this point Marilyn is still slated to play the bar girl who seduces a missionary in the television adaptation of the story, but the project would fall through that spring. George Chasin was an executive for the powerful MCA talent agency that represented Marilyn.*

(above) *Andre de Dienes, a well-known photographer of women, had photographed Marilyn early in her career and had briefly been her lover. "Turkey foot" was his nickname for her, which he uses here in his February 11, 1961 telegram.*

FEB 10
6³⁰ PM
1961
CONN.

U.S.POSTAGE
4¢

Miss Marilyn Monroe
444 E. 57th Street
New York, N.Y.

MRS. FRANK E TAYLOR

Dearest Marilyn,

It seems to me again, as it did last summer,
very sad that we who have been given so much
by you cannot give you even what little we
might in return.

You have my admiration for your courage, my
gratitude for the many delights of charm and
beauty and humor your presence has meant,
and my deep sorrow for your troubles.

I believe in your strength, Merilyn, as I
believe in the sun. If at any time I can
help in any way, please let me.

Love,

Nan

Byram Drive
Greenwich
Feb. 10, 1961

*"I believe in your strength, Marilyn, as I
believe in the sun," writes Nan Taylor in this
letter dated February 10, 1961. Nan Taylor
and her husband, Frank, producer for* The
Misfits, *were close to Arthur and Marilyn.*

Dearest Kay,

eb 2325

I am thinking about you and
I send my love to you and
the children. I'll be in touch.
 Love,
 Marilyn

Mrs Kay Gable
Bermuda Dunes
Palm Desert, Calif.

Diamond 70515 X2189

After Clark Gable died in November 1960, vindictive columnists accused Marilyn of being responsible for his death because of the delays she caused in filming The Misfits. *Guilt over his death was a factor behind Marilyn's severe breakdown after her divorce from Arthur in late January 1961. Kay Gable, Clark's wife, had assured Marilyn that she bore no responsibility. This telegram, which has been parsed down to spare expense, is probably in response to a letter Kay sent Marilyn in the spring of 1961 inviting her to visit—and to bring along Joe DiMaggio.*

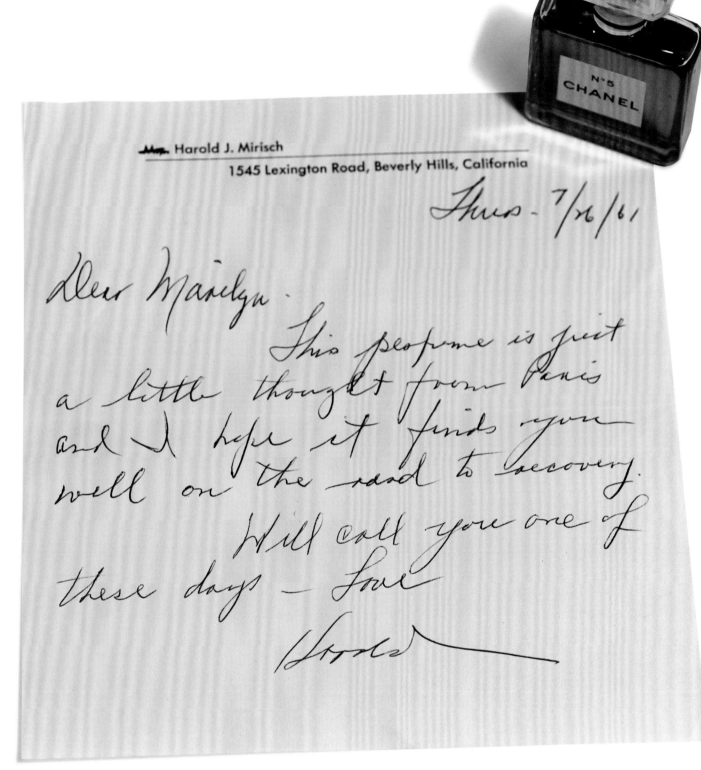

Harold J. Mirisch

1545 Lexington Road, Beverly Hills, California

Thurs - 7/16/61

Dear Marilyn -

This perfume is just a little thought from Paris and I hope it finds you well on the road to recovery.

Will call you one of these days — Love

Harold

Harold Mirisch was a producer
on Something's Got to Give.

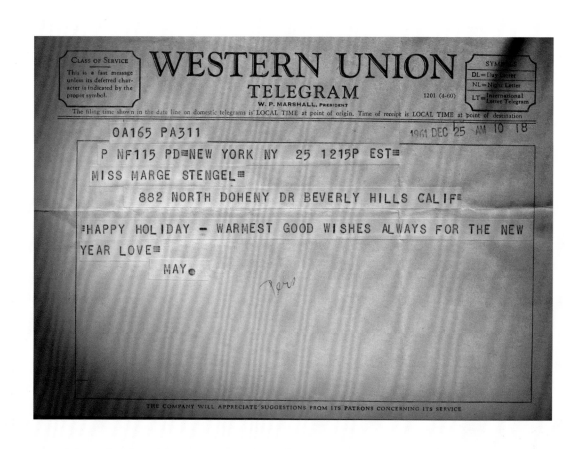

WESTERN UNION
TELEGRAM

CLASS OF SERVICE
This is a fast message
unless its deferred char-
acter is indicated by the
proper symbol.

W. P. MARSHALL, PRESIDENT

SYMBOLS
DL=Day Letter
NL=Night Letter
LT=International
Letter Telegram

1201 (4-60)

The filing time shown in the date line on domestic telegrams is LOCAL TIME at point of origin. Time of receipt is LOCAL TIME at point of destination

OA165 PA311 1961 DEC 25 AM 10 18

P NF115 PD=NEW YORK NY 25 1215P EST=

MISS MARGE STENGEL=

 882 NORTH DOHENY DR BEVERLY HILLS CALIF=

=HAPPY HOLIDAY — WARMEST GOOD WISHES ALWAYS FOR THE NEW

YEAR LOVE=

 MAY.

THE COMPANY WILL APPRECIATE SUGGESTIONS FROM ITS PATRONS CONCERNING ITS SERVICE

Holiday greetings to Marilyn, a.k.a. "Marge Stengel,"
from her secretary May Reis. To confuse fans and reporters,
Marilyn put Stengel's name on the mailbox at her Doheny
Drive apartment. Marjorie Stengel was a secretary of Marilyn's.
Her name disappears from Marilyn's records after Cherie
Redmond accused her of mismanaging Marilyn's finances.

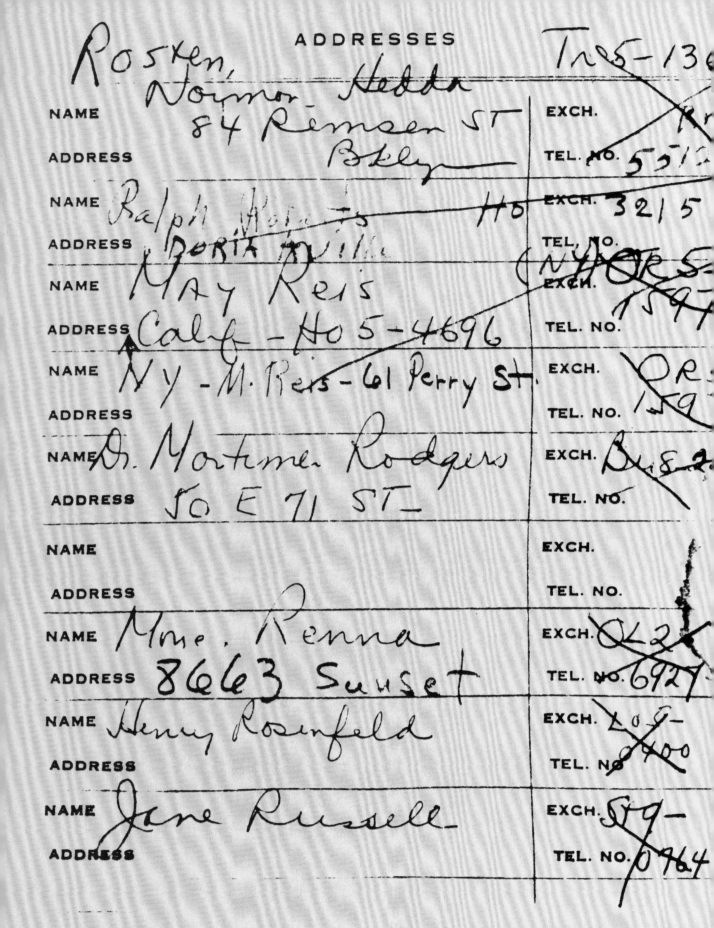

Rosten, Tr 5-136

NAME Norman Hedda
84 Remsen ST
ADDRESS Bklyn
EXCH.
TEL. NO. 55

NAME Ralph Roberts HO **EXCH.** 321 5
ADDRESS Boria ville **TEL. NO.** (NY

NAME MAy Reis **EXCH.** 154
ADDRESS Calf - HO 5-4696 **TEL. NO.**

NAME NY - M. Reis - 61 Perry St. **EXCH.** OR
ADDRESS **TEL. NO.** 159

NAME Dr. Mortimer Rodgers **EXCH.** Bu 8
ADDRESS 50 E 71 ST **TEL. NO.**

NAME **EXCH.**
ADDRESS **TEL. NO.**

NAME Mme. Renna **EXCH.** OL 2
ADDRESS 8663 Sunset **TEL. NO.** 692

NAME Henry Rosenfeld **EXCH.** LO 5-
ADDRESS **TEL. NO.** 400

NAME Jane Russell **EXCH.** 59-
ADDRESS **TEL. NO.** 0464

Pages from Marilyn's address book, probably from 1962.
Madame Renna was a complexion specialist whose salon in
Hollywood Marilyn frequented. The Rostens, Henry Rosenfeld,
and Jane Russell were friends. Ralph Roberts was her personal
masseur, and May Reis her secretary. Marilyn's secretaries
usually put together her address books.

Miss Newcombe:

 Mirs Blanche Gottlieb (LT 1-2650) who handles the $1,000 tickets; needs:

 1) The names of the other two people who will use the tickets

 2) Check for $5,000 payable to NEW YORK'S BIRTHDAY SALUTE TO

 THE PRESIDENT, INC. This should be a personal check

 — not a corporation check.

(top) A note Marilyn wrote reminding herself to call Carl Sandburg and Henry Weinstein. Sandburg was a close friend of Marilyn's. Weinstein was the producer of Something's Got to Give.

(bottom) Marilyn bought five tickets—a thousand dollars each—for John F. Kennedy's birthday celebration at Madison Square Garden on May 19, 1962.

Marilyn Monroe
444 East 57th street
New York City
New York

PERSONAL !!

CONFIDENTIAL

Marilyn M

Clifford Odets
Twentieth Century-Fox Film Corporation
STUDIOS
BEVERLY HILLS, CALIFORNIA

AIR MAIL SPECIAL DELIVERY

AIR MAIL
Special Delivery

Miss Marilyn Monroe
444 East 57th Street
New York, New York

Marilyn Monroe Production
444 East 57th Street
New York, N.Y.

Marilyn Monroe
444 East 57th
New York, N.Y.

Beverly Beard
Marilyn M

Claude
(on an ice floe)

AIR MAIL

KOTZEBUE
JAN 27
1959
ALASKA

AIR MA

UNITED STATES O

Mr. + Mrs. Miller
444 E. 57 m St
New York 22, N. Y.

Mrs. Arthur Miller
444 Eas 57th Street
New York

BROOKLYN
FEB

BROOKLYN, N.Y.
FEB 27
4 30 PM
1960

UNITED
FOUR
CENTS
4

Marilyn Miller
44 East 57 th St
New york

Mrs. Arthur Miller
Amagansett, Long Island
New York

Marilyn Monroe
Beverly Hills Hotel
Beverly Hills, Calif.

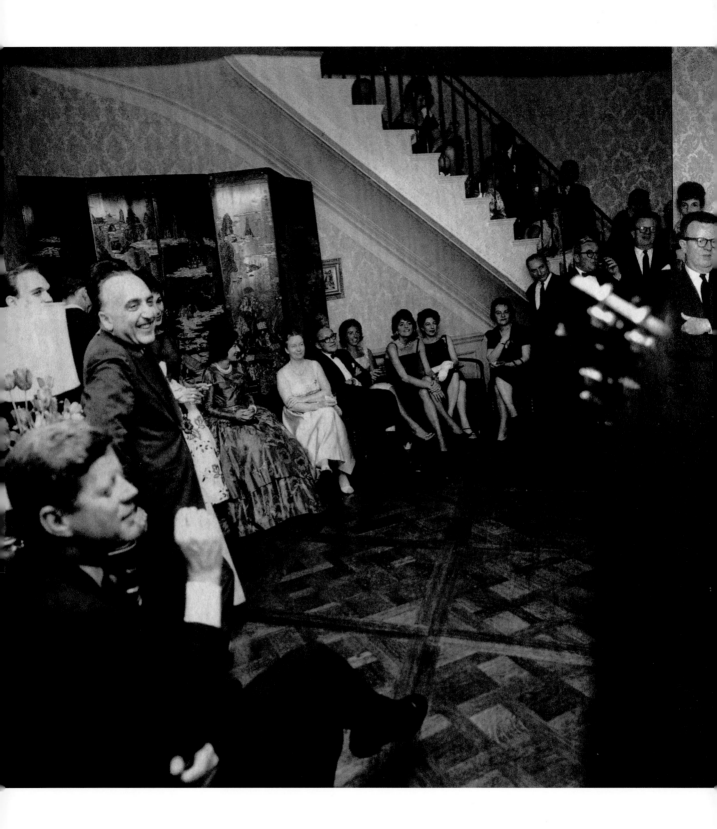

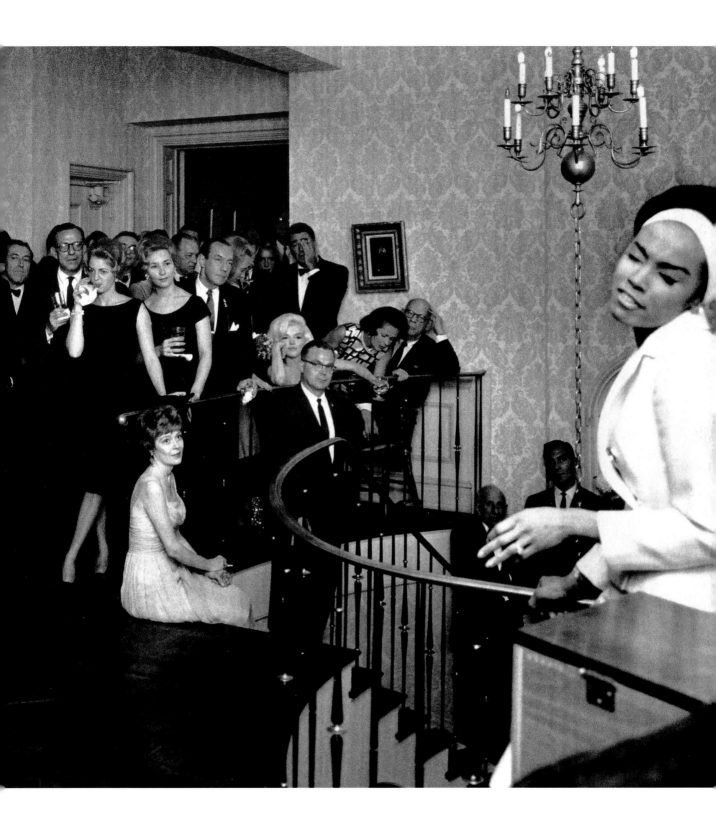

This clipping of a magazine spread shows the scene after Kennedy's birthday celebration, at a party given by wealthy Kennedy supporters. Isidore Miller, Arthur's father, whom Marilyn took as her "date" to the celebration, is leaning against the wall on the right, with Peter Lawford standing beside him. Opera great Maria Callas is among the listeners on the left, as are Eunice Kennedy and Patricia Kennedy Lawford. Diahann Carroll is performing.

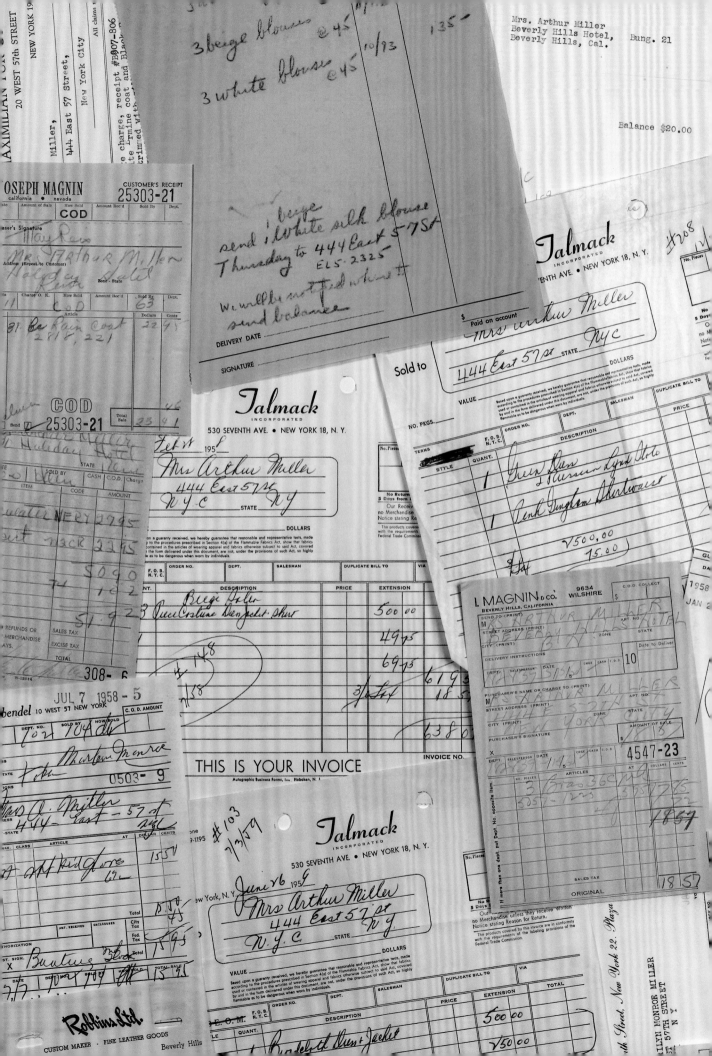

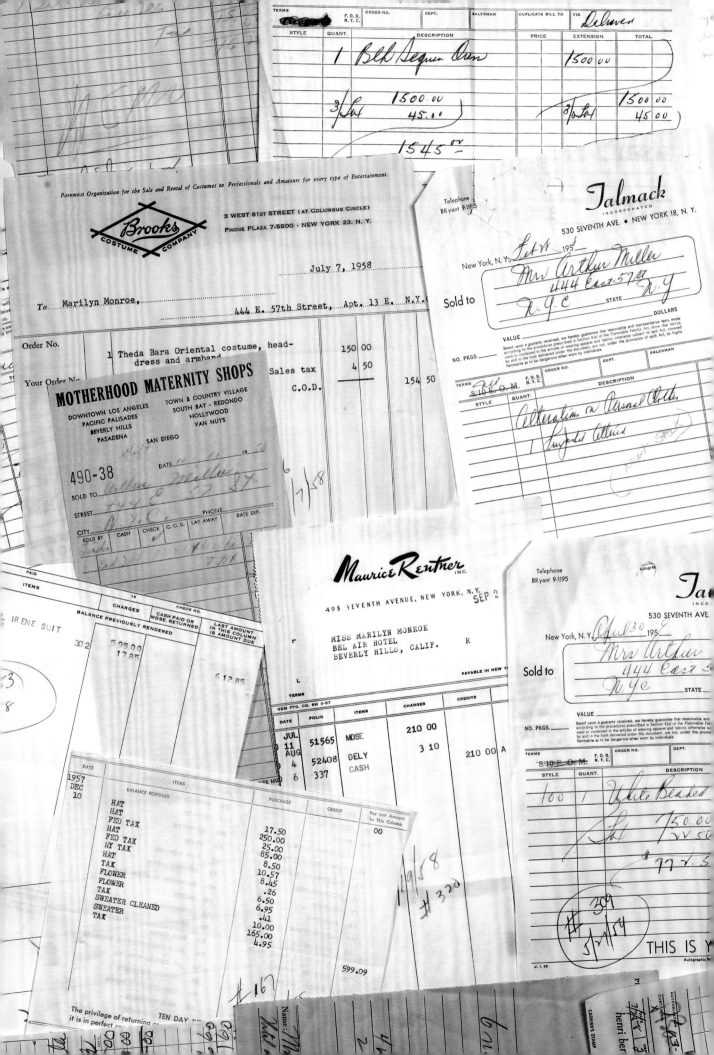

CLOTHING REMOVED FROM BEK
SHIPPED TO MARILYN MONROE

1 White Coat - Fur Cuffs
1 Beige Coat - Brass Buttons
1 White Fox Fur Stole
1 Black fur stole - embroidered "M M"
1 Beige Don Loper Suit
1 White Satin Sheath dress trimed in bugle beads
1 Purple Sheath Dress and Jacket trimmed in bugle beads
1 Black Velvet Middy Top
1 Blue Velvet Middy Top
1 Black and White plaid sheath dress (cotton)
1 Black Faille Sheath Dress with Net Top
1 Black Crepe Sheath Dress
1 Grey Jersey Sheath Dress
1 Knit Dress - bands of yellow and grey on white
1 Black Satin Embroidered Japanese Robe
1 Crepe Japonese Robe (Pink and Green)
1 Orange Tube Knit Dress
1 Black Faille Bolero
1 Black Linen Sheath Dress with net top
1 Blue Crepe lounging robe (Old but Marilyn likes this)
1 Black Faille Jacket with lining of black polka dots on white
1 Large Corduory Middy Top
1 Blue Shantung middy Top (Pants worn out and not sent)
1 Red Japanese Tea Gown
1 Black Linen Sheath - Zipper front
1 Black Gabardine Suit (Magnin label)
1 Red Dress - black bead collar
1 Black Satin Sheath - Rhinestone Suspender
1 Japanese - short kimona - red
2 Blue Jeans - 1 Blue Jean cloth skirt
1 Claire McCardell Jersey pants and top
1 Black Velvet Madcap Hat (Florence says M. M. likes this)
1 Blue Cotton - print - skirt
1 Black Wool Skirt 1 black gaberdine skirt
1 Grey Wool Skirt
1 Black Gaberdine Slack
1 Lined silk jersey slack
1 Black Jersey slack - buttons on legs
1 Beige Gaberdine Slack
1 Charcoal Greay Wool Slack
1 Beige Velvet Bermuda Pants 1 striped cotton bermuda pants
1 Black Jersey Bermuda Pants 3 white cotton pedal pushers
1 Beige Silk bermuda pants with matching top 1 beige cotton "
1 Grey Flannel Pedal Pusher 1 black cotton "
5 Cotton blouses 1 red jersey overblouse for slacks
1 Grey Jersey Slack Top 1 blackknit top - blue and gold trim
1 Black Knit Top - lacey yolk 1 White Ribbed Knit Top - peasant Knit trim
1 Blue Boucle yarn - knit top 1 White Boucle yarn - knit top
1 Hand Knit Bolero Type White sweater 1 White taffeta petticoat
1 Black petticoat with ruffle 1 Pink crepe Shortie nightgown
1 Brassiere 14 Assorted Belts.

Even before she left Hollywood for New York in 1954, Marilyn owned a lot of clothes. In May 1955, Inez Melton shipped Marilyn what she had stored in a Bekins storage area. Note that the seventh item on the list is a purple sheath dress and jacket, trimmed in bugle beads. This is probably the outfit that Marilyn wore for her performances in Korea.

PLAZA 3-6334

J A X

BEVERLY HILLS
BALBOA ISLAND
MANHATTAN

SOLD TO Marilyn Monroe Miller
ADDRESS 444 E. 57th St. NYC

DATE	SOLD BY	CASH	C.O.D.	CHARGE	ON ACCT.
8-5	Korby			✓	

MFG.	STYLE NO. & DESCRIPTION	COLOR	SIZE	CODE	AMOUNT
C	Contessa	Blk	12	$0	69 95
B	538	Pk	12	#	35 —
B	57	wh/wh			75 —
B	405	Blu	12	#	14 95
B	457	Blk	12	#	14 95
C	Paris S	Rd	12	ve	49 95
R	544	Taupe Suvah			39 95
B	210	Coffee	12	Cott	12 95
B	150	Blk	N	#	14 95
C	Black Cat	Blk	M	kid	75 —
C	Black Cat	Beige	M	kid	75 —

All claims and returned goods MUST be accompanied by this bill.

11361 NO CASH REFUNDS

REC'D BY

MOORE BUSINESS FORMS, INC., NIAGARA FALLS, N.Y.

BY
MOORE BUSINESS FORMS, INC., NIAGARA, NIAGARA FALLS, N.Y.

There are many receipts from Jax in the files.
According to the owner of the Beverly Hills store,
Marilyn would often come in before she became
famous to say hi to the salesgirls, Yuki and Korby.[15]

Polly's 480 park

480 PARK AVENUE, N. Y. C.
PHONE - ELDORADO 5-0480

MEMO

650

Mrs Arthur Miller
444 East 57 St.

STYLE	QUANT.	DESCRIPTION	PRICE	TOTAL
6703/430	1	Natural baby lama wool Coat ⑩	350 —	

This Christian Dior Coat
ought to be very good for
You both here and in
California, the fabric is
baby lama & is very beautiful
light in weight & warm

Who said you couldn't inspire a great artist !!!

love
John

Note from John Moore to Marilyn.
Comic reads: "Two aspirin chasing
a Bufferin inside Marilyn Monroe."

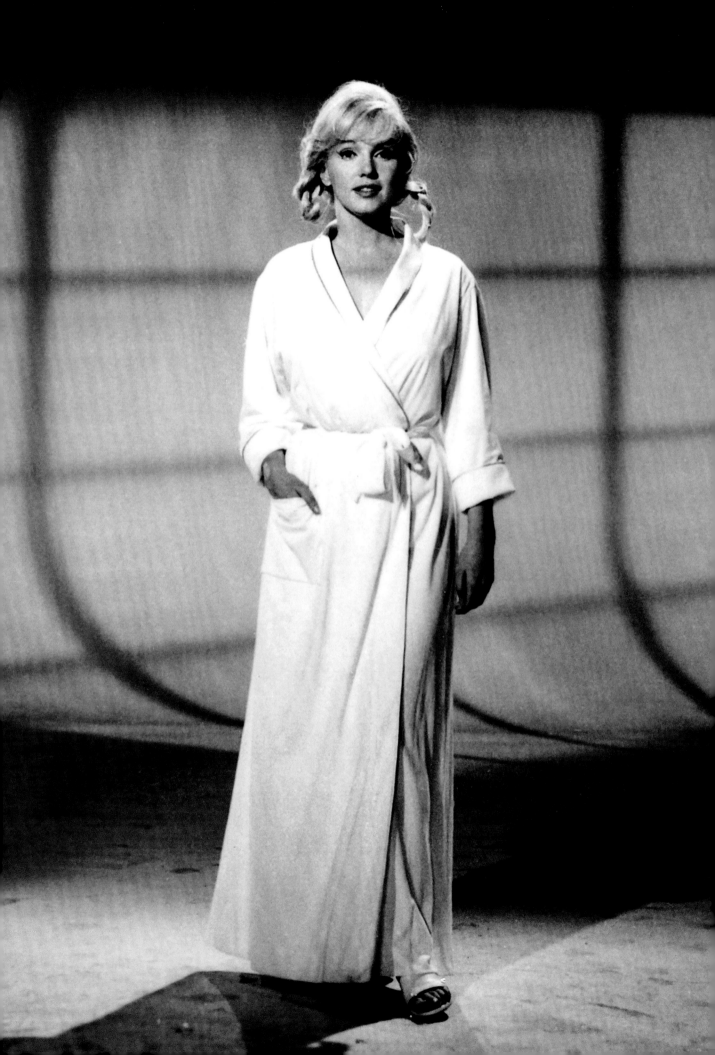

A receipt for one of Marilyn's famous terry cloth
robes, bought at Bullock's Wilshire in Los Angeles.

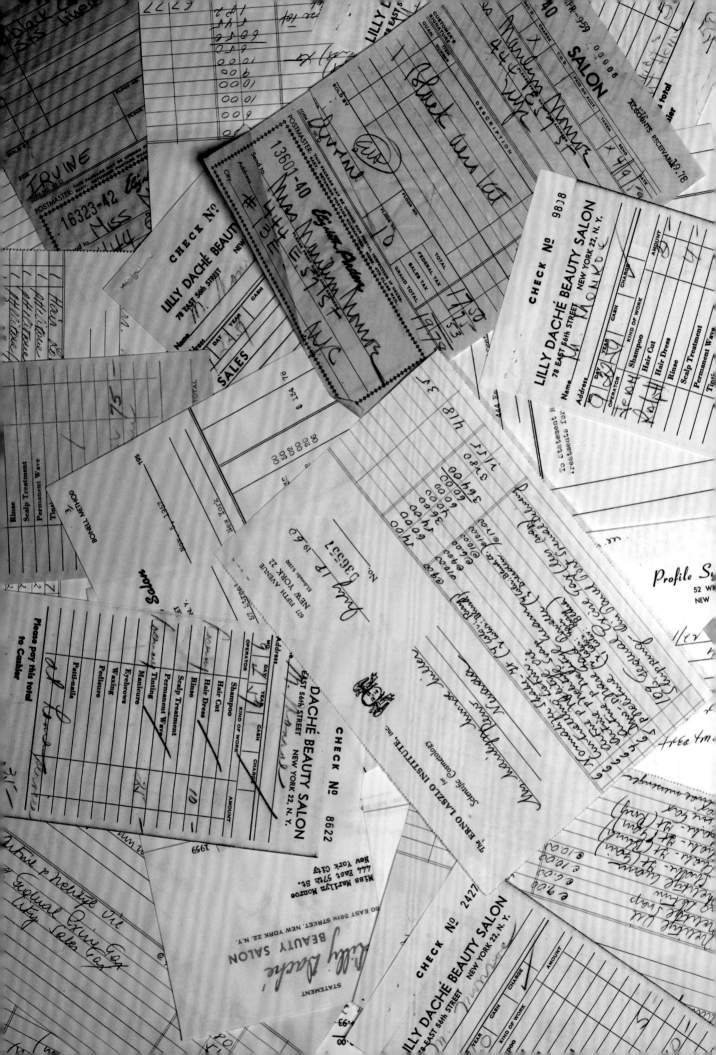

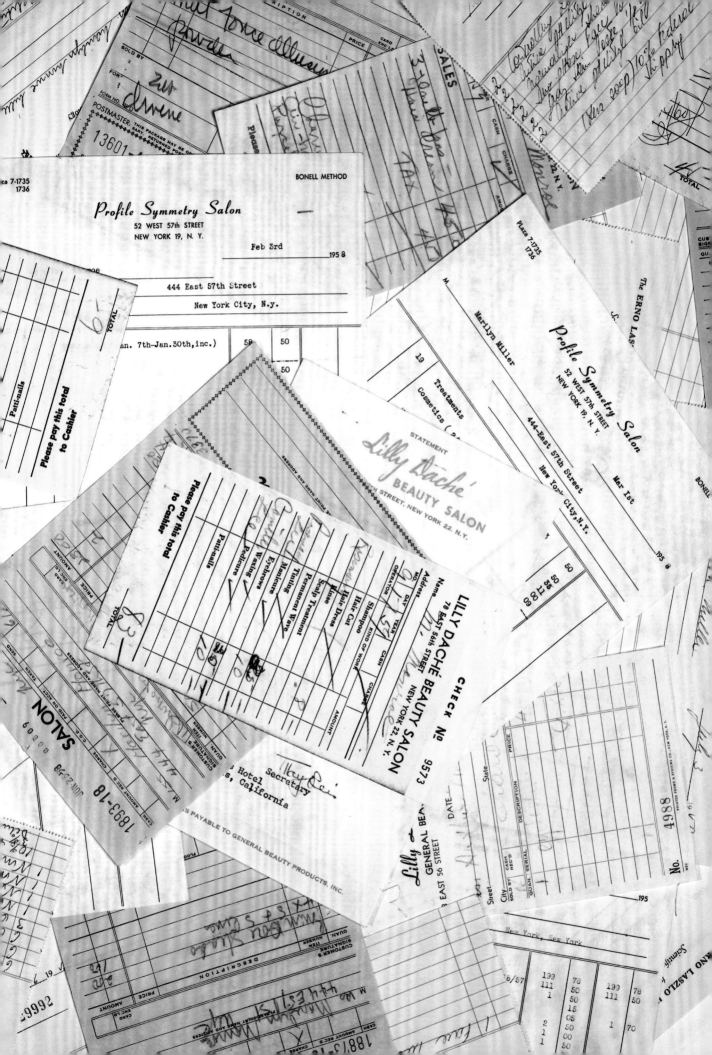

POLLOCK-BAILEY
PHARMACISTS
401 EAST 56th STREET, Cor. FIRST AVE.
PLaza 5-4244 ELdorado 5-6094

Nov. 1 195_9_

Mrs. Arthur Miller
444 East 57 Street
New York City

PLEASE DETACH AND RETURN THIS COUPON WITH YOUR REMITTANCE AMOUNT $_220.58_

DATE		DESCRIPTION	CHARGES	TAX
Oct.	1	247976 15.90 10/5- Amytal sul. 5.75	21 65	
	5	Water for Inj. 1.25 251642 3.75	5 00	
	8	2 Revlon lotion 2.50 2 Pan 2.00	4 50	45
	12	Ace Bdge. 1.89 10/16- Arpege cologne 10.00	11 89	1 00
	16	Vit B, Sol. 3.50 10/9- 250139 10.50	14 00	
	21	4 Mineral oil 4.80 3 Styptic Pencils .75	5 55	
	22	252211 6.25 3 air spray 3.00 1/25- Bed Pan 6.05	15 30	
	23	Hectic fan 5.88 10/26- 252289 5.50	11 38	
	26	252291 13.75 252290 2.50 252288 4.25	20 50	
		252307 4.25 252308 3.50 252327 6.60	14 35	
	27	252290 2.90 Glycerin opthalmic 1.75	4 65	
	28	Revlon Eye liner 1.50 Call on Mueller 2.00	3 50	35
		Gold flecks set 1.95 Eye Shado 1.50 252290 2.50	5 95	60
	29	Royal Jelly .39 10/30- 252290 15.00	15 39	
	30	Revlon Eye Shadow 3.50 Shadow Stick 1.50	5 00	50
		21.75 28.50 2.50 7.25 16.50 158 61 2 65	57 50	
		252513 252510 252511 252512 252509		
			216 11	2 65
		F. Tax	2 65	
		S. Tax	1 82	
		# 220 58		

Like many Hollywood stars, Marilyn used
enemas and colonic cleansing for quick
weight loss.

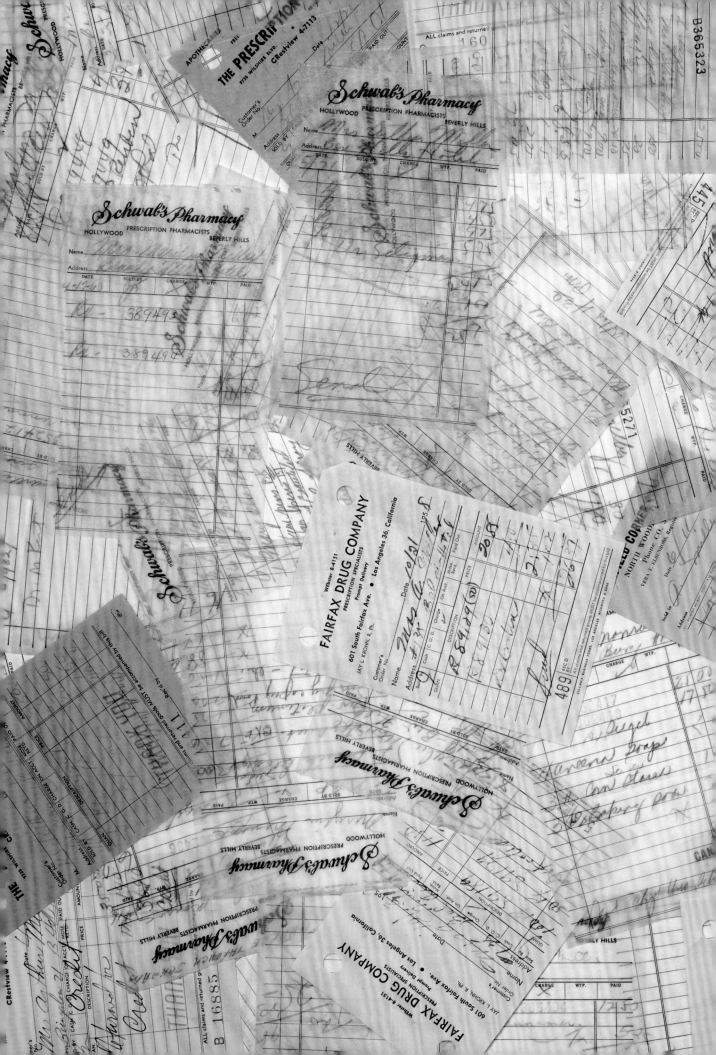

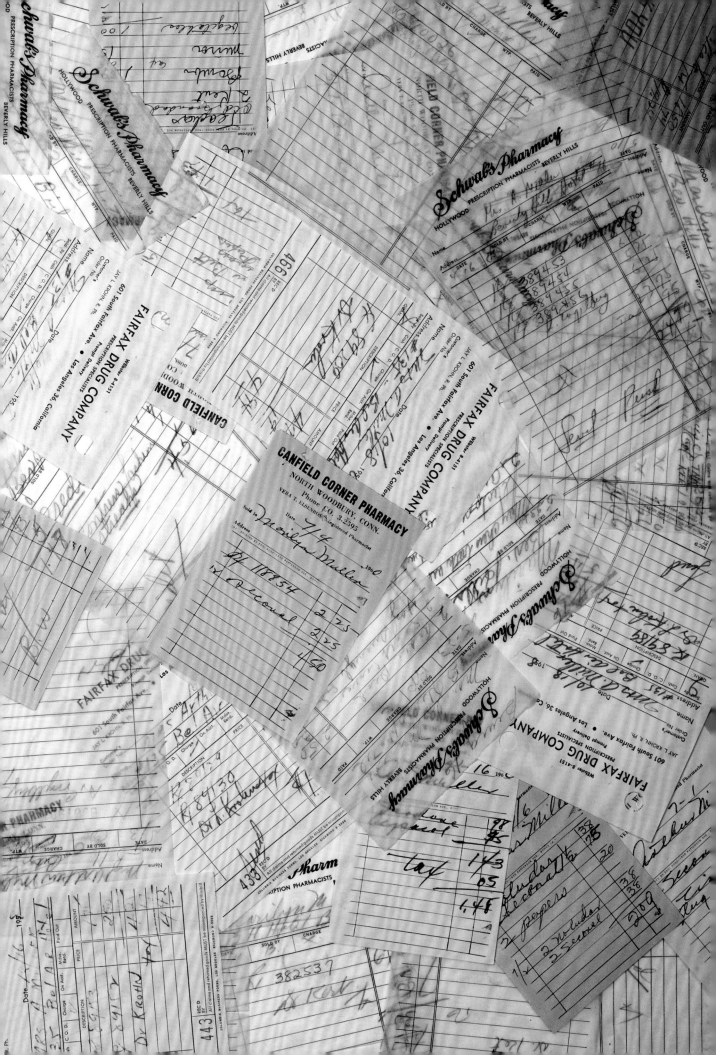

Marilyn liked to take photographs. In 1954
Joe DiMaggio gave her a camera, and Sam
Shaw taught her "a few things about the camera." [16]
These photos were taken by Marilyn on the beach
at Amagansett and on the farm Arthur and Marilyn
rented there, where Jane opens presents at a birthday
party. Hugo is in some of the photographs.

A FTER MARILYN married Arthur Miller, she refashioned herself into an Earth goddess connected to animals, plants, and children. More practically speaking, she became an accomplished gardener and cook. In a typescript tribute to Marilyn, Arthur wrote that she made things grow by the magic of her personality. He also wrote that she would invite six or eight friends over on the spur of the moment and make an impressive meal for them. In an interview, Arthur stated that she made the best leg of lamb he had ever tasted. Marilyn added: "And you like my chicken with wine sauce."[17]

She was a generous stepmother to Arthur's children, Jane (Janey) and Robert (Bobby-bones). She wrote them loving letters, and they responded in kind. Many of Arthur's friends became close to Marilyn. The Rostens stayed at a cottage near them on Long Island and visited them at their farm in Roxbury, Connecticut, and the Shaws visited them at Amagansett and Roxbury.

Marilyn and Arthur's basset hound, Hugo, was central to their family, as were Butch and Bobo, Marilyn's parakeets. Norman Rosten wrote about Butch: "Marilyn calls to him (her); he sits on her shoulder, she coos and whistles, carries him to her lips, and ole Butch leans over and kisses her. 'You're a cute parakeet,' Marilyn says to Butch. Butch loves to hear her voice, figuring she's just as cute as a parakeet herself. I believe that Butch is in love with her." Marilyn also loved Hugo, but the dog seemed perpetually depressed. Marilyn once tried to cheer him up by giving him a teaspoon of Scotch. Soon he "rapturously" ran across the room to her. She got down on her knees and hugged and kissed him, joking that "Hugo had made his psychic breakthrough."[18]

The Millers had other animals. Sugar Finney was a Siamese cat named after a character in a folk story. Ebony was a horse that the Taylors gave to them. Having so many animals caused problems. "Hugo likes the cat," Marilyn wrote, "but the cat doesn't like him. And the cat and the birds get into conflicts." She had to find a way to keep Sugar Finney away from Butch.

Marilyn became close to Arthur's father, Isidore Miller, who had gone bankrupt in the 1930s after making a fortune manufacturing women's clothing—his family was reduced to poverty. A grumpy old man when Marilyn met him, Isidore gained vitality and self-pride under her attention. Even after her divorce from Arthur, they remained close. In February 1962, she met him in Florida for a few days' vacation. In May she took him as her "date" to the Madison Square Garden birthday celebration for John Kennedy.

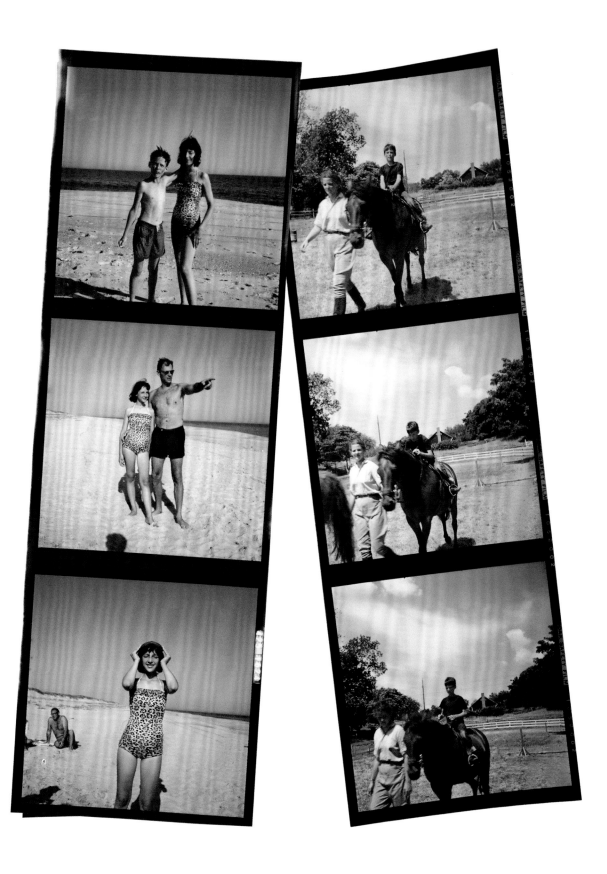

Arthur with Jane, and Jane with Bobby on the beach at Amagansett.

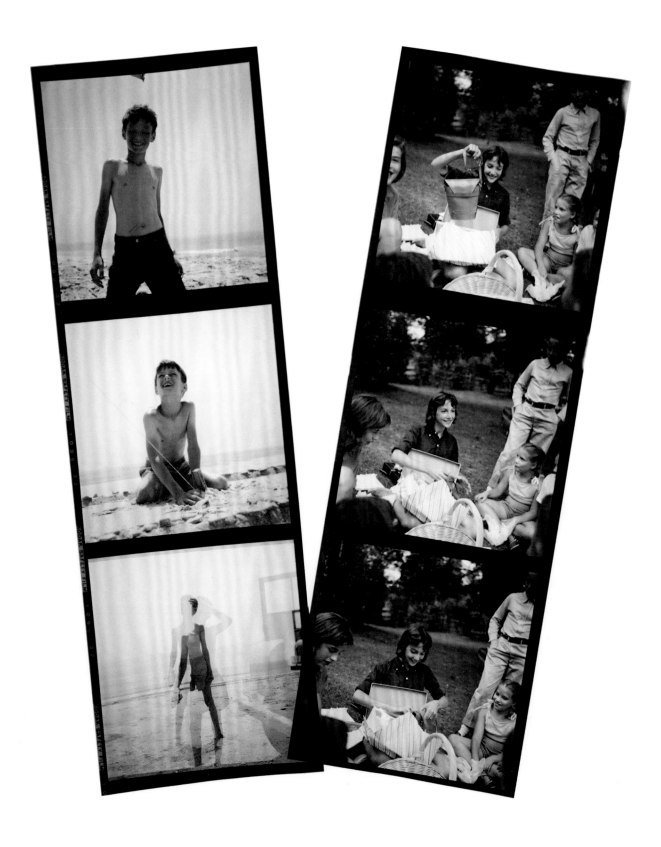

Photos of Hugo and of Jane at her birthday
party. Patricia Rosten, Hedda and Norman's
daughter, is also present.

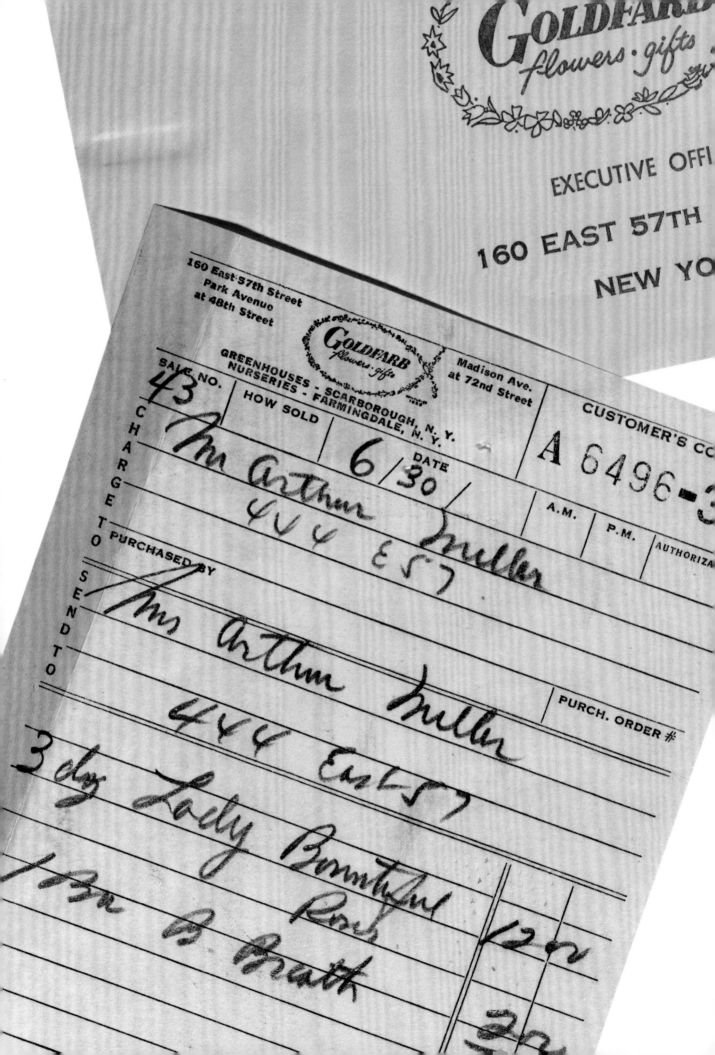

MOTHERHOOD MATERNITY SHOPS

DOWNTOWN LOS ANGELES TOWN & COUNTRY VILLAGE
PACIFIC PALISADES SOUTH BAY - REDONDO
BEVERLY HILLS HOLLYWOOD
PASADENA VAN NUYS
SAN DIEGO

490-38 DATE _____ 19 __

SOLD TO _Arthur Miller_

STREET _444 E. 57 St._

CITY _N.Y.C._ PHONE _____

SOLD BY	CASH	CHECK	C.O.D.	LAY AWAY		DATE EXP.

NO REFUNDS OR EXCHANGES AFTER 7 DAYS. MERCHANDISE MUST BE ACCOM-
PANIED BY SALES CHECK.
NO RETURNS, REFUND OR EXCHANGES ON SALE MERCHANDISE.
UNCLAIMED LAYAWAYS RETURNED TO STOCK AFTER 5 WEEKS.
CUSTOMER'S COPY

*(opposite) Arthur's receipt for three dozen Lady
Bountiful red roses and a bunch of baby's breath sent
to Marilyn at their New York apartment. The date is
probably June 30, 1957. The flowers seem celebratory;
Marilyn was probably pregnant. She had a miscarriage
(an ectopic pregnancy) in early August.*

*(above) Arthur's receipt for a bed jacket from
a maternity store, just before Marilyn suffered a
miscarriage in December, 1958. (Note the word
"gift" written at the top of the note.)*

Ladies' Home

FROM THE OFFICES OF THE JOURNAL EDITORIAL WORKSHOP
1270 AVENUE OF THE AMERICAS
NEW YORK 20, N.Y.
PLAZA 7-1020

Bruce Gould
Beatrice Blackmar Gould
Editors

MARY BASS
Executive Editor

September 17, 1957

Dear Marilyn:

Here are the recipes for bouillabaisse and Beef Burgundy.
I think the bouillabaisse is pretty clear, but on the Beef
Burgundy I would ask the butcher to cut the sirloin in the
pencil-size strips. Saves a lot of time. I hope you have
a cookbook that will tell you what the word "roux" means. If
not, you simply melt the butter in the juices made by brown-
ing the beef and gradually add the flour, stirring to avoid
lumps. I know I was thrown by the word "roux" when I en-
countered recipes and didn't realize how simple it really was.
This recipe is for a crowd - sixteen people, so if you want
to prepare it for fewer, just cut it in half. Both freeze
beautifully.

 Good luck, and best regards to you and Arthur.

 Cordially,

 Mary

Mrs. Arthur Miller
Town Lane
Amagansett, New York

subst.

BOUILLABAISSE: Get 1 1/4 pounds shrimps (a
about 1 1/4 pounds scallops (about 16), 3-4 lo
3 fillets flounder or sole. Wash, shell and
rimp. Put flounder or sole in top of double
boiling water, cover and cook until fish i
30-40 minutes. Set aside to cool. Split
half. Cut off tail and claws. In a lar
cup olive oil or salad oil and when hot
onion, 1 1/2 cups chopped celery and 2
minced. Cook until delicately browne
chopped parsley, 2 #2 cans tomatoes
spoon each of thyme, paprika and
ium glutamate, 1/2 teaspoo
and 2 cups beef b

LPHIA 5, P.

December 4, 1957

Dear Mary:

 Please forgive me for not having an-
swered your note since September but we have been
very busy and going mad getting two places in or-
der, in the country and in the city. Right now
we are in the middle of knocking down walls in
the apartment and all that sort of thing, but we
think of you often, and as soon as our place is
in order we would love to see you and have you
over for dinner.

 Thanks millions for the recipes. Every-
body thinks I am a marvelous cook, thanks to you.

 I don't know whether I ever told you,
but I would like to put it in writing, and thank
you for being so wonderful to us this past summer.
We loved seeing you and we speak many times of
the afternoons we spent in your patio. In fact,
Arthur and I have decided that a patio is a "must"
in our new home.

 Arthur especially asks to be remembered,
and we all send our love to you and Dickie and
hope to see you soon.

 Sincerely,

Mrs. Mary Bass
Ladies Home Journal
1270 Sixth Avenue
New York City

Mary Bass of Ladies' Home Journal *sent this recipe for bouillabaisse to Marilyn, who thanks Bass for giving her recipes and for the afternoons she and Arthur spent with Bass on her patio. In his memoir of Marilyn, Norman Rosten writes about stopping by Marilyn's apartment to sample her stunning bouillabaisse.*

August 9, 1957

Dear dear Bobby,

Thank you for your wonderful cards and letters. I am glad you are enjoying camp so much. Are they teaching you tennis yet? I hope so because then you, Janie, Daddy and I can play foursomes, if we get good enough.

Hugo has been up to all kinds of mischief. He loves people so much that he goes visiting - you know with regular visiting hours. On one of his visits an unfortunate thing happened. The donkey, who did not understand his friendliness, kicked him in the nose. He had a very large lump on his nose and from the side it looked like he had two noses. However, he has recuperated beautifully and there isn't even a scar. We put ice packs on it. One day he brought home a woman's shoe and the other day he came in with a child's toy - a little stuffed dog. We are thinking of calling him Klepto - short for Klepto-maniac, which means one who takes things. I think I shall have to buy him a few things of his own or we will be getting more complaints from the neighbors.

Guess what? I planted some flowers and Hugo loves them. I mean he doesn't bother them. He doesn't even pee on them. He just smells them. I think he is a little longer since the last time you saw him. He is very lone-some for you and Janie.

We haven't played badminton since you left because nobody plays as well as you do - not even Norman.

Everybody asks about you, if you are having a good time at camp. Of course we tell them what you tell us in your letters.

Your Daddy misses you very much and so do I. Sometimes Hugo is think-ing of you. I can tell because he smiles.

Have you continued your horseback riding? I hope so since you got such a good start.

Is there anything you need at all in the way of anything? Your Daddy and I will send it immediately. Just let us know.

Will you please do me a favor? Without letting her know, so we can surprise her, find out some things Janie would like for her birthday because we could have a party and have lots of fun. Let me know even if you just number a few things on a postcard; that is, if you have time. I know how busy a man is when he is at camp.

The barometer is working splendidly. Every time it rains we can tell when it is going to stop and vice versa.

Kiss Janie for me, if you see her. We are so lonesome for you both.

Love,

A letter to Bobby Miller, with Marilyn writing as Hugo, the dog.

H**U**O**O

August 22, 1957

Dear Bobby,

It sure is lonesome around here! But first of all I will tell you I made a mistake and I am sorry, but I chewed up one of your baseballs. I didn't mean to. I thought it was a tennis ball and that it wouldn't make any difference but Daddy and Marilyn said that they would get you another one, so is it all right for me to keep playing with this one as long as you are getting a new one?

The other day I was out on the lawn in front and I saw a lot of kids at the beach flying kites. None of them were as nice as your box kite. Every time I go upstairs (I sleep upstairs in Janie's room on her bed) I see your kite and it makes me lonesome for you.

Oh, I did something else that I should tell you about. I jumped up very high and knocked down the badminton set. Then I proceeded to chew up the net but I didn't wreck the rackets or the birds. I am sorry I did this Bob, but what is a dog going to do? I got hit in the nose by a donkey so I don't dare chase him anymore and Daddy and Marilyn were away when I did these things. It was just because I was lonesome for all of you, but I promise to be a good dog - one you will be proud of. In fact, I miss playing with you almost more than anything.

A wild rabbit came on our front lawn. I thought it was going to chew up the flowers so did I chase him away! So you see Bob, even if I make mistakes sometimes, I don't always. Also, I have been a pretty good watchdog this summer except I can't watch while I'm sleeping. Who can?

The trouble is, I think, I miss you and Janie so much that if there is nothing to do here I tend to get into mischief. But Daddy and Marilyn don't mind too much. They always forgive me and pat me on the head.

Bob, I was wondering if you could make me some kind of toy while you are up in Camp. I realize it might be impossible but in case you could make something for me to play with, so I wouldn't chew on your baseballs, etc., at least I might not feel so lonely while you are away, especially with something from you. But if you can't, I'll understand.

Do they have any dogs in that Camp? Any bassets? Any cats? I don't really mind cats. In fact, Daddy and Marilyn said when we get to the country we might get some cats and maybe another dog so I could have more companionship, but I know what I really need is for you to come back home Bob. But, in the meantime, have a good time at Camp.

 Love from your friend and ankle-chewer,

P.S. I really mean lots of love and slurpy kisses O X O X O X O X O X O X O X
 I know Daddy and Marilyn send their love too.

August 22, 1957

Dear Janie,

How is my own Mommie? Boy, was I glad to get your letter written only to me! Of course Daddy and Marilyn have been telling me things from your other letters and Bob's too, about what you have been doing at Camp and how much you are enjoying it and I don't want you to feel badly, but I have to tell you that I have missed you something awful. But also, I want to say that I am happy that you are having such a wonderful time at Camp. Do those other kids there have dogs? Are any of them bassets like me? Next time you go to Camp couldn't you take me? If not, I'll wait.

Now I'll tell you what I have been doing lately. I have been chasing horses, butter-flies and just flies. In fact, I run after anything that moves. But I don't chase that donkey anymore. I fool him though because sometimes when I am barking at him and running - and I have to run pretty fast from him because you wouldn't believe donkeys travel so fast - I run under the split rail fence since I am low enough to the ground but he bumps into the fence and it makes him so mad and he makes a lot of loud noises like Hee Haw. But I am really sad that he gets mad at me because I just want to play with him.

Lets see, what else? Oh yes, guess what? This morning I found a beautiful hair brush. Well somebody washed it clean and laid it out in the sunshine and I thought it would be wonderful to chew on so I carried it home. Early every morning I make my rounds. Soon as Daddy lets me out the door I visit all the neighbors. Daddy wouldn't let me keep the hair brush. It was so much fun to chew on too, darn it! Oh well, maybe I'll find another shoe.

Marilyn puts on the sprinkler for the lawn and lots of birds gather around and do you know what I do? I wait off behind the tree and just watch them and as soon as there are about twenty birds I run in the middle and make them all fly up into the trees. Then I run away and then they come down to the water again and I wait behind the tree and then I run in the middle again.

Also Janie I must confess (and I am not telling anybody but you) I have been sleeping on your bed. It's because it is your bed. So far I don't think Daddy or Marilyn knows about it but every night after they close their door and they go to sleep I wait a little while and then I tiptoe upstairs and I sleep right on your bed. I think they are getting suspicious though because I heard Bernice (that's the new maid and you will like her) say, "I found the strangest footprints up on this bedspread." Of course, between you and me, they were mine. Well, what can a dog do when he is lone-ly? But Janie, I really am trying to be a good dog - one that you would be proud of - but I make mistakes sometimes, but other times I don't. For instance, I haven't even set one of my four feet on any of the flowers that Daddy and Marilyn planted and I just love them. I sit in the sunshine just smelling them.

There was a dog that came by our place a couple of weeks ago and I thought at last I would have a playmate and I went running out to him to greet him. But do you know what that dog did? While I was running he started to run very fast away from me. I thought he was playing, but suddenly he turned and snapped at one of my ears. It didn't hurt much and it healed very fast.

Lets see what else is happening. Oh yes, some caterpillars let themselves down on those fine little threads from the front tree. I don't bother with them though unless I haven't anything else to do.

The meals in this house are pretty good. I can't kick about that. I guess my biggest complaint and what makes me the saddest is that I can't see you and Bobby and what would make me the gladdest is if I could see you both.

Well, this is the first time I have ever written a letter and I don't know what else to say so I guess I'll close.

 With love and slurpy kisses,

X (hugs and kisses)

P.S. Some terrible insects by the name of ticks have been getting on me lately and Janie it's just terrible but I am managing the problem pretty well because when I get one on me I just run to Daddy or Marilyn and they get them off me in a hurry. But they are pests! I even picked up a couple of fleas. Pests also!

P.P.S. Daddy and Marilyn send their love. I know because they love you. Me too!

A letter to Jane Miller from Marilyn,
again writing as Hugo.

DEAR MUMMY& DAD:

I'M WELL BUT MISS YOU. I'M HAVING
 FUN DRIVING OLD ROCKY AND THAT
OLD GRUMPY MAID OF YOURS NUTS.
I SIT IN THEIR WINDOWS AND LOOK
 OUT AT THE TRAFFIC, THEY LIVE
ON A ONE WAY STREET.

MUMMY HAZEL BOUGHT ME A STRATCHING
POLE, I DIDN'T LIKE IT AT FRISTBUT
I HAVE LOTS OF FUN WITH IT NOW. SHE
AND ROCKY HAVE TO HOLD ME ALL THE TIME.

 THERS NEVER A DULL MOMENT IN THIS SHACK.

 AGNESS JUST CALLED TO SAY HELLO.
AND SENDS HER LOVE. SIDNEY WILL BE THERE
TOMORROW, HURRY BACK.

 LOVE,
 SUGAR FEENY

A letter to Robert and Jane Miller from Marilyn,
writing as Sugar Finney, the cat.

July 16, 1958

Dear Bobby-bones,

So I told you there were swans here (note picture on postcard).

So far I haven't heard from Kenny Altman. I hope he can come to see me. If he does I can take him to the studio where I'll be working. On the set there are about 8 or 9 very, very old cars of the 1920 period and earlier. They really look very strange at this time.

I haven't seen Jack Lemmon yet because he is still working on another picture. He has a very funny part in this picture. Also, he plays a friend of mine.

I started to take ukulele lessons because I'm supposed to know how in the picture. I've got an idea! Maybe we can learn something together -- you on the guitar and me on the ukulele -- you know, charge people admission to hear us. For instance, Morty, Johnny, David and Anne.

It sometimes gets very lonely here -- I'm thinking of buying a bird like Morty has then we could always keep him -- but what will I call him? About two days ago someone gave me a Cocker Spaniel puppy 10 months old, completely house-broken. So I was going to call your Dad and ask him if it was okay to keep him -- then I found out quite by accident that he bites -- he didn't bite me but he bit a woman on the throat the day before, so I said "thanks a lot but no thanks". His name was "Walter" and he was a golden-haired spaniel and beautiful but he seemed just too "schizo" --short for schizophrenic -- you remember you explained what that meant.

Are you swimming every day? Or almost? Is it fun there? Have you joined the Little Leaguers yet? How many home runs? What else? Reading any books? How's Janie? Has she heard from Kent? Did you hear from Claire? Okay, okay, I was just kidding (About the last question).

Don't forget to write to your Dad. He hasn't anyone to talk to except Hugo and Ebony and Paul Woike and Paul Woike, Jr., and he's dumb -- you said so yourself.

I'm including stamps in case you feel like writing. If not maybe you can trade them in for candy bars somewhere.

Goodbye for now. I'll write again, leaving you with this thought: Hugo can only get brighter as he gets older -- he might even get smart enough to go camping.

Love,

PS: I'm still getting the sweatshirts, in fact, this week, so I'll send them --it's about time. I miss you.

Marilyn, on the set of Some Like It Hot,
writes Bobby Miller.

 Noon
 February 2

Dear Bobbybones,

The first thing I want to say is that I am
very disappointed that you don't get to have
your telephone. I don't quite understand why
it didn't work out, and I am very sorry, but
remember that in a few years you will be able
to do more things that you want. For instance,
like having your own telephone. What I am
trying to say is that you will be growing up
and having your own responsibilities (even
thought I still think, and agree with you, that
it would be fun to have a phone and I can't see
any harm in it, especially since I want to give
it to you as your Christmas present, and you
feel you have a need for it.) Anyway, Bob,
cheer up. I would like to get something that
would replace it, but I don't know how. I am
glad you liked the sweater, but I would still
like to do something else with your check be-
cause it really belongs to you. If you can
think of anything else, let me know. Or, maybe
you would like to start a savings account, or
something like that? Or, who knows--but you
let me know.

That pool table you told me about in that Danish
Hotel sounds great. Did I ever tell you that I
can really play pool? I learned when I was
about sixteen and it is something that you never
forget. I don't understand why they don't let
you in to play pool. Do they they think you are
a delinquent of some kind just because you like
the game? Maybe you could go over and take a
friend when all those Danish sailors aren't there,
like at some odd hour early in the morning, or

maybe you could find out which odd hours those
Danish sailors don't play. Anyway, don't give
up the ship, if you know what I mean, because
they might just say yes, as you put it, just
to shut you up.

I am glad your arm is feeling better. Where
are you going skiing -- but do be careful.

By the way, I don't think you're so bad about
sending letters when you consider how bad I am.
I'm very happy to have heard from you and don't
worry about sending me a present because I
realize your allowance is limited and you need
it for school things and what not.

I am going to get that book you recommended;
is it "Lord of the Flies" or "The Flees"? I
would love to read something really terrifying.

Bobby, I have the best news: I have just com-
pletely bought my new house. As I told you,
it is an authentic little Mexican house, but
it's got a gigantic swimming pool, and it looks
just like Mexico. You would just love it. I
have two guest rooms plus a large playroom,
plus lots of patios, and a big Mexican wall
goes all around the place with big high Mexican
gates (that's to keep intruders out, in case
anybody gets intrusive.) It's got a nice
garden - not too large to take care of - and,
as I told you, the swimming pool is so large
it doesn't leave too much lawn to take care of.
Anyway, I would love - for whichever vacation
it can be arranged - if you and Janie wanted
to - at least for a part of the vacation, even
if it is for a few days, or a week - you are
welcome to stay as long as you wanted to. I
will take care of your plane tickets and meet
you at the airport. You remember how much you
liked California -- well, it's still here, and,
what I want you and Janie to know is that you
are always welcome. Now, I don't know how you

are going to work this vacation thing out,
but if I know you, you will probably figure
something out - right? And, talk to Janie
about it; maybe she has an idea. Or, if one
of you is busy, you could take turns in coming.
I don't know -- I just thought I would make
these suggestions. First of all, I miss you
very much and I think you would love my new
home.

Oh, Bobby, guess what: I had dinner last night
with the Attorney-General of the United States,
Robert Kennedy, and I asked him what his depart-
ment was going to do about Civil Rights and
some other issues. He is very intelligent,
and besides all that, he's got a terrific sense
of humor. I think you would like him. Anyway,
I had to go to this dinner last night as he
was the guest of honor and when they asked him
who he wanted to meet, he wanted to meet me.
So, I went to the dinner and I sat next to him,
and he isn't a bad dancer either. But I was
mostly impressed with how serious he is about
Civil Rights. He answered all of my questions
and then he said he would write me a letter and
put it on paper. So, I'll send you a copy of
the letter when I get it because there will be
some very interesting things in it because
I really asked many questions. First of all
he asked if I had been attending some kind of
meetings. (Ha ha!) I laughed and said "no,
but these are the kind of questions that the
youth of America want answers to and want things
done about." Not that I'm so youthful, but I
feel youthful. But he's an old 36 himself which
astounded me because I'm 35. It was a pleasant
evening, all in all.

I am leaving today for New York so I'll call
you when I get in. Maybe you could stop over
for a visit or lunch or dinner, or, maybe you
want to go to a movie. I'll be in New York
for, I expect, about a week. Tell Janie all

this and tell her I would love to see her.
I haven't heard from her since Christmas. I
guess we are all a little sloppy about writing.
However, I think we all know what we mean to
each other, don't we. At least I know I love
you kids and I want to be your friend and stay
in touch.

Say Bobsky, what happened about your math test?
I don't know why I took it for granted, but I
always thought you were sort of brilliant in
math. Anyway, I hope that all your mid-term
tests came out very well.

Well, I'll close now, since this letter is get-
ting a little longer than I intended. Golly
I'm sorry about the phone, but you will grow
up before you know it and things like telephones
will be possible and not out of your reach.

I love you and miss you, and, give my love to
Janie.

P.S.
My new address is 12305 Fifth Helena Drive,
Los Angeles 49, California.

Marilyn writes to Bobby Miller on February 2, 1962,
inviting him to visit her new home. She describes her
dinner with Robert Kennedy the previous evening.

Dear Dad,

I am having this letter typewritten because my
handwriting is very poor and hardly legible some-
times. It was good to talk to you the other
evening. I promised I would write, so here I am.
Now, are you sure it is all right if I visit you
at the Sea Isle Hotel in Miami, because I am
really looking forward to seeing you and spending
a very pleasant day and evening with you. The
invitation still stands for April for you to fly
out to visit me. I think you will like my little
house. Even though it is a little house, it has
a big swimming pool. The neighborhood is quiet
and yet it is close to shopping areas.

How have you been feeling, Dad? I hope you're
well and happy, and having a good time in Florida.
Have you heard from Joan and George since they
left for South America? But, I guess I'll get
answers to all these questions when I see you.
In the meantime, I'll call when I arrive in New
York. I am leaving on the plane this afternoon
at five o'clock, and I'll arrive in New York
about midnight tonight.

I got a letter from Bobby just the other day and
I loved hearing from him. He writes a little
more often than Janie, however, I'll probably
hear from her pretty soon.

Where are Sam and Blanche? Are they planning
to see you at all in Florida? Give them my best
the next time you write them or see them. And,
do give my invitation some serious thought because
remember you haven't been west of the Rockies yet
and you ought to just get a look at California,
even if it is just to compare it with Florida.
But, most of all, I would love to have you spend
the time with me.

Last night I attended a dinner in honor of the Attorney-General, Robert Kennedy. He seems rather mature and brilliant for his thirty-six years, but what I liked best about him, besides his Civil Rights program, is he's got such a wonderful sense of humor.

Well, Dad, I'll close now and I'll be calling you as soon as I get to New York to let you know which day to make the reservation at the hotel. I'll sure enjoy seeing you. I guess I'd better bring some clothes for warm weather, isn't that right?

I send all my love and I miss you.

P.S. My new address is 12305 Fifth Helena Drive, Los Angeles 49, California.

Marilyn asks Isidore Miller about his family, checks on their plans to visit Florida, and describes Robert Kennedy in this letter, dated February 2, 1962. Marilyn admires Bobby's stand on civil rights and his sense of humor.

Marilyn —
Are you there?
Am I here?
The leaves in Brooklyn are turning,
The people are burning,
Birds for the south are yearning.
So come home!

Claude

1958

Mister Johnson

WILL DEFINITELY
Strike Back!
(from time to time...)

*Mister Johnson is the young Nigerian protagonist of Joyce
Cary's* Mr. Johnson. *Trying with difficulty to adjust to the
British imperial regime, he winds up committing murder.
Norman Rosten adapted the novel for Broadway. "Claude"
was Marilyn's nickname for Norman because he reminded
her of the actor Claude Rains.*

The leaves are turning
From red to gold,
When you coming home?
We're all getting old.
 T. S. Eliot

Girls may be hollow
But it does not follow
That they are like a boat
Made only to float.

No, no, no!

But I'd much rather see them
Than hope to be them
Hollow or full
Or nylon plus wool.

Twenty-nine
Anytime
But twenty-eight
Is great

come out of your corner

Rosten often signed the nonsense poems
he wrote to Marilyn "T. S. Eliot."

Marilyn dear-
 About the movie- don't jump!
 Look at it this way: it is a completely enjoyable
film, full of fun and YOU.
 It is not a starring vehicle for you because
the story is simply not set up that way- which is
either a shame or a crime, depending on how you
feel. I feel it's a shame you didn't get more to
do, and better lines for what you did do.
 BUT (that necessary word) nothing could really
destroy your wonderful quality xxxxxxxxxxxxxxxxxxxx
that gives the film the one touch of "seriousness"
(humanity) it needs for any sort of balance.
 It will not hurt you one little bit, and let
everyone be more watchful the next time. That is
all and when are you wearing that dress again?

 Philosopher Claude

(Did you get my red rose?)

Marilyn Miller
 444 E. 57 St.
 New York 22

Marilyn dear – old Gemini –
Just a small greeting from a guy
Who likes you from far –
Also from near,
And wishes you cheer
On This day . . .

To be born isn't easy,
And to keep going can drive
 a soul crazy –
But let's us keep to it,
Breathing will do it,
One day we'll all rue it,
Long long ahead (ago?)

A kiss I do send
All The way from This end,
(Hope it comes when its raining
Or when you're complaining).

HAPPY
NAPPY
BIRTHDAY

FROM EVER LOVING ME!

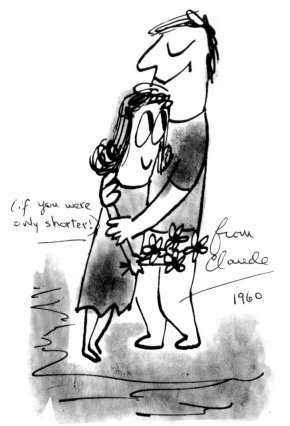

('if you were
only shorter!)

from
Claude
1960

A birthday card and greeting from Norman to
Marilyn. Both were born under the astrological sign
of Gemini. Marilyn often referred to her birth sign,
which supposedly produces individuals split in
personality between rationality and emotionality,
boldness and shyness. The movie referred to in the
letter is Some Like It Hot.

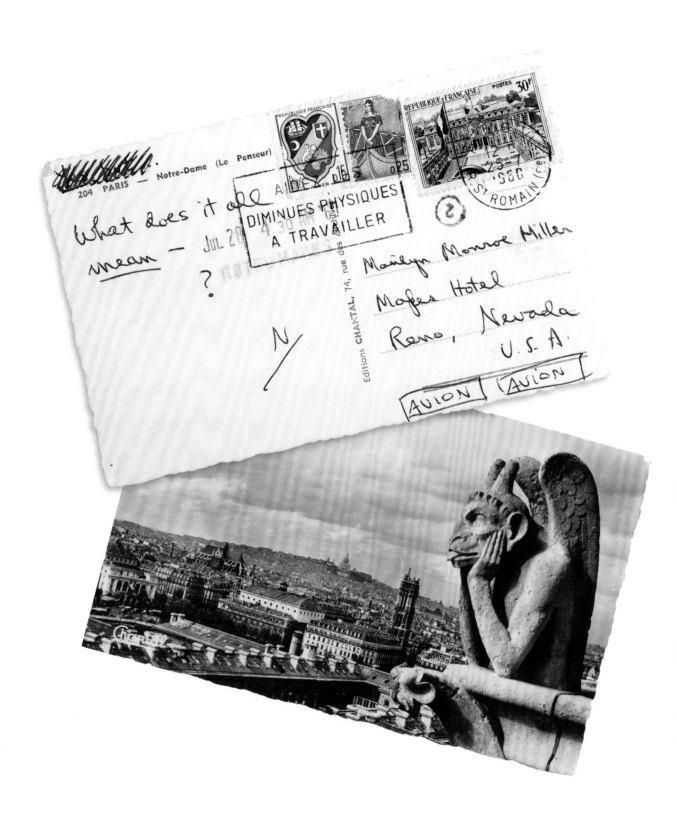

204 PARIS — Notre-Dame (Le Penseur)

What does it all mean —

?

N

Marilyn Monroe Miller
Mapes Hotel
Reno, Nevada
U.S.A.

AVION AVION

DIMINUES PHYSIQUES
A TRAVAILLER

Editions CHANTAL, 74, rue des

*A postcard, featuring a gargoyle on Notre
Dame Cathedral, that Norman sent from
Paris to Marilyn when she was on location
for* The Misfits.

February 10,1961

Marilyn Monroe
444 East 57th Street
New York, N.Y.

Dear Marilyn:

 How are you old girl! Anne and I have been wondering
about you. Do you want to come and stay with us for a while
...we have an extra room. We would have called during the
recent turmoil but didn't know where you were.

 I hope your picture is as great as Jack Hamilton
(LOOK movie editor) wrote and said you were! and that you
make a lot of money, money, money -- I know it must be
important...I hear so much about it.

 PARIS BLUES is finished with shooting. You'll love
it and Joanne is such a wonderful actress. Buy a ticket
to it when it comes out -- U.A. is so cheap I don't think
they'll give out passes. I don't think those squares will
like the picture but thank God you've got round curves
(on your head$) You'll love it even if you buy a ticket.
I insist you do...that's one way of starting a line at
the box office. Hey, that's a stunt we should have done
with your picture.

 Give my regards to anybody you want to. And call us
here just to say hello -- use United Artist's phone or
Paula's. Our number is LITbre 16-80 in Paris. You can
call in the middle of the night...I don't mind.

 There are some great art shows at this moment in Paris.
Come over. An especially big Goya show of his prints.
Marvelous impressionist show etc. and a pip of a
Kandinski.

 Love,

 SAM
 SAM SHAW

Our home address is:

 118 Blvd. Raspail
 Paris 6e, France (not Illinois)

Sam Shaw, in Paris to film Paris Blues,
invites Marilyn to visit him and his wife.
His mention of "recent turmoil" refers to
her divorce and breakdown in late January.

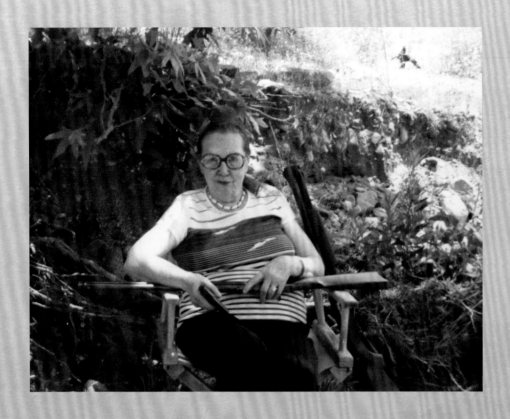

INEZ MELSON SERVED MARILYN FAITHFULLY FOR many years, taking care of her finances, overseeing her mother's care, and writing letters to Marilyn about Gladys's condition.

Gladys often functioned normally, although she often was argumentative or completely silent. When confronted with a crisis, however, she became irrational. In 1935, when she first was declared "insane," she was committed to Norwalk State Hospital, a mental institution near Los Angeles. When she tried to run away a year later, she was sent to Agnews State Hospital near San Jose, California, where she remained for nine years. After her release in 1945, she reappeared in Los Angeles and lived with Aunt Ana and Marilyn for several months, but they didn't get along. Gladys was alternately sullen and quarrelsome, and she didn't like her daughter's status as a sex symbol. Gladys suddenly left, going off on her own again.

For the next eight years Gladys supported herself as a housekeeper and sometime nurse, living in Los Angeles, Oregon, and northern California. In 1949 she married an electrician named John Eley. He tried to blackmail Marilyn, until a private detective that Johnny Hyde found for her discovered that he had another wife. Gladys divorced him. It was another tragedy for her.

Marilyn had always told the press that her mother was dead. In the spring of 1952, a reporter discovered Gladys working in a nursing home in Eagle Rock, potential fodder for another scandal, but Marilyn's fans didn't seem to mind. In fact, they were sympathetic to Gladys, and Marilyn paid for a train ticket for her to go to Florida to live with Berniece Miracle, Gladys's daughter by her first husband. By the end of the year, Gladys turned up on Grace Goddard's doorstep, in the midst of

another severe breakdown. Marilyn and Grace found a private sanitarium, Rockhaven, near Glendale, that would take her as a patient. It was a comfortable and caring place. Gladys lived there for fifteen years, until she moved to Florida to be with her daughter Berniece.

In her early years at Rockhaven, Gladys wrote irrational letters to senators and the president, pleading with them to secure her release. Part of her mental syndrome was her determination to be on her own or at least housed in a Christian Science facility. Inez tried to find one for her, but none would take her. On several occasions, Gladys put razor blades in letters. The head of the sanitarium took the letters out of the post and gave them to Inez. When Marilyn came to see her, Gladys harangued her about her faults. Marilyn stopped visiting her, and Inez assumed her role in Gladys's life.

Despite whatever stability Gladys had achieved by her middle years at Rockhaven, she eventually became unstable again. She attempted suicide in 1966, and was sent to Camarillo State Hospital, which was better equipped than Rockhaven to handle serious mental disorders. Inez, however, had endured enough. She petitioned the Superior Court of the State of California to be discharged as Gladys's conservator. Her request was granted on December 19, 1966.[19] Berniece now intervened to bring Gladys to live with her in Gainesville, Florida. She put Gladys in an assisted living facility, where Gladys lived until her death on March 11, 1984.

Inez and Ruth Conroy, her sister-in-law, were close friends, and Inez gave her access to Marilyn's file cabinets and possessions. Before Inez sent the Norman Norell sequined dress to Lee Strasberg, Ruth wore it. Ruth copied a number of the letters and documents in the file cabinet on pink paper, hoping to publish the fruits of her labors. That never happened, but Ruth's mimeographed collection was among Mill Conroy's possessions. Some of the documents and letters that Mark Anderson photographed for *MM—Personal* are from that collection, recognizable by their pink hue.

Official notice from Loyd Wright Jr. that Inez has been hired as Marilyn's business manager.

WRIGHT, WRIGHT, GREEN and WRIGHT

SUITE 1125 ONE ELEVEN WEST SEVENTH BUILDING

LOS ANGELES 14

MAdison 6-1291

BEVERLY HILLS OFFICE
120 EL CAMINO DRIVE
BRADSHAW 2-3494

November 2, 1953

PLEASE ADDRESS REPLY TO
LOS ANGELES OFFICE

Mrs. Inez Melson
9128 Sunset Boulevard
Los Angeles 46, California

 Re: Marilyn Monroe

Dear Inez:

 I am enclosing (a) a check payable to
Marilyn Monroe in the amount of $979.75; (b) an
itemization of our disbursements on her behalf,
totaling $11,220.25, and (c) receipted bills, etc.,
which we have paid.

 This check is being delivered pursuant
to Miss Monroe's instructions of Friday afternoon.
She is delighted that you are going to undertake
to represent her as her business manager; and we
are too, knowing that you will do her a very com-
petent service.

 Cordially,

 Loyd

 Loyd Wright, Jr.

LWjr:eah
Enclosures
Special Delivery

P.S. Here, too, is a bill which has not been paid.

CRestview 6-1129

INEZ C. MELSON

BUSINESS MANAGEMENT
INSURANCE

9110 SUNSET BOULEVARD
LOS ANGELES 46, CALIFORNIA

September 18, 1958

Dear Marilyn:

First off, let me say that I am sorry that you have been
"under the weather" and hope that you are your old self
again. I did not try to reach you at the hospital since
I felt that you were there for a rest as much as anything
and certainly it isn't restful to have people telephoning.

In the morning mail, I received the enclosed money order
from Florence as a partial payment on the loan. Poor
Florence is really having a difficult time and is such a
conscientious person about her obligations. I suppose
she sent the payment to me so that I would know that she
was trying to get it paid off.

Now, about "Butch" and Clyde. I am beginning to think
thatperhaps "Clyde" should be "Claudia". I am almost cer-
tain that it is a little hen. She is a very nervous
bird and isn't taming as quickly as Butch. However, she
is much tamer than she was. I was beginning to think that
she might have been frightened because she was so wild and
unapproachable. She is a long way from being finger tame
but is much better than she was. Both birds are so absolutely
darling.

Pat loves them and Butch is fond of Pat. Will do much more
for him than for me. We let each of them come out each day
for a stay on the play pen and they love it. Butch will
ride all the way out on Pat's finger and then fly over to the
play-pen. Clyde won't ride out but once he is out, he will
step on a stick. A few evenings back, they were all on the
play pen, Josie, Bobo, Butch and Clyde. Josie came up and
hopped over on my shoulder. Clyde followed her and after watching
for a minute or two, very gingerly put one foot on my shoulder -
took it off and scurried away like a tiger was after her.
Bobo gets after Clyde. In fact, Bobo taught her to walk up the
ladder. She would go a few steps up, look back at Clyde, chirp
at her and presently, Clyde trotted up the ladder after her.
Your children are going to love the birds and have lots of
fun with them.

Please take good care of yourself. Pat joins me in sending
both you and Arthur much affection.

Sincerely,

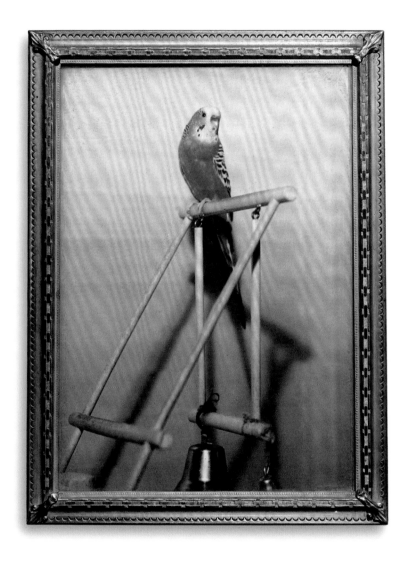

Inez, who is training Butch and Bobo, describes their behavior to Marilyn. Pat is Inez's husband.

This photo may be of Bobo or Butch— or of one of Inez Melson's parakeets.

CRestview 6-1129

INEZ C. MELSON

BUSINESS MANAGEMENT
INSURANCE

9110 SUNSET BOULEVARD
LOS ANGELES 46, CALIFORNIA

June 24, 1957

Dear Mr. Miller:

Thank you very much for your letter with check enclosure of
$858.65. However, the amount I had advanced out of pocket
was $258.65. The extra $600.00 will take care of the June
and July payments , excluding any incidental expenses. I
will notify you of these sums as they occur.

Anything you suggest is certainly agreeable to me. I hope
always to have the privilege of doing this slight service
for Marilyn. I know that I am a sentimental idiot but I
feel that this keeps me in some contact with her and I
should be most unhappy to lose this contact. Marilyn knows
that my feeling for her is that of a mother for a darling
child. To me, she is not a famous personality but just
someone for whom I developed a real fondness from the first
day of our meeting.

I appreciated your letter so much for I know that you are
a busy man and have much on your mind. I earnetly pray
that your trouble will resolve itself not only because I
do not think anything will be gained by subjecting you to
such an indignity but I cannot bear to have another sorrow
come into Marilyn's life. She needs so much love and
affection and I am certain she has found it in her marriage
to you.

I am looking forward to the local release of her new pic-
ture. I am so happy that it has received such wonderful
reviews. Please give her my very special regards and tell
her that Pat (my husband) also sends her a special "hello".

Thank you again for your letter .

Most sincerely,

Inez C Melson

Mr. Arther Miller
444 East 57th Street
New York City.

*Inez writes Arthur Miller on June 24, 1957, telling him that her
feelings for Marilyn are like a mother's for a darling child. She
hopes that his troubles, with the House Un-American Activities
Committee, will end. "She needs so much love and affection and
I am certain she has found it in her marriage to you."*

MARILYN MONROE

December 22, 1960

Dear Inez,

Happy Holiday to
you and Pat —
I'll be in touch
again soon, Love,

Marilyn

Mrs. Inez Melson

Dear Inez,

Thanks for your sweet
letters to both of us. Its a
wonderful thing to know I have
a real friend - not only I
thank you for your kindness
but my husband does too.

I wish there were some
way I could tell Emmy Lou
what a wonderful mother she
has.

There aren't words to express
what you have done for my mother.
I called my half sister yester-
-day and she will get in touch
with you. she was so pleased

to know that someone like
you were looking after her.
I don't expect to be in
California until early summer
when they plan shooting the
"Blue Angel".

Give my warmest regards
to your husband Pat and
I hope he is feeling well.
How is your new bird?
I'll see him sometime.
I do miss you and
think of you even though I
don't write.
My husband sends his
best and I send my love,

Marilyn

P.S.
If you ever see Madame Renna or Dr. Campbell
Please give them my best.

CONFIDENTIAL

Marilyn

A GLIMPSE INTO HOLLYWOOD'S
PAST THROUGH RARE PERSONAL
DOCUMENTS, LETTERS, BILLS,
CORRESPONDENCE, AND COLLEC-
TOR'S MEMORABILIA

(opposite) Ruth wearing Marilyn's green sequined Norman Norell dress. This photo was taken before Inez sent the dress to Lee Strasberg.

(above) The cover from the mimeographed manuscript assembled by Ruth Conroy.

1. Because she had trouble on last nursing job, led her to go and get a ballot on Socialism and study it —

2. She was sent to State Hospital because years ago she voted on a Socialist Ballot at Hawthorn and was being punished for doing so.

3. She is confused now because once she took an aspirin when she lived with Stewart.

4. No one should listen to Radio Broadcasts because the people who are behind them are all drunkards and every one on the Radio are drunk when they go on the air.

5. Thinks she can vote on both Republican and Democratic ballots.

6. She is being punished because years ago she took a drink of liquor (during prohibition) and should have been sent to jail.

7. Sleeps with her head at the foot of bed so as not to look at Marilyn's picture — they disturb her.

8. Never needed to be sent to nowhere or anywhere as she had her nervous break down after being next to Agnew —

9. Blames her confused condition on Unions.

10. After listening to political speech, said she was needed in Russia to help them.

11. Wishes she never had had a sexual experience so she could be more Christ like.

(over)

(I wrote these things down as Gladys said them while she was staying with me) Grace Goddard.

12 - In the past year or so has developed an
aversion for meat or fish. Wont even eat
[...] [...] [...] Pat Wills knows it,
She doesn't think it all necessary for health
to eat meat substitutes. When alone eats
bread, potatoes and spaghetti at the same meal.
Sometimes a vegetable salad.

13 She has a fear of Catholics. Every time she
attends Christian Science Church, instead of
listening to the Readers, she spends her time
mentally protecting herself from the thought
that a Catholic or some one of another (than) (C.S.)
Protestant Denomination, who might be in
the Congregation trying to harm her.

14. She thinks she was a Nurse working for the Govt.
while in Agnew, and thinks she should apply to
the Government for a job in the Army to be sent
over seas.

15 Misplaces or losing her glasses, watch, gloves or
other possessions and either accuses some one of stealing
them, or are to blame for her losing them.

Grace documents Gladys's psychotic behavior, probably around 1952, before she and Marilyn placed Gladys in Rockhaven. Gladys wishes that she had never engaged in sexual intercourse, so that she could be more Christlike, and she sleeps with her head at the foot of the bed so that she doesn't have to look at Marilyn's pictures.

INEZ C. MELSON

BUSINESS MANAGEMENT
INSURANCE

CRestview 6-1129

9110 SUNSET BOULEVARD
LOS ANGELES 46, CALIFORNIA

December 5, 1957

Dear Marilyn:

I was so pleased to have a letter from you. You are such
a dear and you know how dear you are to me. I am all too
aware that you represent a "daughter image" to me and I
think the Lord has been very good to me in bringing you
into my life to love. There is so very little I can do to
show that affection - thus it gives me a warm feeling to
be able to do little things for your mother.

The sanitarium had a bazaar on November 24 so Pat and I
went out . The ladies had made many attractive items in the
occupational therapy class andyou will be pleased to know
that among the prettiest were table mats which your mother
had made on the big loom. In fact, she is the only one who
used the loom. I was only able to get four of the mats
but I am sending them to you since I know you would like
them and can use them when having informal dinner with your
husband and family. She has a small rug set up on the loom
now and I told Miss Traviss if she would like it for her
room, I would send the money to pay for the material.

Refreshments were served in the garden and your mother
presided over the coffee urn. She had also arranged all
the cookies and sandwiches on the trays . For her to do
this and to stay in the garden all afternoon is just the
most wonderful indication of improvement. A cute old
black cat called "Bobby" was walking around and kept wind-
ing around her feet like kittens will do so she said to
me " he is a nice animal and very friendly". Oh yes --
one of the other things made by her was a wreath of candy.
It was interesting to me because she had copied it from
one which I sent to her last year at Christmas. Mine was
made of various Christmas candies wrapped in different
colors of cellophane and she had used striped peppermint
candies and had followed the pattern exactly.

I am shopping to replenish her wearing apparel. It all
wears out at once since it is all bought at once. So I
getting slips, vests, pants (she likes separate vests)
gowns, hose, sweaters and shoes. I am also going to get
a raincoat and drizzle boots since she will now walk around
in the garden and will go for a ride now and then with
Miss Traviss. Incidentally, I would like to give Miss

Traviss a "Gift Certificate" at Christmas for she is a
lovely lady (young) and very sweet and kind. I am also
looking for some white nylon dresses since these are the
only kind your mother likes. However, she did get dressed
up for the bazaar. Since Christmas is so close, I am
going to make a lot of pretty packages containig the
various items of clothing and it will be fun to do so.

I spoke to Madame Renna and she was so pleased to have
your remembrances. Both she and Dr. Campbell are well and
keeping busy. Both hope to see you when you come out.

My Pat hasn't been too well lately but he is too sweet to
do much complaining. However, he sees the doctor regular-
ly and obeys his instructions and thus keeps going. He
enjoyed the visit to the bazaar and bought himself a couple
of belts which the ladies had made of leather links. Pat
is a great visitor and enjoys chatting with the people and
everyone loves him. My little bird, "Josie" is so cute.
Doesn't say a word but plays with her toys and flies to me
when I come home from work and all in all is a great pleasure.
I do most sincerely hope that your time will permit you
to spend a little time with us when you come out this summer.

One of my nephews (the only child of my sister who lives in
Seattle) is now stationed at Fort Holabird in Maryland at
the Army Intelligence Center. Shortly after he arrived,
he made a trip to New York. His mother sent me a copy of
the letter he wrote to her and I thought you might get a
kick out of reading it since you have become a New Yorker.
He graduated from the University of Washington in June and
then enlisted in the reserves and after basic training at
Fort Ord was assigned to Holabird to become a Counter
Intelligence Analyst (whatever that may be). He is a very
nice boy - 22 years old - and should you ever be down that
way, he would be thrilled to death to hear from you.

Pat joins me in sending you much, much love and sincere
regards to your husband. Keep well and happy and have a
wonderful Holiday Season.

 Affectionately,

 Inez

Christian Science Nursing
107 Falmouth St.;
Boston, [Massachu]setts, 02115.
Massac[husetts]

Room 318

FITS PERFECTLY
LIKE A
HUMAN HAIRNET

No. 158

NYLO[N]

Jac-o-n[et]

WITH
HIDE-AWAY ELASTIC IN

NO VISIBLE EDG[E]
NO ELASTIC
IN FRONT

U. S. PATENT NO. 2,346,796
TRADE MARK REGISTERED

Mrs Gladys, Baker (Clay)

Dear Ones;
These poor dears are driving me
crazy with artistic minds they
to get away from what was not
done toward me in the free world
when I was growing in Christianity
God is no mystery to those who
know & love Him

(opposite) Gladys sometimes placed razor blades
in letters. The hairnets in this holder were used
by Gladys when she imagined herself a Christian
Science nurse, in order to keep her hair in place,
as many nurses did.

(above) Gladys Baker Eley.

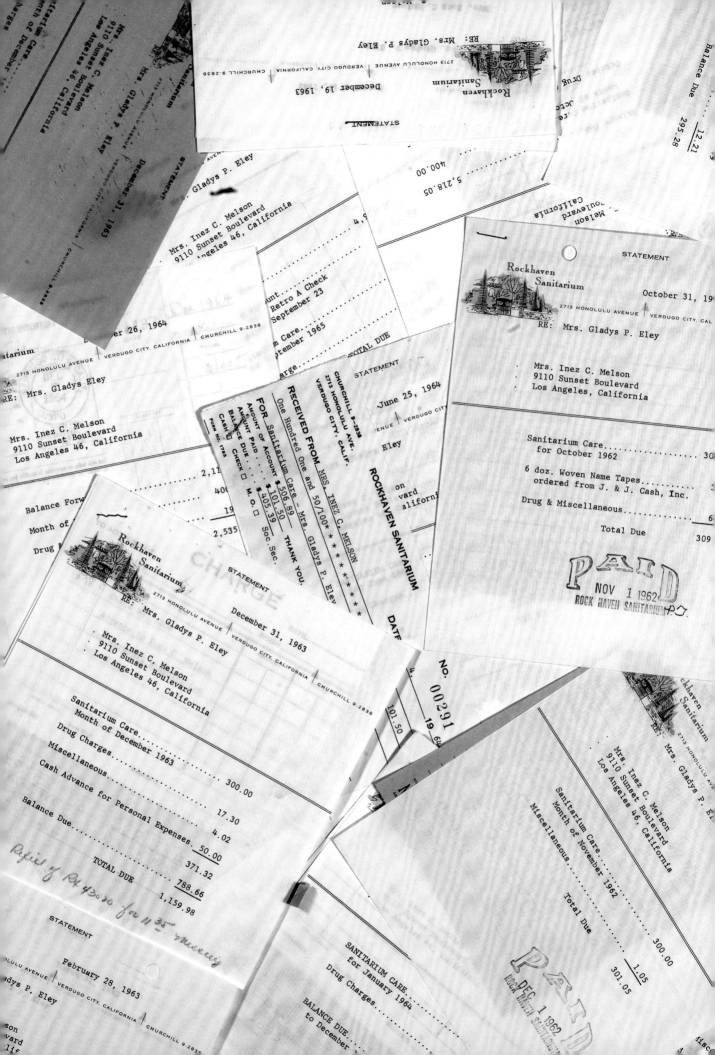

Rockhaven Sanitarium
2713 HONOLULU AVENUE · VERDUGO CITY, CALIFORNIA · CHURCHILL 9-2838

STATEMENT

December 19, 1963

RE: Mrs. Gladys P. Eley

Balance Due 12.21
295.28

400.00
5,218.05

Mrs. Inez C. Melson
9110 Sunset Boulevard
Los Angeles 46, California

Gladys P. Eley

Mrs. Inez C. Melson
9110 Sunset Boulevard
Angeles 46, California

4,9

Rockhaven
Sanitarium
2713 HONOLULU AVENUE · VERDUGO CITY, CAL

STATEMENT

October 31, 19

RE: Mrs. Gladys P. Eley

Mrs. Inez C. Melson
9110 Sunset Boulevard
Los Angeles, California

Sanitarium Care.................. 30
for October 1962

6 doz. Woven Name Tapes..........
ordered from J. & J. Cash, Inc.

Drug & Miscellaneous.............. 6

Total Due 309

PAID
NOV 1 1962
ROCK HAVEN SANITARIUM

December 26, 1964

arium
2713 HONOLULU AVENUE · VERDUGO CITY, CALIFORNIA · CHURCHILL 9-2838

RE:

Mrs. Inez C. Melson
9110 Sunset Boulevard
Los Angeles 46, California

2,11
400
19
2,535

Balance Forw
Month of
Drug &

Retro A Check
September 23
m Care
ptember 1965

Charge TOTAL DUE

STATEMENT

June 25, 1964

NUE · VERDUGO CITY

Eley

on
vard
alifornia

CHURCHILL 9-2838
2713 HONOLULU AVE.
VERDUGO CITY, CALIF.

RECEIVED FROM Mrs. Gladys P. Eley
Mrs. INEZ C. MELSON

FOR Sanitarium Care — Mrs. Gladys P. Eley
One Hundred One and 50/100* * * * * * * * — THANK YOU.

AMOUNT OF ACCOUNT $ 506.89
AMOUNT PAID $ 101.50
BALANCE DUE $ 405.39
CASH □ CHECK □ M. O. □ Soc. Sec.

CASH NO. 1795

ROCKHAVEN SANITARIUM

DATE

Rockhaven
Sanitarium
2713 HONOLULU AVENUE · VERDUGO CITY, CALIFORNIA · CHURCHILL 9-2838

CHARGE

STATEMENT

December 31, 1963

RE: Mrs. Gladys P. Eley

Mrs. Inez C. Melson
9110 Sunset Boulevard
Los Angeles 46, California

Sanitarium Care.................
Month of December 1963

Drug Charges.................. 300.00

Miscellaneous................. 17.30

Cash Advance for Personal Expenses. 4.02
50.00

Balance Due.................. 371.32

TOTAL DUE 788.66
1,159.98

Refill of Rx 43000 for 11.35 quarterly

STATEMENT

February 28, 1963

ULULU AVENUE · VERDUGO CITY, CALIFORNIA · CHURCHILL 9-2838
dys P. Eley

NO. 00291
19 6
101.50

haven
Sanitarium
2713 HONOLULU AV

RE: Mrs. Gladys P. El

Mrs. Inez C. Melson
9110 Sunset Boulevard
Los Angeles 46, California

Sanitarium Care.............
Month of November 1962

Miscellaneous.............. 300.00

Total Due 1.05
301.05

PAID
DEC 1 1962
ROCK HAVEN SANITARIUM

SANITARIUM CARE
for January 1964

Drug Charges..............

BALANCE DUE...............
to December

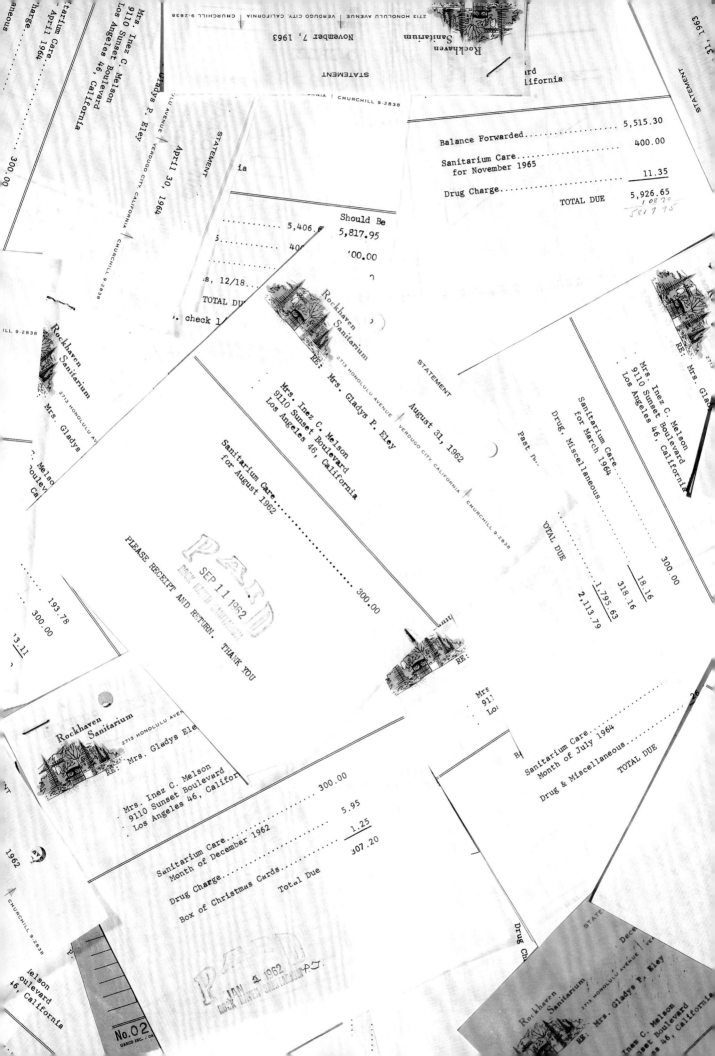

Mrs. Inez C. Melson
9110 Sunset Boulevard
Los Angeles 46, California

April 30, 1964

Mrs. Gladys P. Eley

Rockhaven Sanitarium
2713 HONOLULU AVENUE | VERDUGO CITY, CALIFORNIA | CHURCHILL 9-2838

November 7, 1963

STATEMENT

Balance Forwarded 5,515.30

Sanitarium Care 400.00
for November 1965

Drug Charge 11.35

TOTAL DUE 5,926.65

Should Be
5,817.95

5,406.

400.

s, 12/18.

TOTAL DUE

check 1

Rockhaven Sanitarium
2713 HONOLULU AVENUE

RE: Mrs. Gladys P. Eley

Mrs. Inez C. Melson
9110 Sunset Boulevard
Los Angeles 46, California

STATEMENT

August 31, 1962

VERDUGO CITY CALIFORNIA | CHURCHILL 9-2838

Past Du

Sanitarium Care
for March 1964

Drug, Miscellaneous

TOTAL DUE

18.16
318.16
1,795.63
2,113.79

300.00

Mrs. Inez C. Melson
9110 Sunset Boulevard
Los Angeles 46, California

RE: Mrs. Gla

Sanitarium Care 300.00
for August 1962

PAID
SEP 11 1962
ROCK HAVEN SANITARIUM

PLEASE RECEIPT AND RETURN. THANK YOU

193.78
300.00
3.11

Rockhaven Sanitarium
2713 HONOLULU AVE.

RE: Mrs. Gladys Ele

Mrs. Inez C. Melson
9110 Sunset Boulevard
Los Angeles 46, Califor

Sanitarium Care 300.00
Month of December 1962

Drug Charge 5.95

Box of Christmas Cards 1.25

Total Due 307.20

PAID
JAN 2 1962
ROCK HAVEN SANITARIUM PJ

No. 02
UARCO INC.

elson
oulevard
6, California

Sanitarium Care
Month of July 1964

Drug & Miscellaneous

TOTAL DUE

Rockhaven Sanitarium
RE: Mrs. Gladys P. Eley

Mrs. Inez C. Melson
 set Boulevard
les 46, California

MARILYN LOVED DOM PÉRIGNON CHAMPAGNE and Chanel No. 5, but her first charge account after she came to Hollywood was at a bookstore, not a department store or a liquor store. Her mentors during her early career—Fred Karger, Natasha Lytess, Johnny Hyde—were literate and well-read, and as her friends in New York did later, they encouraged her to read and study to expand her cultural literacy.

Marilyn also treasured the stamp collection Aunt Ana gave her one Christmas during World War II. She especially liked stamps with Abraham Lincoln on them, since Lincoln was one of her heroes. Her friends saved Lincoln stamps for her—a letter from Norman Rosten encloses a newly issued Lincoln stamp.

Marilyn's relationship to jewelry, however, was ambivalent. Unlike Elizabeth Taylor, who liked expensive jewelry and put together an admired collection, Marilyn staked a claim to being a working-class girl and used her indifference toward jewelry to prove to the press that she wasn't materialistic. Following the fashion in evening wear set by Rita Hayworth in the 1940s, she often wore a tight gown of satin or sequins, usually low-cut or strapless, with her chest area bare to set off her face. The dangling diamond or rhinestone earrings that she wore with those dresses also drew attention to her face, while a diamond bracelet on her wrist picked up the sparkle of the glittery earrings. Marilyn occasionally wore a pearl necklace or a pin of pearls or rhinestones; the glow of pearls around the neck softens the look of the skin. Moreover, costume jewelry was popular in the 1950s, and high-end designers created such jewelry for the well-to-do.

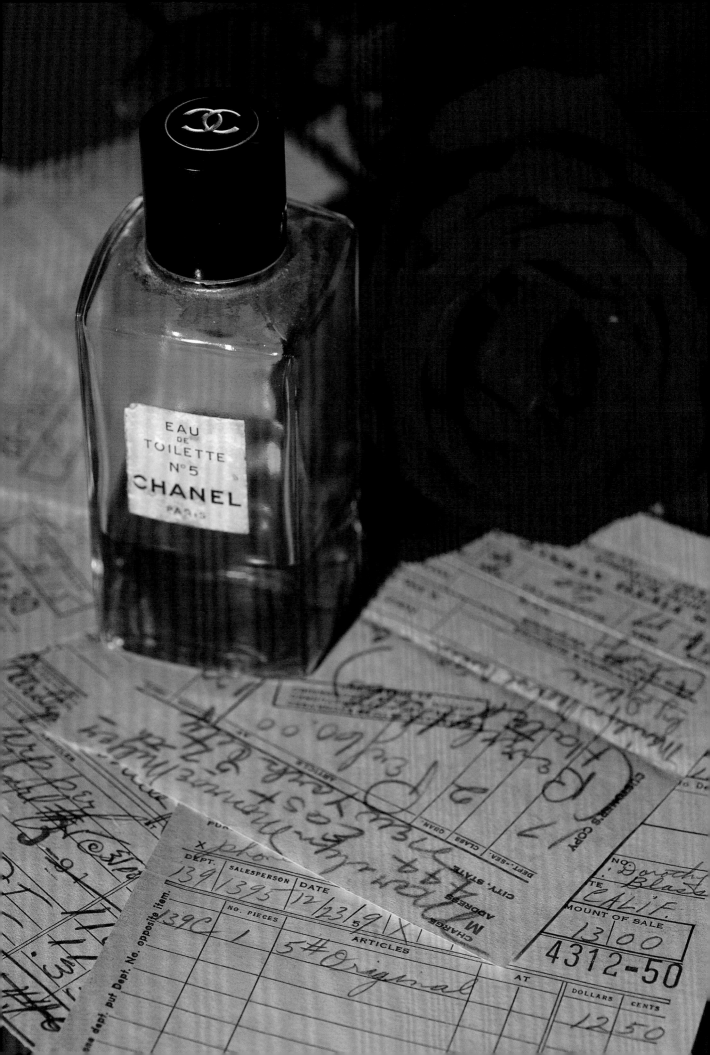

Marilyn could be absentminded and spendthrift, as her first agent, Harry Lipton, described her. Because Marilyn often spent more money than she had, he put her on an allowance, using the rest of her salary to pay off her creditors. One Christmas he discovered that she had charmed the manager of a department store into opening a charge account so she could buy expensive bottles of cologne as gifts for her friends. When he chided her about it, she smiled and said, "How did you like the bottle of cologne that I sent you?" Moreover, Marilyn easily lost things. Hollywood actor John Carroll, Lucille Ryman's husband who may have been Marilyn's lover at some point, gave her an expensive sapphire ring, which she soon lost. When she told Lipton about it, she was crying, "not because she had lost the ring, but because by losing it she had hurt the feelings of the man who gave it to her." But she didn't lose the one piece of jewelry that Lipton gave her. That she still had it, Lipton quipped, "is probably due to the fact that it is difficult to lose a gold anklet."[20]

The following section includes a photo of the DiMaggio jewelry case and some of the jewelry in it that might have been Marilyn's. It also includes photos of items that Marilyn may have brought back from Korea as gifts for Inez or may have given to Inez on other occasions, as well as several fur coats that Inez may have taken from the Brentwood house after Marilyn's death. Both the jewelry and the coats are upscale, but, as previously noted, there is no definitive proof that Marilyn owned them, only reasonable assumption and speculation.

This bottle of Chanel No. 5 from the 1950s may have been in Marilyn's bedroom the night she died.

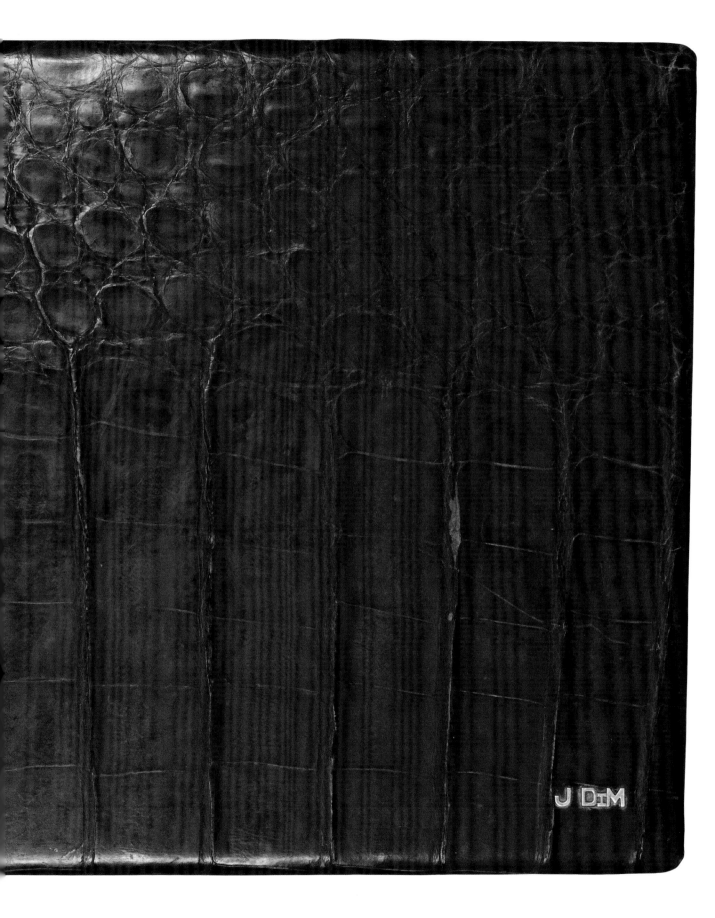

The side of the DiMaggio men's jewelry case, with the initials J DiM embossed on it in gold letters. The case is made of burgundy leather stamped as alligator. It has a tan suede interior, with a removable tan suede divided tray inside.

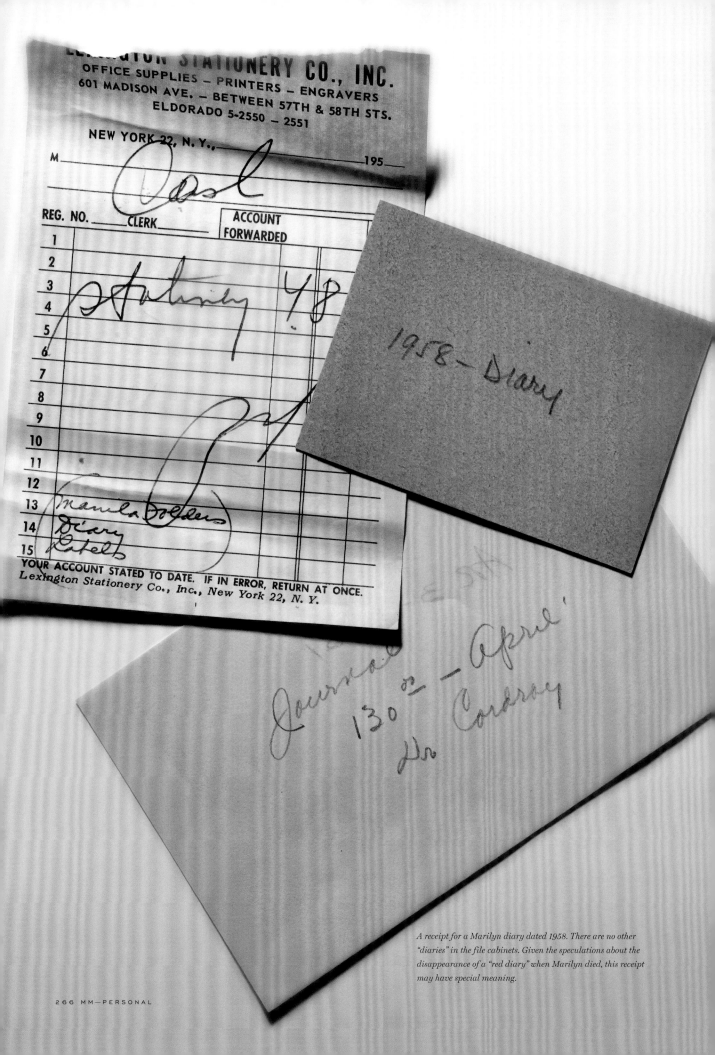

LEXINGTON STATIONERY CO., INC.
OFFICE SUPPLIES — PRINTERS — ENGRAVERS
601 MADISON AVE. — BETWEEN 57TH & 58TH STS.
ELDORADO 5-2550 — 2551

NEW YORK 22, N. Y., _____ 195___

M _____

REG. NO.	CLERK		ACCOUNT FORWARDED	
1				
2				
3	Stationery		48	
4				
5				
6				
7				
8				
9				
10				
11				
12				
13	Marilyn Miller			
14	Diary			
15	dated			

YOUR ACCOUNT STATED TO DATE. IF IN ERROR, RETURN AT ONCE.
Lexington Stationery Co., Inc., New York 22, N. Y.

1958 – Diary

Journal
130 00 – April
Dr. Corduroy

A receipt for a Marilyn diary dated 1958. There are no other "diaries" in the file cabinets. Given the speculations about the disappearance of a "red diary" when Marilyn died, this receipt may have special meaning.

MARILYN MONROE

Aunt Ana bought this stamp collection from the post office during World War II as a Christmas present for Norma Jeane.

GOULD
FOR
PAPER

REINHOLD GOULD·INC.

535 FIFTH AVENUE, NEW YORK VANDERBILT 6-2100
MU 7

IRVING S. KLEIN
CASHIER

Marilyn dear—
 This is the paper company.
 If Markel faints, don't let
him lay there — pick the man up!

 Normalyn

Marilyn later came to love Lincoln stamps. At the bottom of a note to Marilyn, Norman Rosten refers to Marilyn's appreciation of them. (He signs himself "Normalyn," a pun on Marilyn, Norma, and Norman.) "Markel" is a reference to Lester Markel.

Did you see this new Lincoln stamp?
(since you're a fan of the dear dead lad)

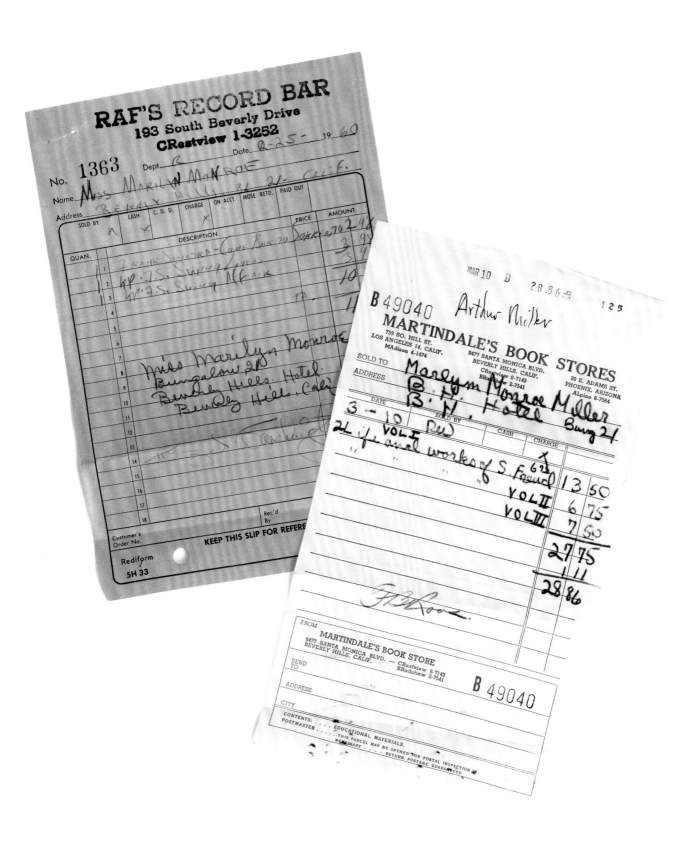

Marilyn loved to listen to Frank Sinatra records. Filled with
pain and longing, and having both masculine and feminine
qualities, Frank's singing expressed the anxieties and
exuberance at the heart of the American experience.

When asked by journalists what her religion
was, Marilyn replied, "Freud." She began reading
Freud's works during her early years in Hollywood.

Darling, I have just brought.
Your birthday present
a Diamond Bracelet. It beautiful
about 200 carats. I hope you
will like it. I want you
to be happy above everything else
in the world.
 Always and always
 Henry.

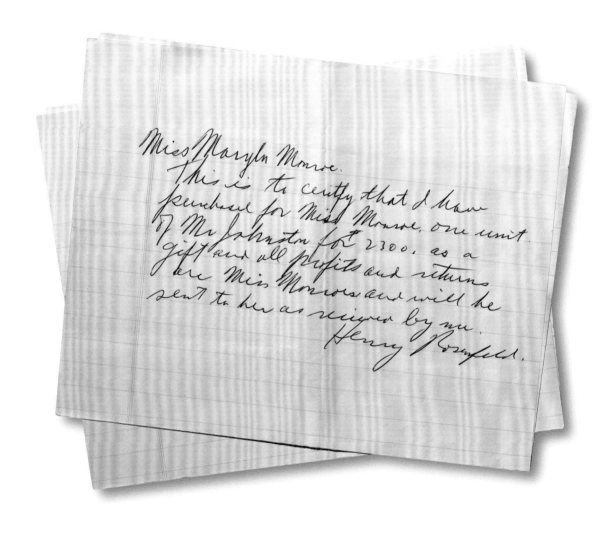

Miss Marylyn Monroe.

This is to certify that I have
purchase for Miss Monroe, one unit
of Mr Johnston for $ 2300, as a
gift and all profits and returns
are Miss Monroes and will be
sent to her as received by me.
Henry Rosenfeld.

Henry Rosenfeld was one of New York's largest producers of inexpensive and mid-range women's clothing. His goal was "to make expensive clothes at inexpensive prices."[21] He was called the "Christian Dior of the Bronx." Marilyn met him in New York during her tour for Love Happy in the summer of 1949.

According to Norman Rosten, Henry asked Marilyn to marry him, but she turned him down. They remained friends. Patricia Rosten remembered her mother and Marilyn returning from shopping in New York loaded with clothing from Rosenfeld's factory.[22]

In these notes, Henry informs Marilyn that he has bought a diamond bracelet for her and a unit in the production financial arrangement for Rosten's Broadway adaptation of Joyce Cary's Mr. Johnson.

(opposite) A gold-tone metal starburst brooch with thirty-five rhinestones and earrings to match.
(above) A high-end Bakelite purse from the 1950s, when such purses were popular.

(following spread, left) An ornate foliate brooch of gold-tone metal set with sixty-nine faux-diamond, clear-cut round stones and signed "483/60 Boucher 7704." It is from the well-known jewelry designer and maker Marcel Boucher and dates from 1955 to 1958.
(following spread, right) A strand of sixty-nine pearls.

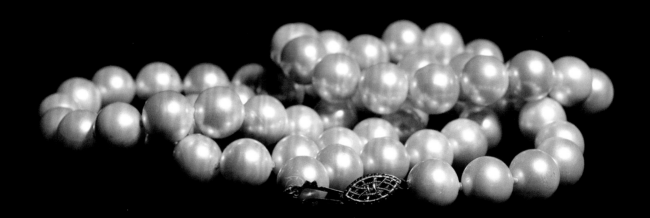

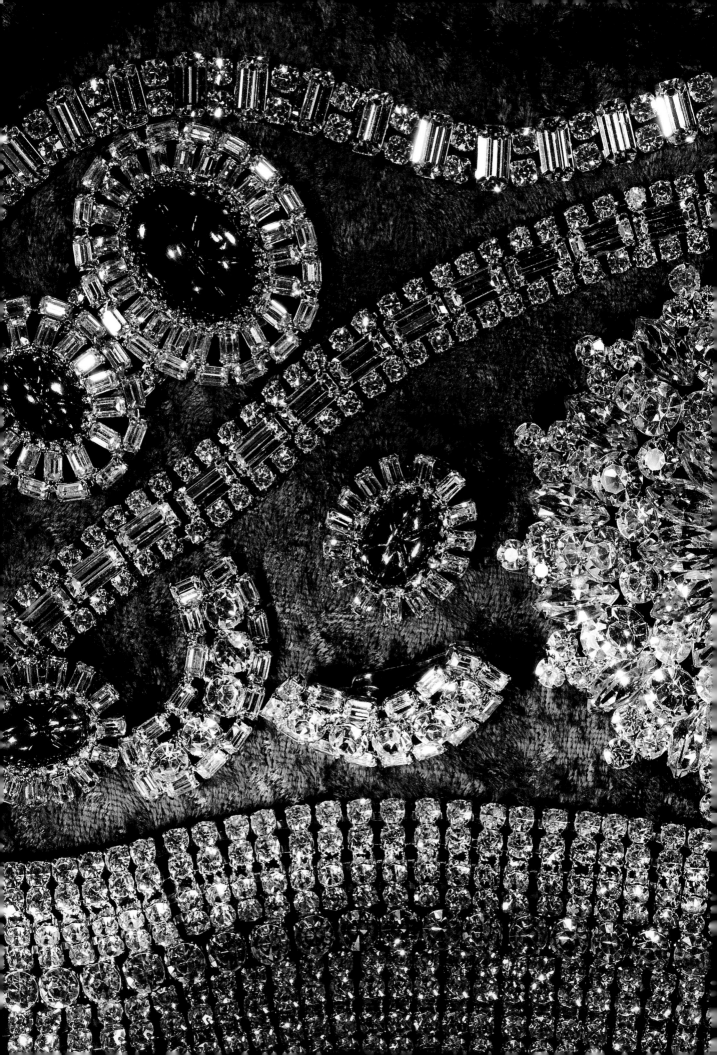

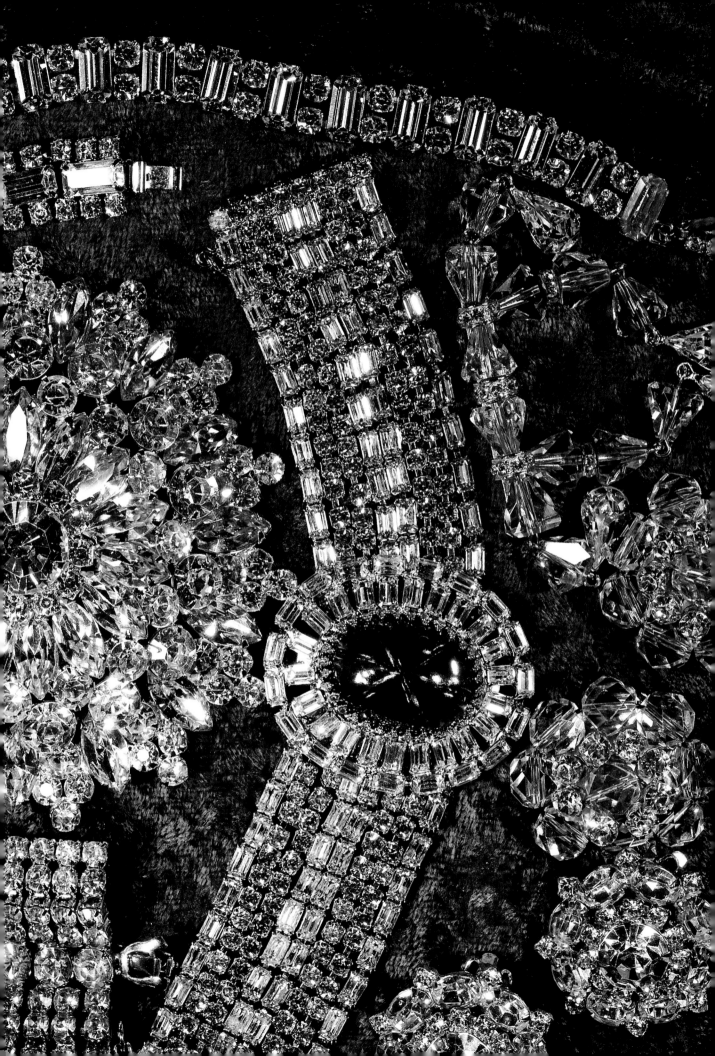

(previous spread) Rhinestone jewelry from the
famous Hobé jewelry company. Hobé jewelry
was popular among Hollywood stars in the
1950s and 1960s.

(above) A black mink coat from the 1950s.
Inez presumably took this coat from Marilyn's
Brentwood home or received it as a gift.

*Black fans are a popular souvenir for tourists to
Japan, and in 2008 a similar fan was auctioned
by Bonham and Butterfields as an item that
Marilyn had bought there.*

Did John Huston give these dice to Marilyn when
she played the gaming tables with him in Reno one
night during the filming of The Misfits?

Jade is another favorite souvenir from Japan,
and this is a strand of seventy-two nephrite jade
beads, with a gold-tone metal floral clasp.

...a Gallery

MODERN PAINTINGS
441 NORTH BEDFORD DRIVE • CRestview 6-1977
BEVERLY HILLS, CALIFORNIA

May 9, 1962

Miss Marilyn Monroe
12305 Fifth Helena Drive
Los Angeles 49

Dear Miss Monroe:

Enclosed are the invoice for your Rodin and Poucette
purchases, and a catalog of the Rodin exhibit held here
last year.

Also, I am including the certificate of authenticity from
the Rodin Museum. You will notice that in it, this piece
is entitled "L'Emprise" which means "The Embrace." It is
also known as "Le Péché."

Lastly, I am sending a catalog of the Braque show, which
will open Sunday, May 13. I do hope you can come to see it,
as there will be many exciting items on view.

I regret that it was not possible to be here when you came,
and look forward to meeting you.

Thank you again.

Yours very truly,

Edgardo Acosta
Edgardo Acosta

P.S. Although there are 12 examples of this b...
is No. 5), you have unquestionably...
in America. Please remind me t...

On May 5, 1962, Marilyn bought two pieces of art at a Beverly Hills gallery: a bronze, numbered copy of Rodin's sculpture The Embrace and La Toureau (The Bull), an oil painting by the Parisian artist Poucette. Each piece seems to reflect her excitement over new romantic involvements and her anger over betrayal by men. Norman Rosten was with her when she bought them. Speaking of the Rodin sculpture of a man and woman in an embrace, Marilyn told Rosten, "He's hurting her, but he wants to love her, too." In the Poucette painting, the phallic bull in the left foreground is depicted against a menacing red sky, which seems drenched with anger over romance gone awry.

THE MONROE COLLECTION contains an unparalleled record of Monroe's finances from 1953 until her death. The records include checks, checkbooks, bankbooks, bank statements, ledgers and spreadsheets, tax records, and correspondence with lawyers and accountants. They show the complexities of Marilyn's finances, as her lawyers and accountants figured out her income and outlays and came up with ways for her to avoid heavy taxes—as high as 85 percent of salaried income in the late 1960s before the reductions during the Reagan administration. The formation of Marilyn Monroe Productions in 1954 created financial possibilities and problems. Corporate taxes were lower than individual incomes taxes, but the IRS suspected that MMP was simply a tax shelter, and Marilyn was often audited.

When Marilyn went on strike against Twentieth Century-Fox in 1955, requiring her to hire lawyers and negotiate a new contract, her legal bills became sizable. Associates, assistants, and lawyers filed lawsuits against her, assuming that she had a lot of money. Even her publicist Joe Wolhandler threatened to sue for back pay; she settled with him for $15,000. When she fired Milton Greene from MMP in 1957, he still owned stock in the company. Moreover, he had spent a considerable sum supporting her financially in 1955, when, engaged in her struggle with Fox, she refused to cash any of the paychecks the studio sent her, on the advice of her lawyers. Greene mortgaged his house to provide the necessities for a major star and for MMP operating expenses. Marilyn settled with Greene for $100,000, only part of what he had spent on her.

When she was married to Joe, he gave her cash gifts. The total comes to about $40,000, aside from the material gifts he gave her, including a $10,000 mink coat.

Once they were divorced, the frugal Joe cut off the cash, except for a loan to her in 1962 for $5,000 that is listed in her records as from "a friend." When she was married to Arthur, she probably supported him. Despite Arthur's successes as a playwright, his income wasn't large, and his alimony and child support payments were sizable. When they divorced, Marilyn gave him the house in Connecticut, even though she had paid for the improvements on it. Marilyn didn't ask any of her husbands for alimony; she always supported herself. She had learned that ethic from her mother and Grace Goddard, both workingwomen. She always proudly stated that even during her financially lean years as a starlet, she had never been supported as a "girlfriend" by a wealthy man.

Both Harry Lipton and Inez Melson tried to hold Marilyn to a budget. By the last year of her life, she was following her own maxim to a fare-thee-well: "I don't care about money; I just want to be wonderful." In 1961 she spent, in round numbers, $20,000 on clothes and $32,000 on doctors' bills. Expenses from January to August 1962 came to $180,000—some $2 million today. Her earnings failed to keep pace. At her death, she was $4,000 in the red. On the other hand, her assets were sizable, and that may be why she didn't seem to worry about money. Estimates of her estate at the time of her death came in at almost $1 million. That figure included her house in Brentwood and expected payments from *Some Like It Hot* and *The Misfits*, for each of which she was due 10 percent of the profits. This income had been structured as deferred salary payments so she could avoid paying astronomical income taxes, but those salary payments, estimated at $150,000 a year, were not scheduled to begin until 1964.[23] The week before she died, Fox offered Marilyn a new contract that would pay her $1 million per picture—an amount commensurate to what stars like Elizabeth Taylor were making, but no documents in her file cabinets ever surfaced that pertained to this arrangement, leading to the speculation that they were removed during the supposed cover-up the night that she died.

By the last year of her life, Marilyn had a loyal group of secretaries and assistants serving her. Hedda Rosten answered her fan mail and oversaw her apartment, and May Reis did secretarial work for her in New York. Milton Rudin, her Hollywood lawyer, persuaded her to hire Cherie Redmond to sort out her financial records, which were a mess. The organized Cherie was able to do so, but Marilyn didn't like her. Cherie suspected that someone was skimming money from Marilyn's accounts. At first she thought the culprit was Marilyn's accountant Julius Winokur, although his fault may have been sloppiness, not larceny, and he told her that Jack Ostrow, who was in Aaron

Frosch's office, was actually doing the skimming. The evidence also pointed to Marjo-rie Stengel, Marilyn's secretary in New York in 1961, still in Marilyn's employ as late as January 1962, although again the problem may have been inattention, not actual fraud. Marilyn used Stengel's name on the mailbox of her last Hollywood apartment, although it appears that Marilyn may have fired her. Finally, Cherie suspected Frosch of negligence, although no one followed up on her misgivings. Indeed, in hindsight it appears that her suspicions had merit, since Frosch was successfully sued years later for having mismanaged Marilyn's estate.

Hedda, May, and Cherie became close, considering themselves a support team for Marilyn. Patricia Newcomb, Marilyn's press agent, was close to her as well, as was Paula Strasberg, who still served as Marilyn's acting coach for her films. A letter from Patricia tells Marilyn that she and Paula love her and want her to contact them if she is feeling down, even in the middle of the night. Patricia suggests that Marilyn should step outside of herself to see how much her friends—and a lot of people whom she doesn't know—love her. Remember Jimmy Stewart in *It's a Wonderful Life*, Patri-cia continues, with words to the effect that Stewart misjudged the great affection in which he was held, but when he realized its existence, his feelings about himself and the world around him were transformed.

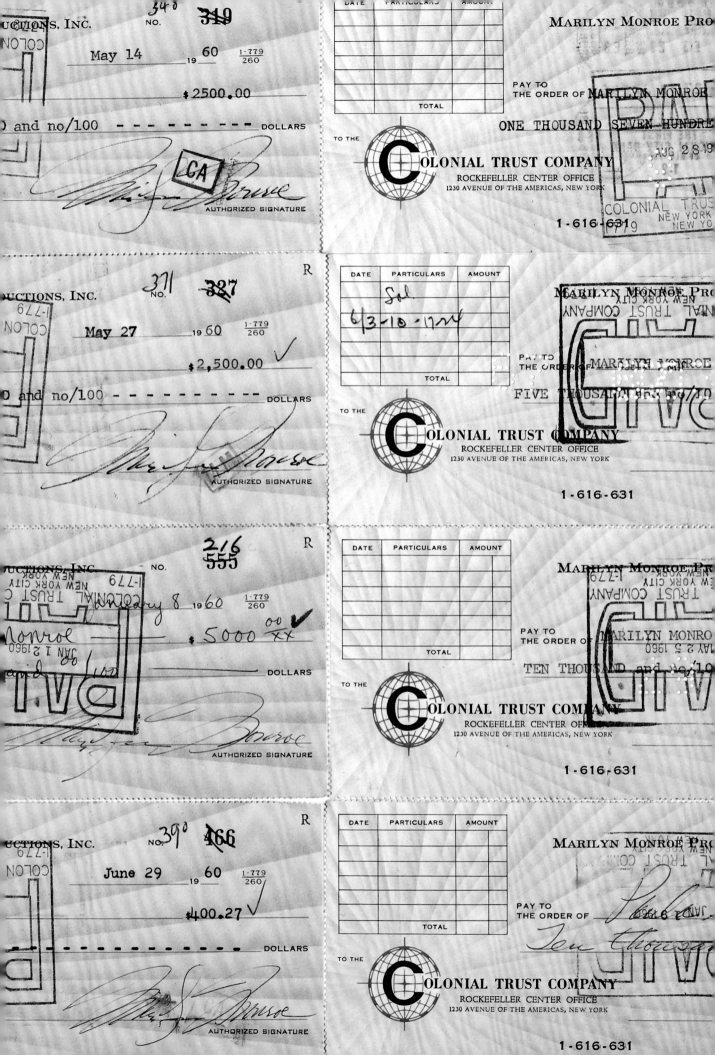

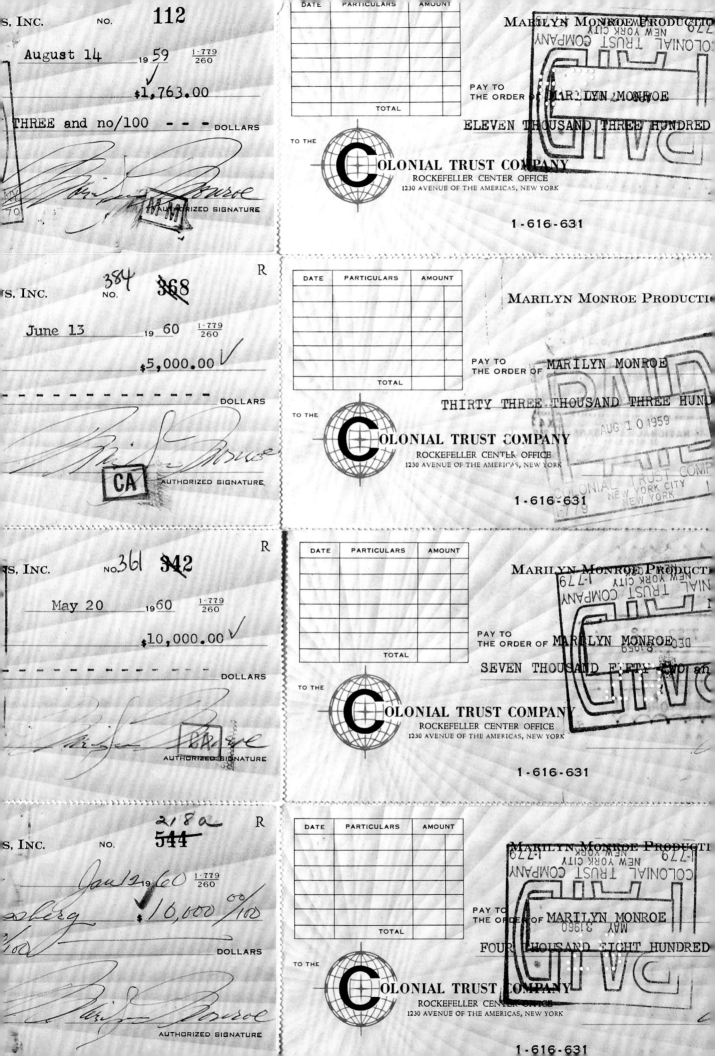

S, INC. NO. **112**

August 14 19 59 1-779/260

$1,763.00

THREE and no/100 - - - DOLLARS

AUTHORIZED SIGNATURE

DATE	PARTICULARS	AMOUNT
	TOTAL	

MARILYN MONROE PRODUCTIONS
NEW YORK CITY

PAY TO THE ORDER OF MARILYN MONROE

ELEVEN THOUSAND THREE HUNDRED

TO THE **COLONIAL TRUST COMPANY**
ROCKEFELLER CENTER OFFICE
1230 AVENUE OF THE AMERICAS, NEW YORK

1-616-631

S, INC. 384 NO. **368** R

June 13 19 60 1-779/260

$5,000.00

- - - - - - - DOLLARS

CA

AUTHORIZED SIGNATURE

DATE	PARTICULARS	AMOUNT
	TOTAL	

MARILYN MONROE PRODUCTI

PAY TO THE ORDER OF MARILYN MONROE

THIRTY THREE THOUSAND THREE HUND

PAID AUG 10 1959 COLONIAL TRUST COMP NEW YORK CITY NEW YORK

TO THE **COLONIAL TRUST COMPANY**
ROCKEFELLER CENTER OFFICE
1230 AVENUE OF THE AMERICAS, NEW YORK

1-616-631

S, INC. NO. 361 **342** R

May 20 19 60 1-779/260

$10,000.00

- - - - - - - DOLLARS

AUTHORIZED SIGNATURE

DATE	PARTICULARS	AMOUNT
	TOTAL	

MARILYN MONROE PRODUCTI
NEW YORK CITY
COLONIAL TRUST COMPANY 1-779

PAY TO THE ORDER OF MARILYN MONROE

SEVEN THOUSAND FIFTY TWO an

PAID

TO THE **COLONIAL TRUST COMPANY**
ROCKEFELLER CENTER OFFICE
1230 AVENUE OF THE AMERICAS, NEW YORK

1-616-631

S, INC. NO. 218a **544** R

Jan 12 19 60 1-779/260

$ 10,000 00/100

DOLLARS

AUTHORIZED SIGNATURE

DATE	PARTICULARS	AMOUNT
	TOTAL	

MARILYN MONROE PRODUCTI
NEW YORK CITY
COLONIAL TRUST COMPANY 1-779

PAY TO THE ORDER OF MARILYN MONROE

FOUR THOUSAND EIGHT HUNDRED

PAID MAY 3 1960

TO THE **COLONIAL TRUST COMPANY**
ROCKEFELLER CENTER OFFICE
1230 AVENUE OF THE AMERICAS, NEW YORK

1-616-631

NAME OF BANK
BRANCH ADDRESS *Sunset & Laurel*
CITY *L.A.*

PAY TO
THE ORDER OF *Saks & Company* $257 5/100

Two hundred fifty seven 5/100 —DOLLARS

SIGNATURE *Marilyn Monroe*

ADDRESS *Bel Air Hotel*

-71271

KAYCO FORM NO. 1002

TH AVENUE

LY HILLS CALIFORNIA

To
PAY TO THE
ORDER O

KAYCO FORM NO. 1002

City

LOS ANGELES, CALIF., *July 14, 1952*

JAX inc. $133 20/100

213

Three 00/100 DOLLARS

NAME OF BANK

ADDRESS OF BANK

ADDRESS *Marilyn Monroe*

Bel Air Hotel AR 71271 PHONE

To
PAY TO TH
ORDER

City

Sunset and Laurel
WILSHIRE-ROBERTSON BRANCH NO. X

Bank of America
NATIONAL TRUST AND SAVINGS ASSOCIATION

90-1184
1223

geles, CALIF., *Aug 25* 19 54

Dr. B. Sternhill $600 00/100

hundred 00/100 DOLLARS

Marilyn S. Monroe

LAUREL-SUNSET BRAN

Bank of Am
NATIONAL TRUST AND SAVINGS ASSO

HOLLYWOOD, CALIF., *Jan*

PAY TO THE
ORDER OF *Dr. A. Bottisson*

Sixty 00/100

Marilyn

ARS AMOUNT

6

50)

TAL

MARILYN MONROE PRODUCTIONS, INC. NO. 342 504

PAID

COLONIAL TRUST COMPANY NEW YORK

1-779
779

May 6 19 60 1-779/260

PAY TO
THE ORDER OF *BEVERLY HILLS HOTEL* $1,423.20 ✓

MAY 12 1960

ONE THOUSAND FOUR HUNDRED TWENTY THREE and 20/100 -- DOLLARS

OLONIAL TRUST COMPANY
ROCKEFELLER CENTER OFFICE
1230 AVENUE OF THE AMERICAS, NEW YORK

CA

Marilyn Monroe

AUTHORIZED SIGNATURE

1-616-631

To

Pay

E

In

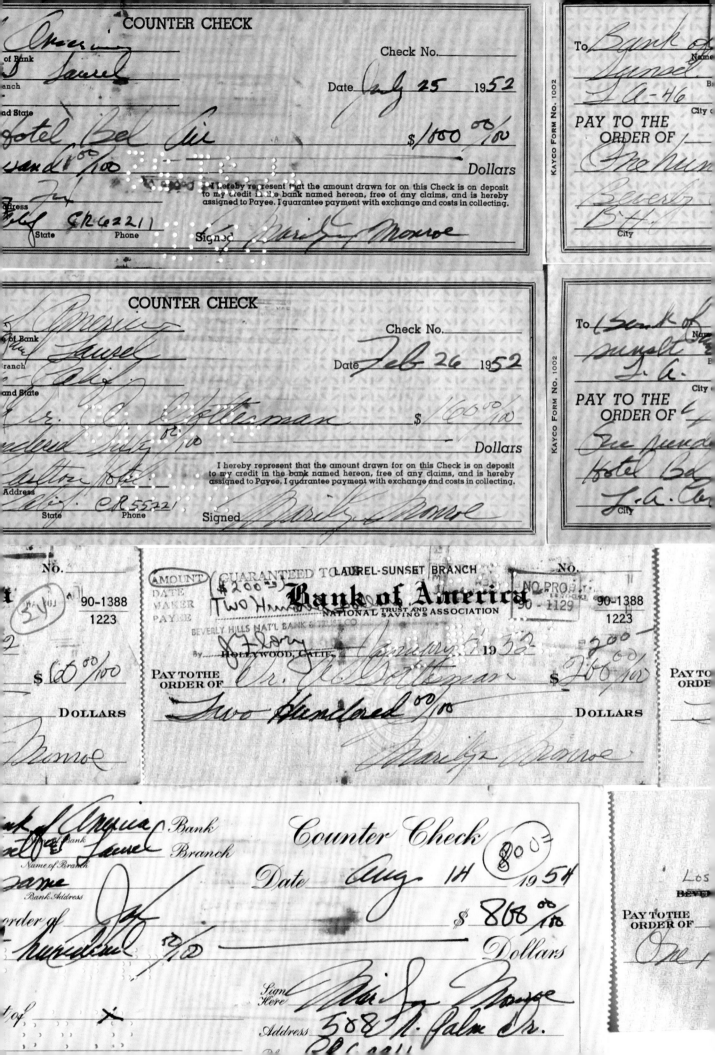

COUNTER CHECK

Check No. _____

Date *July 25* 19*52*

$*1000* 00/100

_____ Dollars

I hereby represent that the amount drawn for on this Check is on deposit to my credit in the bank named hereon, free of any claims, and is hereby assigned to Payee. I guarantee payment with exchange and costs in collecting.

Signed *Marilyn Monroe*

To *Bank of Sunset L.A.-46*

PAY TO THE ORDER OF

COUNTER CHECK

Check No. _____

Date *Feb 26* 19*52*

$ *160* 00/100

_____ Dollars

I hereby represent that the amount drawn for on this Check is on deposit to my credit in the bank named hereon, free of any claims, and is hereby assigned to Payee. I guarantee payment with exchange and costs in collecting.

Signed *Marilyn Monroe*

To *Bank of Sunset L.A.*

PAY TO THE ORDER OF

No. _____ 90-1388 1223

$ *160* 00/100

DOLLARS

Monroe

LAUREL-SUNSET BRANCH No. _____ 90-1388 1223

GUARANTEED TO
AMOUNT $200
DATE
MAKER *Two Hun*
PAYEE

Bank of America
NATIONAL TRUST AND SAVINGS ASSOCIATION

BEVERLY HILLS NAT'L BANK & TRUST CO.

By _____ HOLLYWOOD, CALIF. *January* 19*52*

PAY TO THE ORDER OF *Dr. J. Cotteman*

Two Hundred 00/100

$ *200* 00/100 **DOLLARS**

Marilyn Monroe

PAY TO
ORDE

Counter Check ($800)

Date *Aug 14* 19*54*

$ *800* 00/100

_____ Dollars

Sign Here *Marilyn Monroe*

Address *508 N. Palm Dr.*

Los
BEV

PAY TO THE ORDER OF

(opposite) Marilyn always kept savings accounts, but the balances in them were often low.

Starting with Inez Melson, Marilyn's managers and accountants kept professional ledgers of her income and expenses.

STANDARD CHECK RECORD FORM 188A

Byles

DISTRIBUTION OF CHECKS DRAW

E. F. WILMER INC., MFG'S.

House

Help	3500 ✓	W. Man.
Food	2500 ✓	
	518 ✓	
	486 ✓	
	5295 ✓	
	1500 ✓	
	2000 ✓	
	4000 ✓	
	5041 ✓	
Rent	20000 ✓	
	476	
	45266 ✓	53

STANDARD CHECK RECORD FORM 188A

Personal	Medical	Deps	Loans & Bolen	MISCEL. EXPENSE			GENERAL LEDGER-DR.		
				ACCT.	AMOUNT	√	ACCT.	AMOUNT	√
	851 04 √								
		35 00							
	61 67 √								
							Lumps	90 00 √	
							Rents	70 00 √	
	85 00 √								
	8 80								
				Auto	5 12 √				
			891 47 √						
				B.C.	1 85 √				
1006 51 √	35 — √	891 47 √			6 97			160 00	

GENERAL JOURNAL — REAL ESTATE — ASSETS — LIABILITIES — CAPITAL INCOME — EXPENSE

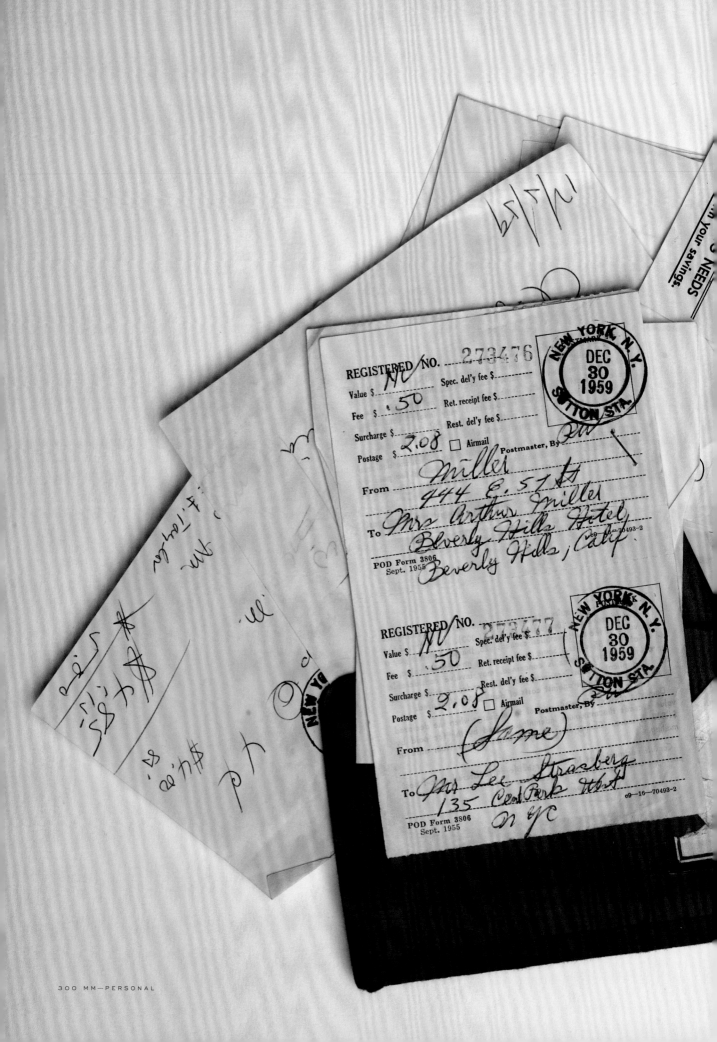

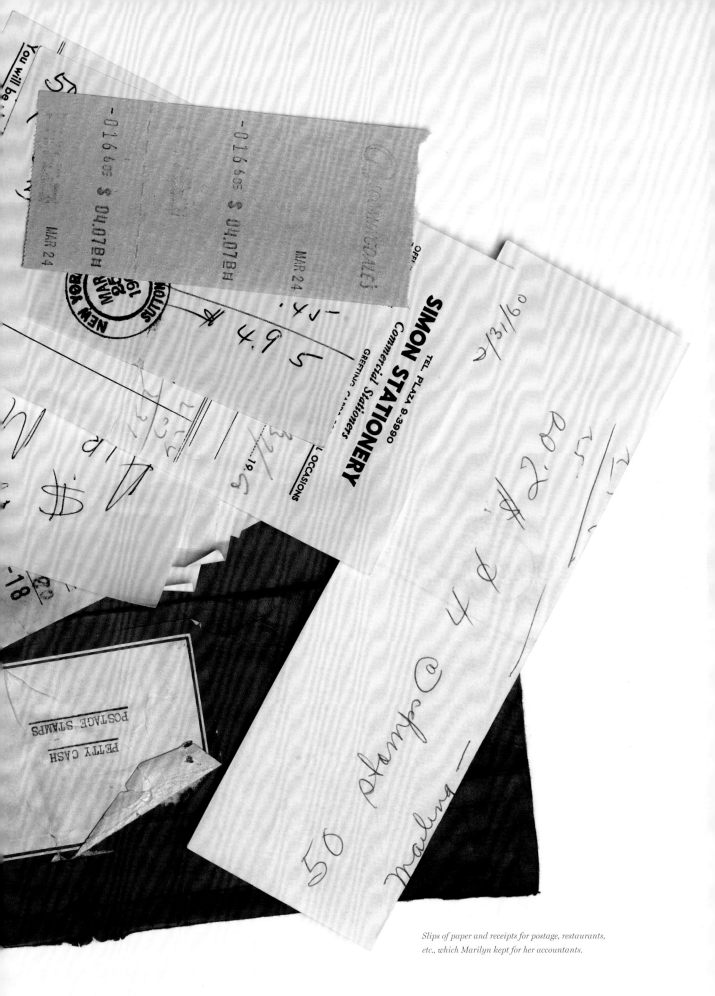

*Slips of paper and receipts for postage, restaurants,
etc., which Marilyn kept for her accountants.*

Have faith

♡ *Paula*

(above) Note from Paula Strasberg after
Fox fired Marilyn from Something's
Got to Give.

(opposite) Statement from the City
National Bank of Beverly Hills showing
that Marilyn is overdrawn by $4,208.32.

CITY NATIONAL BANK
of
BEVERLY HILLS
Statement of Receipts, Withholds & Disbursements
August 1962

Balance in Account - August 1, 1962

WITHHOLDS
Credit - Employer/Employee Taxes - withheld federal income tax — $1,337.53
- employee/M.P.R.F.

RECEIPTS
Advance

		28.20
		1.00
		1,840.94
		$3,207.67

DISBURSEMENTS

	Not Separated	California	
Business Expense - General	$ 10.76	$	
Employer/Employee Taxes	276.84		
Entertainment			
Garden & Pool Expense		166.34	
Household Expense - Food		51.59	
Household Expense - Miscellaneous		57.78	
Interest		45.42	
Fan Mail Expense	193.68		
Medical & Drugs	262.65		
Eunice Murray	1,612.76		
Publicity & Advertising	400.00		
Personal Expense	1,000.00		
Secretary	7.44		
Paula Strasberg	200.00		
Telephone & Telegraph	612.28		
Utilities		206.07	
Wardrobe		52.59	
	382.62		
	4,959.03	579.79	5,538.82
			(2,331.15)

RESIDENCE

Purchase (Loan Payable		
Renovations - Labor	126.32	
- Miscellaneous	360.00	
- Garden & Pool	54.86	
- Home Office	394.61	
Furniture & Furnishings	111.45	
Rug - Home Office		
	360.92	
Overdraft in Account - August 3, 1962	469.03	1,877.19
		(4,208.34)

$105.00
Examination
Injection
March 14 Chest X-ray Complete H...
Balance

FOR PROFESSIONAL SERVICES RENDERED

Mrs. Arthur Miller

March 30, 1957

LOUIS FINGER, M. D.
1056 FIFTH AVENUE
NEW YORK 28, N. Y.

MARIANNE KRIS, M. D.
135 CENTRAL PARK WEST
NEW YORK 23, N. Y.
TRAFALGAR 7-6273

Mr. Arthur 57
444 East 57
New York 2

July 1960
13 sessions

RALPH R. GREENSON. M. D.
436 NORTH ROXBURY DRIVE
BEVERLY HILLS, CALIFORNIA

August 31, 1960

Mrs. Arthur Miller
444 East 57th Street
New York 22, N.Y.

FOR PROFESSIONAL SERVICES

$1250.00

H. F. WECHSLER, M. D.
M. JOEL WOLF, M.
737 PARK AVEN...
NEW YORK 21. N...
RHINELANDER 4-611

Mrs. Arthur Miller
444 East 57th Street
New York, N. Y.

FOR PROFESSIONAL SERVICES

805.00
455.00
$ 1,260.00

Balance
March

April 1,

Mr. Arthur Miller
57 Street New York
East 22, N. New York

FOR PROFESSIONAL SERVICES

K LIPKIN, M. D.
. 61ST STREET
ORK 21, N. Y.
ON 8-4534

Mrs. Arthur Miller

FOR PROFESSIONAL SERVICES RENDERED

MARIANNE KRIS, M. D.
135 CENTRAL PARK WEST
NEW YORK 23, N. Y.
TRAFALGAR 7-6273

December 1, 1959

H. F. WECH...
M. JOEL W...
737 PAR...
NEW YOR...
RHINELAND...

YALE FORM 478

INTER-OFFICE CORRESPONDENCE

To ___Hedda Rosten_____ From ___**Cherie Redmond**_____Office

_____Office _____**8/1/62**_____19__

Dear Hedda,
 Subject

Received your July 31 memo re the red couch.....by the way - just in the
event you have occasion to check about it next week while I am away (I hope--
the 21st day on the possible chicken pox is up on Sunday, and we're due to
leave Monday.....) .. The shipper is Paul Duke, 1744 1st Avenue,
AT 9-0695.....and, I could almost bet you it won't get here by the 10th.....
nothing ever works as smoothly as people promise...but here's hoping.

Please let me know where you're going to be on your vacation - not that
I intend calling you - but I always feel safer when I know where I can
reach "the gang"....

Also, I hope you didn't happen to mention anything to MM about Mrs. Murray
going to Europe.... Mrs. Murray told me she still had not made her
reservation....it seems(to me)that her devotion to MM is so intense (that
may not be the right word - but you'll know what I mean) that she wouldn't
want to go away if she felt it would discommode MM -- and such devotion and
loyalty is really a wonderful quality. But I don't think we should have
a Tinkers to Evers to Chance relationship....if you know what I mean (and
you're probably more hep than I am about baseball, so I'm sure you do)....
because as in this case - Mrs. Murray might not even want to remind MM that
she had intended going to Europe....anyway, it's her business - not mine -
and I only told you to keep you au courant.

 Best - cherie

YALE FORM 478

INTER-OFFICE CORRESPONDENCE

To _____ From _____Office

_____Office _____19__

 Subject

Dear Helen...

 I certainly expect you to open any envelopes I mark "personal"

-- I just want to be sure that if you're away for a day -- for fun not be-

cause you're sick or anything -- that someone else would not open it (them ?)

because the fewer people who know about the state of MM's MM's finances, etc.,

the better.

 cherie
 8/1

Cherie tells Hedda about her vacation plans and calls Marilyn's assistants "the gang." She describes the "red couch" designed by John Moore for Marilyn. Eunice Murray has plans to go to Europe for her vacation. There is no indication that Marilyn planned to fire Eunice, as some biographers have speculated.

Cherie writes to Milton Rudin's secretary that only Rudin's secretary is to open any envelope to Rudin marked "personal." "The fewer people who know about the state of MM's finances, the better," Cherie writes.

Checks Signed By Miss Monroe on August 3 and
 Mailed on that date to payeess
 which as of 9/5/62 had not been presented to bank for payment
 were:

No.	Date	Payee	
1779	8/1/62	Sherman Oaks Veterinary Ser Clinic - 7/26 bill	$ 28.00
1790		Film City Ornamental Iron Works - nail heads for front door	29.38
1791		Bel Air Sands Hotel - for Paula Strasberg bill	406.69

 (This was to replace Mrs. Strasberg's personal check
 to the Bel Air Sands Hotel, which they had agreed to
 hold until August 7. It is quitelikely, therefore,
 that it will not be necessary to re-issue this check

| 1786 | 8/11 | Norman Jefferies - salary for w/e 8/11 | 180.00 |
| 1787 | 8/11 | Eunice Murray - salary for w/e 8/11 | 200.00 |

 (Since Mrs. Redmond was on vacation for this week, these
 salaries were drawn in advance. It is our understanding
 they were signed by Miss Monroe on August 3 and delivered
 to the payees on that date.)

Checks Signed by Miss Monroe on August 3 and
 Mailed on that date to Mr. Rudin who was to
 release them to the payees when funds were
 available through bank loan he was negotiating
 were:

No.	Date	Payee	
1749	7/17	Arthur P. Jacobs Company, Inc. - 6/30 expense acct.	$ 480.18
1781	8/1	Thompson Electric Company - home office renovation	111.45
1782		Saks Fifth Avenue - July statement	382.62
1788		City National Bank - July Depositary	276.84
1792		Peter A. Juley & Son - Fan Mail pictures	262.65
1793		General Telephone Company - 7/30 statement 476-1890	196.07

 (The 7/17 check to Arthur Jacobs' office was signed in July)

Checks dated 8/2/62 and 8/3/63 which had not been presented to
Miss Monroe for signature. Mrs. Murray was to give them to Miss
Monroe to bring to the meeting she was to have with Mr. Rudin
during the week of August 6 -

No.	Payee	
1795	Dr. Hyman Engelberg - 7/26 statement	$ 358.00
1796	Dr. Ralph R. Greenson - 7/31 statement	1,200.00
1797	Arthur P. Jacobs Company, Inc. - publicity fee for four weeks' services commencing August 1 through August 28 - weekly rate $250	1,000.00

 (This fee was customarily billed in advance)

 see next page

Accounting attached to court records regarding
the settlement of the Monroe Estate.

Monroe Papers
Re Death
5/7/62

MABEL WALKER WILLEBRANDT
9110 SUNSET BOULEVARD
LOS ANGELES 46, CALIFORNIA

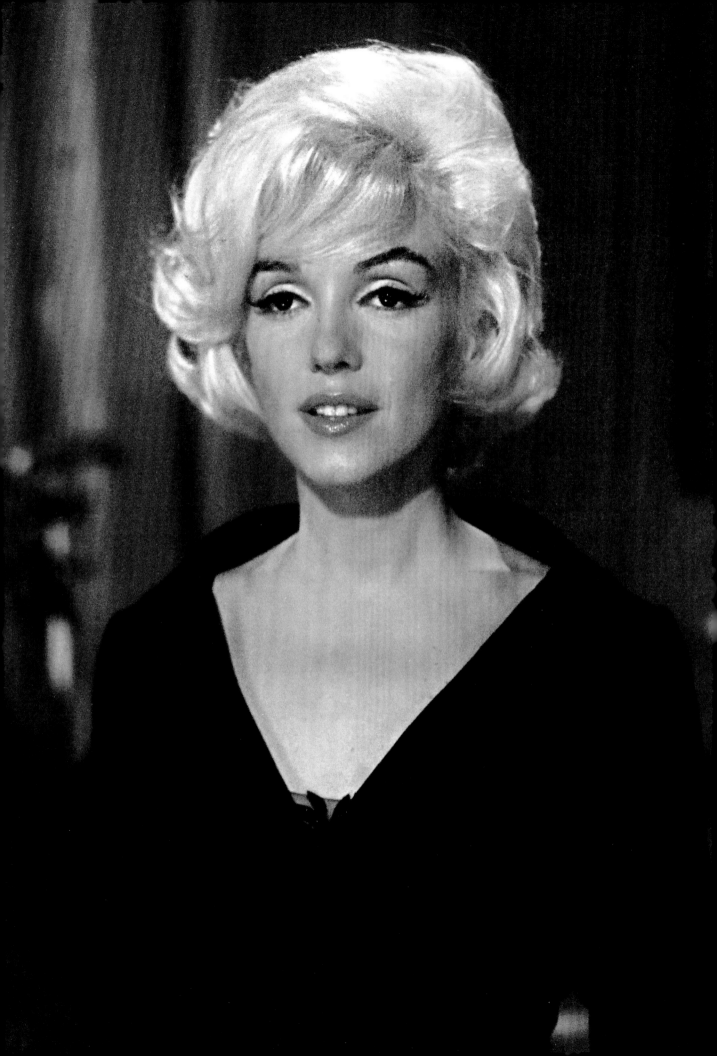

"It might be kind of a relief to be finished. It's sort of like you don't know what kind of a yard dash you're running, but then you're at the finish line and you sort of sigh—you've made it! But you never have—you have to start all over again."

MONROE INTERVIEW WITH RICHARD MERRYMAN, AUGUST 1962

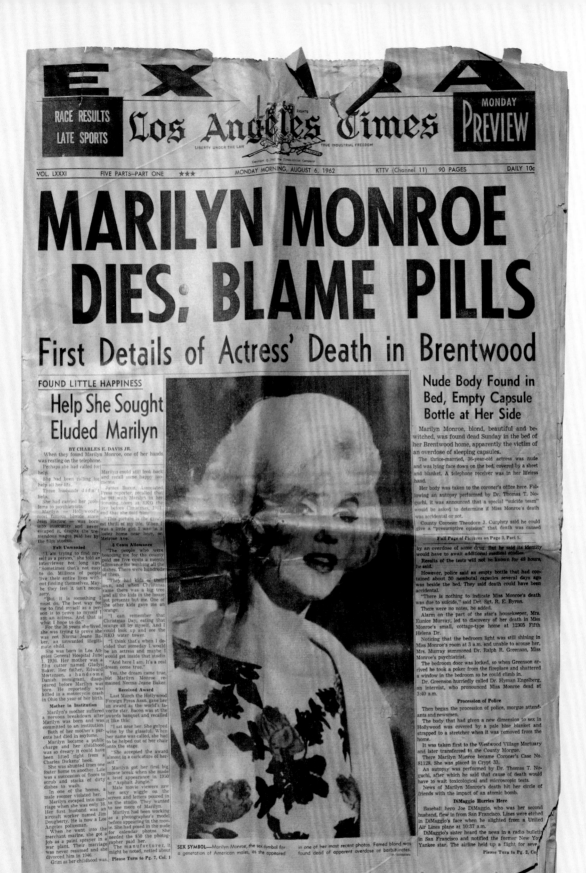

Coverage of Marilyn's death in the Los Angeles Times.

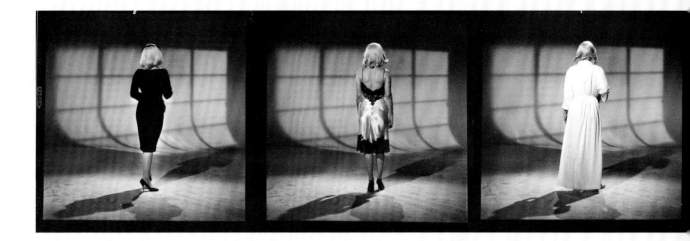

M ARILYN'S DEATH at the age of thirty-six on August 4, 1962, stunned the world. Her firing from *Something's Got to Give* the previous June was well-known, as was her shock and anger over it. But her fight that summer to regain her stature as an actress and a star also received a lot of press. The nude photos of her taken while she filmed a scene for *Something's Got to Give* in a swimming pool had made the cover of *Life* and were published in magazines around the world. A *Life* magazine interview, along with photos of her in her new home, had appeared on newsstands only days before she died.

Her death garnered front-page headlines in every newspaper in the United States and most in Europe. *Life* gave her an eleven-page spread; *Paris Match* devoted thirty-six pages to a retrospective on her life. Every major European picture magazine gave her a feature and a cover. It's said that the suicide rate in Los Angeles doubled the month after she died; the circulation rate of most newspapers greatly expanded that month.

Joe DiMaggio and Inez Melson planned Marilyn's funeral. Most major Hollywood stars had huge funerals, attended by leaders of the industry, before being buried in a showy cemetery like Forest Lawn. But Marilyn's funeral was different. Her body was interred in a crypt in the Westwood Village Memorial Park and Mortuary, a small cemetery and mortuary in Westwood, not far from Marilyn's house in Brentwood. It was one of the neighborhood cemeteries that were built throughout the Los Angeles region in its early years. Many of Marilyn's family members are buried there, including Grace and Doc Goddard and Ana Lower. Marilyn's funeral, held in the mortuary's chapel, was brief. A local minister read verses from the Bible, Lee Strasberg delivered

a eulogy, and a record of Judy Garland singing "Over the Rainbow" was played. Flowers had been sent from everywhere, forming a huge array in front of the crypt. Joe had a huge heart of red roses made, and Jane and Robert Miller, Arthur's children, had sent a floral wreath with a card signed "Bobo" and "Butch." The wife of the Mexican president had sent a wreath of gardenias and roses, with a card reading, "From the Children of Mexico." It honored Marilyn's donation of ten thousand dollars to the National Institute for the Protection of Children in Mexico City when she visited the city in March 1962.[24]

In her interview with the BBC, Inez stated that she took the lead in planning the funeral. Because Marilyn disliked extravagant Hollywood funerals, Inez kept Marilyn's small and intimate. Berniece Miracle chose the casket, along with Joe, but Inez made up the guest list, limiting it to Marilyn's family and personal friends and keeping Hollywood leaders and the Kennedy family out. Only thirty-one people were invited. Joe agreed with Inez's decisions. He was angry over Hollywood's treatment of Marilyn and angry at Frank Sinatra and the Kennedys for what he considered their involvement in her death.

The Westwood cemetery is a small place, a bucolic park in the midst of urban sprawl, set back from Wilshire and Westwood boulevards. Discreet gravestones are set in a sweep of green grass. Crypts are built into walls at one side of the cemetery, with the walls open to the outdoors; an overhang protects the crypts and mourners from rain. After Ana Lower was buried in the Westwood cemetery in 1948, Marilyn went there for spiritual regeneration. She would sit on a bench, rejuvenate herself in the solitude, and sometimes read a book. Marilyn was the first Hollywood celebrity to be buried there. After her death, many others joined her, including Natalie Wood, Darryl Zanuck, Truman Capote, Billy Wilder, Jack Lemmon, and Dean Martin.

Marilyn's funeral didn't end as discreetly as it began. Once the invited guests and the Pinkerton guards hired to keep order left, the large crowd of fans outside the walls leaped over them and rushed into the cemetery. They descended "in one big wave" on the floral tributes and tore them apart. They grabbed every flower from the individual displays in a furious rush to take a souvenir.[25] In death, as in life, Marilyn was an object of fan devotion and the potentially out-of-control crowds those fans could turn into.

The rush to possess her didn't end after her death. Disputes arose over the terms of her will and the disposition of her possessions. On January 14, 1961, a week before

she divorced Arthur in Mexico, Aaron Frosch drove her to New Jersey to sign a new will that made Lee Strasberg her major beneficiary—and that left Arthur Miller nothing. Under this will, a trust fund was created for the support of Gladys Eley and Xenia Chekhov. Lesser sums were allocated to May Reis, Marianne Kris (for the Anna Freud Centre in London), and Patricia Rosten (for her college education). From the signing of this will until her death, Marilyn complained about it to anyone who would listen, and she had an appointment with Milton Rudin to change it the Monday after she died. Did she want to remove Lee Strasberg as her major beneficiary? Was the problem the bequest to Marianne Kris, who committed her to a New York mental hospital several weeks after the will was signed? Exactly why Marilyn disliked the will so much is unknown.

Inez thought that Frosch and the Strasbergs had colluded in drawing up the will. She wrote to Joe DiMaggio about her suspicions—and she also challenged the will in court. Her charges were dismissed; she didn't have much proof. She and Frosch subsequently had a conversation about it, seemingly mending fences. Whatever her personal interest in the will, Inez cared about Gladys and feared that Gladys might not receive sufficient support. In a transcript made by Frosch's secretary of their conversation, he assured her that everyone involved with the will was concerned about Gladys. Even Lee Strasberg was willing to forgo any payments until support for Gladys was assured.

Frosch managed the Monroe Estate, set up under Marilyn's will, for many years. However, nothing was paid to most beneficiaries under the will for nearly twenty years. Gladys's trust fund wasn't established until 1977. To avoid heavy taxes, Marilyn had set up much of her salary as deferred income. That produced about $150,000 a year. But because she wasn't alive to claim deductions, her income fell into the highest tax bracket. Thus, whatever Frosch collected in Marilyn's salary for the Monroe Estate, he contended, was eaten up by taxes and fees paid to accountants and to him for managing the estate.

To quell complaints, Frosch occasionally paid bills, such as several thousand dollars he sent to Inez in partial payment to Rockhaven Sanitarium for Gladys's care, but much of the money owed the sanitarium was never paid. However, Frosch's reports, which he sent to the will's beneficiaries, went largely unchallenged until 1981, when Marianne Kris's estate sued him for "plundering" Marilyn's estate. The case was settled out of court, but it appears that Frosch was assessed $400,000, the exact

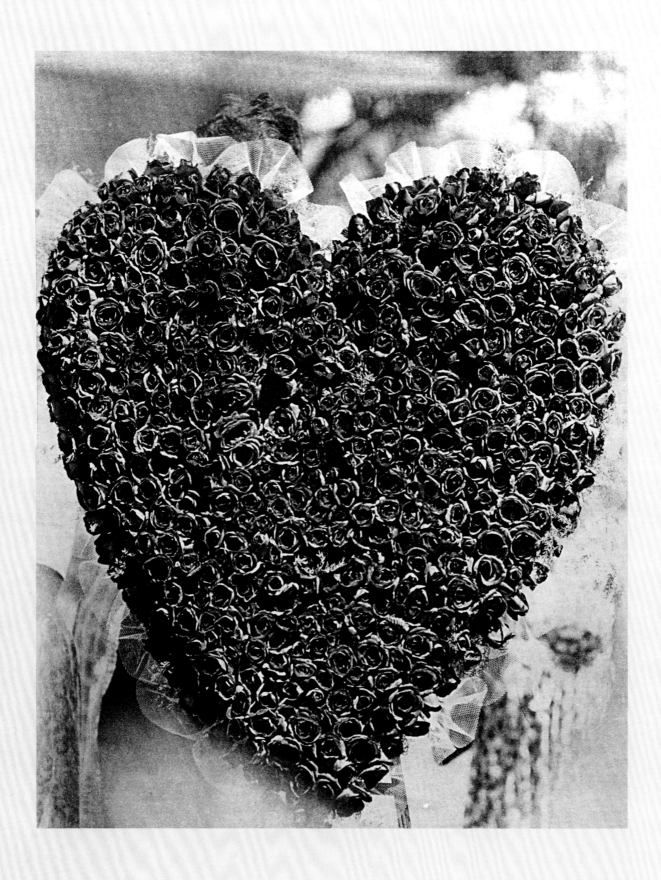

*Joe DiMaggio had this large heart of
red roses made for Marilyn's funeral.*

amount of liability he was protected against by an insurance policy he had taken out years before to protect him against any such charges of mismanagement. He had, in fact, made numerous errors in managing the estate—errors that were to his financial advantage. Years before, Cherie Redmond may have been correct in suggesting that Frosch should be dismissed as Marilyn's lawyer.

From the time of her tragic death onward, the image of Marilyn has haunted the imagination of the United States and of the world. She has been celebrated in story and song, and immortalized in works of art by Andy Warhol and Audrey Flacks, and in novels by Joyce Carol Oates and John Rechy. Major performers and celebrities like Madonna and Britney Spears copy her platinum hair, her mannerisms, and her dress, bringing knowledge of her to ever-younger generations. Her image appears everywhere today: on handbags and T-shirts, on posters and advertisements, in television miniseries about her life, and in magazine retrospectives about her. Joyful, innocent, and sexy, Marilyn is a siren who sometimes looks sad, a self-made woman who yearned for her own family but achieved only an approximation of that family for brief periods of time. Hating to live alone, she spent much of her life doing just that. She was on top of the world one day and deeply depressed the next. An avatar of the American dream, she offers us a cautionary tale about celebrity, mental disorder, and drug abuse. With her life both a triumph of the will and an example of megalomania gone wild, she embodies the contradictions at the heart of the American character, as we tell ebullient tales for public consumption and try to hide the secrets of the heart that might shame us and bring us down.

RITES FOR MARILYN MONROE
Last Act in a Movieland

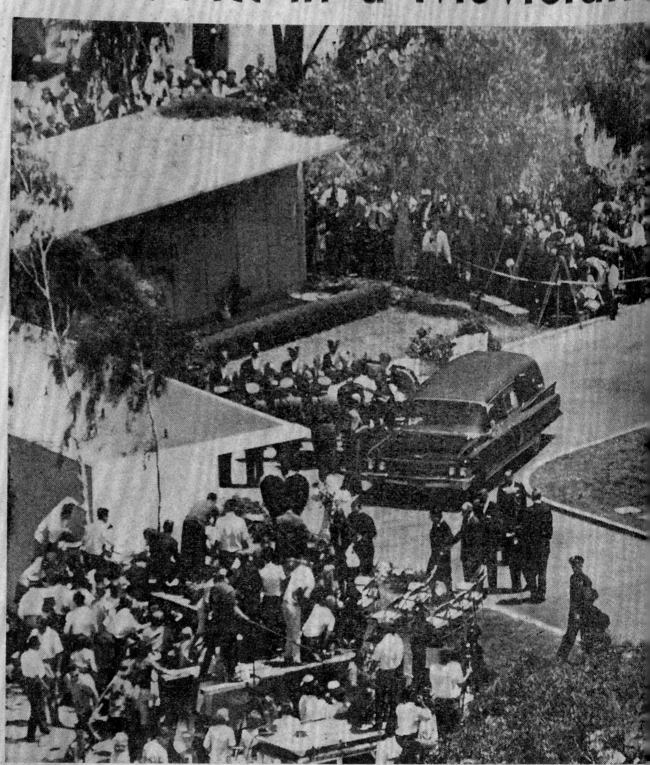

Drama

GRIEVING—Pat Newcomb, who was press agent for Marilyn Monroe, weeps after funeral service. She was one of the invited mourners who attended rites.

Times photo

Quiet Crowd Watches

BN	Was this dependence on pills something new in your experience of her?

INEZ Very new , very new indeed. In the early days of my acquaintance with her I never knew her to need a sleeping pill or a 'Pep me Up' pill , these were all sleeping pills. I didn't find any of those Dexadril or any of that stuff that is supposed to lift you way up.

BN Where would you then put the blame , if blame could be apportioned in such a matter but where would you put the blame for her death?

INEZ How could I blame anybody, unless it would be with the doctors who were too free with their perscriptions .

BN You in fact had much to do with the arranging of the funeral didn't you?

INEZ Yes I did.

BN It was a very quiet one .

INEZ Very quiet.

BN What was he reason for that?

INEZ Because Marilyn had always said to me when every once in a while someone in the film world would pass away and there would be mobs of people all wanting to see what was going on, it just didn't pass in conversation, she said "I hope that would never happen to me" You know never anticipating that some day it could happen so we just decided, Joe came and Joe selected her casket but I selected the guest list and I invited people that were not in the film industry at all, old friends, I had a guest list at the office but at that time Frank Sinatra and Ella Fitzgerald and Lawford and Sammy Davies Junior,

they wanted to come to the cemetry which has
a nice little chapel and have a memorial
service, well I knew Marilyn didn't want a
memorial service so I refused permission for
this to happen and Arthur Jacobs, that is the
reason I say that we got some
because he came to me and he said, "Mrs.
Nelson, don't you realise that you are
insulting the sister of the President of the
United States" and I said "Well I don't mean to
insult the President or his sister but this
isn't a political rally, this is the death of a
very dear friend. He was quite unpleasant, talked
of these lovely wonderful people.

At one point I think Frank Sinatra was the
instigator of this and I don't mind saying
it , we had Pinkerton Detectives at the gate
to keep people away and they came along with
some other security people and announced that
they were from Twentieth Century and that
the Pinkertons could be relieved. They were
their people and they were going to just come
on in and- in spite of things. Well the
Pinkerton men had sense enough to come to me
at the Mortuary Office where I was sort of
sitting around and told us what had happened
and of course I said "That is not so" and we
nipped their little scheme in the bud.

BN That was a bizarre thing .

BN How did Joe diMaggio react to her death?

INEZ Oh he was heartbroken . There is a cute little
 incident in connection with Joe's relations
 with Marilyn and Joe's son. We always spoke of
 Joe's son as Little Joe , about the time
 Marilyn died Little Joe was about six feet
 tall but he was still Little Joe tous and
 Margaret Thompson the housekeeper used to
 make birthday cakes for him when he was over

*Pages about the funeral from the Barry
Norman BBC interview with Inez.*

Dear Joe,

If I can only succeed in making you happy — I will have succeeded in the biggest and most difficult thing there is — that is to make one person completely happy. Your happiness means my happiness.

E.

ALVAH BESSIE
5437A Geary Boulevard
n Francisco 21, California

8 August 1962, 1:30 pm

ar Inez: This letter requires no reply. I never met the
girl in my life but I have loved her dearly for years and
have written a good deal about her, both for Frontier mag-
azine and the Peoples World (under another name) and will
have another piece in September in Contact (here).

But I am compelled today to write to someone who knew her
and to try to unpack my heart of the bitterness I have
felt- and the pain- since the news came on Sunday. No
doubt my former psychiatrist- whom I have not seen in
years- would be able to explain to me why I am feeling
this way, but it is enough for me that I feel it, that
it hurts like mad and that it is going to take a long
time to be healed.

You knew, Inez, no death has affected me this way since
1939 when my closest friend in Spain was killed a few
yards away. Nor have the deaths of Hemingway and Faulkner,
both of whom I knew, jolted me in so fundamental a way.

I met Miller briefly- for 20 minutes- the week after
The Misfits was finished shooting and he wandered into
the nightclub where I work. We had a conversation of a
sort and he struck me as a sweet and sad man, though a
woman I met recently, who was MM's secretary in New
York for some time, has quite a different opinion of him.
No matter.

This is free association, as you see, and I hope it does
not burden you for I have a very good idea of what you
must have gone through in the last few days, and are
still going through today. I think.

Maybe this is the last, feeble flame of my youthful
romanticism, for the person was never any more to me
than an image on the screen, and I am sure she was
none of the things I have imagined her to be, and I
have surely heard as many 'stories' about her as anyone
else. Like all such stories they were totally contrad-
ictory at all times: she was bright, she was stupid;
she was sweet, she was hopelessly selfish; she was con-
sumed with ego; she had none at all; she was talentless,
she was a potential talent of major proportions (this
last I have long known, merely from watching her in film).

You will forgive this outburst and accept my personal
feelings of friendship for you, whom I have scarcely
known and not seen for many years. My love to you,

Yours,

Alvah

September 6, 1962

Dear Joe:

I have been hoping to find time to write you a letter - just to weep on your shoulder - I guess but what with trying to attend to my own little office and attending to the herculean task I found myself shouldered with, I have hardly had time to sleep.

However, I wanted to ask a favor of you if it is possible for you to help me which is as follows:

On January 14th, 1961, the date on which our baby purportedly executed her will, she had car rental charges as follows:

4½ hours - 8:45 - 1:15 (From Paul A. Reilly, Inc.
2½ hours - 4:45 - 7-15 (528 E. 73rd Street, N. Y. 21

I have a reason for wanting to know if the car was used and if so, where did she go but if I write directly, it might create a situation. Do you know anyone who could obtain this information quietly. Those hours appear on the bill and I know the rental agency would have a record of whereshe went. I know it sounds like a "Perry Mason" television script but I am (between thee and me) very suspicious about that will and my only interest lies in the protection of future care of Mrs. Eley. If you can help me, fine - if not, I will see what I can do elsewhere since I appreciate how you feel.

I have pretty well constructed what happened onthat day and I find it impossible to see why Mr. Frosch had to be a witness along with his secretary. I know that you will understand how very discreet I must be about this.

I was sorry to have missed Marie's call. Icalled the next morning but no-one was at home but a cousin. I hope you are feeling better but if you are anything like me, you are feeling worse. I hope to seeyou soon so that we can have a long visit.

My sincerest affection,

ITEM	PURCHASER	SALES PRICE	APPRAISAL
1 Brass hostess cart oval 3 glass shelves	Marcie Ors 4243 Don Carlos Drive Los Angeles, Calif.	45.00	35.00
1 Painted cabinet, irregular * shape, no door	" "	20.00	7.50
1 Matching console cabinet, * no doors	Elaine Laing 1243 N. Maplewood Amaheim, Calif.	15.00	7.50
1 Light finished walnut low * console cabinet, no doors	" "	15.00	15.00
* Appraisal refers to doors but it should have been door openings			
1 Sanitary can, step on lid	" "	2.00	2.00
1 Metal 4 drawer filing cabinet, legal size with lock	W. N. Davis 9110 Sunset Blvd. Los Angeles 69, Calif.	25.00	25.00
1 Marble top table, oblong wrought iron lega	Doris S. See 12128 Travis Street Los Angeles 49, Calif.	30.00	25.00
1 Oval metal wastebasket) 1 Oval fabric wastebasket)	W. Alexander 8805 Santa Monica Los Angeles, Calif.	(3.00
1 Blackboard) 1 Bulletin Board)	" "	((2.00

In this official report of the auction of Marilyn's possessions that Inez held, filed with the probate court overseeing the disposition of Marilyn's assets under her will, Walter Davis (W. N. Davis) is listed as the purchaser of the gray file cabinet. The address given for him is Inez's office address.

Miss Monroe,

I may be wrong - but I have a so
of feeling not everyone is asked to become a
founder member.....the list is not long,
although it is impressive. The life member
fee is $1,000 - it is tax deductible though

Would you like me to discuss it
Mr. Rudin?

cherie

Yes - I'll do it -
make out check ple

APR 9 1962

Dear Marilyn:

The historical opportunity to become
a Founder Member of the Hollywood Museum
Associates will soon pass.

You have been nominated to be a Founder
Member because we believe that the founding of
the Hollywood Museum should record the names
of the leaders of the community.

The name of each Founder Member will
be perpetuated in bronze on the Wall of Honor
in the Rotunda of the Museum at the time of its
dedication.

Your acceptance will hearten those of us
who are working in the interest of the Museum,
and your name will be placed where it rightfully
belongs.

Sincerely,

Mrs. Harry Brand

Dear Marilyn
Do so hope
you will join this
Exciting project -
Fondly
Syrie -

December 27, 1960

Miss Marilyn Monroe
444 East 57 Street
New York City

Dear Marilyn:

Thank you very much for your check for
$1,000, being your pledge to the Actors'
Studio for the season 1960-61.

Best wishes for 1961.

Cordially,

Cheryl Crawford

gc
Receipt encl.

Rudolph Saenz #10
1456 Sacramento
San Francisco

AUG 6
4:30 PM
1962

SAVE ___
BUY U.S. BONDS ON
PAYROLL SA___

Miss. Inez Nelson
C/o Westwood Village
Mortuary Chapel
West Los Angeles. California

Via Air-Mail

Extending
to you
friendliest sympathy
with
deepest sincerity

Rudolph

my greatest sympathy
to you and all Miss Monroes
friends. It ever a great
shock to me or also to the world.
The most beautiful things that ever
lived has gone to rest.

Sincerely

Rudolph
and all her
San Francisco Fans
xx

1926 JUNE 1

Norma Jeane Mortenson is born to Gladys Monroe Baker Mortensen at the Los Angeles County General Hospital charity maternity ward. Gladys appears to have misspelled the name of Edward Mortensen, to whom she was still married at the time of Norma Jeane's birth, although C. Stanley Gifford was probably Norma Jeane's father.

JUNE 11

Gladys places Norma Jeane with Ida and Wayne Bolender.

1933 MAY 23

Gladys brings Norma Jeane to live with her in Hollywood.

EARLY OCTOBER

Gladys, Norma Jeane, and an English couple, George and Maude Atkinson, and their daughter, Nellie, move into a house near the Hollywood Bowl.

1934 MID-JANUARY

Gladys breaks down and is sent to a rest home.

MID-JANUARY–MAY 1935

Norma Jeane continues to live with the Atkinsons.

1935 JANUARY

Gladys is diagnosed as paranoid schizophrenic and committed to Norwalk State Hospital for the mentally insane.

MARCH

Grace McKee files with the Los Angeles Superior Court to become Norma Jeane's legal guardian.

SEPTEMBER

Grace marries Edwin "Doc" Goddard and places Marilyn in the Los Angeles Orphans Home.

1936 OCTOBER

Marilyn moves in with the Goddard family.

1937 OCTOBER

Grace moves Marilyn into the homes of family members.

1938 OCTOBER–1942

Marilyn lives with Ana Lower through 1940 and with the Goddards until 1942.

1942 JUNE

Marries James "Jim" Dougherty.

1944 SPRING

Jim is sent overseas, and Norma Jeane begins working at the Radio Plane Company, an aircraft factory in Burbank, California.

LATE DECEMBER

David Conover photographs Marilyn for the army magazine *Yank*.

1945 AUGUST 2

Marilyn signs with the Blue Book Modeling Agency. Over the course of the next year, she becomes a leading pin-up model.

1946 AUGUST 26

First Twentieth Century-Fox contract.

SEPTEMBER 13

Las Vegas divorce granted from Jim Dougherty.

1947 SPRING

Marilyn studies at the Actors Lab. She meets Dorothy Dandridge, a fellow student who introduces her to her voice coach, Phil Moore. Marilyn will later study with Moore.

SPRING AND SUMMER

Tandem surfing at Santa Monica Beach with Tommy Zahn.

SPRING

Meets Joe Schenck.

AUGUST

Darryl Zanuck drops Marilyn at Fox. Marilyn then does pinup modeling and freelance studio work to support herself.

1948 MARCH 9

Harry Cohn of Columbia signs Marilyn to a six-month contract. Marilyn meets Natasha Lytess and Fred Karger, and costars in *Ladies of the Chorus*.

DECEMBER 31

Meets Johnny Hyde.

1949 JANUARY

Starts *Love Happy*.

MAY 27

Poses for nude calendar.

SUMMER

Six-city tour for *Love Happy*.

AUGUST 15

Starts *A Ticket to Tomahawk*.

LATE 1949

Johnny Hyde and Lucille Ryman secure Marilyn a role in *The Asphalt Jungle*.

1950 MARCH

Marilyn is cast in *All About Eve*.

AUTUMN

Meets Sidney Skolsky.

DECEMBER 5

Signs three-year contract with William Morris talent agency, where Johnny Hyde is a vice president.

DECEMBER 18

Johnny Hyde dies.

DECEMBER 31

Selection by *Stars and Stripes* as "Miss Cheesecake of 1950."

FILMS RELEASED IN 1950
Love Happy (March 8), *A Ticket to Tomahawk*
(April 21), *The Asphalt Jungle* (June 20),
The Fireball (October 7), *Right Cross* (November 14),
All About Eve (November 22).

1951 JANUARY
Meets Arthur Miller and Elia Kazan
on the set of *As Young as You Feel*.

SPRING
Begins private acting lessons with Michael Chekhov.

MARCH
Marilyn's six-block walk barefoot in a sheer negligee
from the wardrobe department to the photo studio
on the Fox lot results in huge publicity for her.

MARCH
Marilyn vamps Spyros Skouras at a lunch for Fox
exhibitors. He tells Zanuck to sign her contract
and cast her in any available blonde role.

MARCH
Charles Feldman and his Famous Artists Agency
begin to represent Marilyn, although she does not
sign a contract with Feldman until March 1953.

MAY
Marilyn becomes friendly with Sam Shaw, a friend
of Elia Kazan's, when Marilyn drives Shaw to location
filming for Kazan's *Viva Zapata* at the Fox Ranch
in the San Fernando Valley.

MAY 11
Signs second contract with Fox.

AUTUMN
Sidney Skolsky persuades Jerry Wald to cast Marilyn
in *Clash by Night* at RKO.

FILMS RELEASED IN 1951
As Young as You Feel (June 15), *Home Town Story*
(July 18), *Love Nest* (November 14), *Let's Make
It Legal* (October 31).

1952 JANUARY
Date with Joe DiMaggio; their romance begins.

LATE FEBRUARY
Nude calendar story breaks.

JUNE 1
Learns that she has been cast as Lorelei Lee
in *Gentlemen Prefer Blondes*.

SEPTEMBER 2
Grand marshal of Miss America pageant.

FILMS RELEASED IN 1952
Clash by Night (June 16), *We're Not Married* (July 23);
Don't Bother to Knock! (July 30), *Monkey Business*
(October 1), *O. Henry's Full House* (September 18).

1953 JANUARY
Starts filming *Gentlemen Prefer Blondes*.
Studies voice with Phil Moore and then Hal Schaefer.
Mime lessons with Lotte Goslar.
Works with Jack Cole on movement.

MARCH 9
Named "Fastest Rising Star of 1952"
by *Photoplay* magazine.
Gladys Eley is moved into Rockhaven Sanitarium.

MARCH 12
Signs with Charles Feldman
and his Famous Artists Agency.

SPRING
Named "Best Young Box Office Personality"
by *Redbook* magazine.

JUNE 26
Imprints hands and feet in the courtyard
of Grauman's Chinese Theater.

AUGUST–SEPTEMBER
Filming of *River of No Return*.

MID-SEPTEMBER
Meets Milton Greene and has photo session
with him (some biographers claim that she
met him in 1949).

SEPTEMBER 28
Grace Goddard dies.

OCTOBER 10
Marilyn hires Inez Melson as her business manager.
Inez soon takes over as guardian of Gladys Baker Eley.

NOVEMBER
Publication of Greene's photos, including one
with Marilyn holding a balalaika, in *Look*.

DECEMBER
Begins interviews with Ben Hecht for *My Story*.

FILMS RELEASED IN 1953
Niagara (January 23), *Gentlemen Prefer Blondes*
(July 31), *How to Marry a Millionaire* (November 5).

1954 JANUARY 11
Rejects *The Girl in Pink Tights*.

JANUARY 14
Marries Joe DiMaggio.

JANUARY 28–MARCH 5
Honeymoon in Japan with Joe.

FEBRUARY 17–21
Tour of Korean military bases.

MARCH
"Best Actress," *Photoplay* awards, for *Gentlemen
Prefer Blondes* and *How to Marry a Millionaire*.

APRIL—AUGUST
Filming of *There's No Business Like Show Business*.
Hal Schaefer is Marilyn's voice coach.

SEPTEMBER
Filming begins on *The Seven Year Itch*.

SEPTEMBER 15
Skirt-blowing photograph taken by Sam Shaw.

OCTOBER 5
Announces separation from Joe DiMaggio.

OCTOBER 27
Preliminary divorce from Joe.

NOVEMBER
Persuades Mocambo to honor contract
with Ella Fitzgerald.

DECEMBER
Fires Charles Feldman and his Famous Artists
as talent agent, signs with Lew Wasserman
and his Music Corporation of America.

LATE DECEMBER
Moves to New York City, establishes Marilyn
Monroe Productions with Milton Greene.

FILMS RELEASED IN 1954
River of No Return (May 5), *There's No
Business Like Show Business* (Dec. 25).

1955 C. JANUARY—FEBRUARY
Rekindles romance with Arthur Miller.

FEBRUARY
Begins studying acting with Lee Strasberg
and attends sessions at his Actors Studio.
Begins therapy with Freudian analyst
Margaret Hohenberg.

JUNE 1
Premiere of *The Seven Year Itch*.

NOVEMBER
Final divorce decree from Joe DiMaggio.

DECEMBER 31
Signs contract with Twentieth Century-Fox.

FILMS RELEASED IN 1955
The Seven Year Itch (June 15).

1956 JANUARY
Inez Melson resigns as Marilyn's business manager.

FEBRUARY 16
Press conference with Laurence Olivier to announce
filming of the play, *The Sleeping Prince* (released
as *The Prince and the Showgirl*).

FEBRUARY 22
Cecil Beaton photographs Marilyn in front
of a Japanese wall hanging.

LATE FEBRUARY—MAY
Filming of *Bus Stop*.

JUNE 11
Miller granted Reno divorce.

JUNE 21
Miller testifies before HUAC.

JUNE 29
Marries Arthur Miller.

JUNE—LATE NOVEMBER
Filming of *The Prince and the Showgirl* in London.

NOVEMBER 20
Marilyn flies back to New York from London.

FILMS RELEASED IN 1956
Bus Stop (August 1956)

1957 JANUARY 19
Moves into New York apartment on East 57th Street
with Arthur Miller.

JANUARY 1957—58
When in New York, spends mornings during the week
in therapy session with Marianne Kris before acting
session with Lee Strasberg.

FEBRUARY 18
Miller indicted on two charges of contempt of Congress.

APRIL 11
Milton Greene is fired from Marilyn Monroe Productions.

SUMMER
Begins renting house on beach at Amagansett.

AUGUST 1
Miscarriage due to ectopic pregnancy.

AUGUST 11
Purchase of farm in Roxbury, Connecticut.

FILMS RELEASED IN 1957
The Prince and the Showgirl (July 3).

1958 MAY 29
Initial posing for Avedon shoot as "Famous Temptresses."

AUGUST 4
Starts filming *Some Like It Hot*.

DECEMBER 16
Miscarriage.

DECEMBER 22
Publication of Richard Avedon siren photos in *Life*.

1959 MARCH
Wins "Best Foreign Actress of 1958," a David di Donatello
prize (the Italian equivalent of the Oscar), for *The Prince
and the Showgirl*.

Wins "Best Foreign Actress" Crystal Star Award
(the French equivalent of the Oscar), for *The Prince
and the Showgirl*.

SEPTEMBER
Sees Yves Montand in New York show, considers casting
him in *Let's Make Love*.

SEPTEMBER 19
Attends Hollywood lunch for Nikita Khrushchev.

DECEMBER 1959—JUNE 1960
Filming of *Let's Make Love*.
Begins therapy with Ralph Greenson.

FILMS RELEASED IN 1959
Some Like It Hot (April 8).

1960 MARCH
Wins Golden Globe award from the Hollywood Foreign
Press Association for "Best Actress in a Comedy,"
for *Some Like It Hot*.

APRIL–JUNE
Affair with Yves Montand.

JULY 18
Starts filming *The Misfits*.
Pat Newcomb of the Arthur Jacobs Agency assigned
as Marilyn's press agent.

AUGUST 6
Collapses, flown to Los Angeles for ten days
of hospitalization for drug abuse and exhaustion.

NOVEMBER 10
Announces that she and Miller are divorcing.

NOVEMBER 16
Clark Gable dies.

FILMS RELEASED IN 1960
Let's Make Love (Aug. 24).

1961 JANUARY 21
Divorces Arthur in Juárez, Mexico.

FEBRUARY 5
Admitted to Payne Whitney Clinic in Manhattan
for serious psychiatric disturbance.

FEBRUARY 10
Moved to Columbia Presbyterian (stays until March 5).

MARCH 6–20
Vacation in Florida with DiMaggio.

APRIL
Begins affair with Frank Sinatra.

JUNE 29
Gallbladder operation in New York.

AUGUST
Moves to Hollywood, begins daily therapy
sessions with Ralph Greenson.

LATE NOVEMBER
Undergoes detox treatment at home.

FILMS RELEASED IN 1961
The Misfits (February 1).

1962 LATE JANUARY
Purchases Brentwood house.

FEBRUARY 1
Meets Robert Kennedy at dinner at Peter
and Patricia Lawford's house.

FEBRUARY
Visits Isidore Miller in Florida.

FEBRUARY 21–MARCH 2
Spends eleven days in Mexico buying furniture
and decorations for her new house.

MARCH 5
Awarded Golden Globe from Hollywood Foreign Press
Association as "Female World Film Favorite 1961."

MARCH 24
Marilyn spends the weekend with JFK at Bing Crosby's
ranch in Palm Springs.

SPRING
Ends association with MCA (Wasserman); Milton Rudin
her lawyer, becomes her agent.

APRIL 30
Marilyn's first day on set of *Something's Got to Give*.

MAY 19
Performs at JFK's forty-fifth birthday party
at Madison Square Garden.

MAY 23
Does nude scene for *Something's Got to Give*.

JUNE 8
Fired from *Something's Got to Give*.

AUGUST 1
Reinstated in *Something's Got to Give*;
offered star contract by Fox.

AUGUST 4
Dies from overdose of Nembutal; coroner rules
death "probable suicide."

AUGUST 8
Funeral.

1 Richard Avedon, Philippe Halsman, in Ralph
 Hattersley, "Marilyn Monroe: The Image and Her
 Photographers," in *Marilyn Monroe: A Composite
 View*, ed. Edward Wagenknecht (Philadelphia:
 Chilton, 1969), 58–61.

2 Paul Weeks, "Ex-Press Agent Recalls Monroe's
 Magic Appeal," *Los Angeles Times*, August 7, 1962.

3 *Los Angeles Times*, "40th GIs Stampede at Sight of
 Marilyn Monroe," February 18, 1954.

4 Tony Curtis, *American Prince: A Memoir* (New
 York: Harmony Books, 2008), 214.

5 Arthur Miller, *Timebends* (1987; New York:
 Penguin, 1995), 428–29.

6 Earl Wilson, "This is a New Marilyn," *Movie World*,
 June 1955.

7 The reconstruction of Marilyn's contract disputes
 with Fox is based on the letters in the file cabinets
 and on the file on Marilyn Monroe in the Records of
 the Twentieth Century-Fox Legal Department, Film
 and Television Archive, University of California,
 Los Angeles (UCLA).

8 Author interview with John Strasberg, May 2006.

9 Donald Bogle, *Dorothy Dandridge: A Biography*
 (New York: Amistad, 1997), 256.

10 Twentieth Century-Fox board meeting, New York,
 December 29, 1955, file 7781, legal file for Marilyn
 Monroe, Records of the Twentieth Century-Fox
 Legal Department, UCLA.

11 Norman Rosten, *Marilyn: An Untold Story* (1967;
 New York: Trident, 1973), 16.

12 Virginia Pope, "Patterns of the Times: American
 Designer Series: John Moore," *New York Times*
 (April 5, 1954), 22.

13 Susan Strasberg, *Marilyn and Me: Sisters, Rivals,
 Friends* (New York: Warner Books, 1992), 242.

14 Eunice Murray with Rose Shade, *Marilyn: The Last
 Months* (New York: Pyramid Books, 1975), 133.

15 Randall Riese and Neal Hitchins, *The Unabridged
 Marilyn: Her Life from A to Z* (London: Congdon
 and Weed, 1987), 255.

16 Sam Shaw and Norman Rosten, *Marilyn Among
 Friends* (New York: Henry Holt, 1972), 158.

17 AP wire service story, May 28, 1958, Stacy Eubank
 Collection.

18 Rosten, *Marilyn: An Untold Story*, 54; and Hedda
 Hopper, *Chicago Sunday Tribune Magazine*, June
 22, 1958.

19 See Inez Melson to J. Emory Cross, December
 19, 1966 (MC); and Berniece Baker Miracle and
 Mona Rae Miracle, *My Sister Marilyn: A Memoir
 of Marilyn Monroe* (New York: Boulevard Books,
 1994), 226–37.

20 Harry Lipton, "Marilyn's the Most," *Motion Picture*,
 May 1956, Stacy Eubank Collection.

21 "Big Season Is Seen for Cotton Garb," *New York
 Times* (March 30, 1952), 7; and Virginia Pope,
 "Russeks Displays Budget Fashion," *New York Times*
 (December 1, 1954), 37.

22 Author interview with Patricia Rosten, March 12,
 2008.

23 The most insightful source on Marilyn's finances at
 the time of her death is David Stenn, "Marilyn Inc,"
 Film Comment, August 1985.

24 Eric Woodard, with David Marshall, *Hometown
 Girl* (North America: HG Press, 2004); interview
 with Angelo Daluco, in Maury Allen, *Where Have
 You Gone, Joe DiMaggio? The Story of America's
 Last Hero* (New York: Dutton, 1975); Bob Considine
 in *Herald Examiner*, clipping, n.d., Jimmy Starr
 Collection, Arizona State University, Tempe;
 Dorothy Manners, filling in for Louella Parsons,
 August 13, 1962, Stacy Eubank Collection.

25 Many descriptions of Marilyn's funeral were written
 by individuals who attended it. The term "in one big
 wave" comes from Lotte Goslar, *What's So Funny:
 Sketches from My Life* (Amsterdam: Harwood,
 1998), 119. In his syndicated column, however,
 journalist Nathan Cohen contended that the mob
 destruction of the flowers at Marilyn's funeral
 never occurred; Nathan Glazer, "Star Material,"
 Toronto Daily Star, August 12, 1962, Stacy Eubank
 Collection.

ACKNOWLEDGMENTS

LOIS BANNER

My thanks to Eric Klopfer for his brilliant editorial direction and to William Clark, my always calm and imaginative agent, who kept this project going during its difficult gestation and subsequent life. The help of Meta Shaw Stevens, Edythe Shaw Marcus, and Melissa Shaw Stevens—the daughters and granddaughter of Sam Shaw—was invaluable, as it always is. Joshua Greene, Milton Greene's son, helped me find photographers who had photographed Monroe. Karin Huebner helped me with research, as did Stacy Eubank, who also gave me access to her superb Marilyn collection. And thanks, of course, to Gabriele Wilson, and the design team at Abrams.

Without the assistance of Marilyn Remembered members Greg Schreiner, Scott Fortner, David Marshall, Roy Turner, and Jill Adams, this book couldn't have been written. John Laslett, my husband, was patient and supportive, and Olivia Banner, my daughter, contributed her brilliant writing skills. I am also grateful to the University of Southern California for the sabbatical leaves I have been given to complete this book.

Very special thanks go to David Strasberg and to Anna Strasberg, the head of the Monroe Estate, for extending permission to use the materials from the Monroe Archive that is in her possession.

MARK ANDERSON

My wife Marietta Anderson for her unending love and support.
Lois Banner for her constant passion and intelligence.
My publishing agent, William Clark, whose guidance brought us here.
To my attorney, Kenneth Ingber, for navigating me through rough seas.
Thank you to Jerry and Lois Levin for their honest critique.
To Eric Klopfer and his keen sense of honest direction.
A special thanks to Profoto Lighting, Hasselblad Cameras, and Leaf Digital for their gracious support.

EDITOR: Eric Klopfer
DESIGNER: Gabriele Wilson
ART DIRECTOR: Michelle Ishay
PRODUCTION MANAGER: Anet Sirna-Bruder

Library of Congress Cataloging-in-Publication Data

Banner, Lois W.
 MM; personal : from the private archive of Marilyn Monroe / Lois Banner;
photographs by Mark Anderson.
 p. cm.
Includes bibliographical references and index.
ISBN 978-0-8109-9587-1 (alk. paper)
1. Monroe, Marilyn, 1926-1962. 2. Motion picture actors and
actresses—United States—Biography. I. Title.
PN2287.M69B34 2010
791.4302'8'092—dc22
[B]

 2010007774

ABRAMS
THE ART OF BOOKS SINCE 1949

115 West 18th Street
New York, NY 10011
www.abramsbooks.com

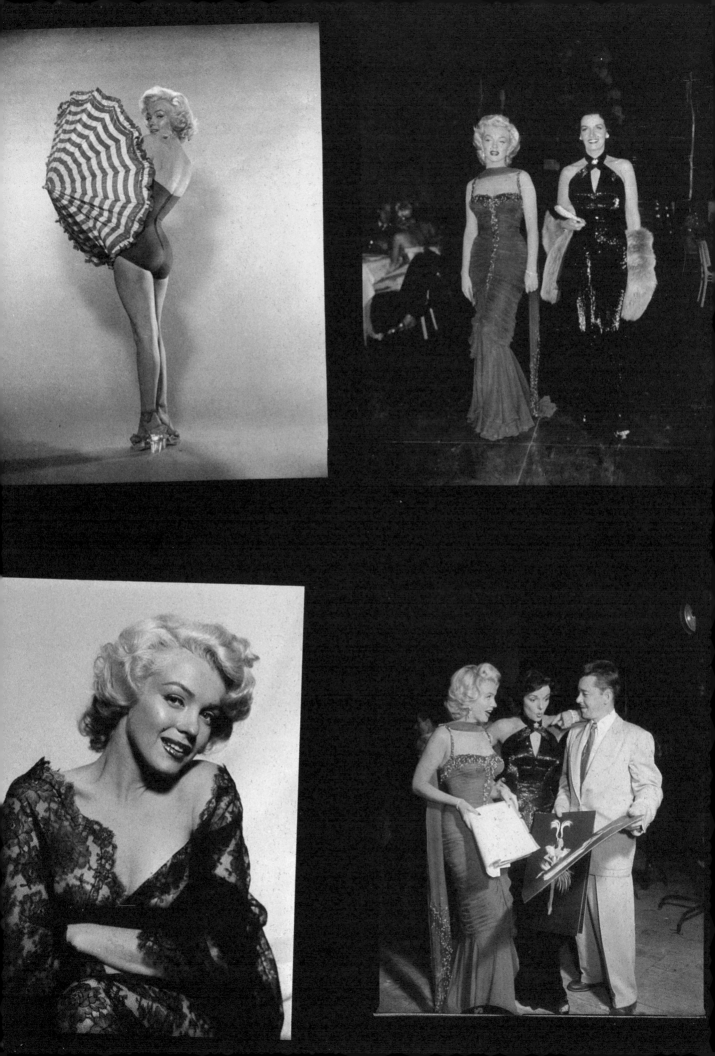